The Fate of Art

To my father and sister
— and in memory of my mother

Literature
and
Philosophy

A. J. Cascardi, General Editor

This new series will publish books in a wide range of subjects in philosophy and literature, including studies of the social and historical issues that relate these two fields. Drawing on the resources of the Anglo-American and Continental traditions, the series will be open to philosophically informed scholarship covering the entire range of contemporary critical thought.

The Fate of Art

*Aesthetic Alienation from Kant
to Derrida and Adorno*

J. M. Bernstein

The Pennsylvania State University Press
University Park, Pennsylvania

First published 1992 in the United States by The Pennsylvania State University Press, Suite C, 820 North University Drive, University Park, PA 16802

ISBN 0–271–00838–5 (cloth)
ISBN 0–271–00839–3 (paper)

Library of Congress Cataloging in Publication Data
A CIP catalogue record for this book is available from the Library of Congress

It is the policy of The Pennsylvania State University Press to use acid-free paper for the first printing of all clothbound books. Publications on uncoated stock satisfy the minimum requirements of American National Standard for Information Sciences—Permanence of Paper for Printed Library Materials, ANSI 239.48-1984

Typeset in 10½ on 12 pt Ehrhardt
by Graphicraft Typesetters Ltd., Hong Kong
Printed in Great Britain by T J Press, Padstow

Contents

Acknowledgements

This work would not have taken its present shape had it not been for the intense and congenial atmosphere I have enjoyed in the Philosophy Department of the University of Essex over the past dozen years. In particular, I must thank Robert Bernasconi; his enthusiasm for Heidegger kept me reading him, and it was he who first explained to me Heidegger's history of being. During the decade we were colleagues, we shared our first reading of Derrida with each other, and a lot more.

While I have learned much from several research students in the Department, I must mention Nick Land; Michael Newman, who helped me to understand Van Gogh and modern art; Olivier Serafinowicz; and Ian Williamson, whose efforts in helping me translate passages from Adorno's *Aesthetic Theory* will be a bonus for all readers of this text. If there is credit here, it must be his; mine is the blame.

Three friends read the manuscript as a whole and offered advice, criticism and support. No one will read this work as carefully and thoughtfully as Robert Pippin did. His pages of criticism and argument shaped the direction of my rewriting. Howard Caygill knew just what I was trying to do and told me how to do it better. He and Gillian Rose gave me Brighton during the summer of 1988 where the first draft of chapter 4 was written. There is no one to whom I am closer intellectually and spiritually than Gillian Rose; what is best in this work would not have been there without her. For the rest I alone am responsible.

My editor at Polity Press, John Thompson, kept faith and through his cautions made me produce a more generally accessible text.

Portions of this work have been published previously as: 'Aesthetic

alienation: Heidegger, Adorno, and truth at the end of art', in *Life After Postmodernism*, ed. John Fekete (London: Macmillan, 1987), pp. 86–119; 'The politics of fulfilment and transfiguration', *Radical Philosophy*, 47 (1987), pp. 21–9; 'Art against enlightenment: Adorno's critique of enlightenment', in *The Problems of Modernity*, ed. Andrew Benjamin (London: Routledge, 1989), pp. 49–66.

J. M. Bernstein
Colchester, Essex

Abbreviations

AT T. W. Adorno, *Aesthetic Theory*, tr. C. Lenhardt (London: Routledge & Kegan Paul, 1984)

CJ Immanuel Kant, *The Critique of Judgement*, tr. James Creed Meredith (Oxford: Clarendon Press, 1952)

DoE Max Horkheimer and T. W. Adorno, *Dialectic of Enlightenment*, tr. John Cumming (London: Allen Lane, 1973)

E Jacques Derrida, 'Economimesis', *Diacritics* 11, 2 (1981), pp. 3–25

N Martin Heidegger, *Nietzsche*, vol. I: *The Will to Power as Art*, tr. David Farrell Krell (London: Routledge and Kegan Paul, 1981)

Niii Martin Heidegger, *Nietzsche*, vol. III: *The Will to Power as Knowledge and as Metaphysics*, tr. Joan Stambaugh, David Farrell Krell and Frank A. Capuzzi (London: Routledge and Kegan Paul, 1987)

ND T. W. Adorno, *Negative Dialectics*, tr. E. B. Ashton (London: Routledge and Kegan Paul, 1973)

OWA Martin Heidegger, 'The origin of the work of art', in *Poetry Language, Thought*, tr. Albert Hofstadter (London: Harper and Row, 1971)

PH Hans-Georg Gadamer, *Philosophical Hermeneutics*, tr. and ed. David E. Linge (Berkeley: University of California Press, 1976)

QT Martin Heidegger, *The Question Concerning Technology and Other Essays*, tr. William Lovitt (New York: Harper and Row, 1977)

RB Hans-Georg Gadamer, *The Relevance of the Beautiful and Other Essays*, tr. Nicholas Walker (Cambridge: Cambridge University Press, 1986)

SAT T. W. Adorno, *Äesthtische Theorie* (Frankfurt a.m.: Suhrkamp
 Verlag, 1970)
TM Hans-Georg Gadamer, *Truth and Method*, tr. W. Glen-Doepel
 (London: Sheed and Ward, 1975)
TP Jacques Derrida, *The Truth in Painting*, tr. Geoff Bennington and
 Ian McLeod (London: University of Chicago Press, 1987)
TSR Albrecht Wellmer, 'Truth, semblance, reconciliation: Adorno's
 aesthetic redemption of modernity', *Telos*, 61 (1984/5), pp. 89–
 115

Introduction:

Aesthetic Alienation

> Very early in my life I took the question
> of the relation of *art* to *truth* seriously:
> even now I stand in holy dread in the face
> of this discordance.
>
> F. Nietzsche, *Nachlass*

The discordance of art and truth, in the face of which Nietzsche felt holy dread, is as old as philosophy itself. Philosophy began with Plato's challenge to the authority of Homer, and with the expulsion of the poets from the republic that was to be grounded in reason, truth, alone. That challenge and expulsion stand over and constitute modernity even more emphatically than they did Plato's philosophical utopia. Modern, autonomous art – the art whose forms have become autonomous from the dominion of the metaphysical assumptions and orientations of Christian faith – has been 'expelled' from modern societies, from the constitutive, cognitive and practical mechanisms producing and reproducing societal modernity: that is the thesis animating this work, and its primary aim is to sustain Nietzsche's holy dread through an analysis of the discordance between art and truth as it informs contemporary philosophy.

For Nietzsche but not for him alone, the discordance between art and truth arouses dread because art and aesthetics (the theoretical discourse that comprehends art in its autonomous, post-Christian guise) appear as somehow more truthful than empirical truth (knowledge understood as the subsumption of particulars under concepts or kinds under laws, and

truth as a correspondence between statements – laws, theories, etc. – and facts), more rational than methodical reason, more just than liberal justice (beauty, or what beauty signifies, designating the first virtue of social institutions), more valuable than principled morality or utility. There is dread in this for two reasons: first, because part of our experience of art is its becoming only art, mere art, a matter of taste; secondly, because as such, art and aesthetics always appear to be outside truth, reason and morality, thus art being 'more' than these is always indemonstrable, and incommensurable with what truth saying and valuing have become as rational enterprises. If art is taken as lying outside truth and reason then if art speaks in its own voice it does not speak truthfully or rationally; while if one defends art from within the confines of the language of truth–only cognition one belies the claim that art is more truthful than that truth–only cognition.

In order to make sense of this aporia it must be conceded that the discordance between art and truth is misconstrued if regarded as an opposition that simply inverts their relationship: art and aesthetics are true while truth–only cognition, say in its realization in the natural sciences, is false. The challenge is rather to think through what truth, morality and beauty (or its primary instance: art) are when what is denied is their categorial separation from one another – a separation, I shall argue, following Weber and Habermas, that is constitutive of modernity.[1] It is the entwinement of art and truth, the experience of art as somehow cognitive and of truth as sensuous and particular, and not the substitution of one for the other within a stable metaphysical hierarchy, that constitutes the challenge. The immediate repercussion of this thesis for art and aesthetics is that they are wrongly understood if they are treated in opposition to knowledge and truth, morality and right action. To consider art as 'merely' aesthetical, where 'aesthetics' has come to mean the understanding of beauty and art in non-cognitive terms, entails alienating art from truth and morality. Hence the challenge to modernity from the perspective of art and aesthetics, which insofar as it truly comprehends the experience of art must exceed its constitution as standing outside truth, tends to occur primarily through philosophies of art that take artistic phenomena as more than a matter of taste, as more than merely 'aesthetic' phenomena.

The theoretical and practical etiolation of the meaning of aesthetic phenomena, the relegation of art and aesthetics to what is outside truth and goodness, occurred as a consequence of a double isolation: first, through the diremption of the question of moral value from questions of truth and falsity – the fact/value distinction – that resulted from the growth of modern science and its methodological self-understanding; and secondly, through the separation of artistic worth from moral worth – the inscribing of art within the autonomous domain of the 'aesthetic'. This

latter separation received its most perspicuous representation in the Kantian dictum that works of art are purposeful in themselves, while lacking any positive, practical (moral) end over and above their internal complexion. Of course, even in Kant, aesthetic judgement was defined not only by means of the exclusion of cognition and moral worth, but equally through the approximation and analogy in aesthetic judgement of judgement in a concept and the requirement of universality. Which is to say, from the beginning of the aesthetic construal of art there was a strain on our conception of aesthetic judgement and what it told us about art works – assuming for the purposes of argument that our conception of art and judgement are roughly delineated by the Kantian exclusions. What can we make of a domain in which questions of truth, goodness, efficacy, even pleasure (since our interest in art is 'disinterested') are eliminated at the outset? What sort of beast might beauty be if in considering it we are not considering how the world is (truth), how we do or should comport ourselves in the world (morality), or what might be useful or pleasureable to us? A silent beast, then, given voice only through the gestures of approximation and analogy to what it is not. It is a small wonder that the reigning philosophical orthodoxy in the English-speaking world considered such a phenomenon at all, for it says nothing in its own voice, and when it does speak it is but an act of ventriloquism whereby truth and morality speak through it.

The central intention of this study is to interrogate and underwrite the aesthetic critique of truth-only cognition, and demonstrate how that critique results in a critique of enlightened modernity. I shall further claim that there is an indirect reconceptualization of politics and the meaning of the political at work in the aesthetic critique of modernity; the discourse of aesthetics is a proto-political discourse standing in for and marking the absence of a truly political domain in modern, enlightened societies. In order to indicate how this argument is to be pursued, we should first turn to the very idea of philosophies of art that seek to go beyond aesthetics.

If 'aesthetics' in its narrow sense refers to the understanding of art as an object of taste outside truth and morality, then 'post-aesthetic' theories of art are themselves critiques of truth-only cognition insofar as their going beyond aesthetics implies a denial of the rigid distinctions separating the claims of taste from the claims of knowing or right action. Post-aesthetic theories are the kind of philosophies of art examined in this work. They are, very approximately, the analogue in the philosophy of art for what post-positivist thinking is in the philosophy of science.[2] According to post-aesthetic theories, art works must be understood in nonaesthetic terms because the very idea of aesthetics is based upon a series of exclusions which themselves assume a conception of truth in terms of its

isolation from normative and 'aesthetic' values – an isolation which, recently, post-positivist philosophies of science have undermined. Further, just as post-positivism sees science and its object as historical constructions, so post-aesthetic theories of art attempt to interrogate art historically, asking not what art is, ahistorically, but what it has been and become. To understand art, to answer the question of the meaning and being of art, is to understand, grasp and gather a certain history. Which history, however, is just the question in dispute among competing post-aesthetic theories.

Post-aesthetic philosophies of art, the kind of theories that employ art in order to challenge truth-only cognition, tend to move in an opposite direction to post-positivist philosophies of science, locating the meaning and being of art in its cognitive dimension, thus connecting or reconnecting art and truth. This should not surprise us, for in denying positivism we have come to deny the separation of domains; thus the central plank in science's claim for a hegemony over questions of truth is taken away, which allows for the possibility that other forms of activity might have significant cognitive capacities, however different those capacities are from those of science. However, although the history of art up to the modern age appears to license the claim of art's cognitive potential (for example, religious art re-presenting the truth of Christian metaphysics), the modern experience of art does not; on the contrary, modern experience of art, it is argued, is precisely the experience of art as cut off and separated from truth, as silenced, as dirempted from all that would give it significance. Autonomous art is art that is autonomous from (rationalized) truth and morality. This is the historical truth that supports the claims of truth-only cognition and principled morality; it is the truth underlying Nietzsche's holy dread, and it provides us with the first hint as to how the discordance of art and truth comes to stand as a sign of modernity. The experience of art *as aesthetical* is the experience of art as having lost or been deprived of its power to speak the truth – whatever truth will mean when no longer defined in exclusive ways. This loss, no matter how theorized or explained, I shall call 'aesthetic alienation'; it denominates art's alienation from truth which is caused by art's *becoming* aesthetical, a becoming that has been fully consummated only in modern societies.[3]

Further, to the extent to which post-aesthetic philosophies of art conceive of art as having suffered a loss, the past is projected from the state of alienation as a time when art and truth were not in discordance, when they were united or in harmony. Thus every conception of the alienation of art from truth is simultaneously a work of remembrance, a work of mourning and grief, even for those philosophers who doubt that such an 'original' state of union ever existed. In modernity beauty is not only alienated from truth, but grieves its loss; modernity is the site of beauty bereaved – bereaved of truth.

One way of conceptualizing aesthetic alienation which includes the

moment of mourning is in terms of the end or death of art. Art ends as it becomes progressively further distanced from truth and moral goodness, as it loses its capacity to speak the truth concerning our most fundamental categorial engagements and commitments – an event Hegel identifies with art's separation from its epoch-long submersion in Christianity. But this first end of art is ambiguous for two reasons. First, what is lost or suppressed in aesthetic alienation, the end of art, equally involves a deformation of what art is separated from: truth prior to subsumption and goodness prior to procedural, universalistic moral reason. These too are deformed, but in ways that are not obvious; on the contrary, value-neutral reason and universalistic morality are often taken to represent the cognitive achievements of enlightened modernity. Nonetheless, if art is alienated from truth and goodness by being isolated into a separate sphere, then that entails that 'truth' and 'goodness' are alienated, separated from themselves. Aesthetic alienation, then, betokens truth's and reason's internal diremption and deformation. There is a second reason for the ambiguity. Because only art 'suffers' its alienation, because art discovers its autonomous vocation to be unstable and incapable of being sustained, because art must continually conceive of its autonomy as a burden it must both embrace and escape from, in all this art comes to speak the truth – in a 'language' that is not that of truth-only cognition – about the fate of truth and art in modernity. Art's exclusion from first-order cognition and moral judgement is, then, a condition of its ability to register (in a speaking silence) a second-order truth about first-order truth. Art is the critical self-reflection of truth-only cognition and its conscience. To consider art as alienated from truth, and not just separated from it in a happy language game of its own, is necessarily to conceive of it as acting in excess of its excluded status. When art loses its critical capacity it ends, will end, for a second time.

There is one moment in this story of art's alienation from truth and its attempt to overcome that alienation that is of special significance: it is Kant's *Critique of Judgement*. The significance of Kant's work is twofold. On the one hand, it is Kant's third *Critique* that attempts to generate, to carve out and constitute, the domain of the aesthetic in its wholly modern signification. In securing an autonomous domain of aesthetic judgement, a domain with its own norms, language and set of practices, Kant was simultaneously securing the independence of the domains of cognition and moral worth from aesthetic interference. Following Habermas, I shall argue that the categorial divisions of reason represented by the three *Critiques* inscribes a theory of modernity through its provision of a categorial understanding of the differences between what have come to be called the language games of knowing, right action and moral worth, and art and aesthetics.[4] Modernity is the separation of spheres, the becoming autonomous of truth, beauty and goodness from one another, and their

developing into self-sufficient forms of practice: modern science and tech-
nology, private morality and modern legal forms, and modern art. This
categorial separation of domains represents the dissolution of the meta-
physical totalities of the pre-modern age. To this day, for most philosophers
this division of labour remains unimpeachable. Even writers on art who
think that the proper way of comprehending art is as an institutional
phenomenon, a move that at first glance appears to parallel post-positivist
philosophy of science, hold that the language of art, art practices, are au-
tonomous practices, wholly unlike ethical or cognitive practices. And this
should tell us that the move to 'practice' talk, to providing an account of
what it is and what it is not to be a full citizen of the art world, does not of
itself directly entail the kind of sublation of distinctions central to over-
coming aesthetics; such talk merely replaces mental talk (aesthetic attitudes
and the like) by practice (institution or language game) talk, but leaves the
categorial separation of art and truth firmly in place.

On the other hand, part of Kant's project in the *Critique of Judgement*
was to use aesthetic judgement in order to locate the underlying unity of
reason and to cross the gulf separating the domains of freedom and nature,
ought and is. Almost no one has thought Kant successful in this endeav-
our. On the contrary, for many of the generation of philosophers following
Kant, his failure here was a clue to the failure, the wrong turning, of the
Critical programme itself. For them, the arguments of the third *Critique*
indicated the falsity of the categorial divisions between the three faculties
of mind and their respective object domains. They saw in the third
Critique the shadowy outlines of a philosophy premised upon the subla-
tion of those legislative divisions. But since for them, for Schiller,
Schelling and Hegel, the categorial divisions of the Critical system were
indices of the fragmentations constituting modern societies, then in
seeking to contrive an overcoming of Kant they were simultaneously
engaged in a critical project for the overcoming of modernity.[5] And
because for them, for German Idealism and Romanticism, it was precisely
the domain of art and aesthetics that was the Archimedean point that
allowed for the overcoming of modernity, then there was also a natural
temptation to regard the provision of a new aesthetic, a post-aesthetic
philosophy of art, as the political means through which modernity was to
be reconstituted. For them the highest act of reason was to be an aesthetic
act, and their goal was to provide a new mythology of reason that would
unite mankind. For aesthetic modernism, as these critical projects may be
called, the alienation of art from truth must be construed as both a
categorial cause and a symptom of the dislocations and deformations
underlying modernity; the aesthetic domain as characterized by Kant
provides insight into those dislocations and deformations as well as
insinuating the conceptual resources for transformation and reintegration,
resources for the political transformation of the modern world. Whether

blindly or knowingly, this is the critical programme pursued by the writers discussed in this book.

What the claim for the double effect of the third *Critique* amounts to is the thesis that the division between critics and supporters of enlightened modernity (a division sometimes thought of as central to what separates the traditions of modern continental and analytic philosophy) is best located on and around the ambiguous legacy of the third *Critique*. If one reads the *Critique* as moderately successful in establishing the autonomy of the aesthetic domain, one will follow the trajectory of analytic philosophy in its pursuit of truth-only cognition. Following this trajectory amounts to the uncritical acceptance of enlightened modernity. If one reads the *Critique* as the radical undoing of the categorial divisions between knowledge, morality and aesthetics, one will follow the trajectory of the continental tradition. Following this trajectory involves a critique of enlightened modernity. The *Critique of Judgement*, and not the philosophy of Hegel, is the place where the question of modernity is most perspicuously raised, where the categorial claims that Enlightened modernity must substantiate for itself are most visibly at issue. Are the goals of the Enlightenment truly fulfilled through the categorial separation and division of spheres; or do those divisions prohibit the fulfilment of the goals and intentions which their emergence promise?

Initially, I had intended my opening chapter on Kant to be a rehearsal of the coming to be of the domain of the aesthetic premissed upon a series of negations: aesthetic judgment is without concept, without interest, without pleasure; its object purposeful but without purpose, etc. This was to be followed by accounts of the post-aesthetic theories that attempt to give back to art and 'aesthetics' all that Kant had negated. The husk of such readings is, perhaps, still visible. However, in the course of writing I found myself beginning to perceive not the familiar third *Critique* of Anglo-American commentaries, but the *Critique* as it might have appeared to its German Idealist reader. Chapter 1 attempts analytically to reconstruct such a reading; my goal is to demonstrate how aporetic is aesthetic autonomy (from truth and moral rightness), and to locate within Kant's text its own implicit historical reflection, its own act of mourning, on the coming into being of autonomous aesthetics.

The repercussions of such a reading of Kant's third *Critique* are immense, for not only does it provide a first hint about the nature of the overcoming of the alienation of art from truth, but it begins to engender what we have come to think of as the fundamental conceptual vocabulary of continental philosophy, the philosophy that challenges enlightened modernity through recourse to the phenomena of art and aesthetics. A good deal of what I want to demonstrate in this work is that what we have come to recognize as the continental tradition involves, or is best construed as involving, a series of variations on themes drawn from Kant's

Critique of Judgement. Theoretically, this means that each writer con-
sidered will be shown to be pursuing a version of aesthetic modernism, an
aesthetic critique of enlightened reason and modernity; interpretatively,
each chapter will seek to demonstrate that the fundamental insight of the
text under consideration is best understood as the working out of one
(or more) of the fundamental concepts of Kant's aesthetics. The central
concepts of Kant's aesthetics – aesthetic reflective judgement, genius,
sensus communis, the sublime – are themselves critical interrogations of
our standard epistemological and moral vocabulary: aesthetic judgement
questions the paradigm of knowing as subsuming particulars under uni-
versals; the act of genius conceptualizes free action as creative and legisla-
tive rather than as rule following; the idea of the *sensus communis* installs
a notion of an epistemic community that breaks with the claims of meth-
odological solipsism and permits a reinscription of sensibility; while the
idea of the sublime provides for a conception of alterity or otherness that
challenges the sovereignty of the self-determining, autonomous moral sub-
ject. The language of Kantian aesthetics is not simply different from the
Critical vocabulary of knowing and right action, but, despite Kant's
intentions, raises a challenge to that vocabulary. In exploiting Kant's aes-
thetic discourse Heidegger (genius), Derrida (the sublime) and Adorno
(judgement and *sensus communis*) systematically pursue the work of deform-
ing and reforming our understanding of truth and morality.

To put this same point another way, at least one significant strain of
modern thought has been seeking ways of (re) connecting the modern
subject or self with an order beyond it, searching 'for moral sources
outside the subject through languages which resonate *within* him or her,
the grasping of an order which is inseparably indexed to a personal
vision'.[6] Now the writers I interrogate consider that such sources cannot
be discovered in, say, the fact of language as always intersubjective, or in
linguistic community as the inevitable bearer of the possibilities of indi-
vidual speech and action, that only requires a positive commitment to it in
order for communal life to be reinvigorated as a moral source and auth-
ority. This is the bland hope of so-called communitarian political theory.
The deprivations of modernity are experiential as well as theoretical, a
societal or cultural fatality as well as a philosophical perplexity. So for
Heidegger and Adorno access to sources of meaning beyond the self are
blocked, on the one hand by the disposition of modern social formations
as technologically oriented or rationalized, an iron cage, and on the other
hand by the disposition of our categorial frameworks, which in separating
the discourses of truth, goodness and beauty from one another debars us
from comprehensively recording our situation, from making intelligible
and significant its specific human weight and salience, its violences and
griefs, disruptions and insensitivities. A certain deformation of society and
culture simultaneously engenders a deformation of the terms through

which those first-order deformations could be cognized and critiqued. For reasons that will need extensive expounding, autonomous art manages, or managed, however indirectly, such a cognition and critique; and, even more significantly for my purposes, *aesthetic discourse contains concepts and terms of analysis, a categorial framework, which, if freed from confinement in an autonomous aesthetic domain, would open the possibility of encountering a secular world empowered as a source of meaning beyond the self or subject.* Aesthetic judgement, the judgement of taste, intends a cognition of what is significant or worthy in itself through the way it resonates for us; sublimity intends an experience of emphatic otherness or alterity irreducible to truth-only cognition or moral reason; genius intends an acting beyond the meaning-giving powers of the subjective will; the *sensus communis* intends a conception of community whose mutualities and attunements condition and orient what aesthetic judgement judges and genius creates. Together these concepts trace or envision an alternate form of community which is irrevocably 'political' in its complexion.

Hibernating within aesthetic discourse is another discourse, another metaphysics, the very one we apparently need in order to cognize and transform the one we routinely inhabit. Thus the refuge that aesthetics represents for this alternative conception of community and mode of cognition simultaneously entraps it, a trap that remains until its aesthetic confinement is brought to an end. In Heidegger, Derrida and Adorno the attempt is made to undo the block, release what art and aesthetic discourse signify from the spell that encloses them within the illusory world of art. Part of what is involved in this attempt is the assimilation of the discourse of this philosophical enterprise to the discourse of aesthetics; the hope of this practice is that through this assimilation philosophy will come to possess the critical characteristics of the (aesthetic) objects it is talking about. Aesthetic modernism in philosophy is not only *about* art's alienation from and critique of modernity, but equally *is* that alienation and critique; it is the attempt by philosophy to liken itself to an aesthetic object in order that it can both discursively analyse the fate of art and truth while simultaneously being works to be judged (the way poems are works to be judged). While this assimilation allows these philosophies to appropriate for themselves some of the power and force of art works, it equally entails their silencing and diremption from the sort of truth that remains dominant for us.

At one level, this state of affairs is inevitable. If truth-only cognition is both a deformed conception of truth and constitutive of modernity, then philosophy cannot say what is true without abandoning itself to that which it seeks to criticize. Alternatively, if the critique of truth-only cognition and modernity is lodged outside what truth has become, and hence is marginal and external to the accomplishments of modernity, then in remaining loyal to its object, in its conceptual fidelity to art, philosophy loses the

capacity discursively to understand and explain. This is the constitutive aporia of aesthetic modernism: in remaining fully discursive it betrays what reason and truth could be, what art and aesthetic discourse remain a promise of; but if it abandons the rigours of full discursivity it necessarily falls silent, an inmate in the refuge and prison of art.

Perhaps the procedural dilemma that the thesis of aesthetic alienation entails can be put this way. If art works and aesthetic discourse do not embody a self-sufficient alternative to truth-only cognition, but rather reveal its limits through exemplifying their own partial character, their own internal contradictions and aporiai, then one cannot take up a position either inside or outside them. To take up a position inside would mean having philosophy join art in its strangled discourse, thereby leaving the origin of that state of affairs unexplained and unaccounted for. Conversely, to explain modernity philosophically means standing outside the critical vantage point art permits and subsuming it under the very terms of reference it is struggling against. An 'outside' position is suggested by each of the philosophers considered except Derrida: it is the history of progressive moral culture in Kant; the history of being (as the epoch of metaphysics) and modernity as governed by the essence of technology in Heidegger; and the history of rationalization completing itself in capitalism in Adorno. Each of these histories explain modernity, providing the ultimate frame of reference for understanding it. And in order to situate these competing accounts and arbitrate between them, I shall place their accounts within what I take to be the best historical account of modernity. That will be this work's 'affinity to barbarism',[7] its rationalistic moment.

Yet Derrida is not wrong in demurring from such accounts, for these transcendent perspectives approximate in one way or another to the very thing they are attempting to twist free from and overcome. In positing, through whatever means, a history as the specific determinant of our fate they, and I, take up a position outside history and unify it, giving it the very unity and transcendence they are otherwise writing against. A philosophical history of art, or politics, displaces the uniqueness of the art work or human action with a meaning external to it. So, Hannah Arendt has argued,

> Hegel's philosophy, though concerned with action and the realm of human affairs, consisted in contemplation. Before the backward-directed glance of thought, everything that had been political – acts, and words, and events – became historical, with the result that the new world which was ushered in by the eighteenth century did not receive...a 'new science of politics', but a philosophy of history.[8]

Arendt's own work is vitally concerned with the disappearance of political action and judgement, political life itself, since the time of the Greeks; and one of the central events in her narrative is the development of the philosophy of history which simultaneously acknowledges and wipes away, as with a sponge, the immanence of human affairs, entwining them in providence, progress, class conflict, the workings of the 'invisible hand', etc. But in recording the story of the suppression of political judgement and action Arendt becomes another philosophical contemplator of history. She can only reveal, judge, the fate of political judgement through recourse to the very kind of history which is the suppression of judgement.

If art is alienated from truth but not its absolute other, if political action is alienated from historical meaning but not its absolute other (as Arendt appears to believe), then the procedural, philosophical aporia encapsulated in the dialectic of immanent (inside) and transcendent (outside) criticism, deriving from their incommensurability with each other, must equally be a product and symptom of the phenomenon being analysed. When Adorno, for example, concedes that transcendent criticism, the providing of a philosophy of history, contains an 'affinity to barbarism' and yet insists upon it, he is making more than an epistemological point about the unavoidability of the critique recoiling upon the critic.[9] What appears as a recoil that usurps the critic epistemologically is *ethically* a moment of self-implication, an acknowledgement of complicity and guilt. For Adorno that acknowledgement of complicity and guilt is the ethical gesture that makes critique possible. I shall follow Adorno in this, arguing that the question of method, the question of inside and outside, of immanence and transcendence, the question of how philosophy is to comport itself when its terms of analysis are always already elements of a deformation of reason, must be construed as a question of ethics and politics. Or rather, if truth-only cognition does represent both the reality and deformation of existing reason, then philosophical writing must find a way of 'expressing' its non-neutrality, its defence of a rationality that its own standard forms of working proscribe.

Nor is the mention of ethics and politics extraneous to the main lines of argument in this essay. I began this introduction by invoking the discordance between art and truth that arose in the expulsion of the poets from Plato's ideal state. That the discordance between art and truth first arose in this 'political' setting is significant. In order to adumbrate the nature of that significance I want to tell a fable, a mythic story.

Once upon a time there was a precipitous moment in the history of the West when the debate between philosophy and politics, between theory as contemplation and political *praxis*, was in a state of tense equilibrium, undecided one way or the other. Such a moment was certainly after the moment of Greek tragedy; perhaps it occurred at or just after the time of

the trial of Socrates. It is a moment recalled, but which may never have existed, in Aristotle's imaging of the *bios politikos*, Greek ethical life, as the life of the *polis*. In Plato's *Republic* the issue between political life and the theoretical, the life of contemplation, is decided: the autonomy and independence of theory is established through the institution of a disinct and authoritative domain outside the changing and fragile arena of human affairs. Henceforth, politics (practice) was to be only the application of theory to the world. Practice lost its own sight, its own form of reasoning and activity. Practical reason became the application of theoretical understanding to practical matters rather than a form of worldly engagement in its own right. The triumph of the life of contemplation in Plato – which would be continued in Christianity, in modern philosophies of history and in the economic organization of mass societies – spelled the end of ethical life almost before it had begun. This is a story familiar to readers of Arendt and Hegel.[10]

Now at the same time as Plato was erecting his theoretical republic, and in order to secure the sovereignty of theory for it, he expelled the artists. This expulsion and/or marginalization was unavoidable, for the practice of art, no matter how construed, institutes a threefold departure from the dominance of theory: because art authorizes unique, individual items, it tendentially works against the hierarchy of universal and particular; because art is bound to the life of particulars, it tendentially celebrates the claims of sensuousness and embodiment; because its practices are tendentially governed by the claims of sensuousness and particularity, it instigates an alternative conception of acting, one which binds doing and making, *praxis* and *poiesis*, together. The entwinement of these three departures from theory is art's instigation of a knowing and a truth outside theoretical knowing and truth. If not completely visible at the beginning of the story, where the reason for art's expulsion had to do with its being a copy of a copy, a reason wholly internal to the logic of theoretical knowing, then the development of art provides another insight into art's suppression, namely its likeness to political knowing and political practice. Art's suppression, its marginalization and exclusion from truth, occurred as a direct consequence of the suppression of the *bios politikos*.

Of course, since the understanding of art has always been determined by the theoretical perspective, it was not until art became autonomous from theory, truly external to it, that the grounds for its original suppression could emerge. Throughout its history philosophy attempted to tame art, to suppress its tendential protest to the reign of theory. But while philosophy had no difficulty in consigning art to the realm of sensory experience, to the world of opinion (*doxa*) and appearance (the very 'world' of political life), almost to non-being, nonetheless the beauty of works shone, and their shining, their claiming spectators through their sensory characteristics, tendentially gave pause to the relegation of art

to non-being and non-truth. As the dominance of theory grew, art's tendential difference from it grew as well; the discordance between art and truth began to rage. Slowly, then, artistic knowing, what came to be called aesthetic reflection by Kant, took on the visage of an after-image of practical knowing, of *phronesis*; and slowly artistic practice, creative genius, emerged as an after-image of political *praxis*. Hence the modern work of art itself in its unity without a principle or concept determining that unity, and the community gathered around particular works with their shared *sensus communis*, became images or after-images of the (idealized) *polis*. The discordance between art and truth is the after-image, the memory, of the discordance between politics and philosophy, politics and truth-only cognition. Art now, or just before now, is (or was) the cipher for an absent politics, a political domain autonomous from the stamp and subjugation of theory.

It is thus no accident that Arendt should have come to regard Kant's third *Critique* as the place to look for his politics, for it is in his theory of taste that we find a consideration of appearances in their own right together with the concepts of communication, intersubjective agreement, and shared judgement that are constitutive for emphatic, autonomous political thinking. However, Arendt gives no indication as to why fundamental thinking on political life should now be found in a text on aesthetics.[11] Certainly Kant did not view his aesthetics in this way; nor is the thesis that art is the place-holder for an absent politics directly stated by any of the philosophers considered in this book. Nonetheless, if we view art from the vantage point of its autonomy, and view that vantage point as revealing something intrinsic about art works and the practices surrounding them, something latent or implicit in them whatever theoretical covering they have been given, then the suppression of the *bios politikos* and the expulsion of the artists become convergent elements of a single act of domination and suppression. Speculatively, art and politics are one. Beauty bereaved is politics bereaved. This reading of the meaning of aesthetic modernism is the one towards which the present work is directed. It is a thought that I shall attempt to insinuate into the readings of the texts studied.

To summarize my terms of analysis: first, each reading will interrogate a version of the alienation of art from truth and the critique of modernity implied by that alienation. Secondly, each reading will comment upon the analysis of modernity and the philosophy of history supporting it in the text under consideration. Each philosophy of history will be seen to invoke a different effort of memory, a different object of mourning. Thirdly, each reading will seek to reveal the operation of a fundamental aesthetic category drawn from Kant as constituting the dominant thought or insight of the text in question. Fourthly, each reading will take up the issue of the recoil upon thought of that which it is attempting to overcome. Finally,

each reading will insinuate a thinking through how art and politics are categorially related.

These, of course, are general guidelines and not directives; they provide the orientation for my readings and not an outline of them. Further, readings are not restricted to chapters. I do not give my reading of Kant on genius and art until chapter 2, and I do not complete my analysis of Derrida on Heidegger on Van Gogh until the final chapter. Hence chapter 2, on 'The origin of the work of art', is really about Heidegger and Kant; Derrida's *The Truth in Painting* is itself a reading of Heidegger and Kant; and chapters 4 and 5, along the way, instigate critical engagements between Adorno and both Heidegger and Derrida respectively.

In chapter 2 I turn to Heidegger's 'The origin of the work of art' in order to begin thinking through the thesis that art must be understood historically, and that aesthetics, as the reflective comprehension of art alienated from truth, is a product of modernity. Non-aesthetic art Heidegger terms 'great art'; hence, modernity is understood by Heidegger through the end or death of great art. In Heidegger's essay aesthetic art is represented by Van Gogh's painting of the peasant woman's shoes; and it is through an analysis of the role the painting plays in Heidegger's account that the 'meaning' of modern art first begins to emerge. For Heidegger that meaning is intimately connected with art's likeness to and difference from technology, which itself must be understood in terms of the unity and difference holding between 'creating' and 'making'. One somewhat austere and technical way of drawing that distinction would be through Kant's distinction between the transcendental, productive imagination and the reproductive imagination. The former is thematized in the third *Critique's* analysis of the work of genius. Works of great art are pre-modern works of genius. The provocation of chapter 2 lies in my attempt to demonstrate that the thinking about the meaning of being that Heidegger develops from his analysis of great art is but a generalized thinking of the Kantian notion of genius. But genius in Kant is the quintessence of freedom, so Heidegger's account draws on the most emphatic consideration of modern freedom, without which his theory would be unthinkable, in order to propound a thinking (of being) where freedom and subjectivity have no place.

Two difficulties emerge in my reading of Heidegger. First, his theory lacks the resources to explicate the role that modern art plays in it. Secondly, its moment of transcendence, Heidegger's conception of being and the history of being, remain too distant from the phenomena they inform, and as a consequence end up suppressing what was to be salvaged. This suppression is most pronounced in the way Heidegger binds the consideration of art with politics. Derrida's practice of reading appears to provide a solution to these difficulties. It locates the moment of transcendence, which is equally a moment of the loss of grounding, in particular texts; thus, unlike in Heidegger, the moment of transcendence is

wholly and discretely enmeshed within particular items. This is what is at issue in his analysis of 'The Origin of the Work of Art': the painting of the shoes grounds the possibility of Heidegger's theory while exceeding it. Derrida's reading reveals the Van Gogh as a fully modern and modernist work of art. Only with high modernism is art's departure from and critique of representation and truth-only cognition achieved. Modernist works of art are sublime: they exceed representational categories while opening up the categorial space in which they are represented. My provocation in this chapter is to contend that this characterization of modernist art is equally applicable to deconstructive readings: they work to discover/create the sublime moment in each text – the moment that cannot be represented in the text but which nonetheless grounds its most fundamental possibilities.

Derrida's theory (or anti-theory, analogous to the anti-art element of high modernism) is consubstantial with the thought of the Kantian sublime – the ultimate target of his reading of Kant. In reading Derrida reading Kant I follow what amounts to a Hegelian tack: can we understand the meaning of the sublime formally without at the same time reflecting on the historical substantiality sedimented in it? Does not such a history intrude on and upset its formal workings? Must not the formative work of history be acknowledged? The sublime, I will suggest, has sedimented within it the thought of Greek tragedy and the politics appropriate to it. That absent politics remains unknown to Derrida.

Derrida challenges such a thinking of history – the affinity to barbarism at work in my reading of him – on the basis of just the sort of consideration we will have come to expect: its repression of the very items that are to be salvaged through recourse to it. In avoiding this history Derrida leaves unknown the fate against which the modernist sublime works; in place of understanding and explanation he offers an ethical challenge to modernity, a challenge that is emphatic and blind at the same time.

The failures of aesthetic modernism are failures adequately to reflect upon its terms of analysis, the terms of Kant's aesthetic theory. Such a reflection is the project of Adorno's *Aesthetic Theory*. Using the achievements of modernist art as its guiding thread, it seeks to trace the critical transformation that aesthetic discourse performs upon the language of reason (truth-only cognition and categorical morality). Only through such a reflection can we comprehend how art's apparent unreason reveals the irrationality of formal, enlightened reason. In chapter 4 this reflection is followed to the point where art's likeness to and difference from technological reason is revealed; this provides the counter to Heidegger's thinking of the art/technology nexus. Chapter 5 works toward an understanding of the modernist sublime, an understanding of its power and limits exemplifed by the philosophical writing of both Derrida and Adorno.

I will contend that the best formal characterization of the work of

Heidegger and Derrida is that they follow the path of the Kantian transcendental (in the direction of immanence and concreteness) while displacing its self-reflective nature – transcendental arguments are reflections from within experience on what makes it possible. Heidegger and Derrida hold on to the elements of Kant's theory except for the fact that it is a *self*-reflection, which is perfectly reasonable since they are out to explode the modern humanist belief that what grounds experience and makes it possible is a self or subject. Adorno explicitly gives up the transcendental; the classical philosophical quest for transcendental foundations, however immanent or transcendent they are thought to be, is dropped. It is the path of self-reflection itself that is to be followed. Adornoesque critical theory is a continuation of the modern project of self-reflection beyond all transcendental understanding. Self-reflection without transcendental reflection is the ethical act of self-consciousness that brings the subject before and into his or her historical situation. Heidegger's and Derrida's affirmative thought, their thinking beyond good and evil, is contested in Adorno's act of self-implication: he is a part of the barbarism that he is seeking to understand and overcome. Only through the confession of guilt can immanence be achieved; that guilt is the guilt of self-reflection's totalization of experience: the history it recounts and the explanations it offers. When the totality is reflected and challenged in the same thought, ethical action begins to surmount itself toward the political world whose absence calls it into being.

1

Memorial Aesthetics:
Kant's *Critique of Judgement*

In the otherwise unnoteworthy opening paragraph of §54 of the *Critique of Judgement*, Kant remarks on 'how deep pain may still give pleasure to the sufferer (as the sorrow of a widow over the death of her deserving husband)'. Let us denominate this complex of pleasure and pain 'memorial'. In what follows I shall argue that the experience of the beautiful, the pleasure we take in beauty as it is defined and delimited by Kant in the third *Critique*, is best undestood *as if* this pleasure were memorial, a remembering that is also a mourning. The 'as if' of this thesis marks the fact that Kant does not directly claim that the pleasure in the beautiful is memorial, nor is a memorial view directly implied by what he does claim. Rather, this reading of the third *Critique* offers the memorial thesis as an explanatory hypothesis answering to widely recognized theoretical tensions, difficulties and antagonisms scoring Kant's argument.

What, then, is mourned in the *Critique of Judgement*? Of what loss is the pleasure in beauty a remembrance? As a first approach, the pleasure we take in the beautiful recalls a knowing, a cognition of things that was itself pleasurable; and a pleasure, interest, desire and need for things and persons that was neither privative nor in need of constraint nor produced out of an abstract demand for respect. In short, what is mourned in the experience of beauty as such is the separation of beauty from truth and goodness. Of course, the architectonic goal of the third *Critique* is, through reference to the supersensible, to engineer a reconciliation or unity of nature and morality, understanding and reason, truth and goodness, through judgement and beauty. Kant's argument in this regard has convinced no one since the German Romantics. If my argument is correct,

then what issues from the experience of beauty is not the recognition of a possible reconciliation of morality and nature in a transcendent beyond, but rather a recognition of their present intractable but contingent separation. Kant's reference to the supersensible marks a displacement of a (perhaps mythological) past into the beyond; the arché-tecture of architectonic blueprinting is not a bridge to span the 'great gulf' (CJ, Intro. II, 175) separating the realms of freedom and nature, but rather a sepulchre to stand over their lost unity.

i Judgement without Knowledge

According to Kant a judgement of taste of the form 'This is beautiful' is a reflective assertion of the pleasure one takes in a particular object or state of affairs which, without the mediation of concepts, lays claim to intersubjective validity. The first and third 'Moments' of the 'Analytic of the Beautiful' state that one is justified in making such a judgement if the judgement is made without interest, that is, apart from any practical, moral, or sensible interests one may have in the object of judgement; and if the judgement considers only the pure form of the object as it is reflected upon by the imagination.

Kant's categorial inscription of the judgement of taste, in its determination of aesthetic reflective judgements as autonomous judgements, offers what amounts to the discovery of a new philosophical subject.[1] What Kant discovered is that in aesthetic reflective judgements, although the object judged is not subsumed under either cognitive or moral concepts, what issues is a judgement which can be either true or false, and not a mere expression or statement of like or dislike. To claim that a judgement of taste is not subsumptive is to claim that the determining ground of the judgement does not rely upon the object judged falling or failing to fall under a particular cognitive or moral concept. An object's possession of one or several empirical properties capable of conceptual discrimination can never entail that object being beautiful. So even if one had validly judged an object to be beautiful which fell under just concepts α, β, γ, in arrangement ϕ, it would not follow that one must judge the next similarly describable object as beautiful, nor that one's negative judgement was in any way invalid. For the purposes of aesthetic reflective judgement no conceptual articulation of an object can saturate it sufficiently so as to license a valid judgement of taste. The ideal, limit case for this thesis would be quantitatively distinct but qualitatively identical items. This is a limit case because qualitative indiscernability can be either 'macroscopic' or 'microscopic'; but only strict, 'microscopic' indiscernability could require the logical passage of validity from one item to another; however, this is not the level at which we make aesthetic judgements. Aesthetic

reflective judgements, then, are irrevocably singular and their objects unique.

Analogously, an object's being the representation of something morally worthy cannot of itself determine that the object is beautiful; nor can the object's being a representation of something morally unworthy, or ugly or distasteful, entail that the object cannot be beautiful. On the contrary, fine art can describe beautifully 'things that in nature would be ugly or displeasing' (CJ, §48, 312), including such 'harmful' things as disease and the devastations of war. Nor, again, would it follow from an artist having successfully fulfilled his or her artistic intention in the production of a work that the work must be beautiful.

Despite the fact that in judgements of taste the object and the pleasure are connected without the mediation of concepts, which is what Kant means in requiring such judgements to be 'disinterested', he believes that in such judgements the connection between the pleasure and the representation of the object is a necessary one and hence universally or intersubjectively valid. In other words, despite their lack of conceptual grounding, judgements of taste nonetheless claim or demand assent from all others. Judgements of the form 'This is beautiful' state more than 'This object pleases me'; they also state that any and all others who judge this object disinterestedly will and should find it beautiful. It is precisely this elucidation of the 'grammar' of aesthetic reflective judgements as constituted by their nonconceptual grounding but claim to universal validity, which comprises Kant's discovery of the autonomy of judgement of taste, and of what we call 'aesthetics' generally.

Now the universality of judgements of taste, while evidentially supported by disinterestedness, is consequent upon the pleasure arising from the reflective harmony of the imagination and the understanding. What Kant means by this is that in the mere estimation of an object by the imagination it discovers the sort of unity or togetherness of a manifold which is required by the understanding for the making of determinate cognitive judgements generally, only here the discovery of unity is neither regulated by an existing concept nor does it yield a concept. That such an aconceptual or nonconceptual synthesis of the imagination should be a source of pleasure follows from the achieved synthesis satisfying the goal of cognition generally, namely, discovering unity within empirical diversity.

Judgements of taste are in need of a deduction because they lay claim to universal validity. As Kant notes, that it is with pleasure that I estimate an object is an empirical judgement; but 'what is represented *a priori* as a universal rule for the judgement and as valid for every one, is not the pleasure but the *universal validity* of this pleasure...' (CJ, §37, 289). Hence, what is to be sought in the deduction of judgements of taste is a ground for this attribution of universal validity. The deduction will turn

on the fact that the harmony between imagination and understanding, which is the source of the pleasure founding aesthetic reflective judgements, is just the relation between imagination and understanding that is necessary for cognitive judgements generally, and hence may be presupposed as common to all.

Kant's argument in §38, the 'Deduction of judgements of taste', is short and to the point. If we accept his previous arguments, then in a pure judgement of taste the delight we take in the object is due to the mere estimate of its form; that is, the delight excludes all particular subjective sources of delight, as well as any pleasure that follows from the object falling under a particular concept. As a source for the feeling of pleasure this leaves only the 'subjective finality' of the representation of the object for the faculty of judgement, by which Kant means the suitability of the object to the faculty of judgement. This suitability of the object for judgement Kant terms its adherence to the 'formal rules of estimating', formal because apart from 'all matter (whether sensation or concept)'. If these conditions are met, then the judgement can 'only be directed to the subjective conditions of its employment in general'; and this subjective factor 'we may presuppose in all men (as requisite for a possible experience generally)'. This is to say, since the pleasure which arises from the mere estimate of the form of an object occurs because there is a harmony between the imagination and the understanding, and this harmony is what is requisite for a possible experience generally, then we are warranted 'in requiring from every one' judgemental accord. More simply, the conditions met in a valid aesthetic reflective judgement are just the necessary subjective conditions for determinate cognitive judgements, and are thus a priori and universally valid.

Everything that goes wrong with this argument goes wrong in virtue of the way Kant attempts to underwrite aesthetic reflective judgements in terms of their connection with determinate cognitive judgements. A minor objection to Kant's argument would exploit the difference between aesthetic and cognitive judgements by noting how it does not follow from the legitimacy of attributing to everyone the subjective conditions for determinate judgements – judgements with a concept – that one is entitled to attribute to everyone the capacity of becoming aware or conscious of that unity when it is to be achieved without conceptual mediation.[2] In order to meet this objection Kant would need either to show that the difference between cognitive and aesthetic judgements is a question of attending to different aspects of the same process; or to demonstrate that the capacity for bringing manifolds to unity without concepts consciously is itself presupposed by the capacity for forming determinate cognitive judgements. To adopt the first limb of this disjunction would involve Kant in detailed questions of empirical psychology; to go for the second limb of the disjunction would almost certainly entail modifications to the central arguments of the first Critique, as we shall see.

However, there is a more general and obvious objection which goes to the heart of the way in which Kant connects aesthetic and cognitive judgements. Given its wide canvassing and acceptance, I shall call it 'the standard objection'.[3] The force of Kant's deduction turns on the unity of the representation of an object present in aesthetic reflection being just the unity present in cognitive judgements when the final synthesis of the object under a concept is removed. But this is implausible since it entails that for every object about which we can make a determinate cognitive judgement we can, by abstracting from the final synthesis of the object under a concept, make a valid aesthetic judgement. If Kant is to maintain a tight linkage between aesthetic and cognitive judgements, making the necessary subjective conditions for the possibility of empirical cognition provide the sufficient conditions for the general validity of aesthetic judgements, then he cannot properly distinguish the objects about which we can make determinate cognitive judgements and those for which an aesthetic judgement is appropriate; on this accounting, he must allow all objects about which determinate cognitive judgements can be made to be beautiful (as did Wolff).

In §20 Kant claims that the judgement of taste depends on the 'presupposition' of a 'common sense' (CJ, §20, 238); and in §21 he attempts to demonstrate that we do in fact have good reason for presupposing the existence of a common sense. Kant's argument here parallels the deduction offered in §38 with an apparently slight, albeit significant, difference. Kant begins by claiming that judgements and the propositional attitudes we take towards those judgements must admit of being universally communicable (*allgemein mitteilen*). The requirement for communicability here is stronger than the first *Critique*'s demand that we be able to separate how things appear to me from how things are in the world, or subjective succession from objective succession. Let us put this objection aside for the moment.

Kant continues in a way directly analogous with the argument in §38; if our cognitions and attitudes are to be communicable, then 'the attunement (*Stimmung*) of the cognitive powers required for cognition in general', i.e. the subjective conditions for the act of knowledge, must equally admit of being communicated. It is at this juncture that a small twist occurs in Kant's argument, for instead of talking about the harmony of the imagination and understanding he introduces the idea of 'relative proportions' between these faculties. These proportions differ, he says, with the diversity of objects presented to them. However, 'there must be one [proportion] in which this internal ratio suitable for quickening (one faculty by another) is best adapted for both mental powers in respect of cognition (of given objects) generally' (CJ, §21, 238–9). The setting of our faculties towards this optimal ratio can only be determined by feeling, since it is only in virtue of the attainment of this ratio that the completion of synthesis in a concept becomes possible. Since both the disposition of our

faculties as attuned in this optimal ratio and the consequent feeling represent necessary subjective conditions for the possibility of cognition generally, both must admit of universal communicability. (Kant moves ambiguously between the thesis that feeling does the 'tuning' between the cognitive powers, and the thesis that pleasure is the consequent of attunement.) On this reading common sense is just the faculty of judgement itself, the capacity for judgement without concepts; hence Kant can conclude that we are entitled to presuppose the existence of a common sense.

Clearly, our initial objection to the deduction in §38 is equally applicable here.[4] What is more interesting is Kant's proportion argument. In the first *Critique* Kant contends that every manifold of which one can become aware can be brought to the unity of judgement. If we hold to this requirement, then the idea of an optimal ratio does no independent work, and Kant's argument here is directly reducible to the argument in §38, carrying with it the same implausible assumption that all objects of which we can become aware are beautiful. If, however, we consider that what the idea of an optimal ratio presents is a picture whereby a heightened attunement of our cognitive faculties is attained, and we connect this argument with Kant's claim that the relative proportion between our cognitive powers differs with differing objects, then we can quite properly claim that some objects are beautiful and some not, since not all objects will engender the optimal ratio between imagination and understanding. The difficulty with this argument is that the notion of an optimal ratio can no longer be construed as being an optimal ratio *for cognition*. In order to maintain cognition in its controlling role one would not only have to assume that some objects were beautiful and some not; but further, that those that were beautiful were better in the sense of more knowable, which is counter-intuitive in the extreme. Hence, if the idea of an optimal ratio is to do independent work, then we must assume that the conditions which provide for it are not directly related to the conditions for cognition.

Although this would free us from the requirement of having to regard as beautiful all objects of which we may become conscious, it would equally break the intimate connection between cognitive and aesthetic judgement which motored and motivated Kant's argument from the beginning. And this would be no idle loss since beauty's anticipation of knowing provides the purchase through which we gain some insight into how and why unity, diversity, form, pleasure and the like cluster together as 'aesthetic' terms. Without the clustering that the telos of knowing provides, these concepts lose both their togetherness and, as a consequence, their usual meanings. What might the force of 'unity' be apart from its usual cognitive roles? As such, the generous reading of the proportion argument entails an objection which is the inverse complement, the reverse side, of the standard objection.

Together, the standard objection and its inverse complement tell a

revealing and, for Kant's programme, devastating story. In the 'Preface' to the third *Critique* Kant states that while aesthetic estimates of objects do not contribute 'a whit to the knowledge of things, they still belong to the faculty of knowledge *alone*' (CJ, 169; my italics). From the beginning Kant presupposes that the conditions for the aesthetic estimate of things represents just the necessary subjective conditions for knowledge in general; and further, the pleasure attendant on aesthetic estimates arises *because* such estimates fulfil the general and overriding goal of cognition. Both his epistemological claim and theoretical, explanatory claim must now be brought into question. A necessary linkage between aesthetic and cognitive judgement cannot be maintained without either requiring that all objects be capable of being regarded as beautiful, or raising the question as to why some manifolds are found beautiful and others not. One could look to empirical psychology to answer this question, but to do so would reduce questions of aesthetics to questions of psychology. On Kantian grounds, if no other, that move should be resisted until a more thorough canvassing of the options available has been completed.

Further, even if it were conceded that the minimal subjective conditions for cognition provided a necessary condition for aesthetic reflection, the optimal ratio argument would still show that these conditions were too weak to explain aesthetic pleasure or to underwrite universality, since it implies that for an aesthetic response to be prompted more than these conditions have to be satisfied. That 'more' is precisely what distinguishes beautiful objects from the totality of things of which cognition is possible. Hence, it must be assumed that both the grounds for attributing universal validity to aesthetic judgements, and the pleasure that results from aesthetic reflection, derive from sources that do not belong exclusively to the faculty of knowledge.

Given that Kant claims that a consideration of judgement will help bridge the gulf separating freedom from nature, morality from knowledge, it is tempting to look to Kant's linking of beauty and morality in the third *Critique* as providing a solution to the difficulties thus far encountered. Further, by looking in this direction we can perhaps discover an alternative telos to give salience and significance to the concepts of aesthetic discourse. What we find is not very encouraging.

ii Imperative Beauty?

It is not unusual to claim that Kant's deduction of taste is not completed until §59 where he treats of beauty as a symbol of morality.[5] Three considerations tell in favour of this thesis. First, given the all too obvious difficulties with the epistemological attempt to ground judgements of taste as stated in the standard objection and its inverse complement, it is hard

to believe that Kant was not aware of the problems the deduction in §38 faced. And this receives informal confirmation from the sense one has in reading the third *Critique* that it is continually circling back upon itself, deepening and modifying its inaugural gestures rather than moving directly forward through a series of arguments progressively and logically linked to one another. It reads, that is to say, more like a journey of discovery than a rigorous argument.

Secondly, Kant states in §59 that 'the beautiful is the symbol of the morally good (*Sittlich-Guten*), and only in this light...does it give pleasure with a claim to the agreement of every one else' (CJ, §59, 353). Now it certainly sounds here as if Kant is contending that the claim to universality in judgements of taste is in some sense parasitic upon the claim to universality constitutive of morally worthy practical judgements; and further, that the pleasure enjoyed in aesthetic reflection is likewise parasitical. This claim would give room to the role Kant apparently wants to assign to aesthetic ideas and dependent beauty in regulating the development of aesthetic judgement.

While this directly contradicts the claim of Kant's 'Preface' already considered, it is backed up by our third consideration, namely, Kant's consistently reiterated contention that judgements of taste 'demand' or 'exact' agreement from everyone; and that everyone 'ought' to give the object in question their approval and pronounce it beautiful (e.g. CJ, §7, 213; §19, 237). When someone says a thing is beautiful, Kant claims, it is not just that or sufficient that she merely counts on others agreeing because they have agreed in the past; rather she 'demands' (*fordert*) their agreement, and she 'blames' (*tadelt*) them if they judge differently; she denies them taste, while nonetheless requiring it of them as something they 'ought' (*sollen*) to have.

Now while Kant's point here may be to separate a well-founded belief that others will agree with us, as can occur even with things that are merely agreeable, from the claim to universal validity implied by a judgement of taste, such a distinction does scant justice to the 'claim' invoked. If we accepted a purely epistemological reading of the claims of taste, then what the deduction would establish, were it true, is that we have a priori good reasons for expecting that others will agree with our judgement (or better: it is not impossible that others will agree given that we all must have the same cognitive equipment). What Kant calls a 'demand' is really, on such an account, 'a prediction, but an ideal prediction – a prediction which presupposes ideal knowledge of one's own responses and ideal circumstances of response for others'.[6] However, if we press the question of what is invoked by the reference to the 'ideal' circumstances of response for others, then necessarily included would be their capacity and willingness to judge disinterestedly; and while disinterestedness operates evidentially when I pronounce something to be beautiful as a reflectively

deployed criterion for the validity of my judgement, it clearly cannot be so regarded in its reference to others. So while there is indeed an 'epistemological impertinence'[7] in my speaking with a 'universal voice' (CJ, §8, 216) in making a judgement of taste, that impertinence includes a demand on others to adopt a certain – disinterested – stance towards the object of judgement. And since taking up that stance is an achievement – whether we consider it a moral or epistemological achievement is here a matter of indifference – it necessarily falls outside what can be predicted, even when that prediction is made on a priori grounds.

To state the same point more emphatically, disinterestedness is, in a sense, measured against, and perhaps determined by, the powerful interests from which it withdraws. In withdrawing from sensuous interests, the very 'pathological' interests which moral reason requires us to withdraw from, the achievement of aesthetic disinterestedness is nearly as great, granting the diminished character of the 'sacrifice' involved, as the achievement of moral autonomy. The diminished character of the sacrifice of sensuous interests turns on the fact that aesthetic disinterestedness requires only the temporary 'bracketing' or deferral of sensuous interests and not their wholesale abandonment. However, this distinction may carry less force than it at first appears to suggest since, if disinterestedness is an achievement, then its accomplishment will have a cumulative, character-informing affect. How large the scope of this affect may be should not be pre-judged, since the measurement of that requires contrasting the sense of objectivity entailed by disinterestedness with the sense of objectivity entailed by practical and theoretical categorial synthesis. In brief, if aesthetic disinterestedness is an independent route to objectivity, an alternative form of objectivity, then the question must be posed as to whether or not it is straightfowardly complementary with the other forms of objectivity secured by the critical philosophy; and if not complementary, then what ordering of objectivities is to be 'rationally' required and maintained?

In suggesting that disinterestedness is an achievement arguably on a par with the achievement of moral reflection on natural desire, we must distinguish receiving pleasure from 'aesthetic' objects, i.e. works of art, which can be as subjective and privative as any other sensuous pleasure, from aesthetic disinterestedness proper. It is, for Kant, not the object which determines the character of the pleasure, but rather the form of our engagement with the object. If we now append to the disinterestedness in sensuous pleasure the abstraction from the interests of morality and cognition also required for aesthetic reflection, then the accomplishment of aesthetic disinterestedness begins to emerge.

Of course, putting the matter this way entails searching out an interest sufficient to motivate disinterest, otherwise the adoption of the stance of aesthetic disinterestedness will become altogether mysterious. This is the course adopted by Nietzsche in *The Genealogy of Morals*, where Kantian

aesthetic disinterest, strictly interpreted as abstraction from the interests of formal morality and categorial, truth-only, cognition, is linked to Stendhal's sensualism, his *promesse de bonnheur*.[8] Even, however, without an explicit account of the interest of disinterestedness, it is evident that the epistemological role of disinterestedness is idle in abstraction from the interests subtending it; but the inclusion of them entails regarding disinterestedness 'practically' as well as evidentially.

It is hence not surprising that Kant regularly uses the language of 'demand' and 'exacting' with respect to judgements of taste; he also says, if we could assume that the mere communicability as such of our feeling already carried with it an 'interest' for us, then we could explain how it is that the 'feeling in the judgement of taste comes to be exacted from every one as a sort of duty (*Pflicht*)' (CJ, §40, 296). And this, in fact, accords well with our pre-theoretical intuitions on this matter. What I mean by this is that we regard moral relativism and epistemological scepticism as threats to our self-understanding about our relations to the world, to others, and to our most fundamental beliefs. In these cases, at least, we know what not finding an a priori principle of legislation would mean. In the question of judgements of taste, of aesthetic scepticism, where the sceptic denies that judgements of taste are properly judgements at all, we are asking if this denial is more like denying the objectivity of epistemic judgements or more like denying the objectivity of some value. In particular cases, is our sense that others do not share our judgement a concern with them not seeing something that is there; or is it a sense of their refusing to take up a certain stance, and thereby coming to acknowledge a certain import, significance or value? Is failure in taste a failure to possess a certain type of skill or ability, a lack of practice (in appreciation); or does it mark the lack of a certain sort of character trait? In asking these questions I am not trying to force an answer on one side or the other; and I doubt whether an easy or consistent response can be given. Here I want to say, to be forced to choose would be to be forced into an unnatural posture. Without some further argument the claim is unfounded that the threat posed by aesthetic relativism or scepticism is an extension of the anxiety attendant on the threat of scepticism concerning knowledge; and conversely, it is not obviously wrong or untoward to regard the aesthetic sceptic as someone who is *refusing* to acknowledge or recognize what demands or claims acknowledgement; and that this refusal by the sceptic, who is perhaps also the philistine, is best interpreted as a refusal to take up a certain stance toward a range of objects, a disinterested stance.

In urging that the claim to taste is more than epistemological, more than predictive, we have not gone the full distance that a properly moral interpretation of the claim to taste requires. Nor can we. First, Kant does not say that a judgement of taste is exacted from everyone as a duty, but 'as a sort of' (*gleichsam*: as it were, so to speak, almost) a duty. Secondly,

even this analogous duty would hold only if mere communicability of our feeling implied an independent interest; in fact, we cannot infer such an interest solely on the basis of the reflective power of judgement (CJ, §40, 296). This denial of an interest will concern us below. Thirdly, while an aesthetic reflective judgement involves a 'claim' (*Anspruch*) upon everyone to assent, the feeling inspired by the absolutely good invokes a 'command' (*Gebot*) upon everyone to assent (CJ, 'General Remark upon the Exposition of Aesthetic Reflective Judgements', 267). And this distinction itself simply reiterates the distinction Kant draws as early as §5, where he states that while the good is what is esteemed and 'extorts approval', taste in the beautiful is a 'disinterested and *free* delight'. From the outset, the free pleasure we take in the beautiful is contrasted with 'an object of inclination, and one which a law of reason imposes upon our desire, [which] leaves us no freedom to turn anything into an object of pleasure' (CJ, §5, 210).

Much of the point of judgement of taste is that they inhabit a domain between what can be expected and what is commanded (by the morally good); and that the force of the demand and the claim they make is their lack of force and their lack of an ability to command assent. So, while the demand involved in aesthetic judgements has a prima facie claim to be regarded as stronger than an ideal prediction, it must equally be regarded as being weaker than the commands of the morally good. Failure to respect the latter is as invidious as ignoring the former; epistemological readings underestimate the normativity of aesthetic judgements, while moral readings underestimate the sort of freedom they invoke, their non-compulsory character. For the most part, Kant's vocabulary and argument moves so as to sustain, precisely, the autonomy of judgement from the interests of knowledge and morality. To attempt, as all Kant's interpreters have, to force Kant's argument into either an epistemological or a moral mode necessarily does violence to the overall strategy governing his argument. To subsume judgements of taste wholly under either the goals of understanding or the demands of reason necessarily violates the free delight specific to judgements concerning the beautiful. Conversely, however, if aesthetic reflection were wholly separated from questions about the true and the good, it is difficult to see what sense or point could be attributed to it beyond simple pleasure (which would reduce the question of beauty to mere agreeableness, and hence accede to aesthetic scepticism). It is this that explains Kant's own temptations to assimilate aesthetic judgement to either morality or understanding: they are to provide the 'hidden' interest behind aesthetic disinterestedness. But then the category of disinterestedness loses its grip; it becomes a mask or façade for the 'hidden' interest. Kant's difficulty is that he has no other instruments available, at least in the first instance, with which to prise open the domain of taste, other than those provided by understanding (the faculty of

knowledge) and reason (the faculty of freedom). This does not exempt Kant's commentators from attempting to sustain the anomalous demand of taste, but it does perhaps explain their failure to do so.

Moral interpretations of the judgement of taste tend to turn on Kant's contention in §20 that a judgement of taste presupposes the existence of a common sense; and thence to argue that common sense is a regulative idea of reason, which as such we can be commanded to seek after. On this account, the claim of taste becomes a mediated moral obligation: you are obligated to develop common sense and so taste as an imperfect duty; and if you had taste, then you would find 'this' beautiful. As a consequence we are entitled, indirectly, to 'blame' others for a lack of taste, and, indirectly, to 'demand' their assent to our judgement of taste. The subjective universality of the judgement of taste, on this account, is derived from the universality and necessity of the categorical imperative itself by means of the demand it sets us to seek after the highest good. Here, then, an object can be regarded as beautiful and so have pleasure necessarily connected with it because it is like the morally good. This makes morality constitutive of beauty, directly making taste a means to a moral end; where taste's status as a means is itself dependent on beauty's likeness to the morally good.[9] Once the capacity for the appreciation of beauty becomes essentially a moral virtue, then the autonomy, integrity, disinterestedness and impartiality of judgements of taste are destroyed.[10]

While the attempt to ground aesthetic necessity on morality unequivocally abrogates the autonomy of the judgement of taste, a prior question should intercede here, namely, is this attempt to ground taste in morality Kant's? There are good reasons for answering this question in the negative. Not only does Kant not raise the question of providing a title and a deduction for taste after §38, as one might expect if he were using his discussion of morality to do what he had failed to do earlier; but he regularly and consistently states that beauty is what pleases in the mere 'estimate of it' (e.g. CJ, 'General Remark...', 267; §31, 281; §38, 289; §45, 306; §54, 330). And Kant opens §15 by stating that the beautiful is estimated on the ground of a mere formal finality, that is, 'a finality apart from an end (*eine Zweckmässigkeit ohne Zweck*), [one] wholly independent of the representation of the good'.

Further, a little reflection will reveal that the attempt to ground aesthetic necessity in morality *deprives* the analogy between morality and beauty of its force. The force of Kant's analogical argument depends upon taste and beauty intrinsically possessing the characteristics grounding the analogy, and therefore being a suitable vehicle for the promotion of moral ends. To subsume taste under morality would deny morality re-enforcement from elsewhere. Hence, after noting the four points of analogy between the two domains – beauty pleases immediately; it pleases apart from all interest; the freedom of the imagination in estimating the

beautiful is in accord with the understanding's conformity to law; and the claim of taste is universal – Kant concludes by urging us to note that it is not moral judgement alone which 'admits of definite constitutive principles' (CJ, §59, 354); that is, what we are offered is a system of analogies *and* disanalogies between the aesthetic and the moral, with Kant carefully noting the disanalogies for each point in parenthesis; and the system of analogies and disanalogies gives force to the points of positive likeness because the two are based on different constitutive principles. Unless beauty's pleasing apart from all interest were constitutively different from morality's, no analogy between the two domains could be drawn.

This claim is borne out by the phrasing of Kant's famous final sentence in §59:

> Taste makes, as it were, the transition from the charm of sense to habitual moral interest possible without too violent a leap, for it represents the imagination, even in its freedom, as amenable to a final determination for understanding, and teaches us to find, even in sensuous objects, a free delight apart from any charm of sense. (CJ, §59, 354)

Notice that it is not claimed that taste provides a transition to morality directly, but only 'as it were' (*gleichsam*), by, that is, its analogical relations with morality. And what these analogical relations reveal is a freedom in conformity with law (though here, note, in conformity with the laws of the understanding) and a non-causally induced experience of pleasure in the objects of sense. In other words, the experience of beauty provides us with an analogue of the refusal of the demands of natural desire and of a freedom in conformity to law which is essential to Kant's moral doctrine. Kant's point is that art can possess moral significance and moral import because it autonomously possesses characteristics which harmonize with the demands of morality. Of course, the autonomous moral-likeness of aesthetic experience raises a difficulty of its own, namely, if that experience is autonomously structured, then will it not project a conception of our relation to our own highest ends and others that is an alternative to the morality of reason?

iii The Antinomy of Autonomous Aesthetics

Kant's epistemological deduction of the judgement of taste leaves it radically underdetermined: it cannot explain, on the basis of the required similarity of our subjective faculties, why we must all aesthetically respond to specific objects in the same way; it reduces the normativity of the claim of taste to a prediction; and, because of these two failures, it cannot

explain the pleasure we take in the beautiful. Conversely, the moral interpretation of the judgement of taste overdetermines it by converting the claim of taste into a moral command; in so doing it abrogates the essential disinterestedness and autonomy of taste.

When, however, we construe the analogy between taste and morality as one which intends to demonstrate the moral significance of art without transgressing its autonomy, then we might perhaps come to think that a new difficulty is being introduced: not only is the underdetermination of taste not made good, but it ought to be able to be made good by turning to reason and morality; the connection between aesthetics and morality should somehow be able to support taste without violating its impartiality. As things stand, however, the pleasure we take in the mere estimation of things aesthetically and the moral significance of taste, however compatible they are, nonetheless remain at a distance from one another. The logical distance separating the judgement of beauty from its moral significance would be altogether unproblematic, and indeed in complete conformity with Kant's Critical programme, were it not for the inexpungible lacunae remaining in the deduction of taste.

Clearly, the logical distance separating the judgement of taste itself from its significance for morality simply repeats the logical distance separating the constitutive principles of knowledge from the constitutive principle of morally worthy action. And from here it would not be implausible to suppose that, rather than directly or analogically bridging the gulf between knowledge and morality, the analysis of taste would register their problematic duality as problematic. And in a sense, this is the situation we now find ourselves in.

However, we must not be sanguine about this situation, for Kant's operating assumption is that there is nothing directly problematic about the duality between knowledge and morality:

> Understanding and reason, therefore, have two distinct jurisdictions over one and the same territory of experience. But neither can inter-fere with the other. For the concept of freedom just as little disturbs the legislation of nature, as the concept of nature influences legis-lation through the concept of freedom. (CJ, Intro. II, 175)

Kant believes the two-jurisdictions perspective opened up by the first *Critique* satisfactorily underwrites the non-interference of understanding and reason. To be sure, Kant argues, moral freedom is meant to influence the domain of nature; and to think this we must be capable of regarding nature in a way compatible with the ends of morality; and the way to think this possibility is to refer both morality and nature to a unitary ground in the supersensible, about which we can, of course, have no knowledge. On the moral interpretation of the judgement of taste it is typically argued

that beauty as a symbol of the morally good operates by leading us to a contemplation of this unitary, supersensible ground.[11] Because what is here referred to is the basis of both morality and cognitive judgement, then this argument fails to secure a specific connection between the aesthetic and the moral (as the idea of beauty as a symbol of the morally good requires).[12]

The question that now needs to be asked is whether the analysis of judgement, and the experience of beauty itself, does not 'disturb' the logical and peaceful duality of knowledge and morality. The central thesis which urges this question is already before us, namely, Kant's apparently considered view that the universality of the claim of taste is stronger than an a priori grounded prediction and weaker than the command of reason. It is, in the first instance, precisely the anomalous normativity of aesthetic reflective judgements which 'disturbs' and unsettles the duality knowledge and morality, calling forth a new constitutive principle that will nonetheless make essential reference to our capacities as knowers and moral agents.

The reverse side of this disturbance is the way in which the logical separation of knowledge from morality unsettles and disturbs the analysis Kant offers of the judgement of taste. It is this disturbance which is manifest in our reading of the third *Critique*, where we find ourselves confronted by a series of dualisms – between free and dependent beauty; between pure and ideal beauties; between the intrinsic and a priori interest we take in the beautiful, and the empirical interest the beautiful has for us as a medium of communication; and finally, and perhaps most significantly, between the beautiful and the sublime – which are presumptively underwritten and required by the logical distinction separating cognition from morality, but which, almost imperceptibly, sunder our understanding and experience of beauty into parts that destroy it, leaving it less than it is.

The suggestion is broadly that Kant's failures in providing title for the judgement of taste derive from the legislative duality between understanding and reason. While no direct evidence for this claim is possible, indirect evidence would be forthcoming if it could be demonstrated that the specific legislative duality between reason and understanding was destructive of the conceptual integrity of beauty. The structural necessity enjoining the destruction of beauty may be encapsulated in the formulation of a kind of antinomy, the antinomy of aesthetic autonomy. It states: *The conditions necessary for securing the autonomy of the judgement of taste necessarily exclude the worth of beauty from belonging to it intrinsically.* In other words, what constitutes the autonomy of taste necessarily makes the value of beauty contingent, external and instrumental. And this has antinomic force because the pleasure and the universality of the judgement of taste are to be regarded as intrinsic to it. Hence, the fact/value distinction

inscribed in this antinomy will be destructive of beauty just in case its existence can be regarded as directly entailing the failure of Kant's deduction, and as violently and illegitimately sundering the integrity of taste.

a Free and Dependent Beauty

In §16 Kant states that there are two kinds of beauty: free beauty (*pulchritudo vaga*) and dependent beauty (*pulchritudo adhaerens*). Free beauty presupposes no concept of what the object of judgement should be; while in judging dependent beauties we presuppose a concept for the object of judgement, and with that concept 'an answering perfection of the object' (CJ, §16, 229). Further, Kant states, free beauties are regarded as self-subsisting, while dependent beauties, because they are always judged through a concept, are conditioned as beautiful by that concept, and hence must be regarded as coming under the concept of a particular end.

Free beauties typify the ideal of objects which are purposively ordered without, however, having that order as *for* some other end or purpose, be it internal or external to the object. Free beauties are not perfect exemplars of a kind of object because they are not considered under the concept of the object they are (if one is available); nor do free beauties represent anything or possess any intrinsic meaning. Amongst the free beauties of nature, Kant mentions flowers, many birds (the parrot, the humming-bird, the bird of paradise) and a number of crustacea. Amongst the free beauties of art, Kant lists designs à la grecque, foliage on picture frames or on wallpaper, musical fantasias (without a theme), and generally all music that is not set to words.

On the basis of these rudimentary distinctions, Kant feels himself entitled to claim that when we form an estimate of a free beauty we are making a *pure* judgement of taste. Now it is precisely for the sake of delimiting and inscribing a pure judgement of taste that Kant draws his distinction between free and dependent beauty. A pure judgement of taste is an estimate of a thing's beauty and nothing else; and it must be at least possible for us to make pure judgements of taste, otherwise taste's claim to autonomy would be jeopardized from the outset. Kant's strategy, then, is to seek to uncover a range of objects – free beauties – for which there exists a prima facie case for him to claim, *pace* rationalist aesthetic theories, that in judging them beauties we are not making any sort of claim, confused or otherwise, about their perfection. Kant's theory requires that there be pure judgements of taste if he is to be able to claim them to be autonomous from cognition and morality; and the existence of free beauties would legitimate this claim.

As stated, Kant's distinction between free and dependent beauties cannot be sustained, for it systematically conflates the basis on which we

make a judgement of beauty, and hence our attitude toward the object of taste, with the idea of certain objects, be they products of art or nature, being intrinsically either free or dependent beauties.[13] A flower may be judged beautiful, mistakenly, because its form 'beautifully' and 'perfectly' fulfils the aim of reproduction. Conversely, concepts, images and symbols, say, can legitimately enter into the manifold of an aesthetic representation just so long as they do not inhibit the free play of the imagination by requiring that manifold to be subsumed under a concept. In §49 Kant defines aesthetic ideas as 'that representation of the imagination which induces much thought, yet without the possibility of any definite thought whatever, i.e. *concept*, being adequate to it' (CJ, §49, 314); and if this is so, then the objects expressing aesthetic ideas may be the subjects of pure judgements of taste. All that is required for judgements of beauty to be pure is that the basis of the judgement not include a conception of what the object represented ought to be.

For Kant, this requirement was less easy to meet than might at first appear, since he tended to believe that a central, if not constitutive, purpose of art works was to represent some object or concept. So he says that 'a natural beauty is a *beautiful thing*; an artistic beauty is a *beautiful representation* of a thing' (CJ, §49, 311); and if representing is a purpose of a work, then its success in achieving that end will be the criterion for our evaluation of it (as beautiful). It does not follow from this, however, that representational works cannot be the objects of pure judgements of taste, for Kant does nothing to demonstrate that a consideration of a work's success in satisfying its representational end necessarily must be deployed in a judgement of taste. A successful – accurate and informative – representation of a thing is not necessarily a beautiful representation of that thing; and conversely, a beautiful representation of some thing or idea is not necessarily accurate, informative and the like.

Yet, these familiar arguments against Kant's distinction are altogether too quick, for at least one of the objects he lists under dependent beauties stands out, namely, 'the beauty of man (including under this head that of a man, a woman, or child)...' (CJ, §16, 230). Even if we read the categorical imperative as legislating an attitude, namely, that we ought always to *treat* ourselves and other subjects as ends-in-themselves and never as mere means, and hence as not making an ontological claim about what human beings are, nonetheless this attitude, by means of the concept governing it, is constitutive for Kant of how we must regard ourselves and all others. And this does entail that while there may be no intrinsically free beauties, one beauty, that of man, is intrinsically dependent.

If the representation of persons cannot be a mere means to aesthetic beauty, then the impure judgement of works that do represent persons, and ideas characteristic of them, will necessarily include moral criteria amongst their constitutive aesthetic criteria. Initially, Kant presents the

employment of moral criteria, as he had tended to do with the categorical imperative itself, as providing only a negative constraint. So Kant suggests that the tattooing done by the Maori, with its 'flourishes and light but regular lines', could be considered beautiful were we dealing with anything other than the figure of a human being. And this seems compatible with the sorts of things we might say about works which were overtly racist or misogynist. As we shall see directly, Kant also has strong views concerning the positive employment of moral criteria in judgements of taste.

In order to preserve the autonomy of aesthetic reflective judgements, Kant is required to demonstrate that there can be pure judgements of taste. On the other hand, Kant's moral theory requires that there be some objects of aesthetic judgement about which pure judgements cannot be made. Now although I have suggested otherwise, Kant's actual argument up to this point does not entail that in making impure judgements of taste aesthetic and moral criteria are *articulated* with one another; rather, the suggestion is only that in some cases moral considerations can override aesthetic consideration. And yet Kant speaks of 'dependent beauties', that is, he speaks as if the beauty of these objects cannot be disarticulated from their being the kind of objects they are, namely, ones possessing an intrinsic dignity and worth. It is, of course, not surprising that we should only become aware of the question of articulation when these two values become disarticulated, that is, when there is a conflict between the moral and the aesthetic. But the suggestion that the beauty of objects, or representation of objects, possessing intrinsic moral worth could be indifferent to that worth is surely implausible, if obscure.

Perhaps this provides some leverage for viewing the distinction between free and dependent beauties somewhat differently, as wholly dependent on Kant's moral theory. Objects about which pure judgements of beauty can be made are essentially, as it were, just those that lack any intrinsic moral worth; they are things that can be means and are never necessarily ends-in-themselves; while objects or representations of objects about which only impure judgements of beauty can be made, are those which possess intrinsic moral worth, are ends-in-themselves. And this leads to the rather unsatisfactory conclusion that there can be pure judgements of taste, and hence an autonomous domain of aesthetic judgement, judgements which, remember, lay claim to the assent of all, just in case there are some objects which lack intrinsic worth or value. The point here is not simply that Kant's distinction between free and dependent beauties replicates the logical duality already present in his system, where objects of pure aesthetic judgements are neither good nor bad, while objects which are intrinsically good or evil are never just beautiful or not beautiful; it is more that the very existence of things lacking intrinsic moral worth (which is not equivalent to 'things intrinsically lacking moral worth') is a con-

dition (*überhaupt*) for the very possibility of aesthetic judgements of taste, and hence beauty.

b Free Beauty and the Ideal of Beauty

Toward the end of §16, Kant presents the articulation of reason (the good) and judgement (beauty) as an external subordination of the latter to the ends of the former, and states that 'strictly speaking, perfection neither gains by beauty, nor beauty by perfection' (CJ, §16, 231); this he must maintain if he is to prevent his theory from regressing to some form of rationalist aesthetics where perfection is treated conceptually as a criterion of beauty. Hence in §17, where Kant offers his positive articulation of beauty and goodness, reason and judgement, he does so by beginning with beauty, and continuing in a manner meant to insure against any conceptual criterion of beauty from being established. And this, surely, is the correct procedure to adopt here.

Although, Kant argues, there can be no objective rules of taste, the domain of taste is sustained and reproduced; this occurs through the employment of certain products of taste being treated as models which are, for taste, exemplary (*exemplarisch*). And the highest model of taste – that model, or models, which best exemplifies beauty, and in so doing provides some orderliness and unity to the diversity of models of taste by means of which the domain of taste is reproduced – is the archetype (*Urbild*) of taste. So this archetype of taste is a model or an idea of taste which each of us must attempt to beget within ourselves, and in accordance with which we form our estimates of 'everything that is an Object of taste, or that is an example of critical taste, and even of universal taste itself' (CJ, §17, 232). The archetype of taste, and the other models of taste, are what stand in for objective rules and conceptual criteria in judging the beautiful. Exemplary items take up the burden of orienting us in the field of the aesthetic, a field in which the question of orientation is emphasized because it is not transcendentally legislated. But if, at any level, the aesthetic thematizes the subjective conditions for (theoretical or practical) judgement, then the orientation provided for us here may turn out to be either equivalent to or a proxy for what provides orientation in general. The question might then arise as to whether what orients, what provides for 'direction in the world',[14] in the absence of adequate objective principles is, in fact, antecedent to all objective principles. At the very least, then, Kant's questioning here takes up the question of how activities can be governed or oriented in accordance with feeling and need, when not underwritten by objective principles. (At the very most, orientation through exemplary items, art works, will be seen to displace Kant's

categorial anticipations of reality in Heidegger's 'The origin of the work of art'.) That we do have a diverse but 'regulated' field of discourse about art and beauty is testimony to the existence of a rationality determined through a discriminating formation of sensibility and not through transcendental legislation.

Kant goes on to distinguish between an 'idea', which signifies a concept of reason, and an 'ideal', which is the representation of an individual existence as adequate to an idea. Hence the archetype of taste, while resting on reason's idea of an indeterminate maximum, since it cannot be represented by means of concepts, will necessarily be an ideal – the ideal of the beautiful. Now the ideal of beauty cannot be drawn from the realm of free beauties because, as free, the fact that an individual member of a species is beautiful is purely contingent. Since there is nothing about free beauties that makes them, as such, beauties, then by definition they are ill-suited to play the role of ideal beauties. An ideal beauty, then, must be one for which there exists a fixed, or constant, concept of objective finality. But where the objective finality of the object is attached to changeable ends, as with the idea of beautiful homes, churches, gardens etc., then here too contingency disqualifies this range of objects from forming an ideal:

> In other words, where an ideal is to have place among the grounds upon which any estimate is formed, then beneath grounds of that kind there must lie some idea of reason according to determinate concepts, by which the end underlying the internal possibility of the object is determined a priori...Only what has in itself the end of its real existence – only *man* that is able himself to determine his ends by reason, or, where he has to derive them from external perception, can still compare them with essential and universal ends, and then further pronounce aesthetically upon their accord with such ends, only he, among all objects in the world, admits, therefore, of an ideal of *beauty*, just as humanity in his person, as intelligence, alone admits of the ideal of *perfection*. (CJ, §17, 233)

The ideal of beauty rests upon the rational idea of man, that is, the idea of man as possessing intrinsic moral worth, and the virtues attendant on such an idea. These ideas are to be employed as governing the representation of the human figure such that it becomes the outward expression of these purely inward, abstract and conceptual, ideas. The ideal of the beautiful is the image of human worth and virtue embodied.

If we couple this conclusion with the conclusion of our consideration of free and dependent beauties, then we are presented with what at first sight looks to be a paradoxical position. A necessary condition for the existence of beauty is that there exist objects that possess no intrinsic worth or value; it is only of these objects that pure judgements of taste can be

formed. Conversely, the ideal of beauty, the archetype and standard of all beauties, which forms the model in accordance with which all judgements of taste are made, depends upon the existence of objects possessing intrinsic worth about which pure judgements of beauty can never be formed. Free beauties are necessarily not ideal; and about ideal beauties necessarily pure judgements of taste cannot be formed. If there were only free beauties, no ideal of beauty would be possible, and aesthetic relativism would result. If there were only objects having intrinsic moral worth, then there would be no autonomous domain of beauty, which might be taken as equivalent to claiming that there would be no beauty at all – rationalist perfectionism would triumph. How are we to intepret this situation?

It seems immensely tempting to say here that the ideal of beauty figures (represents or images) what does not exist, namely, the embodiment or material instantiation of what is essentially not material, the ideas and concepts of human worth. Beauty appears to be posed between inner and outer, freedom and nature, reason and understanding, representing the 'speculative' realization of the former in the latter. But this representation is dependent upon there being a bifurcation between inner and outer. In a strictly causal universe judgements of taste would be impossible, while in a completely rational universe judgements of taste would be unnecessary. Human beings, however, inhabit both worlds; hence the human figure comes to image the ideal union of the brutely material and the ideally rational. In this argument free beauties figure the idea that beauty belongs essentially to a world that is not fully morally/rationally determined, while ideal beauty represents the overcoming of the duality between nature and freedom. Within this scheme the ideal of beauty represents, we might say, the point of beauty. And the pleasure we take in beauty would be explicable as different from mere agreeableness or moral pleasure since it would figure, perhaps, virtue and happiness united.

This direct argument for the unification of freedom and nature in beauty, while appealing, is not Kant's, nor is it really satisfactory. The argument is not satisfactory because it merely uses the idea of free beauties to figure the moment of nature, without actually explaining why we must be capable of forming pure judgements of taste (although the hint it offers us should be kept in mind). Secondly, the argument surreptitiously drops the autonomy of taste, letting the universality of the moral ideas informing the ideal of beauty pick up the slack left in the epistemological deduction. Here too, however, there is a hint worth holding on to, since the universality of the ideal of beauty, as ideal and not idea, is necessarily indeterminate and non-conceptual. Thirdly, while the analysis makes use of the bifurcation between nature and freedom, that bifurcation does enter into the experience of beauty itself; yet if beauty obtains only under conditions of lack, then surely that lack should appear in the experience of beauty itself. Finally, the whole of this line of inquiry contains a serious

misdirection, for the ideal of beauty is properly a concern for the beauti-
ful. However, if the dignity and worth of human beings are at issue, then
the aesthetic reflective judgement of the human form brings to light what
transcends sensibility; as such, but only to that degree, the judgement of
the human form must be regarded as sublime.

With the failure of the direct argument we are returned to the original
paradoxical formulation of the situation: if there were only free beauties,
no ideal of beauty would be possible, and aesthetic relativism would
result; if there were only objects having intrinsic moral worth, then there
would be no autonomous domain of beauty. The non-equivalence between
free and ideal beauty records again, but more emphatically, the duality
between fact and value. But now we have been provided with a hint as to
how that duality itself conditions the existence of beauty. This hint is idle,
however, unless some inroad can be made against the direct link Kant
draws between free beauties, pure judgements of taste, and the harmony
between the imagination and understanding as constitutive of aesthetic
estimation. Just so long as aesthetic estimation necessarily excludes reason,
or, more broadly, some normative conception of the worth of the objects
of aesthetic judgement, then the irrefrangible connection between free
beauties and pure judgements of beauty will remain, and the autonomy of
aesthetic judgement will depend on it being attached to the value-freedom
of the understanding. In short, the fact/value distinction in Kant turns on
the distinction between understanding and reason. Their duality is
thematized in the separation between the beautiful and the sublime.

c The Beautiful and the Sublime

In general terms, Kant's account of the sublime is familiar enough, and
initially at least quite plausible. '*Sublime*,' Kant says, 'is the name given to
what is *absolutely great*' (CJ, §25, 248). What is beyond all comparison
great is something in comparison with which all else must be accounted as
small; no thing, and hence no object of nature, can have this characteristic.
Thus the absolutely great is not to be found outside us, but refers to the
ideas of reason; and the greatest of these is the moral law, which
conditions and governs all others. In judging the sublime, then, we are
faced with certain objects whose extent or size exceeds the capacity of the
imagination to synthesize them in accordance with the understanding's
general demand for unity; such objects are apprehended as 'inherently
contra-final' (CJ, §23, 245) to the goals of the faculty of knowledge. Such
contra-finality is felt as displeasure; but this displeasure, which is felt
with the breakdown of the imagination in coming to grips with what
is presented, gets referred to reason, which is mediately awoken in its
transcendence of everything sensible.

In Kant's account two very dubious thoughts are intimately linked. On the one hand, he claims that 'the sublime in nature is improperly so called' since the apprehension of objects 'otherwise formless' is the 'mere occasion' for the adoption of an attitude of thought and that which (the ideas of reason) serves as its basis (CJ, §30, 280). Hence the contra-finality of the object of a judgement of sublimity is not estimated on its own account, but *used*; and the use to which it is put is to have us consider the supersensible in us. On the other hand, since the attitude of thought which is the properly sublime must already be conceded to be a priori valid, then a separate 'aesthetic' deduction of the claim to universality made in judgements of the sublime is unnecessary. Its claim to inter-subjective validity is not simply parasitic upon the validity of the moral law: it is the moral law's claim to validity which is being invoked. Which is why Kant states in §30 that the sublime is not in need of a separate deduction; and further that it is 'far less important and rich in conse-quences' than the beauty of nature, on the whole giving 'no indication of anything final in nature itself, but only in the possible employment of our intuitions of it inducing a feeling in our own selves of a finality quite inde-pendent of nature' (CJ, §23, 246).

If, however, it is *this* mountain range, deep ravine, volcano or raging torrent that induces the judgement of sublimity; if there are objects which properly and improperly induce such judgements; if a judgement of sub-limity can be falsely or truly occasioned, so to speak, then a judgement is being made. As we have just seen, Kant does, and must, make reference to specific intuitions, and 'particular representation[s]' (CJ, §25, 250). More-over, he briefly suggests what may be the underlying assumption of the whole account, that in the experience of sublimity we find 'the straining of the imagination to use nature as a schema for ideas' (CJ, §29, 265). Of course, everything here turns on the imagination's 'straining' to employ nature as a schema for the ideas of reason, to make certain sorts of natural objects sensible presentations of what exceeds all sensibility. Nonetheless, such 'straining', however doomed to failure it may be, requires that only certain objects be fit or proper candidates for being possible schemas for an idea of reason. If it were true that 'sublimity' did 'not reside in any of the things of nature, but only in our own mind, in so far as we may become conscious of our superiority over nature within, and...without' (CJ, §28, 264), then we would never be entitled to claim that someone ought to find *this* prospect sublime; but if this were the case, then judgements of sublimity would not be judgements at all. Rather, there would only be 'aesthetic' occasions wherein we were led to pronounce the 'morally sublime'.[15]

Kant's attempt to avoid giving credence to the aesthetically sublime was doubtless prompted by his view that the only proper object of awe or rev-erence in a non-teleological universe is the moral law itself; hence the

feeling generated by the sublime must be attached to it. Further, if a direct aesthetic judgement of sublimity were to be made, then reason would be put into direct, and not merely mediate, contact with the sensible world, yielding a confusion of faculties. Finally, since the only proper object of awe and reverence is the moral law, and it is this that is the ground of the universality attributed to the feeling of sublimity, then external nature can only be permitted or tolerated to be an 'occasion' for a judgement of the sublime. If an external object were accounted as more than an 'occasion' for such a judgement, then the objects of such judgements would be 'aesthetically perceived' as of infinite value, or so Kant appears to fear. Kant's difficulty here arises because he wants the notion of 'occasion' to be merely causal; but if it were only causal, then sublimity could not belong to the aesthetic at all. Kant thus requires a notion of 'occasion' that possesses a judgemental and reflective moment; but to allow this runs contrary to the actual quasi-causal narrative of the experience of sublimity he provides. Hence his account slides between the causal and cognitive senses of 'occasion', secreting the latter in the former.

Kant handles the apparent perception of sublimity by contending that it involves 'a certain subreption (substitution of a respect for the Object in place of one for the idea of humanity in our self – the Subject)' (CJ, §27, 257). To argue otherwise would involve Kant in allowing that we could *perceive* something to be of value (worth). What slight plausibility Kant's argument has derives from his contention that the formlessness of the objects of reflection leading to the (dynamically) sublime is the opposite of form; hence no judgement of them is made, but a feeling of the failure of the possibility of a perceptual judgement is recorded in our feeling of displeasure. However, in so far as an estimation of an external object reflectively claims it ought or ought not to be judged a suitable candidate for a judgement of sublimity, then a judgement about it is being made. As a consequence, formlessness is not the utter absence of form, and hence its opposite, as Kant's argument requires, but internally implicated in form as its contrary. The thesis that the objects generating judgements of sublimity are formless only appears plausible in connection with a certain range of natural objects. Kant avoids conceding the obvious counter-example to his theory, sublime art works, by suggesting that in such cases what we have is a presentation of the sublime in 'union' with the beautiful (CJ, §52, 325); and he appears to suggest that this same union is at work in certain aesthetic presentations of the 'human form' (CJ, 'General Remark...', 270).

Conceding the point over the human form, however, concedes too much. In the passage where Kant makes this remark, his argument is to the effect that in making judgements of sublimity we must avoid regarding what is perceived teleologically, that is, we must not perceive the starry

heavens, for example, as 'suns moving in orbits prescribed for them with the wisest regard to ends. But we must take it, just as it strikes the eye, as a broad and all-embracing canopy.' When considering the human form, the same point holds: the determining ground of the judgement must not have direct recourse to the moral ends '*subserved* by all its limbs and members, or allow their accordance with these ends to *influence* our aesthetic judgement'. The claim here is that the judgement only remains aesthetic to the degree to which what is present to sensibility *exceeds itself* in the direction of the supersensible; if we project our ideas of human worth onto the presentation, then our judgement can no longer be regarded as aesthetic. If we hold to what de Man has called Kant's 'materialism' here,[16] that is, to a perception of what is present to the senses without projection and without reducing the presented object to a medium through which another person expresses her ideas, then it follows that what is 'technically' not sensible – not sensible in accordance with the dictates of Critical theory – can appear to sensibility by taking on sensible form. In anticipation, we might hazard that what this tells against is a certain conception of what is and is not sensible rather than against aesthetic perception. Either way, this moment is an awkward one for Kant's theory.

What 'strikes the eye' in perceiving Michelangelo's *Moses*, for example (but consider also such works as *King Lear* and *Guernica*), is the indeterminate self-transcendence of the sensible in the sensible. And if we are pressed as to what feelings are aroused in this perception, then we had better say a pleasured pain, or a painful pleasure. In these representations what is at issue is precisely the entwinement of human dignity and the endless vulnerability of the human form, a dignity and worth constituted through that vulnerability. Hence even the thought of a unity of the sensible and supersensible here seems misleading. The question raised by Kant's 'materialism', his restraining of projection, and restriction of aesthetic perception to 'what strikes the eye', is *what* can strike the eye?

In a significant passage Kant states: 'The beautiful prepares us to love something, even nature, apart from any interest: the sublime to esteem something highly even in opposition to our (sensible) interest' (CJ, 'General Remark...', 267). Now the example of sublimely beautiful art throws into question the duality of love and esteem, or rather, throws into question the duality between the two different concepts of disinterest that underlie it. Kant associates the disinterest involved in judgements of beauty as a freedom from what sensibility desires as such, together with a freedom from a direct interest in the aims of cognition and morality. In contrast to this, Kant regards the disinterestedness of the sublime as acting *against* the interest of sense. So he states that the moral law is only made known to us aesthetically 'through sacrifices', and hence is only known to us through the sublime and not the beautiful; 'for human

nature,' Kant continues, 'does not of its own proper motion accord with the good, but only by virtue of the dominion which reason exercises over sensibility' (CJ, 'General Remark...', 271).

This contrast makes poor sense of what Kant says about beauty and love, and involves him in a misinterpretation of his own moral theory. The latter point first. Kant's moral theory does not require that there be a conflict between the interests of sensibility, what we 'naturally' desire, and the dictates of the moral law. Rather, it is the case that the worth of actions depends on their being done for the sake of the moral law, and hence not naturally. The overriding supremacy of the moral law, however, only becomes self-evident and visible given the general opacity of the human heart, in cases of conflict. Kant here appears to be making the heuristic and pedagogical supremacy of the conflict model into the paradigmatic relationship between the moral law and sense; or, rather, he appears to read the conditions for cognitive awareness of the moral law, namely, overt conflict between it and desire, into what the dominion of the moral law entails.

It could be argued that Kant is not committed to such a view, but his point concerns rather the availability of the moral law in aesthetic reflection; thus paralleling rather than contrasting with his moral theory. Not only does this claim ill accord with what he says about 'sacrifice' and human nature, but it falsely poses the question from the point of view of the moral law, rather than from the perspective of the sublime itself.

What is the sort of love prepared for by beauty? And how does beauty prepare us for love? While a fuller answer to the second question must await our discussion of reflective judgement, we know already that aesthetic reflection involves, in its disinterestedness, a freedom from the dictates of our personal wants and needs; this level of disinterest is taken by Kant to be sufficient, assuming the other requirements of judgement are met, to allow us to claim universal validity for our judgement. Such a judgement prepares us to love the object in that it allows us to perceive the object in its own right. And this thought is backed up by Kant's demand that we conceive of the object as not determined by any positive end, be it external or internal. The object is perceived *as if* it were an end in itself. So to perceive an object aesthetically is to perceive it *as if* it were of worth in itself apart from our own or any other ends or interests.

Although Kant radically distinguishes love and esteem in the third *Critique*, in Part II of his *The Metaphysics of Morals*, 'The doctrine of virtue', he argues that love and respect should be regarded as operating like the principles of attraction and repulsion in the physical world, together binding the world into a whole:

> The principle of mutual love admonishes men constantly to *come nearer* to each other; that of the respect which they owe each other,

to keep themselves at a *distance* from one another. And should one of these great moral forces fail, 'then nothingness (immorality) with gaping throat, would drink the whole kingdom of (moral) beings like a drop of water'.[17]

What is at issue, then, in the distinction between love and esteem is a question of 'distance', of the distance necessary in order to have a proper regard conjoined with a proper concern for the other. Now in the following paragraph Kant distinguishes various sorts of love and esteem in order to discover which is the proper object of moral legislation. The sort of love appropriate here is not 'aesthetic love', which is based on a feeling of pleasure one takes in the perfection of the other; nor is it 'emotional love', for others cannot obligate us to have feelings for them; it must rather be 'practical love', based on a maxim of benevolence, which has beneficence for the other as its consequence. Analogously with respect: it cannot be based on a feeling derived from comparision (Kant instances a child's attitude toward a parent, a pupil's for his teacher, etc.); rather, respect in its practical sense must be taken as a '*maxim* of limiting our self-esteem by the dignity of humanity in another person'.[18]

What is noteworthy here is that although the love–respect prepared for by aesthetic reflective judgement clearly has the same consequences as practical love and respect, it is not based on a maxim nor on the sorts of feeling Kant mentions. Rather, it is based on perception, an 'as if' perception made in accordance with the requirements of aesthetic reflective judgement, but perception nonetheless. Aesthetic reflective judgement of the kind being considered here cuts across the distinction between aesthetic love and practical love, and between aesthetic respect and practical respect; in so doing it reveals love and respect to be not different in kind, but different in degree, a question of balance, more precisely of distance – a question, then, of orientation, to pick up a concept already in place. So aesthetic reflective judgement of the human form can orient us in our relations with others without the intermediary of practical maxims under the legislative authority of the categorical imperative. And this certainly suggests that practical love and practical respect, as Kant deploys these concepts, are not the foundation of our regard for others, but salutary defences marking the place where vision, perception or judgement has failed. (It is a moot question whether Kantian morality in its postulated fulfilment or art is a better reminder of this vision.)

If sublimity is to be a question of judgement, then it must be a species of beauty, and not something separate from it; and the artistic sublime, which has the human form as its focus, unites the sublime and the beautiful. This union does not deny the fact/value distinction; it is premised upon it. This premise is granted in the 'as if' linking the disinterestedness

of aesthetic reflective judgement with the intrinsic finality, the purposive-ness without purpose, the end-in-itself-ness, of the object of judgement. What has been denied is that the distinction between reason and under-standing is a priori and hence necessary, rather than a posteriori and con-tingent. And this is what must be denied if the judgement of sublimity is going to be a judgement at all. But if the distinction between reason and understanding is contingent, and they appear 'as if' united in at least a species of aesthetic reflective judgement, then this should alter radically what the claim of taste is a claim for. And this yields a somewhat proleptic affirmative answer to the question with which we began this section: aes-thetic judgement, the experience of the beautiful and the sublime, does disturb the logical and peaceful duality of knowledge and morality.

iv The Question of Reflective Judgement

If reason and understanding can operate in union, if, that is, we can per-ceive the world as coloured in accordance with value, or better, if we can perceive things 'as' valued where the question of whether perceived value is original to the thing or projected on to it can be shown to be otiose, then the possibility for this will have to lie in the nature of reflective judgement itself. An initially plausible suggestion that would allow us to think this possibility would involve regarding reason and understanding as having *become* separated out from a state of unity in reflective judgement. And this temporal becoming would have compulsive force if it were doubled by a logical becoming, that is, a demonstration to the effect that something like what we call aesthetic reflective judgement could be shown to be logi-cally prior to determinate judgement. We need, then, to demonstrate: first, some evidence that a temporal or historical story might be appropriate; secondly, a logical account of the priority of reflective over determinate judgement; and thirdly, an account of reflective judgement answering to the needs of these two claims. We shall take up these questions in reverse order. Once these points are established, then the memorial hypothesis introduced at the very beginning of this chapter will be able to be fowarded.[19]

While generally judgement is the faculty for thinking the particular as contained in the universal, Kant distinguishes between determinate judgement, where the particular is subsumed under the universal, from reflective judgement, where 'the particular is given and the universal has to be found for it' (CJ, Intro. IV, 179). Reflection, Kant tells us in §6 of his *Logic*, is a going back over different presentations in order to discover in them something that remains constant or invariant.[20] Now if reflection is required when a concept is lacking, when, for example, we want to generalize over similar but different individuals, then the work of reflec-

tion, although carried out for the sake of the understanding, properly belongs to the productive imagination, which freely conforms to the laws of the understanding and is form-giving, hence law-giving (CJ, 'General Remark...', 240–1). And by form, at its most abstract, we should understand 'the coming together (in a manifold of an object) of some or all of the elements of the manifold in a unity in accordance with a concept or in a unity suitable for some possible, even if unspecified, concept'.[21] Since the form of concepts consists in their generality, and this generality responds to, corresponds with, or is answerable to the generality of the elements discovered through reflection in a manifold, then the work of reflection is the generation of concepts adequate to the forms of the elements of a manifold.

Now what is clear, even from this brief sketch, is that the activity of judgement, when considered as a reflective activity, has about it an appraising or qualitatively discriminatory character, what Kant calls 'estimating' (*Beurteilung*; CJ, §9, 218). And this appraising character of judgement is operative, if submerged, even in ordinary acts of subsumption. So at B172 of the first *Critique*, Kant says that if understanding is the faculty of rules, 'judgement will be the faculty of subsuming under rules; that is, of distinguishing where something does or does not stand under a given rule'. Kant's thought here is just that the question of whether something stands under a given rule cannot itself be decided by the application of a rule without generating a infinite regress. Hence judgement itself is not rule-governed; its appraising is the non-conceptually governed 'scanning' or apprehending of a manifold in order to arrange a match between it and a concept. A judgement is determinate, then, not because this appraising can ever be absent, but when this appraising work is done under the governance (determination) of some legislative faculty other than judgement itself:

> Take a doctor who knows what typhoid (the concept) is, but does not recognize it in an individual case (judgement or diagnosis). We might be inclined to see in the diagnosis (which implies a gift or an art) an example of determining judgement, since the concept is supposed to be known. But in relation to an individual case the concept itself is not given: it is problematic, or altogether indeterminate. In fact the diagnosis is an example of reflective judgement. If we look to medicine for an example of determining judgement, we must turn to a therapeutic decision: there the concept is given in relation to an individual case, but what is difficult is its application (counterindications in the patient, etc.).[22]

Generically, then, judgement is always an act of appraising, discerning or estimating that is underdetermined by rules, and the operation of this

discernment is a necessary condition for the subsumption of synthesized manifolds under rules.

There is nothing surprising or untoward in this result: from the outset we have taken Kant's strategy in the third *Critique* to demonstrate how aesthetic reflective judgement involves, essentially, the necessary subjective conditions for determinate judgement. What we might have regarded as disputable was whether such conditions were properly epistemic or merely psychological.[23] Focusing on the appraising and discerning work necessary for determinate judgement reveals that talk about a 'harmony of faculties' cannot be brutely psychological, but is properly epistemological. And Kant's strategy in the third *Critique* can hence be regarded as the interrogation of judgement when it is freed from its submerged role in determinate judgement, when, we might say, judgement is operating autonomously or for its own sake.

Phrasing the problem in this manner, however, provides a hint as to how we might displace the centrality given to determinate judgement, for in asking how judgement appears when operating autonomously we might suggest that when it operates under the governance of the legislative faculties of reason or understanding it is being employed heteronomously. Knowledge-getting for Kant is a form of intentional activity; which is to say, when Kant speaks of synthesizing manifolds, and of subsuming a perceived manifold under a concept, he is considering knowledge-getting as a goal-directed activity. The simplest realization of this goal occurs in ordinary, predicative judgements of perceived objects; while the highest level of this activity is the construction of a unified physical theory.[24]

That acting to gain cognition by means of concepts is a form of activity has also been presupposed from the beginning, since it is from the general purposes of cognition that the pleasure in judgements of taste is to flow:

> The regularity that conduces to the concept of an object is, in fact, the indispensable condition...of grasping the object as a single representation and giving to the manifold its determinate form. This determination is *an end in respect of knowledge; and in this connexion it is invariably coupled with delight (Wohlgefallen)* (such as attends the accomplishment of any, even problematical purpose). Here, however, we have merely the value set upon the solution of a determinate problem, and not a free and indeterminately final entertainment of the mental powers with what is called beautiful. In the latter case understanding is at the service of imagination, in the former the relation is reversed. (CJ, 'General Remark...', 242; my italics)

Now the pleasure taken in the solution of a 'determinate problem', that is, the pleasure we take in ordinary acts of cognition, is *interested* because 'the concept is determinate, so that the pleasure is pleasure in the fact that a

manifold conforms determinately to a concept and its associated schema'.[25] And this is just as the above passage suggests: in acts of determinate judgement the imagination is being pressed into the 'service' of the understanding, which entails that the imagination is being used heteronomously, a point we shall return to; and the pleasure evoked is the understanding's pleasure in subsumption. Kant stated the same thought earlier in more vivid terms:

> But the latter kind of finality [i.e. the purposiveness of cognition], as it refers to the form of the Object, not to the Subject's cognitive faculties engaged in its apprehension, but to a definite cognition of the object under a given concept, *has nothing to do with a feeling of pleasure in things*, but only with the understanding and its estimate of them. (CJ, Intro. VIII, 192; my italics)

Note that the pleasure taken in ordinary acts of cognition has nothing to do with a pleasure taken in the things themselves, but only in their *subjection* to the understanding.

It is precisely because in ordinary acts of cognition pleasure is interested, and because in such acts the imagination is being employed heteronomously, and finally because in such acts of subsumption – subjection our pleasure has nothing to do with a pleasure in things but is a pleasure in dominion, that there are grounds for thinking that perhaps ordinary cognition (at least as it is conceived of as being continuous with the work of science) is a heteronomous form of knowledge-getting. The reason why Kant does not consider this possibility is because for him the understanding, as a legislative faculty governed by the categories, cannot be regarded as in any way optional. Hence he contends that the origin of the universal laws of the understanding does not presuppose any further intention or aim (*Absicht*), 'seeing that it is only by their means that we first come by any conception of the meaning of knowledge of things...' (CJ, Intro. VI, 186–7). Knowledge-getting as legislated by the understanding, and as involving the subsumption of objects under concepts, cannot be regarded as heteronomous because such activities define knowledge in the first instance. This claim, of course, has the weight of the whole of the first *Critique* behind it. Yet the reversibility of the relations between the understanding and the imagination, as exemplified by the passage from the 'General Remark...' appended to §22 quoted above, and the concession that the pleasure in aesthetic reflective judgement is a pleasure taken in things, might suggest that the situation is other than as Kant construes or intends it.

In ordinary cognitive activity the imagination is constrained by the laws of the understanding, it is 'tied down to a definite form of this Object and,

to that extent, does not enjoy free play, (as it does in poetry)' (CJ, 'General Remark...', 240). In the judgement of taste, however, the productive imagination exerts an activity of its own 'as the originator of arbitrary forms of possible cognition'. The term here translated as 'arbitrary' is *willkürlich*; the proper translation of this term is central for understanding Kant here, and it has much exercized commentators.[26] Clearly 'arbitrary' or 'random' hardly fit Kant's intentions here. But *willkürlich* also has the sense of 'at pleasure', as in doing something at one's own pleasure, that is, not at anyone else's. And this seems to match Kant's point perfectly. In judgements of taste the productive imagination produces possible forms of intuition freely, at its own pleasure, and not as constrained by the determinate needs of understanding or reason. What it produces is 'lawful', that is, orderly, having a significant diversity within unity, but corresponds to no given (external) law. Hence what we discover or produce in a judgement of taste is a 'conformity to law without a law *(Gesetzmässigkeit ohne Gesetz)*'.[27]

Now the production (which can only be properly understood through Kant's analyses of art and genius, to be taken up in the next chapter) or reception (which is also a production) of an object exemplifying a lawfulness without law is not, for all that, something which is non-conceptual or non-discursive; hence Kant instances poetry as an example of the free play of the productive imagination. What makes judgement free here is that no one concept or set of concepts is taken as subsuming the object under any ends external to it. Hence the idea of a lawfulness without law is the complement of the idea of a purposiveness without purpose: the first formula designates the modus of the imagination, while the second designates the characterization of the object that attends such a form of apprehension. In discovering a lawfulness without law we are attending to the object in its givenness (where the nature of 'givenness' is determined epistemically and not causally), and hence apart from any subjective or objective ends, including those of categorial cognition, that we might bring to it. Our estimation of the object is unconstrained by any necessities apart from appraising the object in its own right.

The question as to whether we are here treating objects 'as if' they were ends-in-themselves or simply 'as' ends-in-themselves cannot, from a Kantian perspective, be a question as to whether or not they 'are', metaphysically or ontologically speaking, ends-in-themselves, for in this context that question devolves onto the question as to whether so regarding them is a parasitic and analogous mode of comprehension or originary (a priori). And thus far the only evidence we have for claiming that such indeterminate judgemental comprehension is neither intrinsically evaluative nor intrinsically epistemic is the a priori claims to validity of reason and the understanding. The disinterested pleasure of the judgement of taste speaks against these claims.

Of course, if that pleasure is considered to be continuous with the

pleasure arising from successful acts of cognition, then the subordination of aesthetic reflection under determinate judgement would remain in force. What forwards that subordination is the thought that the kind of unity or togetherness of a manifold discovered in aesthetic reflection is the same as would satisfy the demands of the understanding generally. But is this really so? What the understanding seeks (through the productive imagination) is invariant features of individuals in virtue of which they can be regarded as the same as other individuals; and it is this cognitive goal that is continued in the constructive activities of modern science. The pleasure taken in such cognition is, precisely, pleasure in the subordination of an individual by a concept (or the subordination of one or more laws under some more general law), a pleasure in the mastery of an individual (or law) by a concept (or more general law) covering a range of individuals (or laws). Alternatively, aesthetic reflective judgement marshals concepts, which by definition apply to more than one individual, for the sake of the individual judged. In the abstract, the idea of seeking unity in diversity applies in both sorts of cases; however, the direction of cognition varies between the two cases, and so, one would expect, would the corresponding pleasures.

In other words the interests of understanding and reason are neutralized and dignified by their claim to a priori validity. Aesthetic reflective judgement's disinterestedness at first sight appears as another effort of neutralization. However, the tensions in Kant's argument, which derive at bottom from his assigning to taste a difficult autonomy, which both support that disinterestedness and simultaneously attempt to curtail its claims by keeping it subsumed under either the understanding or reason, make the a priori claims of reason and understanding appear interested in a more subjective, less neutral sense. For reason and understanding objectivity involves the discovery (or invention) within subjectivity of forms that are, presumptively, more than subjective; while the disinterestedness of aesthetic reflective judgement involves, in a curious manner, the wholesale bracketing or self-relinquishment of subjectivity for the sake of the object judged. From the perspective of disinterestedness, reason and understanding still wear the mark of their subjective origin, a mark revealed by their interest structure and underlined by the nature of the pleasure resulting from their successful operation. Transcendental subjectivity is still subjectivity, and it is revealed as just or only subjectivity in the discovery of judgemental pleasure without dominion. If we are not to blame Kant for this fate, a fate that would be outside his control in the 'matters' themselves, then the simplest hypothesis explaining his difficulties suggests that aesthetic disinterestedness works *against* the interests of reason and understanding. *Aesthetic reflective judgement in the moment that it (historically) becomes autonomous, which is the moment of Kant's unearthing of the logical grammar of the aesthetic, reveals the subjective interests of truth-only cognition and categorical moral reason.* These

subjective interests are so deeply entrenched in our conceptual scheme and life practices that heretofore they had appeared as objective. And to the degree to which they are *historically* non-optional that appearance is not absolutely false.

It thus now becomes at least plausible and perhaps necessary to regard the pleasure taken in determinate judgements as deriving from ends or interests external to the intrinsic bent of reflective judgement itself; and further, to regard the subsumptive employment of concepts in determinate judgement as involving a heteronomous deployment of the productive imagination. One might attempt to resist this thesis by denying the claim that appraising judgement is cognition, either because it is non-subsumptive, which directly begs the question at issue, or because such judgement is merely contemplative, and hence of no (practical) significance apart from its connection with determinate judgement. This too, however, is question-begging since the remoteness of appraising judgement from practical concerns presupposes that the only significant employment of appraising judgement is aesthetical; but this either ignores or repudiates the possibility that reflective judgement became merely aesthetic under determinate historical conditions. The only direct grounds for repudiating this hypothesis would be Kant's original transcendental formulations of understanding and reason; which is why the repudiation can only be question-begging. Further, in our examination of the modal force of aesthetic reflective judgements we were forced to recognize the practical as well as the evidential status of disinterestedness.

All this still leaves quite problematic the interest of disinterest, and hence the end or purpose constitutive of aesthetic reflection. In discussing the antinomy of aesthetic autonomy I mentioned, but did not elaborate, the duality between the a priori disinterestedness of taste and our empirical interest in beauty as a medium of communication. Kant takes up this issue in §41. There he treats the empirical interest in beauty as a means and medium of sociability, as itself an end added to the intrinsic pleasure we take in beauty. However, prior to his Critical endeavours (*c.*1769–70) Kant had in fact thought communication and taste were more closely conjoined:

The contemplation of the beautiful is an estimation (*Beurteilung*) and no gratification (*Genuss*). This appearance, to be sure, makes for some enjoyment but, by far, not in relation to the judgement (*Urteil*) of delight in the beautiful; rather, this (pleasure) consists solely in the judgement of the generality of the delight in the object. From this it may be seen that, since this general validity is useless in the absence of society, in that case all charm of beauty must also be lost. Just as little will any inclination to beauty arise in *statu solitario*.[28]

There is a tension in this account between whether the pleasure we take in the beautiful derives from an intrinsic response to the object of contemplation, or from the interest we have in communicating that response. To urge the latter point, however, would be unsatisfactory since unless we did feel pleasure in contemplating the beautiful there would be nothing needing to be communicated. Hence even in his early writings Kant usually separated the pleasure one might take in beauty from the judgement of taste itself, that is, the judgement that such-and-such an object has been judged disinterestedly, etc., and therefore the claim that it is beautiful is a claim to intersubjective assent. Hence a logical wedge is being inserted here between the ability to respond to an object aesthetically, which is a priori, from the ability to evaluate that pleasure, which is social and a posteriori.

In favour of preserving such a logical separation is the thought that unless we had the capacity to respond aesthetically, unless some story like the harmony of the faculties were operative, no theory of beauty could even get a foothold. Nonetheless, such an absolute duality seems implausible. First, because an aesthetic response is not a raw or unmediated response to the object of contemplation, but involves a complex act of discriminating judgement. If this is so, then to say that it is only the discrimination between pleasures that is social but not the pleasures themselves is to press the distinction between natural and acquired further than it can take. This, by itself, would not make the possible assent of others part of the ground determining the pleasure in the beautiful, but it would throw into question the attempt to make the account of taste and beauty require two discontinuous stories: the first about the feeling for the beautiful, and the second about the judging of that feeling.

Secondly, as Kant himself asks the question, what is the sense or point of beauty outside of society? In the third *Critique* Kant suggests an answer to this question, namely, the pleasure we take in the beautiful derives from the discovery of an attunement between objects and the general ends of cognition even when cognition itself is not the interested goal of the activity. It is just this response, however, the explanatory component of Kant's theory in the deduction of taste, that we have claimed to be inadequate. Once aesthetic response and the judgement of taste are dirempted from serious questions of truth and goodness, then they do appear peculiarly pointless, senseless, empty.

Finally, in §41 Kant's sense of the urgency of this question surfaces. After conceding the point that an interest in communication cannot form part of the determining ground of the judgement of taste, he goes on to state:

> Only in society does it occur to him to be not merely a man, but a man refined after the manner of his kind (the beginning of

civilization) – for that is the estimate formed of one who has the bent and turn for communicating his pleasure to others, and who is not quite satisfied with an Object unless his feeling of delight in it can be shared in communion with others. Further, a regard to universal communication is a thing which everyone expects and requires from everyone else, just as if it were part of an original compact dictated by humanity itself. (CJ, §41, 297)

A statement like this puts the distinction between the a priori and the a posteriori, between the natural and the acquired, under intense pressure since it raises directly the question of the relation between methodological solipsism as a philosophical procedure, and the apparent fact of human sociability. Part of this pressure derives from the fact that the procedure of methodological solipsism is here associated with a pre-self-conscious state of affairs; but if self-consciousness of our selves as beings of a certain sort is constitutive of our being, then the assumptions of methodological solipsism are more than counterfactual. It is this which gives urgency to our question: What point or claim can the claim of taste have if it is made from a perspective not governed by acting after the manner of our own kind? What is the question of beauty apart from civilization, apart, that is, from human intercourse in general? How originary does an original compact have to be before it becomes a priori? Especially if man is 'a creature intended for society'? And if man is a creature intended for society, whose sociability belongs essentially to his humanity, then are not these facts a priori facts about us too?

Nor should one suppose that these questions refer only to the claims of taste; directly analogous considerations arise with respect to beliefs. In 'What is orientation in thinking?' Kant argues against the sharp distinction between thinking and communicating in these terms:

> But how much, and how correct, would we think if we did not think as it were in common with others, with whom we mutually communicate! Thus one can well say that the external power which wrests from man the freedom to publicly communicate his thoughts also takes away the freedom to think – the sole jewel that remains to us under all civil repression and through which alone counsel against all evils of that state can be taken.[29]

The issue raised by this passage is the connection between objectivity, intersubjectivity and oppression. While the first two *Critiques* give priority to objectivity (as grounded in transcendental subjectivity), the third moves in the direction of giving priority to intersubjectivity through reflective judgement's lack of an objective determining principle. Presupposed commonality and not presupposed principles are its aim. But this aim,

again, cuts across the aims and principles of the earlier *Critiques*. Hence the methodological solipsisim of the *Critique of Judgement* becomes self-undermining: it can only have what it seeks, namely, commonality, by turning against its own methodological starting point.

The explicit thesis Kant pronounces here is that communication (or at least communicability) is necessary for the possibility of thinking; 'objectivity' is a product of taking into account the possible and real views of others. Without access to other opinions we have no perspective through which to evaluate our own; for real purposes logical consistency is too weak a constraint. Loss of the freedom of speech entails a real loss in the possibilities of thinking, and thereby a real loss in objectivity. Hence the very possibility of thought is 'political'. (It is this connection between the possibility of objective thought in general and political freedom that led Arendt to employ Kant's aesthetic for the purpose of reconstructing the concept of the 'political'.[30]) But if the argument of the previous paragraph is correct, *then the transcendental legislation of reason and understanding is equivalent to a transcendental repression of the political,* which entails, a fortiori, a transcendental deformation of thinking and reason itself. Of course, such a thesis cannot be established on the basis of a paragraph from one of Kant's minor essays; its real backing can only begin to emerge from the consideration of the fate of the communicability of reflective judgement.

Picking up the argument from the third *Critique*: if the claim to communication inaugurates civilization, it equally consummates it, for when civilization reaches its height, then it 'makes this work of communication almost the main business of refined inclination'; to such an extent that the 'entire value of sensations is placed in the degree to which they admit of universal communication' (CJ, §41, 297). At this juncture, Kant states, the interest in direct pleasure in the object of judgement is almost inconspicuous, while 'the idea of its universal communicability almost indefinitely augments its value (*ihren Wert beinahe unendlich vergrössert*)' (ibid.). An infinite augmentation in the value of something would altogether displace its original value, so here the augmentation is only 'nearly' or 'almost' 'indefinite'. But so nearly, that one wonders what the sense and effectiveness of the original interest might be? Can we comfortably, knowingly and confidently separate an original and what supplements it 'indefinitely', without end? Why even attempt to sustain what, prima facie, begins to appear both quite unsustainable, and worse, without point?

Well, Kant does have a point; and what requires questioning is whether he needs the radical distinction between a priori grounded aesthetic pleasure and empirical pleasure in communication in order to sustain it. Kant's central reason for disallowing an interest in communication from entering into the determining grounds of a judgement of taste concerns,

again, the logical grammar of taste. One does not judge a thing beautiful because that judgement will or is likely to find universal assent; for so to ground one's judgement is to judge heteronomously. But this is only to say that the empirical possibility (likelihood) of universal agreement cannot be the criterion of one's judgement. One must judge for oneself. But what if the pleasure in aesthetic judging was, from the outset, grounded in a commonality which only became visible, palpable and communicable, in virtue of the judgements delivered? In such an instance common sense, the *sensus communis*, could be both the ground and the goal of judgement. The aesthetic would then mark an interest in community, as well as signify a different relation to objects that had been severed by reason and understanding in their strict legislative sense. This claim naturally returns us to the disputed priority of objectivity over intersubjectivity.

The claim being forwarded here is that commonality, communication and sensibility entwine in aesthetic reflective judgement to provide a notion of validity that is distinct from the notion of universal validity derivable from transcendental reflection. In the former case sensibility, the deliverances of the senses and their cultural formation, provide for orientation; while in the latter case only what is a priori valid does so. The specificity of the aesthetic turns, then, on the fact that in this domain we are intrinsically both rational and sensible, in a manner that is not the case in categorial cognition through the understanding or reason. Our sensibly fashioned finitude, one might say, is constitutive of the very idea of taste; and having taste is, it would appear, constitutive of our humanity. In distinguishing the three kinds of pleasure to which we are subject and of which we are capable, Kant says:

> Agreeableness is a significant factor even with irrational animals; beauty has purport and significance only for human beings, i.e. for beings at once animal and rational (but not merely for them as rational – intelligent beings – but only for them as at once animal and rational); whereas the good is good for every rational being in general... (CJ, §5, 210)

Being capable of taste (judgement) and being human hence appear to be consubstantial, since here, even more so than with respect to 'knowledge', where we take an interested pleasure in objects, we operate as sensible beings who have the capacity to discover within our sensible determination the possibility of aligning it simultaneously with both objects and others. What makes this discovery both pleasurable and terrifying is that nothing (transcendentally) guarantees or insures it. 'Sensibly', intersubjective validity just is, in the final instance, communicability. For judgement, then, the gap separating the claim to universality and the claim to universal communicability must disappear.

Judgements of taste, then, are hardly idle; on the contrary, the attunement between us and things they signal is also, and necessarily, an attunement between persons, without constraint or interest. The lawfulness without law enjoyed in a judgement of taste enjoins an unconstrained attunement amongst men concerning the world they inhabit, imaging a solidarity among persons and things. The normative anomalousness of the claim to taste irrevocably transgresses the duality of moral demand and free liking; the claim to taste being the 'claim' of unconstrained delight, or, to state this in its full paradoxical form, the demand of love.

v Beauty and the Labour of Mourning

There is a general, theoretical problem with Kant's theory of taste, which is also a textual problem, as we shall see shortly. Aesthetic response, we have been told time and again, involves synthesis without a concept; and this directly contradicts the stated conclusion of the Transcendental Deduction in the first *Critique*: 'All synthesis...even that which renders perception possible, is subject to the categories; and since experience is knowledge by means of connected perceptions, the categories are conditions of the possibility of experience, and are therefore valid a priori for all objects of experience' (B 161). While it might be tempting to argue that aesthetic synthesis intrudes between categorial synthesis and synthesis through an empirical concept – filling the gap, so to speak, between the two – such a thesis, it has been argued, would have the dubious consequence that we could employ a category in general without employing any empirical concept being the value of that categorial variable.[31] Further, the most plausible solution to this difficulty, namely, to consider the harmony of the faculties in psychological rather than epistemic terms, has already been shown to underestimate the epistemic – discerning, appraising – work carried out by judgement.

Here is the textual conundrum. In section VI of the Introduction to the third *Critique* (187), Kant notes that, as a matter of fact, neither the application of the categories in general nor the application of ordinary empirical concepts to objects is a source of pleasure; however, if cognition is an activity, then success in these matters should yield pleasure. Of course, Kant needs this pleasure, since it is to be the source of the pleasure taken in aesthetic reflective judgements. So he hypothesizes: 'Still it is certain that the pleasure appeared in due course [or: existed in its day: *zu ihrer Zeit gewesen*], and only by reason of the most ordinary experience being impossible without it, has it become gradually fused with simple cognition, and no longer arrests particular attention.' This must have been a strange time, a time when the applicability of the categories to experience

was sufficiently unsure that their successful employment was experienced with pleasure. And this pleasure, of the intelligibility of nature in general and of the unity and division of nature into kinds, would clearly have been a pleasure in the mastery of nature, a pleasure in the subsuming of the many under the one.

Both perplexities refer to an indeterminate 'pre-critical' time, logical, psychological or temporal, in which neither the applicability of the categories nor the distribution of individuals into kinds had a sufficient grip such that one could speak of either as unproblematically constitutive of objectivity (as such), as establishing an objective domain that could consequently be intersubjectively shared. And yet, throughout the first and second *Critiques* Kant considers the a priori as that which opens up and simultaneously establishes the world as 'world', as capable of being a shared and shareable intersubjective domain of objects, on the one hand, and as providing the conditions for free action and the 'worth' of the individual on the other. This opens the question of what it is to have a world, and what is signified by the claim that the categories of reason and understanding are constitutive of their respective domains. It can be conceded in the case of reason that there is a connection between our awareness of the categorical imperative and its power to govern our activities; what is now being suggested, with the proviso that it is perhaps something Kant never meant to oppose even if he is normally read otherwise, is that the grip of the categories of the understanding on empirical reality, in virtue of their normative status in governing cognitive activity, is to be regarded in the same manner.[32] Such a suggestion would certainly undermine any claim that there is a tight connection between the constitutive powers of the categories and our (or anyone's) possession of an intersubjective world, as well as, more generally, calling into question how strongly Kant intends his conception of objectivity to be. This questioning of the meaning of constitution in Kant's epistemology cannot proceed directly, however, for throughout the analysis of the judgement of taste it has not been the epistemic categories of the a priori and a posteriori which have been centrally at issue, nor has it been the modal categories of necessity and contingency; rather, the comparison has been between the *indeterminacy* of reflective judgement and the *determinacy* of subsumptive (determinate) judgement.

Part of the difficulty in thinking through the interplay between determinacy and indeterminacy in Kant's thought is removed once we recall that his transcendental idealism is not equivalent to any form of phenomenalism. Objects of experience are not synthetic productions constructed out of sense data. Rather, categories are best conceived of as characterizing 'the way in which we connect perceptions in thought...if we are to experience *through* them' objectively obtaining states of affairs.[33]

Consider, again, the example of the medical diagnosis: in examining the patient, in appraising and discerning the body before him, the doctor must decide, on the basis of what he perceives, whether a feature of the patient is or is not a symptom; to treat something as a symptom is to claim that it is an event in accordance with the category of causality; to claim that the feature is not a symptom could involve either thinking of it as an event without medical significance, or as a stable, albeit statistically irregular property of the subect (e.g. a mole), and hence without pathological causal antecedents. In reflective judgements of this sort it is not just particular concepts, such as 'symptom', which are subject to disconfirmation, but equally the category governing those concepts. Category application does not occur automatically, mechanically or through the operation of an algorithm; category application, just as much and in the same way as concept application, requires the discerning powers of judgement. But this is just to bring to the fore what was contended earlier, namely, that the work of understanding presupposes reflective judgement; and that it is best to conceive of the difference between reflective and determinate judgement as a difference of degree (and use) rather than an absolute difference in kind, since the former is submerged but present in the activity of the latter.

It now seems pertinent to ask the question: How indeterminate is reflective judging? The force of this question becomes apparent when we apply the standard objection to the judgement of taste directly to Kant's epistemology. Remember, the standard objection stated that if just the necessary subjective conditions for objective judgement were sufficient for a judgement of taste, then Kant would have to declare all sense-perceptible objects beautiful. What this presupposes, and what now appears to be presupposed by Kant's general theory of knowledge, is that there are invariant features of perceptual manifolds which are regarded as invariant in virtue of their conformity to the invariant features of the understanding.[34] What goes wrong with this account, and what is pointed to if not stated by the standard objection, is that there is a slippage between invariance and recognition, and between recognition and synthesis. The complex doubling of invariance (ascribable to features both of manifolds and of the understanding), we might say, tends to license a more causal conception of what occurs than is readily compatible with an acceptance of the account offered of the kind of mental activity requisite to register invariance. The gap opened up and insisted upon by the standard objection, while appearing to ask for something more than invariance as a condition of beauty, which it of course does do, does so through an invocation of a discerning, discriminatory activity which simultaneously undermines the putative causal role of invariant features of manifolds in the epistemological story. But this is just to say that applicability of the

categories to experience must be regarded as a non-trivial achievement; and only by conceding this point can any sense of the role of reflective judgement be maintained.

Again, what makes this argument plausible is the role of reflective judgement in determinate judgement. What seems to be implied by this role is that the determination of which appraised features of an object conform to the invariant features of the understanding presupposes a non-nomological common sense in virtue of which variant and invariant features are sorted. Even this might appear too strong, since it presupposes that the distinction between variant and invariant is settled a priori, rather than discovered. Although problematic, let us ignore this point. It would still follow that the sorting of features of objects and states of affairs into variant and invariant is presupposed by determinate judgement. Now let us attempt to conceive of a state of affairs in which categorial invariance is not yet secure; what, then, would have had to be the case in order for it to be secured? Two conditions would need to have been fulfilled, some evidence for which will be given below. First, there must have existed a common sense, a shared appraising discourse; and second, an interest in producing what we (now) regard as objective judgement, that is, an interest in regarding objects in terms of those properties that permit determinate identitary judgements. (In forwarding these two conditions I do not intend to deny that certain nomological conditions are presupposed for the possibility of an intersubjective domain; rather, the claim is that Kant conflated the causally necessary conditions for judgement with the properly epistemic conditions; and further, that that conflation is made possible by the valorizing of determinacy over indeterminacy, and by conflating, as we shall see, common sense as pure form with common sense as a concrete form of epistemic sociation.)

Both conditions are of consequence. To claim that, in the first instance at least, we cannot conceive of the application of objective categories in the absence of a common sense, is to claim that nothing insures or guarantees the existence of an intersubjective world a priori; unless we already shared a way of viewing the world, shared concepts and capacities for appraising and discriminating, then the distinction between variant and invariant could not find purchase. That it does find purchase, equally assumes that we have an 'interest' in producing judgements that are disconnected from what anyone desires, or thinks beautiful or holy or good. Even this is too weak; for if we are to imagine an instance in which the satisfaction of this interest is to be a source of pleasure, then we must equally be imagining a situation in which this interest, in producing objectively valid judgements in accordance with the categories of the understanding, has become an identifiable interest apart from other forms of interest.

Is this the time of which Kant was speaking when he claimed that, once upon a time, pleasure appeared from the application of categories and the

sorting of individuals into genera and species? It is certainly difficult to imagine a set of conditions other than what has been proposed that would satisfy this claim. In conceiving of such a time we are initially conceiving a world in which the judgements of common sense predominate; in which, that is, reflective judgements as such had a certain sort of dominance over determinate judgements. Such a dominance would obtain if the core judgements concerning objects were made on the basis of indeterminate rules incapable of determinate evidential confirmation. But to conceive of a situation like this is just, I want to suggest, to conceive of a situation in which objectivity and 'truth' are not distinguished from the beautiful or the good or say the holy; where, perhaps, to be true is to be good, or where nothing is beautiful that is not also holy or good or true.

As suggested at the end of the previous section, a world premised upon common sense and not objective rules is one in which there would be a lawfulness without law; and this approximates what Hegel will term *Sittlichkeit*, customary practices in which form as condition is not separated from what it informs. Such an idea models, we might say, such a world. The modelling is not ideal, however, since the objects of such a world are not conceived of as without end or purpose external to themselves; on the contrary, they are deeply enmeshed in an endless series of teleological references (this approximates to what Heidegger will designate as a 'world'). What differentiates objects so judged from the objects of the understanding, however, is that the judgement placing them within the teleological whole is reflective rather than determinate: their ultimate determination is not made on the basis of their sense-perceptible features. Judging them would have been more like an indeterminate diagnosis than an assertive judgement of fact. Conversely, *Kantian invariance is reductively bound to the sense-perceptible features of objects, or rather, Kant's idea of the sense-perceptible features of things, which provides for the invariance his theory requires, must be construed as reductive if reflective judgement is perceptual.* This claim, then, confirms and reiterates the argument of the previous section: what is sense-perceptible gets reduced through transcendental legislation to its lowest common denominator, namely, what accords with the dictates of categorial causality and physical theory so understood. As soon as the indeterminate conditions of determinate judgement are brought into play, however, the presumptively a priori determination of what is or is not sense-perceptible is automatically called into question.

To now conceive of a world in which determinate, subsumptive judgement predominates over common sense is to conceive of a world in which the interest in knowledge has come to mean an interest in what things are apart from any other interests; and where, therefore, what provides the commonness of the world, its shareability, are the sense-perceptible properties of ordinary objects in their (reductively) determinate relations to one

another. Since the claim has been that the interest subtending this state of affairs is 'subjective', then the recovery of the history producing it will amount to a genealogy of reason. Versions of such a genealogy will be offered in subsequent chapters.

From the perspective of reflective judgement the attainment of such a world looks like a loss; a loss of commonness and solidarity. Or better, it images a common world without solidarity. Things and persons are meaningless, without value, in terms or what can be said about them 'objectively', perceptually, through the deliverances of the senses.

In such a world, our world, judgements of beauty are memorial: in making aesthetic judgements we judge things 'as if' from the perspective of our lost common sense, a common sense that may never have existed (evidence for it deriving strictly from the torsions of the analytic articulation of aesthetic experience). This 'remembered' common sense is, as Kant has it throughout the third *Critique*, both presupposed in the judgement of taste and yet to be obtained. It is present by virtue of its absence. As remembered/presupposed, common sense is constitutive of the judgement of taste; as not existent, it is regulative. Hence the answer to Kant's remarkable and curious question (CJ, §22, 239–40): is common sense, the necessary condition for the possibility of judgements of taste, constitutive or regulative?; the answer is both. Of course, if a common sense did exist, then Kant's moral theory would become redundant; alternatively, if Kant took common sense as regulative, then the disinterestedness of aesthetic judgement would have been infringed upon. In accordance with the letter of the critical system, then, common sense can neither be presupposed nor demanded and judgements of taste are not possible. Only by conceiving of the judgement of taste as memorial can we comprehend how and why Kant vascillated over what is a linchpin of his argument.

Common sense can provide the ground for a judgement of taste only to the degree to which it exists, since by definition it lacks the sort of a priori form which can be imposed on an independent content. As its placement in the imagination indicates, and as Kant's wide definition of imagination in the third *Critique* as sensibility plus imagination emphasizes, common sense is the becoming-form-of-content *and* the becoming-content-of-form. The freedom of the imagination in reflective judgements of taste marks its freedom from the constraint of a priori legislation as such. Kant contrasts the understanding's determinate judgement with aesthetic reflective judgement on precisely this basis:

> The aptitude of men for communicating their thoughts requires, also, a relation between the imagination and the understanding, in order to connect intuitions with concepts, and concepts, in turn, with intuitions, which both unite in cognition. But there the agreement of both mental powers is *according to law*, and under the constraint of

definite concepts. Only when the imagination in its freedom stirs the understanding, and the understanding apart from concepts puts the imagination into regular play, does the representation communicate itself not as thought, but as an internal feeling of a final state of mind. (CJ, §40, 295–6)

Although there is an activity of the understanding in aesthetic reflective judgements, it is not the understanding of the first *Critique*; here it is 'stirred' into activity by the materials offered to it, and although it interacts with the imagination, it does not subsume or legislate.

Kant, then, was quite right in §41 not to let the presupposed communicability of aesthetic judgement become a demand; to demand common sense, to morally require it, is to destroy it. Common sense is not form, but the non-formal condition of form, as lawfulness without law is law without legislation, and therefore without constraint. Common sense is the communicability of feeling, and not the demand for such. But such a common sense does not now exist, or exists only as a memory; but in so far as 'we' remember it (in virtue of serious participation in aesthetic discourse and practice), judge through it, it does exist. In its existing it binds us, not as a constraint or external law binds us but as ties of affection (and disaffection) do.

From the perspective of common sense, legislative morality is a remedial virtue.

Because common sense is only activated through participation in aesthetic discourse, and because, as Kant concedes, that participation is exhausted by the kind of communicability tokening common sense, then it is unsurprising that Kant should regard the 'universal communicability of the mental state' in judgement as the ground of our 'pleasure in the object' (CJ, §9, 217). Only when we judge in accordance with our lost common sense is there an *aesthetic* feeling of pleasure in the object. Kant's making the feeling of pleasure in the object consequent on its universal communicability, a presumption that appears backwards from a naturalistic perspective, however hesitantly, acknowledges the primacy of common sense over categorial understanding and moral reason.

By conceiving of the judgement of taste as memorial we can now provide at least the rudiments of a solution to the problem of the standard objection, that is, the problem of what sorts of non-trivial, if indeterminate, conditions are met by objects judged beautiful that distinguish them from other sense-perceptible objects. Roughly, a judgement of taste is appropriate to the degree to which we are able, in considering the object, to abstract from the determinate concepts that constitute that object as belonging to an objective realm. The thought lying behind this requirement is that the less an object 'must' be conceived of in terms of determinate judgement, the less it is caught in the 'web' of subsumptive

thought, the more suitable it is for the work of remembrance constitutive of aesthetic reflective judgement.

At first glance, this requirement appears to get caught in a difficulty directly analogous to the difficulty which so troubles Kant's discussion of free and dependent beauties. There Kant appeared to suppose that for some objects, like churches and horses, we are unable to abstract from the determinate ends they serve; and with art works, we are unable to abstract from the causal, intentional history through which they are produced. Against Kant, on the question of works of art, it has been argued that he 'failed to notice that a power of abstraction broad enough for his general theory of aesthetic response would also be broad enough to allow free judgements on the beauty of objects which are, as a matter of fact, works of art and even representational art'. And that generally, 'it is not clear whether the mere *presence* of any concepts – the mere knowledge of their applicability to a given manifold, even the mere fact of such applicability – is sufficient to constrain the imagination, or whether the imagination can always abstract from concepts known to apply to objects.'[35]

Now in contending that we are not always free to abstract from the net of determinate concepts and ends which 'saturate' different objects to various degrees, and further, that whether we are or are not so free is essential to what makes an object suitable for aesthetic appraisal, Kant was, I am claiming, on to something important. It seems evident that such constraints do operate. Kant ran into difficulty on two counts: first because he wanted to draw the line between where we could and could not abstract on a priori grounds; and secondly because he could not explicate why pure judgements of taste should be so central to constituting the domain of taste, given that its value (import and significance) seemed to reside in dependent beauties. And, again, the latter difficulty is operative because Kant could not conceive of value (import and worth) apart from the space opened up by the categorical imperative, while the disinterestedness of taste and the presupposition of common sense clearly opens up an alternative conception of value. (Indeed, from this perspective the claim that beauty is a symbol of the morally good appears the wrong way round: is not the morally good a symbol for the indeterminate beauty of common sense?)

Nonetheless, Kant rightly recognizes that there is a question here, and that there is a contestation between constraint and freedom; what he cannot do is successfully locate the ground of the contestation. We now have the thesis that the ground of that contestation is precisely the degree of saturation of an object, or set of objects, by determinate thought and practical ends, a point Kant obliquely registers in his disqualification of craft works as suitable objects of aesthetic regard on the basis of their entrapment within commodity production (CJ, §43, 304; §51, 321) with the further proviso that the indeterminate judgement of saturation is itself his-

torically and culturally variable. If this is correct, then we would expect there to be a history of taste wherein different objects (arts and styles of art) became paradigmatic on the basis of their suitability for aesthetic reflection; where such suitability was judged on the basis of those objects' distance from or ability to resist the claims of determinate judgement and the social practices which forward those claims. Perhaps the movement from representational painting, to 'free' nature, to romantic poetry, to the realist novel, to modernist art and literature inscribes just such a history. What that history would record is the collective labour of mourning through which the claims of common sense have been kept alive. A version of just such a history forms the core of Adorno's aesthetic theory.

vi Indeterminacy and Metaphysics
(Anticipating Deconstruction)

That the freedom of the imagination to abstract from determinate concepts and ends is a socio-cultural variable and not indelibly inscribed in our 'human nature' hardly needs defending. What has needed clarification is the determinants of the process of abstraction and the point of engaging in that activity. Kant's claim that such activities forwarded the ends of cognition skewed from the outset our pre-theoretical intuitions concerning the role of aesthetic judgement in relation to knowing and acting. For all that, Kant's account pin-points the real source of difficulty in this area: how are we to sustain the autonomy of aesthetic judgement, the indeterminacy of aesthetic reflective judgement, while simultaneously sustaining its intimate connection with cognition and morality? And in so far as we now regard, must regard, the 'grammars' of the true, the good and the beautiful as operating in disjunction from one another, this question becomes all but unanswerable.

However, the grammar of beauty evinces, marks, a resistance to this disjunction; a resistance that is evinced in both the positive theses and the theoretical tensions and lacunae of the third *Critique*. To listen to beauty, to hear its claims, is to come to doubt the a priori validity of the disjunction of domains. Because Kant had already committed himself to the a priori validity of this disjunction, he could only register the claim of beauty through reference to a supersensible beyond. In a sense, the gesture of displacing that beyond into the past is a (meta-critical) gesture of conservation; a gesture licensed and motivated by Kant's own persuasive account of judging (as opposing to understanding), and his raising of the question of our lost pleasure in knowing.

The indeterminate judging of our lost common sense is not the joining of things otherwise separate, but the logical and temporal root and origin

of what have become autonomous forms of discourse. Reflective judge-ment, we have seen, is logically prior to and a necessary condition of determinate judgement; and the indeterminate free play of the imagin-ation, which underpins and is underpinned by disinterested pleasure/desire/interest, is prior to the movement from heteronomy, external determinacy, to autonomy and self-determinacy. Reflective judgement, or heautonomous self-*in*determinacy, is the logical and historical root of sub-sumptive understanding (bringing intuitions *under* concepts) and sub-sumptive reason (bringing practical representations – materially desires and formally maxims – *under* the categorial principles of right action: the categorical and hypothetical imperatives). Kant's critique of metaphysics repeats metaphysics because his system as produced sustains the ideal of complete determinacy – utopian science and the *summum bonum* – even though these ideals all too evidently function as imaginary supplements to the fundamental critique to which they are aligned and appended.[36]

Resistance to the memorialization of aesthetics on the grounds that it destroys the universality of Kant's critical system through the introduc-tion of an essentially aporetic moment, a non-recuperable indeterminacy at the core of determinate reason, is nonetheless misplaced since it ignores the fact that his metaphysics was aporetic from the beginning, invoking, as it did, inscrutable conditions for understanding (the 'I think', and the spontaneous powers of the mind), unknowable domains and untotalizable totalities. It is only against the background of these aporetic moments that Kant feels constrained to promote the ideal of determinacy. However, to ignore the moments of limit and opacity in the critical system is to render it uncritical.

Another line of objection to the memorialization of aesthetics might be that it makes too much of what is, after all, only a failed argument of Kant's.[37] More forcefully, my claim has been that the attempt to sustain a radical isolation of determinate from reflective judgement is incoherent, and that resisting this attempt means finding a way to point out the inherently saturated nature of all object-determining, and that in different socio-historical contexts more and more radical means for pointing this out might be necessary. Perhaps modernist art has become such a means for us. But how can we be sure that reflective judgement is submerged in determinate judgement? How can we with confidence separate the claim that 'here' reflection has been suppressed from the claim that 'here' we have shifted to a different domain, a different kind of significance and meaning? Perhaps Kant was just wrong to employ the language of objec-tivity, disinterest and the like for aesthetics.

No answer to this objection can be definitive. Since the memorial hypothesis turns on acknowledging the existence of an act of historical suppression (or, at least, the semblance or trace of such an act), its defence will require both a historical account of the repression of reflection (or

some analogue of what appears in Kant as reflection), and an account of those contexts, predominantly now those of modern art, where that repression gets pointed out. If, however, all this amounts to an account of the deformation of reason, if the large and systematic philosophy of history presupposed by this account concludes by depicting the triumph of reason in modernity as itself irrational, then we reflect in the dark. Nonetheless, in so far as Kant's grammar of aesthetics remains our own, and in so far as his account of the efforts involved in aesthetic judgement continue to phenomenologically capture our experience of judgement, we cannot fail to find the practice of aesthetics uncannily akin to and different from the practices of knowing and right action. More, we cannot fail to find our experience of art stuttering, wanting always to say more than is permitted, to speak of a past or a future, half-remembered or half-glimpsed, continuously evading presentation, but whose evasions are the guiding-thread for thinking. It is to the decipherment of this stutter that these pages are dedicated.

In aesthetic reflective judgement we (re-)experience in painful pleasure our lost common sense; we mourn the death of nature and community. Our interest in beauty is neither empirical nor intellectual, for such a concept of aesthetic judgement detaches it from the past to which it belongs. In the (re-)experience of beauty we discover a trace (*Spur*) or sign (*Wink*) (CJ, §42, 300) of that lost common sense; our pleasure in this is discovering now what we thought was gone forever.

2

The Genius of Being:
Heidegger's 'The Origin of
the Work of Art'

i Introduction: Imagination and Finitude

Four fundamental shifts, corresponding to four fundamental gestures of
post-Kantian philosophy, are implied by the arguments of the previous
chapter. First, we can now only understand aesthetics, or what we think of
as aesthetics, the new subject whose logical grammar Kant elaborated, *his-
torically* as the coming to be of the separation of reflective judgement from
determinate judgement and moral reflection. In accordance with terms
that have become familiar, aesthetics and its material and institutional
equivalent, autonomous art, represent the *end* of art, where 'end' signifies
just art's alienation from knowledge and procedural morality, truth-only
cognition and right action. Hence to respond to the implicit genealogy of
the third *Critique*, aesthetics must become historical interrogation that can
think past beauty's (reflective judgement's, art's) placement in the domain
of the aesthetic.

Secondly, the genealogy of aesthetics must also be a genealogy of
truth-only cognition that reveals it as a form of domination or sup-
pression. How did truth-only cognition become hegemonic for cognition?
Implied by both these shifts to historical inquiry is the necessity of gener-
ating a conception of truth extensionally equivalent to the model of know-
ing imaged in the time of our lost common sense. Further, both these
shifts are inaugurated by aesthetic art, by the insight that the art that has
become alienated from truth does not suffer its alienation silently; on the
contrary, the protest of aesthetic art, its way of being more than merely
aesthetic, is what first reveals truth-only cognition as domination and

hence opens up their suppressed history. Aesthetics is from its beginnings the overcoming of aesthetics.

Thirdly, however, the shift to a historical consideration of art and aesthetics cannot be done naively, that is, in historicist terms, if the idea of the alienation of art from truth and morality is going to have weight. To hold on to an alienation thesis requires us to think not only historically but categorially and 'transcendentally' at the same time, to find a way of thinking about the historical emergence of autonomous aesthetics and art that respects the historical specificity and integrity of the phenomena under consideration, while simultaneously according a place to a critical comprehension of the history in question. If history matters to philosophy then philosophical forms are also historical forms and events bound up with other historical events; but they are not just historical forms and events since, if they are of philosophical significance in some sense continuous with what philosophy has been, then they 'inform' the events surrounding them in a categorial way. In brief, we appear to require a philosophy of history, where the (teleological) movement of that history takes up the burden of the work previously accomplished through transcendental legislation by providing categorial orientation for the concrete items under review.

Yet, finally, such a philosophy of history cannot be the full response to the analysis of Kant since on its own it would repeat, and make worse, the suppression of judgement the analysis sought to demonstrate – this is the point made by Arendt briefly noted in the Introduction; and further, it would contravene the concluding thesis that the transcendental conditions for the possibility of knowing are not fully exponible. This final conclusion, it was claimed, was not a contravention of critical metaphysics but its realization. As was indicated in the Introduction, and will become more apparent throughout what follows, we have no definitive way of resolving the tension between the requirements of these final two gestures, that is, no non-contingent way of following the path of increasing immanence without losing a critical perspective or attaining a critical perspective that does not repeat the suppression of particularity. Our position is aporetic, Kafkaesque; whatever we do is wrong; we cannot get 'there' from 'here'.

It is the aporetic character of our situation, the aporiai that flow from Kant's thinking, that has made post-Kantian philosophy so reflective, so intimately concerned with its own procedures and possibilities of 'going on': we can't go, we must go on. The critique of Kantian formalism implies that philosophical reflection must become more immanent, more concrete, more historical. Alternatively, to go all the way in the direction of immanence would entail surrendering any philosophical, critical perspective: the very temptation of poetic thinking and pure phenomenology. Yet the very character of the 'aesthetic' critique of a priori legislation itself entails that such a completely immanent perspective, one in which no

transcendental or categorial discrimination would be either necessary or possible, is false. History is determinant for the disposition of the categorial possibilities of thought, but not every disposition is of equal value.

My reason for turning to Heidegger here is that, on the reading of him I shall offer, his 'The origin of the work of art' directly engages with questions and issues that were posed above as flowing from the reading of Kant. Indeed, I shall want to claim that 'Origin' is, despite appearances to the contrary, a response to Kant and a continuation of the project implied by the above analysis. After a brief aside, we will follow Heidegger's interrogation of the possibility of thinking the end of art, the alienation of art from truth, which equally involves thinking how art is or could be a provider of truth. Heidegger's turn to art and away from the question of aesthetic reflective judgement follows Hegel's analogous move; however, the justification for this move is simple enough to understand directly. If aesthetics is understood Kantianly in terms of displacing direct metaphysical analysis with transcendental investigation, then once that transcendental and hence subjective turn is taken as a historical result, its placement must turn back to the 'original' phenomena: here, beauty generally and art specifically. And our best clue to the understanding of beauty is its most typical instance, the work of art.

Heidegger's project is to understand the end of art as art's alienation from truth. That end will have critical significance for our understanding of the world which institutes it: the end of art will be a loss to be mourned. However, the truth that is lost to art on Heidegger's account is not empirical truth but a categorial or transcendental truth. Heidegger's overcoming of Kantian formalism, his move into history, fundamentally involves letting concrete, empirical items, items that are irrevocably *in* history, possess a transcendental function, be legislative in the Kantian sense. Nor is it by accident that Heidegger's attention should focus on art works as the items where this legislative function is most perspicuous, since for him the question of historical legislation is a question of the transcendental imagination.

To readers familiar with Heidegger it still comes as something of a surprise that his most extended engagement with the question of art is not oriented by a reading of Kant's third *Critique*.[1] This might have been expected on the grounds that in *Kant and the Problem of Metaphysics* he had already focused upon Kant's concepts of the transcendental imagination and schematism as a clue to thinking through the problems of temporality and metaphysics in a manner consonant with the trajectory of his major work *Being and Time*. What, then, could be more natural than to extend and develop that original argument through an examination of how the transcendental imagination operates when it is thematized in its own right in the judgement and production of works of art? And this question receives further emphasis when it is recalled that in *Kant and the Problem*

of Metaphysics Heidegger argues that the transcendental imagination, which we found displaced in the previous chapter into the *sensus communis*, is the 'common root' of understanding and sensibility; this perhaps parallelling our identification of common sense as the common root of reason and understanding.

In his book on Kant Heidegger demonstrates that it is the constitutive or 'essential' finitude of human beings that explains why it is that knowledge requires sensibility and discursive discrimination, and not, as a naturalistic account would have it, the other way round. This precedence of finitude itself over sensibility and understanding is substantiated in the thesis that the schematizing procedure of the productive imagination, whereby pure categories are given temporal forms, is the common root of both sensibility and understanding, and is not, therefore, to be regarded as merely a mediating activity between the two stems of human cognition. In making this claim Heidegger is not denying that transcendental synthesis is a projective understanding of our concept of an object; schematism and projective understanding are to be retained. The claim is rather that the structure of the three-fold synthesis itself reveals the essence of finitude. All synthesis is fundamentally temporal: apprehension in intuition: present; reproduction in imagination: past; and recognition in a concept: future. However, these three moments are not themselves temporally ordered. On the contrary, there can be no apprehension without reproduction, and no reproduction without recognition in a concept. There is no possibility of an original apprehension, an intuited presence, prior to the 'imaginary' condition generating the possibility of its repetition in reproduction; what is first is second. And there is no reproduction without futural anticipation of the kind of unity necessary for conceptualization. The future is 'logically' prior to the past that makes presence possible. Past and future are not privative or defective modes of the present; the present is always a coming-to-presence through the conditioning syntheses of retention and anticipation. This rigorous entwining of the three temporal modalities has some title to be acknowledged as what Heidegger terms 'ecstatic temporality'.

Time is not a product of the self or subject, but its essence: 'As pure self-affection, time is not an active affection concerned with the concrete self; as pure, it forms the essence of all auto-solicitation. Therefore, if the power of being solicited as self belongs to the essence of the finite subject, time as pure self-affection forms the essential structure of subjectivity.'[2] If time, in the form of ecstatic temporality, precedes and conditions subjectivity, rather than being a product of it, then Heidegger would have grounds for believing that finitude, in the form of ecstatic temporality, constitutes the original possibility of finite, sensible and discursive knowing.[3]

What Heidegger's radicalization of Kant's schematism accomplishes is a

kind of completion or realization of the critique of metaphysics. Kant's turn away from metaphysics was, after all, just the insight that philosophy could not be pursued from a God's eye perspective; to do that we would literally have to leap out of our skins. Our skins, our flesh, our finitude is constitutive of our very being. Hence our understanding must be finite and not infinite. Infinite understanding would be able to see everything just as it is, with nothing missing: the world would be wholly *present* to such seeing. Finite understanding is limited and conditioned. The limit, as it were, is time: the world cannot be wholly present to us because the present is always conditioned by what is not present, namely, the past and future. Hence what constitutes metaphysics as what is to be critiqued is its belief in the possibility of presence. Metaphysics just is the metaphysics of presence.

If the analysis of the Kant book are regarded as a summary version of the argument of *Being and Time*, then we have a hint as to why Heidegger retreated from this line of inquiry. One might think that it would follow from the analysis of the finitude of human knowing in terms of temporality that such knowing was, at bottom, always historical in character; and it certainly was the case that in *Being and Time* Heidegger attempted to think through the link between temporality and historicality.[4] Such a linking does not, however, easily follow on from the kind of regressive analysis of the conditions for the possibility of experience pursued in the Kant book. That analysis, to be sure, regresses to ontological conditions that are prior to Kant's own epistemological conditions. Nonetheless, the Heideggerian reading itself remains atemporal and transcendental in character: ecstatic temporality, in which the present (and hence the presence of any item to consciousness) is always mediated and deferred, always conditioned by moments that are not present, is itself *presented* as the transcendental condition of subjectivity. The presentation of ecstatic temporality contravenes its inner nature: if we are finite because ecstatically temporal creatures, then we cannot achieve an atemporal, fully present self-comprehension. The moment of absence must somehow manifest itself in our philosophical thinking; this is what it means to radicalize the Kantian thought that we know only appearances and not things in themselves.

If the finitude of human cognition is to be fully acknowledged, then two conditions must be satisfied: (i) history and historicality must precede temporality: and therefore (ii) the distinction between transcendental condition and empirical realization cannot be established on the basis of the distinction between a priori form and empirical content. To satisfy (i) and (ii) together, the conditions for the possibility of experience must reside fully within experience, be conditioned by an unequivocally empirical item. This is what motivates Heidegger to focus on the work of art, not in

terms of works as products of the transcendental imagination, but in terms of their being created things, things whose very nature is to appear at some time and in appearing add to our understanding of things. While it is initially arguable whether the understanding that works of art provide is itself temporal or atemporal, Heidegger follows the path of Hegel's end of art thesis in order to interrogate the former possibility, a possibility in which works are understood as themselves finite, as cognitively living and dying.

Nonetheless, this approach to the problem is something of a foil, an avoidance of Kantian aesthetics, an avoidance that turns out to be almost too well motivated. In the analysis of the third *Critique* we focused on the treatment of judgement, and hence on the 'passive', or at any rate contemplative, aspect of his aesthetic theory. This led to history being introduced as implied by particular aspects of Kant's account. Yet if history is implicated in Kant's account it must be there 'actively' as well as by implication. More precisely, the question must arise from what has been said thus far: how does the implied history of the separation of the activity of judgement from understanding and reason look when the power of judgement, the work of the transcendental imagination, is conceived of as active and productive? To answer this question involves examining Kant's conceptions of art and genius. What were art and genius prior to the separation of domains? The provocation of this chapter is the claim that 'Origin' is best understood as an answer to this question. Heidegger will take up and generalize the briefly mentioned option that 'transcendental' orientation is possible without a priori legislation through the intermediary of 'exemplary' works. And this amounts to an answer to a question implied but not stated previously: how is a *sensus communis* possible? Heidegger will claim that pre-aesthetic exemplary works, works of what he terms 'great art', were historically legislative, doing for historical peoples what Kant has the principles of transcendental subjectivity doing for all peoples at all times.

Why, then, the use of Hegel as a foil? Why doesn't Heidegger follow through his earlier account of the transcendental imagination with a confrontation with it in its productive, creative mode? Genius is a consideration of art not only under the auspices of the question of the activity of the productive imagination, but equally as enunciating, perhaps in its most radical form, the problem of freedom and autonomy; indeed, the work of genius may be regarded as the production of freedom. However, this emphasis on freedom and autonomy is deeply alien to Heidegger's project since it concerns the subjectivity of the subject. Alternatively, however, one might wonder what force the reference to the *sensus communis* can have if it is detached from the question of freedom. At least part of the claim of the last chapter was that the separation of

domains involved the production of an illusory freedom (the freedom of the rational will through the formal mediation of the categorical imperative), and the suppression of substantial, communal freedom. Hence, in encountering Heidegger's conception of art we shall find ourselves engaging with the question of the compatibility, the congruence and non-congruence, between autonomy, history and community. The question of the relations between these items is the question of the political. In modernity art is the site where this question is raised.

The first two sections of this chapter follow Heidegger's introduction of history into thinking about art. These two sections, which are meant to provide a gentle transition into Heidegger's style of thinking, begin to show what is involved by taking on board the first two gestures of post-Kantian philosophy. Sections (iv) and (v) are my provocation: Heidegger's thinking the question of being, his project, is modelled on and best understood as a generalization of Kant's analysis of fine art as the art of genius. Hence the critical impetus we noted in the third *Critique* is developed by Heidegger through the development of one of its moments. If the work of genius is what happens to great art when it becomes aesthetic, then how does Heidegger explain the critical potentiality of non-great art? What opens up the present to the past for him? How can he begin? One of Heidegger's responses, namely, that which works through the identity and difference of art and technology, is canvassed in section (vi). The failure of Heidegger's argument there will lead us to question the significance of his setting paradigmatically great art in the Greek past. Heidegger's conception of great art, I shall argue, involves *projecting back into the Greek past a conception of art which only modernity makes possible.* The direct consequence of this projection is that it allows Heidegger to think the relation between art and politics; its indirect consequence is his anti-modern politics itself.

ii Overcoming Aesthetics (I): Thing, Historicity and Double Reading

In the 'Epilogue' to 'The origin of the work of art' Heidegger offers us a significant clue as to what the beginning intention, the original problem, governing his meditation on the work of art might be. People speak of immortal works of art and of art works possessing eternal value; even if these claims are inflated, claims like them are always in circulation in those places where art is seriously considered. What substance or content do such claims possess? Heidegger regards Hegel's *Aesthetics* as the most comprehensive – because metaphysically informed – reflection on the nature of art that we have; hence its conclusions must necessarily form our starting point. Hegel claims that 'Art no longer counts for us as the

highest manner in which truth obtains existence for itself,' and because this is so 'art is and remains for us, on the side of its highest vocation, something past'.[5] Art will continue, it will advance, change, develop and perhaps even 'perfect' itself; hence art will continue along its historical way. Nothing Hegel says is meant to deny these obvious truths. How then are we to construe the end of art? To begin with I want to develop this thesis in a manner that is neutral between Hegel and Heidegger in order to allow for a fairly quick transition into Heidegger's thought.

To speak of the end of art is to claim that art is no longer for us the place in which the truth (of who and how we are, and of how 'things' are for us) occurs; art is no longer unavoidably formative for our experience of ourselves or the world; it no longer constitutively presents or even represents what is absolute for us. The death or end of art denotes not the halting of historical movement, nor, then, the cessation of an activity and the concerns surrounding it; but a dislodgement, as it were, of those activities and concerns from the (metaphysical-historical) centre to the periphery. That such a fate can befall a mode of human activity is easy to grasp; it is commonly claimed as the fate of religion in the transition to modernity. Of course, once such a dislodgement occurs, then those activities and concerns cannot be quite the same as they were prior to the dislodgement; the sense, meaning or significance of those activities must change too; and those changes will have repercussions on the activities and concerns themselves.

Two distinct claims are at work here. The first is that any complex social world will be composed of a diversity of interrelated forms of activity: political, moral, scientific, practical, religious, recreational, economic, etc. It is at least historically true that the categorial separation of domains into cognitive, normative and aesthetic did not traditionally follow the lines of demarcation between various forms of activity. Indeed, in traditional societies different forms of activity each might have had their own distinct cognitive capacities and normative authority. However, different forms of activity stood in definite relations of dominance and subordination with respect to one another. So at different historical junctures myth, law, scripture, politics, art or science might have been dominant – might have been the place of transcendental legislation – while other forms of activity stood in definite relations of subordination (and relative autonomy) with respect to what appeared as legislative. Those forms of activity whose cognitive and normative authority were most marginalized (or eviscerated) by what appeared as the place of transcendental authority stood at the cognitive/normative periphery of the society in question. Analogous to changes between scientific frameworks, we can consider one major sense of historical change to be any shift in the locus and character of what is transcendentally authoritative for a social world.

Now if we conceive of social worlds along the lines of scientific

frameworks understood in terms of their historicality, then a change in the
meaning (sense, point, significance) of a form of activity which occurs in a
dislodgement (or 'lodgement') of a form of activity from its place of auth-
ority to the periphery (or vice versa) will involve a change in the 'essence'
of that activity. For example, when 'God' ceases to be the transcendental
source of meaning, then both the concept 'God' changes and with it the
meaning of the activities governed by that concept. Which is to say that
the essence of phenomena is not unhistorical; historicity invades the very
nature of the modes of activity (and their products) with which we are
concerned.

In order, however, for this conclusion to carry, which thus far involves
only a quick historical induction over the variety of forms of human
activity and their changing relations with respect to one another, a further
thesis is required. For Heidegger, like Hegel, what marks the site of the
transcendental as opposed to the periphery is 'the manner in which truth
obtains existence for itself'. This does not mean that what is, and truth,
remain the same throughout history and all that changes is our mode of
apprehending what is. Such a realism presupposes some form of subject–
object dualism: what is remains the same but we bring to it various
instruments, forms of practice or categorial frameworks (art, science,
religion, philosophy) in accordance with which we make different types of
claim as to what is, in truth, there. In order for such an approach to have a
chance of being valid it would have to be the case that things were just
'there', and we could thence just bring our cognitive (and evaluating)
instruments to them. From that perspective it would then become an
intelligible problem to search for the framework which was most adequate
or most fundamental for knowledge; that is, to follow the path of either
positivism or Kant. An approach along these lines certainly does not
cohere with what is now said about the historical character of scientific
frameworks; and in both *Being and Time* and 'Origin' Heidegger denies
that this is the case.

Heidegger pursues two, distinct albeit interrelated, lines of argument.
The first, quasi-Kantian, line begins by conceding that we consider a
proposition true if it correctly represents what is there. Heidegger then
goes on to ask how a fact can be shown to correspond to a proposition, and
proposition to fact, if it were not already the case that the fact was avail-
able prior to and independently of the proposition representing it? 'How
can fact show itself if it cannot stand forth out of concealedness, if it can-
not stand in the unconcealed?' If such did not occur, then the fact could
not 'become binding on the proposition' (OWA, 51). In other words, for a
proposition to be true 'in virtue of' its correspondence to fact requires the
independent availability of fact. That independent availability Heidegger
thinks in terms of the facts' unconcealedness, their being 'in the open'.
And this being 'in the open' and available must be of such a kind that

the way in which facts are available allows them to be 'binding' for the correctness or incorrectness of propositions. In 'Origin' Heidegger wants to pursue a regressive analysis of the conditions for the possibility of correctness, conceding that truth has traditionally meant correctness or correspondence. However, a projective understanding in the manner of a transcendental anticipation of the categorial determinations of objecthood conflates (i) the appropriate fact that we must be in possession of this anticipatory comprehension, with (ii) the sceptical-entailing inference that these categorial anticipations and determinations must come from us. Much of the central argument of 'Origin' seeks to demonstrate that (i) does not presuppose (ii).

Along with the necessity for regressive analysis Heidegger adopts a second line of critique of truth as representation which turns on the demonstration that the representational construal of the nature of the thing depends on the adoption of defective cases as paradigmatic for our understanding of thinghood. This line of argument, prominent in both *Being and Time* and 'Origin', albeit differently in the two texts, argues that things are first available to us 'as' items of equipment within a functional context and only derivatively available 'as' mere things, as substances having determinate properties. Ordinary items of equipment are used in the argument, but it is meant to hold as well for natural items. Before a hammer or a pair of shoes is an object – out there – in front of us, we are familiar with it as something having a place within the circuit of our practical engagements. Hence its functional and purposive properties are an original component of our non-representational comprehension of it. Equipment becomes an object, a mere thing, only defectively: when the shoe rubs or the hammer breaks, only then, when it stops being functional, does it call attention to itself, fall out of place, out of the circuit of practices, and become a mere thing, something without purpose, to be noticed, viewed, re-presented. The converse of this entails that when an item is in use its character 'as' purposeful, and its intrication within a complex of items and practices is not perceived as such; equipment is most useful when it is appropriate to the task to hand and 'invisible' as a distinct item. The shoe that calls attention to itself because it rubs or the hammer that draws our attention because it does not feel right or has a loose head is one that is not functioning 'properly'. The 'proper' use of an item of equipment is its inconspicuous full working. Hence, the 'as' of equipmentality and the 'as' of bare objecthood are both announced, however obliquely, only at the moment of default. For Heidegger this shows both why we tend to think of things generally without the projective understanding of an 'as' structure, along the lines of the paradigm of the representational object, but that it remains the case that bare objecthood can only be understood from the paradigm of equipment; and that, conversely, equipment cannot be understood aright from the paradigm of

bare things. The 'as' structure of equipmentality approximates the image of ethical life presupposed by the logic of the lost *sensus communis*, while the 'as' structure of bare objecthood approximates the categorial framework of the first *Critique*. Heidegger's argument is that the latter presupposes the former.

The usual practice of treating equipment as things with an extra, added property, namely, purposefulness, inverts the true order of dependency. Our ontology of the thing, and our representational stance toward things in general, depends on making defective, broken things paradigmatic; and our standing back from things and viewing them, our contemplative comportment towards things treats them, primordially and for the most part, as to be viewed, as prior to our practical engagements. Where 'Origin' differs from *Being and Time* is in not taking the 'as' structure of equipmentality and bare objectjood, called respectively 'readiness-to-hand' and 'presence-to-hand' in the earlier work, as the definitive transcendental determinations of the world for us. Introducing the work of art into the account denies the apparent categorial hegemony of the two 'as' structures of the earlier analysis, and instigates the possibility of an alternative account of how the world is 'announced' and revealed in its categorial determinations. The consideration of art will allow for the possibility that the announcement of constitutive 'as' structures occurs historically.

In displacing the dominance of the representational understanding of truth and thing Heidegger does not intend to deny the obvious, namely, that this understanding works, that it is effective, and indeed that it is hegemonic for ordinary practice and for traditional philosophical thinking. 'To be sure,' Heidegger concedes, 'the current thing-concept fits each thing. Nevertheless it does not lay hold of the thing as it is in its own being, but makes an assault (*überfällt*) upon it' (OWA, 25). This 'assault' on the thing is the work of the understanding; this work is an assault, we now know, because the categorial framework of the understanding, which indeed fits each thing, is the recruitment of things for subjectivity; or rather, categorial thinghood is this recruitment. Conversely, then, Heidegger takes Kantian disinterestedness as the bracketing of the unreflective assault of the understanding, the letting of a thing appear in its own right, 'purely as it is in itself...in its own stature and worth' (N, 109). Heidegger does want to draw this distinction, albeit on different grounds, namely, on the basis of the distinction between objects appearing in accordance with the categorial demands of representational thought and those same objects appearing on the basis of what makes representational thought possible. Hence Heidegger does not consider the question of representation innocent; nor does he consider the question of the accessibility of things to cognition as having no repercussions outside philosophical reflection. On the contrary, it is precisely because the current thing-

concept does fit each thing and yet cannot be transcendentally validated without remainder that the question of the thing-concept, of propositional structure, of truth and representation becomes urgently and pressingly historical.

Placing this critique of subject–object dualism together with our previous historical induction – both: things are not available to us independently of our practical involvements with them; and those involvements are always socially and historically specific in nature – entails that truth and the nature of what is (being) are internal correlatives that cannot be exempted from the flux of history. It is only in virtue of the linking of these two claims that we can make sense of the thesis that the essence of phenomena, what it is for any thing to be a thing, is historical (because 'essencing' is itself something historical).

Since what is transcendentally legislative of any social world will provide the normative concept of an object for the social world in question – for example, things are created beings (in the Christian world), things are objects of representation (in the modern world dominated by the new science), etc. – then the series of fundamental conceptions of how things are is the history of truth. As a consequence, Heidegger claims, the history of the nature of Western art will correspond to the changes in the nature of truth (OWA, 81), since within any given social formation what art is will be governed by the concept of an object for that formation's transcendental scheme.

Heidegger's consideration of Western art from the perspective of changes in the nature of truth contains three interrelated lines of interrogation. The first is to understand how art is for us now where truth and being are determined by the essence of technology, for Heidegger believes that the categorial structure of technology is constitutive of our social world. However, this interrogation requires that we first have at our disposal a historical, non-aesthetic conception of art works; since aesthetic conceptions of art are non-historical, then changes in the essence of art would necessarily be invisible from within an aesthetic perspective. Secondly, then, we shall have to purge our comprehension of art works of those 'aesthetic' categories which have prevailed throughout the history of Western reflection on art, for those categories – above all, form, matter and aesthetic experience (of beauty, pleasure, etc.) – consider the art work in terms of the metaphysics of presence, that is, in terms which make thinking the essence of art historically, art's essence as historical, impossible. Part of the lure of those categories is that they are determined by the fundamental categorial inscriptions of bare objecthood, each of which presupposes the priority of representational thought. So art works are things, but things of a special kind: things which manifest something other (art works as allegories); or things which are infused with something other (art works as symbols) (OWA, 19–20).

In such and similar cases we begin by considering the art work a thing in accordance with a traditional categorial analysis of thinghood – substance and accident; the unity of a manifold of sensations; form and matter – and consider the art work as a development or modification of that categorial analysis. Heidegger's meditation on 'Thing and Work', the opening section of 'Origin', is negative and destructive in its movement; it is meant to free consideration of art works from aesthetic categories, and not, therefore, to register a true account of the nature of the thing in order to see better how art works are things.[6] Indeed, Heidegger will contend (OWA, 68–9) that a work's thingly character is no part of it *qua* work; that the question of a work's thingly character wrongly takes the work first as an object directly there, as a thing, and in so doing hides, so long as this perspective is maintained, the work's character as work.

Nonetheless, that we do consider works things – in part because they are capable of being dealt with as mere things: weighed, hung, stored, shipped, etc. (OWA, 19) – is no idle point to be peremptorily passed over once we have come theoretically to disqualify their 'metaphysical' thingly aspects as contributing to their true nature. Taking them as thingly is not a 'theoretical' error; it is part of the historical fate of art works, part of their being for us now.

Heidegger regards the matter–form account of thinghood as derivative from the experience of producing articles for some practical purpose. The generalization of this model for thinking the structure of the thing, extending it to mere things and works of art, is given point by a religious thinking which considers the world as a whole to be the product of a creative god who makes the world the way a craftsman makes a useful item. And while we cannot but find these extensions of the matter–form structure problematic, cases of over-generalization, the continuance of this structure in default of a belief in the world as a created being must render the model otiose, 'an assault upon the thing' (OWA, 30). After all, when thinking of mere things, the 'mere' 'means the removal of the character of usefulness and of being made. The mere thing is a sort of equipment, albeit equipment denuded of its equipmental being' (OWA, 30). Without the thought of God's hidden purposes the 'mere' of 'mere things' idles. Kant's Copernican turn attempts quietly to reinstitute an apparently benign teleology and purposefulness to the form–matter structure. But either the teleology of the system must be suppressed, in which case the attachment of transcendental forms to human subjectivity becomes opaque; or transcendental forms are for the sake of human subjects, and subjectivism appears and the transcendental claim to objectivity becomes problematic.

It is impossible when reading Heidegger on the form–matter structure and the nature of 'mere' things not to regard it as a critique of Kant, of the Kantian categorial 'assault' on the thing; an assault which is halted,

directed elsewhere, when that same categorial conception of form comes to be re-deployed, ambiguously to release the object of aesthetic judgement in an act which is perhaps best described as one of categorial self-restraint. We shall return to discuss how that self-restraint connects with the earlier violence of the assault.

Placing this result next to our earlier critique of subject–object dualism, of which it can be considered a part, we can take Heidegger's destructive argument as given (further aspects of it will be taken up in our considera-tion of Derrida's reading of Heidegger), and turn to the third part of his interrogation: an account of what overcoming aesthetics is, and the devel-opment of a non-aesthetic way of thinking about art.

In his account of 'Origin', Hans-Georg Gadamer interprets Heidegger's project of overcoming aesthetics in terms of his own programme for overcoming aesthetics in *Truth and Method*. While both Heidegger and Gadamer comprehend the overcoming of aesthetics in terms of restoring to art works their status as forms of cognition, Gadamer's programme is rather less radical than Heidegger's in that he regards aesthetics as the subjectification of art that is a product of the age of Enlightenment where 'the autonomous right of sensuous knowledge [was] asserted and with it the relative independence of the judgement of taste from understanding and its concepts' (PH, 218). For Heidegger, while this moment is indeed a turning-point in the history of knowledge about art, corresponding gener-ally to the metaphysical turn in which the individual's states (of thought, will and feeling) become primary and hence the 'court of judicature over being' (N, 83), it does not mark the beginning of aesthetics. Aesthetics, for Heidegger, is any consideration of art which comprehends it in terms of the state of feeling aroused by the beautiful; that is, for a theory of art to be aesthetical it must make sense, sensation or feeling in response to the beautiful primary in our understanding of art. In aesthetic understandings of art, art works are objects for subjects, where the relation between sub-ject and object is one of feeling (N, 78).

'Aesthetics begins,' says Heidegger, 'with the Greeks at that moment when their great art and also the great philosophy that flourished along with it comes to an end' (N, 80). This statement is ambiguous, for it is unclear from it, or from what follows, whether 'great philosophy' includes or excludes Plato and Aristotle (it certainly includes the pre-Socratics). The ambiguity is systematic, however, for Plato's and Aristotle's writing on art both belong and do not belong to aesthetics. To the degree to which the vocabulary – above all: form and matter – and the problems that belong to the tradition of aesthetic writing are first set out in their works, then to that degree their writing and argumentation are shaped by aesthetical considerations and must be read accordingly. However, Heidegger also finds in Plato and Aristotle a thinking that is rooted in an

experience of a different form of understanding being, one in which being and presence are not identified. Consequently there exists as well in their writing an understanding of art which is not aesthetical. It is well to recall here Heidegger's claim in 'Origin', whose most worrying connotations we shall see Derrida exploit, that 'Roman thought takes over the Greek words without a corresponding, equally authentic experience of what they say, without the Greek word. The rootlessness of Western thought begins with this translation' (OWA, 23).

Thus we should not be surprised when Heidegger finds in Plato not only our familiar distancing of art and truth, a distancing that will become a separation, but equally, in the *Phaedrus* (250d), a 'felicitous discordance': the radiance of the beautiful liberates us from appearances (from beings, from the oblivion or forgetfulness of being) to allow us a view upon being (N, 197). We might be surprised, however, when Heidegger suggests an equivalent double reading of Kant on the beautiful (N, 109–10). So Kant's *Critique of Judgement*, the very text that institutes the radical autonomy of aesthetics and art in modernity, equally 'explodes itself' (N, 131), providing a non-aesthetical comprehension of art and beauty.

We can understand this eventuality if we record two interconnected theses of Heidegger's. First, the history and tradition of metaphysics is a history of succeeding construals of 'what is' in general terms modelled on the understanding of particulars simply there before us, on, that is, items taken as fully and unequivocally present. So 'what is' in general has been interpreted in terms of our understanding of particular beings. For example, this way of understanding 'what is' would allow us to apprehend individuals without the conditioning of the reproductive imagination or conceptual synthesis. But this is just to say that this model takes the present as independent of and as prior to past and future. Again, this way of understanding 'what is' Heidegger terms the metaphysics of presence; it belies at least the irrevocable entwinement of the temporal modalities that constitute ecstatic temporality; and now, radicalizing that model, the entwining of being and temporality that makes essencing historical. Linking our earlier statement of ecstatic temporality with what we have been saying about history and historicality, we can put Heidegger's thought this way: the tradition of metaphysics conflated something being present (an intuition) with something coming-to-be present (temporal synthesis), and gave priority to the former. Heidegger's strategy is to turn our attention from the former to the latter, from 'being' as a nominal participle to 'being' treated as a verbal participle. Being is not a thing of any kind, but the process through and in which things come to presence. Acknowledging that things come to presence involves acknowledging that the presence of things belies their being conditioned by what is not present, by what is absent or different. And this, of course, is just how Heidegger construed the significance of the threefold temporal synthesis of the schematism:

apprehension (presence) is never present except derivatively through reproduction and recognition. Only now this conditioning of presence by absence is being construed in terms of the categorial determinations of worlds as a whole. Further, this process is not something natural, an unchanging process of nature, but historical. 'Being', as a first approximation, is just Heidegger's term for the process or history of alterations in what there is, of the various economies of presence which have governed Western thought and history.

But, secondly, the continual substitution of some metaphysic of presence for being, the substitution of beings (a being) for being (as a process of presencing) as the key to understanding what there is, is itself, according to Heidegger, the way in which that history of alterations has worked; the comprehension of the being of beings in terms of presence, that is, in terms of beings, operates in accordance with the fatefulness of being itself. It is being, we might say, which in its epochal determinations of what is offers a mode of understanding what is that belies its epochal and historical way of bringing beings into presence; each way of bringing things to unconcealment, of making them available (*überhaupt*), corresponds to a mode of being's concealment. Each epochal mode of presencing, and hence that in virtue of which an epoch is an epoch, just is a self-occlusion of being whereby it presents itself (presencing) as what it is not (a present thing or being – Ideas, God, the will, etc.). Being works historically through dissimulation. Being loves to hide. Hence in any fundamental metaphysical thinking being is licensing its displacement by beings. As a consequence, we who read metaphysics at the end of metaphysics, we who can no longer ignore the place of history in the essence of phenomena, must read doubly: the texts of the tradition will manifest both the substitution of beings for being, and so the oblivion or forgetfulness of being; and, at the margin, between the lines, the presencing of beings by being. If the texts of metaphysics did not 'explode' or exceed themselves (for us, deciphering them at the end) in the direction of the absential dimensions of presencing, then they could not have a place in the history of metaphysics. Fundamental metaphysical gestures, from the Platonic Idea on, are moments of displacement (of the being process) and unconcealment (of things into presence); and there can be no history of metaphysics in a strict sense unless that history is understood in terms of the history of being's unconcealment (of things) and withdrawal (of its process of presencing).

Heidegger's history of philosophy, where philosophical works are presumed to be where the most revealing traces of past historical fields are to be found, is a history of metaphysical theories of what is that have operated in forgetfulness of that which makes them possible. Metaphysics is the ignoring of the difference between being and beings, presencing and presence, the event of unconcealment and what has been unconcealed;

metaphysics is the failure to think the ontological difference. The history of being is the history of the growing forgetfulness of the event of unconcealment, the event that withdraws, and must withdraw given that absence is a condition of presence, in the very process of revealing.

Aesthetics, what we call or think of as aesthetics, is the working of the metaphysics of presence with respect to art and beauty. Overcoming aesthetics, then, involves noting those moments in the history of aesthetics where thinking on art exceeds aesthetics, just as overcoming metaphysics (inaugurally) involves registering those moments in the history of metaphysics where the texts of the tradition 'explode' themselves by exceeding the logic of presence that apparently, and fatefully, governs them. So, for example, Kant's understanding of judgements of taste as disinterested, as devoid of all interest, can be read aesthetically as a mere bracketing of cognitive, sensible and moral interests that allows us to attend to a work's form, a bracketing that has come to be called 'adopting the aesthetic attitude' to the object in question. As we have already seen, however, there is a tension in Kant's account, that arises at the centre of his deduction of taste as a consequence of his attempt to specify the peculiar status of the judgement of taste, that throws into question the priority of the a priori categories of cognition and moral worth. An echo of this unsettling of categorial parameters can be heard in Heidegger's question whether we can hear in the 'unconstrained favouring' consequent upon disinterestedness 'the supreme effort of our essential nature, the liberation of ourselves for the release of what has proper worth in itself, only in order that we may have it purely?' (N, 109).[7] The self-relinquishment of disinterestedness is equally the relinquishment of transcendental subjectivity. Even our 'merely' aesthetic stance, a stance that is constituted by metaphysics, exceeds metaphysics.

Heidegger continues this consideration of Kant in an intriguing way. Speaking of Kant's interpretation of aesthetic behaviour as 'pleasure of reflection', Heidegger states that this pleasure 'propels us toward a basic state of human being in which man for the first time arrives at the well-grounded fullness of his essence. It is the state that Schiller conceives of as the condition of the possibility of man's existence as historical, as grounding history' (N, 113). How does aesthetic behaviour open us up to our historical existence, indeed, to that which grounds history (by letting it be)?

iii Overcoming Aesthetics (II): Great Art

The practice of double reading does not provide a non-aesthetic comprehension of art; rather, it is an account of how to read writings on art that reveals their compliance with and deviation from aesthetics. The writings of the tradition exceed aesthetics in the course of their work of

instituting and reproducing it. As we shall see later, this practice of double reading is appropriated and transformed by Derrida. It is also worth noting that although patently not Heideggerian, our reading of Kant nonetheless revealed how in the very attempt to generate a proper and pure conception of 'aesthetic' judgement, Kant was continually forced to blur the boundaries between the aesthetic and the cognitive (and moral), to slur all the more the sliding and slipping discordance between art and truth, until in the mourned for lost common sense we discovered a conception of 'truth' more fundamental than that provided for by the understanding. But if that reading was not Heideggerian, was not governed by the exigencies of the revealing–concealing play of being, what logic or law governed it? And how does its exceeding of aesthetics relate to Heidegger's?

Although Heidegger contends that from the very beginning Western thinking on art was bound up with aesthetics, he does mark off what is usually regarded as the era of aesthetics, the epoch of modernity, as distinctive, as making a radical break with the past; and this break relates directly to the history and value of art itself. Roughly, Heidegger argues that in the age of technology, our epoch, there is no more 'great art', where the concept of great art supplies his non-aesthetic conception of art (N, 80). In 'Origin' Heidegger is attempting to theorize Hegel's idea of the end or death of art in terms of the end of great art; or better, he is attempting to theorize a conception of art, namely, great art, as the sort of art that can 'die', that can lose its capacity to reveal a world (OWA, 40). This would be a conception of art as finite rather than 'infinite', which would be an account of art in terms of unchanging characteristics, the necessary and sufficient conditions for any item to be a work of art, etc. The mortality of great art will be specified as art's possessing a historically delimited truth potential. Hence great art is non-aesthetic as finite and as possessing a cognitive potential.

Great art will not be great because of its beauty or formal elegance or aesthetic merit, for these criteria for judging art works are themselves aesthetical. If the theory of great art is to form the basis for a non-aesthetic conception of art, then criteria for greatness will of necessity be of a different order from traditional aesthetic criteria. Of course, Heidegger's proposed new criteria are not proffered as an alternative theoretical framework for defining art, since any such attempt would contradict his fundamental insight concerning the historicality of phenomena. Nor, however, does Heidegger want to reduce the historical understanding of art to a consideration of what historically has been said about it. Rather, his concern is to reveal how art is one of the ways in which history takes place; that is, art is considered as one of the ways in which an epoch comes to itself and is formed; and this will equally say something about that epochal conception of history. Indeed, the structure of 'Origin' works

on the basis of proffering a conception of great art which simultane-
ously, and for the first time in Heidegger, articulates a conception of
epochal history. For our purposes, however, we can read this account
from the other direction: the concept of great art is fairly directly
entailed by Heidegger's epochal conception of history, together with the
thesis that within any epoch certain forms of activity will be either a site
where what is transcendental for that epoch is revealed or a site informed
by that transcendental authority (and hence one whose activities can be
only empirical). From these two ideas it follows that a non-aesthetic con-
ception of art will seek to demonstrate how works can be epoch-making,
possessing an 'originating' power in Heidegger's lexicon, capable of
revealing transcendental truth. Briefly, in his own terms first, Heidegger
contends:

(i) Whenever art happens – that is, whenever there is a beginning – a
 thrust enters history, history either begins or starts over again…
 History is the transporting of a people into its appointed task as
 entrance into that people's endowment. (OWA, 77)
(ii) Of one great work, Heidegger says: it first gives to things their look
 and to men their outlook. (OWA, 43)
(iii) Since the meaning of being, the truth of being is itself epochal, then
 art is one of the ways in which truth happens. (OWA, 55)
(iv) Hence, art is history, in the essential sense that it grounds history.
 (OWA, 77)

At the conclusion of the opening section of 'Origin' Heidegger says,
'Art is truth setting itself to work', and he continues with the leading
question of the remainder of the essay: 'What is truth itself, that it some-
times comes to pass as art?' (OWA, 39). We have already noted how the
correspondence theory of truth embedded in the positivist conception of
science belies how the growth of knowledge occurs in science; modern sci-
ence does involve a systematic, if not directly continuous, growth in our
knowledge of nature, but that growth cannot be comprehended representa-
tionally. Rather, scientific frameworks – paradigms, research programmes,
domains – that at any given time say what any portion of nature is, deter-
mine what is scientific and what not, guide continuing research, provide
criteria for theory choice, etc. What the concept of a scientific framework
invokes with respect to the work of the framework itself is a *productive
rather than 'reproductive' or 're-presentational' conception of truth*. Scientific
frameworks provide the measure of nature rather than being measured
against it; the growth of knowledge within a framework is made possible
by the framework itself, while the shift from one framework to another
simultaneously reveals the parochialism of past knowing and new possi-

bilities for understanding what nature is and what science is, and hence new possibilities for doing science. Scientific frameworks, in their productive capacity, provide the conditions in general for both science and its objects.

Heidegger's conception of truth in art as bringing into unconcealment is, it seems to me, directly analogous with this productive conception of truth in science, with two exceptions. First, the productive conception of truth in science considers the revealing structure (paradigm, research programme, etc.) to be a distinctly human product, while for Heidegger what brings into unconcealment cannot be regarded as a uniquely human product, a product of the imagination or will as they are usually conceived. As we have already seen, being withdraws or occludes itself in those places where unconcealment occurs; this will entail not only a certain 'transcendental' opacity, a certain curtailment of the transcendental in such events, but moreover a question as to their place of origination. Secondly, what distinguishes great art from regionally specific forms of truth-production (bringing into unconcealment) – and scientific truth for Heidegger is always regional, even if productive (OWA, 62) – is that it operates for a totality *qua* totality, a world *qua* world, and not merely for some region or domain within a world. More, there is such a thing as a world only in virtue of the work performed by a great work or its equivalent – the act that founds a political state, sacrifice, the thinker's questioning (OWA, 62). What is meant by 'world' here is the kind of unity or sense of belonging together that the different forms of activity and understanding that a people engage in possess for them. So Heidegger will say that great art reveals how beings as a whole are: 'What is holy and what unholy, what great and what small, what brave and what cowardly, what lofty and what flighty, what master and what slave' (OWA, 43). This work, I am claiming, 'reveals' a world in a way precisely analogous to the way in which a paradigm or research programme institutes an object domain by providing a concept of an object in general, and hence *unifies* scientific practice by providing guidelines for inquiry, criteria for theory evolution and so forth. A work of great art can institute the horizons of a world in just the same way that a scientific framework institutes the horizons of a scientific 'world'. Or better, Heidegger's list should be read as a list of categories, and hence as a historical counter to Kant's categories of the understanding and reason.

To be sure, the kind of totality that Heidegger is claiming great art provides is problematic for us, both because, rightly or wrongly (which I shall comment on later), we do not conceive of ourselves as actually inhabiting a totality having this sort of force; and because it is a normative principle of liberal democracies that the question of what is the good life for man, which includes the question of how each is to make sense of and *unify* the complex of activities in which he or she engages, is a matter for

each individual to decide for him or herself, and is not to be 'legislated' by the state or society at large. Nonetheless, since we take this position to be a historical achievement of liberal states, an achievement of modernity, and Heidegger will be restricting great art to (more or less) pre-modern, pre-liberal social formations, then the conception of traditional societies as normative totalities does not contradict the standard self-presentation of modernity, and indeed gives succour to the philosophy of history under-writing that self-presentation, at least in the first instane.

If pressured, one might say that even if a work of art could be promi-nent in the reproducing of the categorial framework of a social formation, it is surely an exaggeration to say it might *produce* a normative totality, and it is this latter claim that Heidegger is making. Responding to this charge requires following through two distinct lines of thought. First, we need to make clearer what Heidegger's claim amounts to, thereby mitigat-ing the initial implausibility of the thesis. We then need to ask the ques-tion why Heidegger takes great art as his model in developing an account of epochal history, why the history of being, which is a history of econ-omies of presence and hence truth, should find licence for itself in the conceptualization of the question of art in terms of great art, which then metaphorically images the history of being as an art history? In answering the latter question we make explicit what was implicit in the answer to the first question. Now it might be argued that to ask this latter question here in this way is precipitous since a proper answer to it requires understand-ing why, at the end of 'Origin', Heidegger contends that 'language itself is poetry in the essential sense' (OWA, 74), and then analysing the compre-hension of poetry/language/thinking in Heidegger's late works. This stan-dard move is unacceptable, for until we understand the original centring of art, the original deployment of art in breaking with the concept of historicality offered in *Being and Time* (as we shall see is the case below), we cannot enter 'understandingly' into the later thinking about poetry, language and thinking. 'Origin', we might say, provides the Heideggerian ladder to the standpoint of the 'absolute'. Hence it is just this queston, of the motivation and justification for employing art as a model for thinking through the questions of historicality and epochal history, that will form a central target of our considerations for the remainder of this chapter.

As will become increasing evident, Heidegger's account has much to do with what is created as opposed to what is merely produced. Production, making, is always the re-production of what was first created. Which is why the form/matter structure so misleads: it construes creation as production and hence suppresses createdness. Art works are irrevocably created; and great art will figure transcendental createdness, transcen-dental legislation, without imposition or assault.

As a first approximation, Heidegger's conception of what great art accomplishes can be broken down into two constitutent parts, an explana-

tory thesis and a functional thesis. The explanatory thesis occurs in Heidegger's contention that great works happen suddenly, marking the beginning of an epoch. In saying this Heidegger grants that the beginning made by a great work 'prepares itself for the longest time and wholly inconspicuously' (OWA, 76). Why then speak of a beginning? Because great works are not moments *in* a tradition or a history, but are works which *disrupt* some previous history and hence set in motion the possibility of another history. This is why Heidegger speaks of great works as 'unmediated' (*Unvermittelte*: OWA, 76). The point is not that they spring from nowhere, but rather that they cannot be accounted for in terms of their antecedents, however antecedents are understood (e.g. as reasons, causes or ends). Mediation is something that occurs within a (continuous) history, within a historical totality, and hence cannot be applicable to comprehending what brings a world into unconcealment as a world. To put the same point otherwise, it is part of what is meant by calling art 'creative' that no account of the elements or antecedents of a work is sufficient to explain what it is that is achieved in it. Of course works often, if not usually, fall below this level of originality; and not every original work is great art, revealing how things are as a whole. Nonetheless, originality, about which Kant says a great deal, is all but constitutive of our conception and valuing of art. Further, if history is epochal, and if epochs are normative totalities, inscribing the ever non-objective horizons of a world, then it is plausible to argue that there are 'places' where the discontinuity between epochs is enunciated, perhaps akin to the role fundamental theories play in most non-positivist conceptions of scientific progress and rationality. For Heidegger, great art is such a place, and it would appear uniquely suited to the role assigned to it.

This helps to explain why Heidegger speaks of truth as an event or happening. The point is not to institute an intuitionist view of artistic truth or to legitimate a Romantic conception of artistic action, any more than it is Kuhn's point to undermine the rationality of science when he insists upon the revolutionary character of certain developments, or characterizes the alteration of understanding that occurs during such developments as a 'conversion'.[8] Rather, Heidegger uses his terms in order to *contrast* the uneventful activities and works which deal with particulars belonging to a totality to the event of the totality itself. Because that event is always double, both the 'rise or inception of an epochal economy, and... the mutual entry into presence of things, words, and actions',[9] it is always a moot question as to whether the event of the great work designates a temporal priority, the releasing of an economy of presence, or only the explicit cognition of the 'event' of the world itself as the world it is (or even: the event of unconcealment as an event of unconcealment). The idea of being prepared for the longest time is, of course, equally ambiguous between these two possibilities. An inception need not be marked; hence

what does the marking need not be 'responsible', in the causal sense, for the inception. And, indeed, this must be so for Heidegger since the measure-giving entities which epochally stamp being – 'the suprasensory world, the Ideas, God, the moral law, the authority of reason, progress, the happiness of the greatest number, culture, civilization' (QT, 65) – themselves only mark a mode of being's withdrawal. Because this move introduces a radical contingency into the ontic articulation of ontological history, which in time will yield a general question about the apparent unconnectedness of ontic and ontological history,[10] it heightens all the more the question why great art is being employed in order to figure epochal history as well as form a model of the interaction and interpenetration of ontic and ontological, empirical and transcendental.

This brings us to the functional thesis. Great art, by definition, brings things into unconcealment, and hence has a (quasi-transcendental) truth function; by definition, great art reveals a world, and in so doing assigns men a place amongst things, thereby giving their lives a 'sense'. These functions are the non-aesthetic analogues of the familiar Russian formalist thesis that *the* literary effect is defamiliarization (*ostranenie*), making the world strange, allowing familiar objects to be truly 'seen' rather than merely recognized (re-cognized); which itself is analogous to Brecht's estrangement-effect, where the goal of art is to return the apparently eternal, changeless features of life to history in all its contingency and transience. For Heidegger, the effect of great works is equally one of defamiliarization, only for him the movement is not to a mere renewed vision of some particular, or away from the apparently inevitable to the flux of history, but from the ordinary and particular to that which lets the ordinary and particular have their peculiar shape and meaning. So great art transports men out of the realm of the ordinary, where to submit to this displacement means 'to transform our accustomed ties to world and earth and henceforth restrain all usual doing and prizing, knowing and looking, in order to stay within the truth that is happening in the work' (OWA, 66). Letting a work be in this way, letting it have this effect, Heidegger calls 'preserving' (*Bewahrung*), where preserving is to be contrasted with connoisseurship, which parries a work's 'thrust into the extraordinary' (OWA, 68).

Ostranenie and the estrangement-effect work critically; their cognitive claiming is negative in character. This restriction, however, is compatible with the thought that for us art works are peripheral, their significance limited to pointing to or gesturing at what is transcendentally authoritative without being able to invade it. Further, in considering the cognitive purport of literature, there is at least some recognition that its thematic concerns – with love, death, power, identity, etc.; roughly, Kant's aesthetic ideas – address not our empirical beliefs, but the categories and concepts *through* which we process those beliefs. We tend to read art's

truth claims as conceptual or categorial; but because art is peripheral the significance of these claims is usually interpreted in terms of art rehearsing 'possibilities'. If art is peripheral, however, then must not those claims function differently when art can be legislative? And will what we mean by 'possibility' not shift when it is construed historically, as an effect of marginalization?

iv Great Art and Genius: On Being Exemplary

Heidegger's characterization of great art can be construed as an extending and reworking of more familiar accounts of art such that these features of works relate to his epochal theory of history in the context of non-modern or traditional societies. Conversely, we might recognize our aesthetic conception of art as a consequence of our repression of historicality in non-normatively totalized social formations. While such analogical gestures might remove some of the apparent hyperbole in Heidegger's theory, it leaves wholly unexplored the question precisely why it is art, great art, that is being deployed in order to think the problem of epochality.

Heidegger contends that modern subjectivism misinterprets the creation of great art, great art's productivity, 'as the self-sovereign subject's performance of genius' (OWA, 76). Conversely, then, genius is the subjectivization of great art. Hence when Heidegger first introduces great art, tracking what for him is its central characteristic, namely 'self-subsistence', he states that in great art 'the artist remains inconsequential as compared with the work, almost like a passageway that destroys itself in the creative process for the work to emerge' (OWA, 40). As we shall see, while there is a clear sense in which works exceed the controlling consciousness and intentions of their producers, Heidegger's rendering of the artist into a 'passageway', a cipher in the creative process, presents peculiar theoretical difficulties for his account. Nonetheless, the thesis that great art is the art of genius prior to subjectivization coheres with the account we have been offering. Entailed by it is the thought that great art pronounces a mode of freedom, of free action that is different from and anterior to the conception of free action encapsulated in the work of genius. This sense of freedom will need to be compared with Kantian autonomy.

If it is the case that 'every mode of presencing – every constellation of temporal difference – reaches us as a call (*Anruf*), a demand (*Anspruch*)',[11] hence as a claim having the same modal status as the judgement of taste, then perhaps this claimed historical affiliation between the work of genius and great art can tell us why art is being employed to think the problem of epochality. The Kantian understanding of art and genius figures *sotto voce* in Heidegger, not as a guide for exploring the question of art, but rather as a model for epochal history, the history of being; and it is only as a

consequence of this modelling that art comes to have a privileged status, in the first instance, for opening the possibility of thinking such a history. More emphatically, non-great art, the art of genius, enjoins a kind of internal historicity within the realm of art that models historicity, in the sense of the history of being in general. Art is a locus for thinking historicity and truth because art continues to operate 'historically' despite its removal to the periphery of modernity where it loses the capacity to effect anything outside itself.

Pursuing this line of thought will raise a cluster of questions. First, why should 'aesthetic' art be conceived of as the end or death of art? Why should it be the case that when art finally achieves a vocation 'proper' to itself, becoming just art and nothing more, if should in so doing become less than 'art', less than what art has been or could be? Secondly, why is it art in modernity that despite its deracinated state should continue to have the power to provoke a thinking that transcends modernity, that recalls (adumbrates) a past (future) mode of historical existence? How, in short, can that which is not great perform the function of revealing modernity to itself? Thirdly, if it is the case that it is through non-great art that great art and its epochal functioning is revealed, does Heidegger's account possess the theoretical resources to sustain this thesis? Fourth, can genius be understood as only the subjectification of great art, or is it the subjectification of great art and something else? At issue here is the connection between freedom (autonomy) and historicality, a connection that Kant generally represses through the positing of the constraining norms of reason, and that Heidegger attempts to break completely by undermining the modern discovery of freedom.

Heidegger's coupling of revealing and concealing, his emphatic highlighting of the self-occluding character of being and of the absential dimensions of all bringing-into-unconcealment is not as remote from Kant as it first appears. And Kant's thinking of the question of art in terms of genius is more like an investigation into the nature of great art than it is like the traditional attempt to provide a neutral definition of art that would pick out the necessary and sufficient conditions for us calling an item a work of art.

Kant begins his inquiry into art in §§43–4 as if his purpose was to generate a definition of art. So art is distinguished from nature in that it is a production through freedom that has reason at the basis of its action; it is distinguished from science as the practical is distinguished from the theoretical; an art is mechanical if it seeks only to actualize possible objects to the cognition of which it is adequate. Non-mechanical arts, aesthetic art, has pleasure as its immediate goal. Aesthetic art is of two kinds, agreeable and fine: 'The description "agreeable art" applies where the end of the art is that the pleasure should accompany the representations considered as mere *sensations*, the description "fine art" where it is to accompany them

considered as *modes of cognition*' (CJ, §44, 305). Finally, in §45 Kant states that art can only be termed beautiful when, despite our awareness of it as an intentional product, it yet has the appearance of nature. Although I shall want to return to this thesis, for the present a minimalist interpretation of it will suffice. Kant has recourse to the appearance of nature here in order to avoid perfectionism becoming the criterion for artistic excellence, as would be entailed by his intentionalist conception of art alone. Nor is this move disingenuous, since without the 'appearance of nature' condition the distinction between mechanical and aesthetic art would collapse.[12] The extra condition, then, begins to distinguish the kind of intention necessary for aesthetic art as opposed to mechanical art. It generates the space which the theory of genius fills.

Nonetheless, Kant's introduction of genius at this juncture introduces a hiatus into his definitional procedure of seeking after specific differences. While Kant does regard genius in a wide sense as specifying all that is necessary in order to make a work of fine art possible,[13] he equally uses it as a dynamic concept to explicate the 'vocation' of art in virtue of which art has a history, or better, reveals art as satisfying its vocation only in so far as it is dynamically historical. In this latter sense the consideration of art is more normative than neutrally definitional; but more than this, the question of art comes to be recognized as something incapable of being answered, or even comprehended, through the providing of a definition in terms of species and differentia. And it is easy enough to see why this is so. The species and differentia analysis of art breaks off at just the moment where Kant becomes tacitly aware that works of art are products of freedom or autonomy: works of fine art, exactly like objects of the judgement of taste, must be intrinsically final although without an end. An art work that had at its basis the intention to realize an already conceptually determinate object would hence be mechanical, the work saturated by the goal of producing the token of a conceptual type. Analogously, a work of agreeable art has its goal outside itself, namely, in the goal of producing pleasure considered as mere sensations. Now the production of a work of fine art could be considered free in a weak sense just in case it were the product of an intentional act compatible with the demands of the categorical imperative. But in claiming that works of art are devoid of external ends, and hence products of actions done for their own sake, Kant is insisting that such production not only presupposes freedom in the weak sense but manifests freedom, instantiates it, aims at it, has freedom for its meaning. Such acts are the production of freedom through freedom. In works of fine art freedom *appears*, and freedom can only thus appear if it detaches itself from the subjectivity producing it, since whatever would bind a work to subjectivity, above all the commensurability between the object and the intention to produce just it, would equally prohibit the work from being 'fine' art. Hence a necessary condition for a work to be

'fine', a work of genius, is that the rule effectuating the work be essentially unavailable to producer and audience. The work of fine art must be groundless, without determinate antecedents. Its being a free production, a production that cannot be explained or accounted for in terms of its antecedents, either historically or psychologically, must be constitutive of the work and manifest in its appearing. Note that the same distinction between production and creation that is at the basis of Heidegger's account of great art is at the basis of Kant's account of fine art; with Kant, however, to think creation is to think freedom in its most radical form.

Thus art's having a history, its satisfying its vocation only in so far as it is dynamically historical, interrupting previous art history in order for that history to begin again, is connected with, indeed a consequence of, the human vocation for freedom that first becomes manifest in fine art. While the categorical imperative hovers over this freedom and history, it appears to require quite different criteria. The relation between normative freedom and artistic autonomy is played out in Kant's analysis in terms of the relation between genius and taste. The relatively new theoretical trope of genius represents Kant's acknowledgement that both the question of autonomy is at issue here and that it is not directly compatible with the freedom of reason – reason is being transformed into poetized reason, or, what is the same, becoming identified with the transcendental imagination. This placement of genius also tells us why the idea of great art is so discretely handled by Heidegger. Art, for us, is the paradigmatic, the exemplary transgressing of definitional procedures because it is the work of freedom; and for us it is constitutive of freedom that it be self-transgressing in its essential movements. Or so I now want to argue. However, if art does work in this way, then our understanding of it is bound to its history, where its work of historicizing is a criterion for that comprehension.

Kant's account of genius is an attempt to think the question of art in terms of creativity and originality, creativity as originality; in terms, then, of an acategorical, transgressive freedom which decentres his previous focus on pleasure and beauty. If works of art are intentional products, then they must in some sense be rule-governed; however, the very concept of fine art prohibits its products from being grounded in a definite concept. How then is art possible? Only if there are products of intentional activity for which no definite rule can be given, but that can nonetheless demonstrate their intentional origin, the fact that they make 'original' sense as opposed to original nonsense, by serving as models, by being exemplary. A work is exemplary if it can serve as a model for succession. That in us which allows such works to be produced is genius.

Exemplarity functions in Kant's account of art as specifying how something can be an immanent and contingent absolute, how, that is, something can be *empirically transcendental*. The products of genius are items for which no rule can be given but which nonetheless themselves can serve

'as a standard or rule for estimating' (CJ, §46, 308). It is precisely this feature of works of art that severs them from the general assumptions of transcendental philosophy. Here that which supplies the rule for estimating is neither a priori nor necessary, but, from the perspective of the transcendental, contingent; further, as such the rule-giving item is empirical, a concrete particular and not a form of any sort. In these respects works of great art are directly analogous to Kantian exemplary items. In both cases the transcendental/empirical distinction is being turned in the direction of the empirical, thereby undermining the easy necessary/contingent distinction that follows the tracks of the transcendental when it is conceived formally, as form.

In works of fine art freedom appears. Originality, which Kant calls the 'primary property' (ibid.) of the work of fine art, is the appearing of freedom. The way in which freedom appears as originality is what yields the connection between the praxis specific to art and historicality. Originality becomes manifest in two modes: destructively and constructively. In order to carry out their work of setting new rules and standards for judgement, which is just another way of revealing their autochthonous status, exemplary items must challenge and provoke their audience by overtly transgressing the rules, standards, norms and conventions of previous practice, for what has counted *as* art or beauty; they are provocations which call commonsense understanding into question. Works of art succeed in being original only if they can dispossess and estrange their audience of their standing cognitive guidelines for judging and, in so doing, challenge their audience's self-possession of itself and its world, their sense that they know what art *is*. When speaking of great art, Heidegger terms this provocation 'displacement', a transporting of us 'out of the realm of the ordinary' (OWA, 66). Heidegger's language here, the 'extraordinary (*ungeheur*: awesome, sublime) thrust' of the work, consistently suggests the experience of the sublime;[14] and by the very fact that Kant contrasts genius and taste, it would appear plausible to align the provocation of the work of art more with the experience of sublimity than with beauty. Provocation is necessary if the work is going to detach itself from its antecedents, and thereby become self-authenticating.

However, this provocation, which is a mark of originality, is not sufficient since the provocation may be empty and idle, fruitless. Originality must involve more than breaking rules; its deformations must allow for the possibility of reformation. The litmus test of exemplarity, namely, succession (*Nachfolge*), is not as unified or simple as Kant's presentation of it makes it appear. Roughly, on the one hand, Kant equates exemplarity, and hence succession, with providing new ways of making sense:

Succession which relates itself to a precedent, not imitation, is the correct expression for the influence which the product of an exemplary

originator can have on others; which means the same as this: to cre-
ate from the same sources out of which the former himself created,
and to learn from one's predecessor only the way to proceed in such
creation oneself. (CJ, §32, 283)

An example of succession in this sense would be the founding of a new
'school' of painting or poetry. The exemplary work would provide possi-
bilities, in the plural, that were not previously available; and while
succeeding works may alter what we conceive those possibilities to be, it
would remain the case that the 'original' exemplary work was the 'origin'
with respect to which succeeding works had their sense. Of course, seeing
the provocation of an original work may only be possible in virtue of the
works succeeding it. Due recognition of this in modernist art is given by
the centrality of series of works which permit the new rule won for art to
become visible; in short, modernist artists acknowledge the connection
between exemplarity and succession by producing the successive works
themselves. Here, then, exemplarity means the opening up of new
possibilities without the item or items that do that opening up being able
to be accounted for in terms of its or their antecedents. Exemplary items
provide the measure, with only their provocation, on the one hand, and
succession on the other, 'measuring' (without measuring) them.

Kant, however, does not quite see this possibility; harassed by an overly
sharp distinction between the spirit of imitation and the spirit of genius,
between imitation and autonomy, he tends to read the requirements for
autonomous reproduction, for succession, in terms of further exemplary
instances:

> ...the product of a genius...is an example, not for imitation (for that
> would mean the loss of the element of genius, which constitutes the
> very soul of the work), but to be followed by another genius – one
> whom it arouses to a sense of his own originality in putting freedom
> from the constraint of rules so into force in his art, that for art itself
> a new rule is won – which is what shows a talent to be exemplary.
> (CJ, §49, 318)

And this certainly makes it sound as if not to respond to a work of genius
with genius is to respond non-autonomously; to suggest this, however,
reduces the new rule won through exemplarity to a single case, thus
reducing the indeterminacy of the exemplary instance to unity.[15] There is
in Kant so stark a differentiation between autonomy and imitation, and his
account is so resolutely individualistic, that when the issue is freedom
itself Kantian autonomy becomes a requirement for perpetual revolution.
Conversely, the demand for an autonomus response to original works
demonstrates that it is precisely and resolutely the question of autonomy

in its own right that surfaces in the question of fine art. Further, while Kant's autonomy requirement sounds utterly hyperbolical, its urging of novelty and originality coheres, with unnerving accuracy, with at least that dominant stretch of modernist art that restlessly searches after the 'new'. Kantian exemplarity, then, will both reveal a more radical sense of autonomy than that either usually associated with him or found in modern philosophy; and, by the very rigour of its demands, and their frenetic consequence in modernist art, will expose the need for a reformation of the original theory. At first glance, the exaggerated severity of the demand for an autonomous response and the frenetic playing out of that demand appear to be entailed by the individualism of the account *and* the individualist conditions of production in modernist art. As we shall see, however, judgement on the demand cannot be made in isolation of the placement of art in the context of the culture surrounding it. Before attempting to make a judgement here (in fact to be delayed until we consider Adorno's wrestling with the 'new'), we need to fill in the details of the rest of Kant's account.

An exemplary work begins a new movement of history, and will act as a constraining provocation to a later genius. Further, as Kant's genius-to-genius argument suggests, the audience of genius must itself respond 'autonomously'; this form of response will be akin to the manner of Heideggerian preservers as opposed to connoisseurs or aesthetes.

The coherent deformations required of exemplary works are never, for Kant, mere formal innovations; works of genius must have 'soul' (*Geist*). A work's having soul is that in virtue of which it makes a demand upon its audience to respond to it intrinsically, without any further purpose. Soul, as the animating principle in the mind, 'is nothing else than the faculty of presenting (*Darstellung*) *aesthetic ideas*' (CJ, §49, 313). Aesthetic ideas are the counterparts to rational ideas; rational ideas are concepts to which no intuition is adequate, while aesthetic ideas are intuitions to which no concept or concepts are ever adequate, 'and which language, consequently, can never get quite on level terms with or render completely intelligible' (CJ, §49, 314). If rational ideas are for Kant the indemonstrable concepts of reason, then aesthetic ideas must be regarded as the inexponible representations of imagination (CJ, §57, 342). To assert that aesthetic ideas are inexponible is not to say that they are altogether ineffable, but only that no elaboration can make them conceptually determinate; their intuitivity remains unmasterable through conceptual articulation.

Although Kant is less than clear on this question, it appears that aesthetic ideas concern both the matter and form of presentation. Materially, an aesthetic idea is one which must be capable of bearing 'the burden of human significance'[16] *überhaupt*; and if it were not Kant with whom we were dealing here we would say that this means that an aesthetic idea must engage a categorial or transcendental determination of experience. An

aesthetic idea, and what is and what is not an aesthetic idea, is not determined a priori but is rather a function of works of genius; they must mark out certain phenomena as ones which are determinative for our conception of ourselves as human beings. Because Kant regards our categorial determination as final and determinate, and hence represses the 'as' in the 'conception of ourselves *as* human beings', he says aesthetic ideas involve phenomena that transgress the limits of experience, although they occur in experience. The items Kant mentions in this regard – death, envy, vices, fame, love (CJ, §49, 314) – transgress experience only in his technical sense of the word; or better, in having significance they transgress his technical sense of experience. Of itself, to say that is to say too little.

Formally, the aesthetic ideas must be presented in a manner in which the intuitive can be preponderant over the conceptual. Kant conceives of representations where this occurs as symbolic in character. His theory of symbolism is too thin to give this thought much substance. If instead of emphasizing the making of the invisible visible, or bodying forth to sense (CJ, §49, 314) an idea of reason, as Kant is tempted to do, rather than holding to the primacy of intuition, then what Kant is requiring is that the presentation be sufficient to resist the work of the understanding. Putting the point this way picks up the point made at the end of the last chapter that aesthetic phenomena were those capable of resisting the sway of discursive rationality, understanding and reason. Figuration, of course, is one of the ways we accomplish this end; crucially, it is also one of the central ways in which we deform and reform common sense.

It is here, perhaps, that we can connect genius and the transcendental, productive imagination, for how else might we specify the governance of works of genius than as schematizing aesthetic ideas? Is it not as (displaced) transcendental schemata that exemplary works fulfil their exemplary function? This certainly is the hypothesis Heidegger follows. He marks the displacement of the work of transcendental schematism from subjectivity to art work in these terms: 'Truth is never gathered from objects that are present and ordinary. Rather, the opening up of the Open, and the clearing of what is, happens only as the openness is projected, sketched out, that makes its advent in thrownness' (OWA, 71). Equally, he speaks of 'poetic projection', which he specifies in a Kantian manner as coming 'from nothing, in this respect, that it never takes its gift from the ordinary or traditional' (OWA, 76). Great art, for Heidegger, does the work formally done by the transcendental imagination. Such works provide a 'projected sketch', an 'illuminating projection', a 'lighting projection of truth' (OWA, 73-4); a projection, then, which is the condition for the possibility of objects standing in the Open, that is, having an intelligible sense with respect to us and other objects. All this is an echo of what Kant says in the first *Critique* (B, 142) where he specifies the work of schematism in these terms: '...the *image* is a product of the empirical fac-

ulty of reproductive imagination; the *schema* of sensible concepts, such as of figures in space, is a product and, as it were, a monogram, of a pure a priori imagination, through which, and in accordance with which, images themselves first become possible.'

In 'Origin' Heidegger is not only reinscribing the thought of schematism that had informed his earlier book on Kant, he is simultaneously transforming it in accordance with and as a departure from its presence in Nietzsche: 'Not "to know" but to schematize – to impose upon chaos as much regularity and as many forms as our practical needs require' (Niii, 70; aphorism 515 of the *Will to Power*, March–June 1888). Although Heidegger is critical of Nietzsche's thematization of the transcendental imagination and schematism in terms of the problem of life (Niii, 96–100), and criticizes Nietzsche both for his subjectivism and inverted Platonism, what is central is that Nietzsche allows Heidegger to state what was implicit in his book on Kant, namely, that originary knowing is bound up with praxis as the exercise of poetized reason (Niii, 94–100). For Heidegger, schemata take over the elaboration of what was thought previously in terms of limit and horizon, which are not limits in the negative sense but that from which life takes it start (Niii, 86). Schemata, then,

> are not impressed on chaos as a stamp; rather, they are thought out in advance and then sent out to meet what is encountered, so that the latter first appears always already in the horizon of the schemata, and only there. Schematizing in no way means a schematic ordering in readymade compartments of what has no order, but the invention that places on account a range of configurations into which the rush and throng must move in order thus to provide living beings with something constant, and thus to *afford* them the possibility of their own permanence and security. (Niii, 92)

Schemata first give to things their look and to men their outlook. Still, if we were to follow this path then it would be artists and not works which were schematizing. 'Origin' proves the corrective for this belief.

Heidegger attempts to back his rewriting of schematism and transcendental imagination in terms of the lighting projection of works through his interlocking claims that all art is essentially poetry, and that language itself is poetry in the essential sense. By the first claim Heidegger only intends that all works of what Kant calls fine art – architecture, painting, sculture, music and 'poesy' itself – have the capacity for interruption and projection. This projection is always either language-like or linguistic; which is why for both Heidegger and Kant poesy has a privileged position.

It is the second thesis which must take up the burden of Heidegger's account. It turns on two theses:

1 Against accounts that focus on language as medium and instrument of communication, Heidegger insists that it is language alone that brings what is, as it is, into the open for the first time: 'Where there is no language, as in the being of stone, plant, and animal, there is also no openness of what is, and consequently no openness either of that which is not and of the empty' (OWA, 73). In brief, without language even nothingness 'is not'; it is only in virtue of language that the distinction between something and nothing 'comes into being', registers and makes a difference. Exactly why we should not consider this a direct statement of transcendental idealism, and hence a new quasi-formalism, Heidegger does not say.

2 However, this claim is insufficient to align language with poetry, and hence great art with the schematism of the transcendental imagination. For that Heidegger requires the additional thesis that fundamentally all language is, at its base, metaphorical, that the metaphoricity of language precedes its literality (as creation precedes production). This thesis he gets at indirectly rather than directly. His argument turns on the acknowledgement that any categorial framework, for example, things *as* ready-to-hand or *as* present-to-hand or *as ens creatum*, is just the institution of an *as* structure. Heidegger thinks of language working in this way as a form of original naming; naming is used here in order to capture the (transcendental) primitiveness of language working at this level. Nonetheless it is the *as* that is central: 'Such saying is a projecting of the clearing, in which announcement is made of what it is that beings come into the Open *as*' (OWA, 73). Heidegger terms this original naming 'projective saying' (*entwerfende Sagen*; OWA, 74). Projective saying explicates how works can be exemplary and hence accomplish their schematizing function.

It is easy enough to see how works of (great) art involve a linking of the categorial and the metaphorical *as*. Such works work by producing metaphorical transformations of terms as ordinarily understood; and if the new metaphorical senses of terms relate to terms that, in virtue of that transformation, become central to our categorial understanding, then the metaphorical work of language and its work of projection must be recognized as the same work. When language is figured in its most essential possibility it is figured as poetry. Poetry is the figure of the figuring of language in its essential sense. Projective saying in taking up the work of the transcendental imagination displaces it into works; works, we must now say, of genius.

This continuation of the thought of schematism departs from the Kantian on three significant points. First, in the *Critique of Pure Reason* Kant offers to each schematized category a separate proof of its objective validity. Once categories are recognized to be historical, this possibility

is occluded. Succession appears to be the only constraint available for establishing categorial objectivity. Secondly, it was only the setting of the schematized categories in the context of the question of the necessary conditions for the possibility of experience that allowed Kant to drive a wedge between what was constituted by those categories, and was hence fully knowable or cognizable, and what exceeded that constitution, thus remaining outside 'experience'. Once the generality or formality of categorial determination becomes historical, then the constituting spontaneity of reason becomes axiological – which is just Nietzsche's contention that all reasoning is evaluating. In other words, once a moment of empiricity or contingency is required in transcendental legislation, then the primacy of practical over theoretical reason follows straightaway. In this sense, since all ideality is empirically conditioned, remaining subject to an uncontrolled or controllable contingency (which, we shall see, is one of the major significances of Heidegger's concept of 'earth'), then even Kant's presumptive ideas of reason must *be* aesthetic ideas. Finally, what controls this entire development is the discovery that the powers of cognition and evaluation are grounded in their entwinement as the productive power of genius: our capacity to project beyond all that is given factually and conceptually. All categorial determination announces freedom in its transgressive mode. Schematism as creation, the historicizing of categorial legislation, points irresistibly towards what gives to humans an open space, a world; and thus towards the question of the kinds of worlds compatible with duly acknowledging this transgressive power. In approaching this question we come face to face with the question of the relation between art and politics.

v Genius, Community and Praxis

A work of genius is an exemplary work which presents aesthetic ideas. On its own this appears a plausible thesis. Why, then, does Kant stipulate that genius is equally the 'innate mental aptitude through which *nature* gives the rule to art' (CJ, §46, 307)? And why does he further require generally of works of fine art that they have the appearance of nature? And how do these concepts of nature relate to Kant's thought that 'the imagination (as a productive faculty of cognition) is a powerful agent for creating, as it were, a second nature out of the material supplied by actual nature' (CJ, §49, 314)?

Some of the pressure Kant's concept of genius is under here, pressure meant to be alleviated through reference to nature, derives from its essential doubleness: on the one hand, as origins, works of genius are originals, incapable of being explicated in terms of any antecedent rules. And this means that even their creators are not their masters; works of genius are

created, are products of intentional activity, but they are always more than products, more than what their producers intentionally put into them. Kant terms 'nature' the surplus in creator and product that is incapable of explanation through reference to antecedents. On the other hand, the exemplary work sets the rule and the measure, not wilfully or arbitrarily or through a de facto positing, but, somehow, with right and propriety, truthfully; as if, we might say, its law were natural law. And it is in this sense that works of imagination 'remodel experience' (CJ, §49, 314) to produce, as it were, a second nature, a culture which is not arbitrary but fateful, neither reductively conventional nor contingent nor naturally necessary. As antecendent to producer and product, nature is a principle of opacity, of reserve and absence which prohibits fine art 'of its own self [to] excogitate (*ausdenken*: think out) the rule according to which it is to effectuate its product' (CJ, §46, 307); as the appearance worn by the work of art, nature is a principle of (transcendental) legitimation: it is unnatural natural law. Nature in this latter sense legitimates not externally, as a source, but immanently; it is again just Kant's reiterated thought that freedom is lawful not lawless. Hence for the work to appear as a product of nature is for it to appear as lawful, even if its conditioning rule is unavailable. But it is not this appearance itself that legitimates the work, shows it to be exemplary; only succession demonstrates and so legitimates exemplarity. Succession gives to the exemplary item its exemplarity; yet the work must provoke this response, contain it as its most fundamental possibility. This circular movement from work to succession and back is the movement into finitude and away from a priori transcendental legislation. It will come to be designated as the 'hermeneutic circle', the circular movement in which and through which we come to self-understanding.

The unity of Kant's two senses of nature, as opaque reserve and as lawful, as a principle of transcendental opacity – which will later (already by the time of Schelling) become the unconscious – and as that which is our ground relation to ourselves and the world, reveal a conception of nature, and of genius, as neither natural nor cultural in the usual senses of these terms. Genius breaks the culture/nature duality by registering nature's double anteriority; an anteriority, however, which is neither produced nor given. Indeed, it is by the double inscription of nature that the active/ passive distinction, always under threat in the thought of the productive (active) imagination (passive), unseats the rigid distinction between what is produced and what is given/discovered. Creation and createdness, perhaps, surprisingly, condition production (imitation), but in so doing subvert the logical assumptions about making and doing that underlie our productionist comprehension of the will and subjectivity. And genius is the concealing and revealing of nature just as Heidegger has being as withdrawing in the very act of presencing, as presencing and presence, as original and rule; great art measures and is unmeasured. It is precisely

because works of genius are not the products of a sovereign subjectivity, and because their excess beyond subjectivity entails a transcendental opacity that *is* their distance from subjectivity, that they can be brought into direct affiliation with Heidegger's thought of being as revealed in great art.

The equation between genius (nature) and being can be strengthened if we recall that for Kant aesthetic culture is paradigmatic of culture generally.[17] Further, as we have already seen, Kant's attempt to bring reflective judgement under the dominion of the Categorical Imperative, to directly harmonize aesthetic and moral culture by making the latter regulative for the former, fails. Kant attempts a directly analogous subsumption in §50, where he argues for the constraining of genius by taste, in tacit recognition of the radical instability that the concept of genius introduces into the idea of a 'continually progressive [= moral = under the guidance of the Categorical Imperative] culture' (CJ, §50, 319). As Paul Guyer has forcefully argued, Kant's attempt to transform taste from a 'necessary condition' of genius into the 'corrective' and 'discipline' of genius which 'severely clips its wings' (CJ, §50, 319) in order to 'defuse the incendiary implications of his theory of aesthetic autonomy',[18] is not countenanced by any argument Kant offers. Kant's failure to ground the judgement of taste in either cognition or morality merely underlines his failure here.

However, Guyer's contention that the debate here is between *social* integrity and *individual* aesthetic autonomy concedes too much to the idea of a progressive culture and hence oversimplifies the dialectic of Kant's theory. First, as Guyer himself notes,[19] interest and pleasure in actual communication, upon which the integrity of the society is based, can itself be overturned by an interest in autonomy, leading society 'to encourage the production of works of art which are themselves designed to break the bonds of tradition which ground actual if not ideal agreement'. Secondly, the characterization of works of genius as requiring succession and as claiming an audience of genius, as making claims through their critical provocation of common sense, shows that the claims of genius are social claims. But, finally, that this is so should come as no surprise since the lawfulness without law enjoyed in judgements of taste figures, as we saw, an ideal of social autonomy and solidarity. In anticipation, we can put the point this way: works of genius exhaust themselves in community creation (as we have already seen the way in which, according to Kant, aesthetic judgements exhaust themselves in communicability); but such creation (and its reception) works through individuals. Because the activity of genius is individualized and yet exhausts itself in community, it reveals a dialectic between individual and community without limit or end except the perpetuation of its mutually conditioning and incommensurable moments.

In its original invocation the claim of solidarity might have appeared somewhat mysterious; it should now begin to take on a comprehensible

physiognomy. Lawfulness without law provides, more concretely than the concept of judgement, a way of characterizing works of genius as the establishing of indeterminate schemata. Lawfulness now refers to the 'appearance of nature' thesis, while without law refers to transcendental opacity, the withdrawal of the origin. Exemplary items are exemplary for us; this depends upon our recognizing them as such, and recognition of this recognition is provided by our ability to go on in the appropriate way. Our first recognition is problematic since nothing can ultimately ground it, although it would not be possible unless we shared much. This ground-level sharing is the *sensus communis* as always already presupposed. A sharp version of it is suggested in a passage of Stanley Cavell's:

> We learn and teach words in certain contexts, and then we are expected, and expect others, to be able to project them into further contexts. Nothing insures that this projection will take place (in particular, not the grasping of universals nor the grasping of books of rules), just as nothing insures that we will make, and understand the same projections. That on the whole we do is a matter of our sharing routes of interest and feeling, modes of response, senses of humour and of significance and fulfilment, of what is outrageous, of what is similar to what else, what a rebuke, what forgiveness, of when an utterance is an assertion, when an appeal, when an explanation – all the whirl of organism Wittgenstein calls 'forms of life'. Human speech and activity, sanity and community, rest upon nothing more, but nothing less, than this. It is a vision as simple as it is difficult, and as difficult as it is (and because it is) terrifying.[20]

This is to say the reservoir/reserve of nature as a principle of opacity must be at least partially bound up with the inexponible *sensus communis* that allows an exemplary item to be recognized as such. Nothing is more human than to deny the ways in which this sharing, this accordance, conditions and makes possible even those norms of cognition and action that traverse it. This was the claim of the previous chapter concerning the norms of understanding and reason. Nature as principle of reserve that is equally a principle of lawfulness incapable of full discursive elaboration and articulation, is just a pre-critical nature, a nature antecedent to the lawlike nature projected by the understanding or the legal society produced by reason.

But these conditions cannot provide the full story since this is an image of given community, of a passive *sensus communis*, of like-mindedness without history, of like-mindedness that is given rather than created. Above all, such an image pictures history in irrevocably continuist terms, and human beings as without a sense of, or the capacity for, self-transcendence, of becoming other to themselves. Unless the passive *sensus*

communis were open to deformation and reformation it would represent a principle of nature in opposition to culture, thereby contradicting the median role that the *sensus communis* is designed to fill. We need, then, to recall that exemplary works interrupt present history in order to let history begin anew. This raises two questions: Why should autonomous works operate on the basis of interruption? And how does that interruption carry through to an alternative sense of community? How is community both ground and grounded, given and produced?

Let us say the works of genius enjoin community because nothing but community, in the sense of a *sensus communis*, is at issue in the recognition of them. This is just what Kant says: 'Fine art...is a way of representing that is purposive on its own and that furthers, even though without a purpose, the culture of our mental powers to [facilitate] social communication' (CJ, §44, 306). Their being without an end is what separates works of fine art from agreeable art; but works of fine art only 'reveal' that they are not for the sake of mere pleasure, sensory delight, through turning away from the sensory interests of their audience and exhausting themselves in the originary establishment of community. Heidegger denominates this community-forming effort of schematizing 'accordance'. And while one might have thought accordance, agreement in judgement, like-mindedness, was simply a given of social life, Heidegger gives it the same critical sense it has in Kant:

> Accordance is the highest struggle for the essential goals that historical humanity sets up over itself. Thus, in the present historical situation, accordance can only mean having the courage for the single question as to whether the West still dares to create a goal above itself and its history, or whether it prefers to sink to the level of preservation and enhancement of trade interests and entertainments, to be satisfied with appealing to the status quo as if this were absolute. (Niii, 91).

Accordance, which is just the possibility of identity and difference, is the effort of establishing community against what community has become.

The lawfulness of works of genius is a second-order transformative reiteration, in terms governed by some aesthetic idea, of the presupposed common sense that allows them to be recognized in the first instance. Heidegger states just this thought when he says: 'Preserving the work does not reduce people to their private experiences, but brings them into affiliation with the truth happening in the work. Thus it grounds being for and with one another as the historical standing-out of human existence in reference to unconcealedness' (OWA, 68). Of course, what preserving means in concrete terms is for Heidegger historically variable, and always exclusively 'cocreated and prescribed only and exclusively by the work'

(OWA, 68). Further, where Heidegger places 'unconcealedness' Kant would specify some aesthetic idea. And that difference will, again, mark a difference in the place that human action and freedom have in their different accounts.

It is because works are not based on formal laws and cannot authenticate themselves in terms other than those they provide for themselves, that they enjoin community. Recognition of the claims of the work is hence cognitive in a manner incompatible with standard Kantian notions of understanding and free action. Heidegger, making clear reference to Aristotle's notions of *phronesis* and *praxis*, speaks of the knowing and willing involved in responding to great works in these terms:

> Preserving the work means: standing within the openness of beings that happens in the work. This 'standing-within' of preservation, however, is a knowing. Yet knowing does not consist in mere information and notions about something. He who truly knows what is, knows what he wills to do in the midst of what is.
>
> The willing here referred to...neither merely applies knowledge beforehand nor decides beforehand...Knowing that remains a willing, and willing that remains a knowing, is the human being's entrance into and compliance with the unconcealedness of Being...
>
> Willing is the sober resolution of that existential self-transcendence which exposes itself to the openness of being as it is set into the work. In this way, standing-within is brought under law. (OWA, 67)

The knowing and willing ruled out in the second paragraph are *techne* and *poiesis* respectively. Hence these paragraphs are taking up Aristotle's thought that the means–end structure governing productive activity generates an infinite regress. For Aristotle this regress ends with what is done for its own sake; such doing is *praxis*, and the knowing associated with it is *phronesis*. Heidegger, perhaps noting that the structure of Aristotle's defence of the priority of *praxis* over *poiesis* repeats the means–end structure of productivist logic, specifies the alternative forms of knowing and willing at issue here not as what *ends* a regress, as the closure of a series, but as what *opens* originarily, hence as opening in general. Heidegger's transformation of Aristotle thus surreptitiously depends upon the Kantian construal of man as an end in himself who *creates* ends from out of his freedom; freedom, which is not a determinate end and which appears only in created works, is the condition of all ends. Reading Kant now through Heidegger, this informs us that Kant's aesthetic concepts are 'aesthetical' transformations of Aristotle's practical concepts under the dominion of the new thought of autonomy: *praxis* becomes genius, *phronesis* becomes reflective judgement, and the role of *doxa* is taken up in Kant's employment of communication and communicability.

Law is the rule won by the exemplary work. To respond to the work, to respond to its provocation, is to judge in a manner that allows the work to judge what was knowing and willing. The existential dislocations of aesthetic reflective judgement, the series of negations defining it (not interested, not knowledge, etc.) mark works' capacity for interruption, interruptions which are works' judgement on previous modes of understanding. And because the response to the exemplary work is free from constraint, one's freedom only appears in relation to it. Freedom is grounded in the response to the work; autonomy is possible only through the indeterminate alterity the work represents. Finally, because interruption is a judgement on the judger, it again appears correct to point to a deeper confluence of beauty and sublimity, however this is to be understood with respect to art works, than Kant typically allows. This linkage between sublimity, alterity and autonomy will be one of the cruces for our understanding of Derrida.

The most direct manner for understanding how a new rule is won is through the idea of projective saying and metaphorical displacement sketched at the end of the last section. Attending to such a displacement, a displacement that appears neutral between Heidegger's account of projective saying and Kant's conception of the expression of aesthetic ideas, would be to allow certain significances to orient one's perceptions and consequently one's activities, activities which would then be said to 'flow' from those perceptions. On this Aristotelian account, the deliverances of sensitivity which pick out the requirements of a situation constitute and exhaust an agent's reasons for acting as she does.[21] This, surely, is the unity of knowing and willing of which Heidegger is speaking. It is equally, however, the account that is implied by both Kant's conception of the *sensus communis* and his account of the work of genius. The account's difficulties lie in the blunt fact that it refers either to how things perhaps were once upon a time, or how they are now in the domain of the aesthetic; or, finally, to how the aesthetic figures a memory of a past unity of reason.

The doubleness of genius sequesters within itself the doubleness of lawfulness without law, a groundless, abysmal, originary governance, whose realization in community can be only a harbinger of its demise. Aesthetic culture hence becomes a challenge to progressive culture, where the disciplining (taste 'clipping the wings' of genius) and progressive (as defined by the demands of categorical morality) features of the latter are undermined by the deforming and reforming dialectic of the discontinuous history in the former. *When seen from the perspective of fine art the analytic critique of the separation of domains provided in the previous chapter becomes the social critique of aesthetic culture against the regnant claims of progressive culture, the culture constituted by the dominating subjectivity of the understanding and reason.* Aesthetic culture, because merely

aesthetic, is powerless to displace progressive culture. Further, it is perhaps this powerlessness that explains why the search for originality becomes definitive for aesthetic culture, the culture of artistic modernism. Certainly the incendiary dialectic of aesthetic culture appears disturbingly frenetic, restless, as if the autonomy it secured were illusory.

As a model of cultural transformation generally, Kant's idea of an aesthetic culture anticipates and comments upon the Heideggerian epochal theory of history. Where Heidegger has the displacement of presencing by presence, a reformed Kantian history would see the displacement of originary lawfulness (without law) by positive or natural law. Heideggerian thinking becomes Kantian reflective judgement; and where Heidegger has unconcealment, Kantian theory would have lawfulness without law. In refusing transcendental grounding both theories face the question of the *force* of the claim made by what lacks force, by what is groundless or without rule; and in both theories a term of absence – nature, being – gathers into itself an authority it sought to dispossess itself of. This is not to claim that such terms are surrogate foundations, icons of a missing presence; although I am suggesting that their claiming cannot be utterly disentangled from that whose force they seek to displace and inherit. Rather, the suggestion is that there is something deeply enigmatic in the very idea that a work can *be* exemplary, *bring* into unconcealment, *take up* the burden of human significance; and that we unavoidably acknowledge this enigma in acknowledging the risk of failure, the possibility that nothing will take up the burden, claim us for it and for ourselves. And this is to say that there remains here, or perhaps emerges for the first time here, an enigma about truth and art; an enigma that 'genius', 'nature', and 'being' are recognitions of and responses to.

The genius of being and the being of genius raise the question of 'truth' that they are, designedly, unable to answer. Both genius and being refer to a history (or to histories) that they are attempting to undo; or better, we find ourselves with terms which displace a previous history, are a provocation to our common sense, but as yet are without audience or successors. How are we to comprehend this failure? Does the *philosophical* effort to point out these possibilities necessarily capitulate to the thought it is thinking against? Is philosophy irrevocably legislative? Or might not this failure be connected to a pervasive silence about the possibility of failure itself (failure as the reverse side of freedom)? But how is failure here to be understood? Is failure something that happens to us; or is it, rather, a failure of knowing and willing? How are failure, fate and responsibility connected?

The Kantian paradigm of aesthetic history gives us at least a clue as to why Heidegger stages his presentation of epochal history through a consideration of the work of art. That clue lies predominantly in the form of discontinuous history rehearsed by the production of genius: exemplary

works are immanent absolutes; in them transcendental and empirical levels are no longer opposed to one another, nor are form and matter. Exemplary works interrupt previous art history in order that it may begin anew. They are logically and explanatorily without antecedents: such works are unmeasured by past art but measure future productions. That measuring is the work of succession; succession, like preservation, is the litmus test of the originary governance of exemplary works. The motor for this activity is the desire for autonomy without external constraint. What makes past works constraining is their lapse into the demands and claims of abstract reason. While succession is the test of exemplarity, its realization is community. In modernity, this community is 'merely' aesthetic, almost a fictional community, a community isolated from and in opposition to the claims of progressive culture, the culture of Enlightened rationality under positive law and theoretical understanding.

Heidegger will identify this progressive culture with the epoch of technology; his account of great art plays off the death of that art against a culture where art has become merely 'aesthetic'; but it is the logic of aesthetic art that allows the physiognomy of great art to appear. Where else than from the historical consciousness of modernity, its sense of crisis and its eschewal of tradition, could Heidegger even begin to collect the thought of history as formed through what interrupts it? And if this sense of history as formed through what revolutionizes it takes its cue from Descartes's new beginning, the new science, the French Revolution, etc., this thought reaches formal presentation in the idea of art works as products of genius, as Heidegger acknowledges, and material realization in self-consciously modern, autonomous art.[22] 'Origin' is an essay about history and creativity; and the history of the 'new' that informs the modern understanding of historical existence forms the general background against which Heidegger thinks, while radical aesthetic culture is the unacknowledged source of his considerations. Heidegger swerves away from its claims because aesthetic art is art that radically connects historicality in the sense he wants with freedom in a sense he wishes to deny. As we shall see, this leaves his account of the interplay between aesthetic and progressive culture, modern art and technology, utterly indeterminate and without force.

The clue, then, lies in the nature of works of genius and in the space separating progressive, Enlightenment culture from aesthetic culture. Aesthetic culture can, through the 'discipline' of taste, be forced to comply with the demands of progressive culture, and there is no denying the possibility that this discipline may dominate without remainder (Adorno will argue that this, in fact, is the *necessary* fate of artistic modernism); but aesthetic culture does contain an incendiary dialectic which calls that progressive culture into question. It is the art of genius, great art without greatness, that, lodged at the periphery of progressive culture, seeks to undo its demands. Let us consider progressive culture as equivalent to

modern cognitive, moral and legal culture, as our earlier consideration of Kant entails. Now, how are we to characterize progressive culture such that the duality between aesthetic and progressive can appear? Why is art excluded from progressive culture? How, in our concrete engagement with works of art, does the incendiary claim of art make itself manifest? Does Heidegger's theory contain sufficient materials to underwrite its own attention to art and the relation of art to the dominant, progressive culture? Above all, with what right or in accordance with what reasons are we to prefer the Heideggerian thought of unconcealment to the Kantian account of autonomy? This question is no longer an easy one since what should have ruled out Kant's account, namely his conception of genius as subjectivity, in fact is not one which makes the subject sovereign. Indeed, for Kant too the subject is something of a passageway; and in formal terms his account differs not at all from Heidegger's. What, however, does distinguish the two accounts is their orientation: for Kant genius figures our vocation for freedom, and the critical dialogue between aesthetic and progressive culture figures the possibility of autonomy in modernity; Heidegger, by covering his tracks, detaches exemplarity from freedom – a move which both turns history into fate and presages a distinctly anti-modern transformation of culture.

Now this claim could begin to weigh if, following on from the deciphering of the figure of the modern work of art in great art, we could equally come to see a 'Kantian' modern work of art, a work of great art without greatness, as being central to the 'claim' of 'Origin'; and further, if this claiming, because really about 'Kantian' modern art, a work of genius, could then be shown to exceed the framework in which Heidegger attempts to capture it. Such a work is pivotal in Heidegger's argument in 'Origin'; it is his analysis, and the role that analysis has, of Van Gogh's painting of the peasant woman's shoes. These shoes will walk through this text, reappearing in the discussions of Derrida and Adorno in an analogous position, namely, as a touchstone for the appropriate comprehension of aesthetic culture in its struggle with the demands of progressive culture. Derrida will point us to the way in which Van Gogh's painting exceeds the place Heidegger gives it; while Adorno's thought will provide the terms in which we can account for the painting's claiming. First, however, we need to examine the painting in its original setting.

vi Art and Technology

'Origin' concludes with a question: Are we now in our existence historically at the origin of art? Does art now reveal how things as a whole are? Or is art a thing of the past, something whose value we possess only through remembrance? Heidegger defers here to Hölderlin (OWA, 78):

Reluctantly
that which dwells near its origin departs.
'The Journey', verses 18–19

At the beginning of the modern period great art began to decline because
it could no longer fulfil its essential function of designating the absolute,
of beginning history or starting it again. This is not a comment about the
quality of the art works produced at this time, but a recording of their
historical place. That decline became the 'end of art' at the beginning of
the nineteenth century, at the very moment when aesthetics achieved
'its greatest possible height, breadth and rigour of form' (N, 84) in the
Aesthetics of Hegel.

From a Heideggerian perspective aesthetic axiology is in a state of
disorder because we do not and cannot exist at the origin of art – where
art is an origin; nonetheless, and however dimly, our response to art is
more-than-aesthetical, our sense of the significance of art transcends the
aesthetic categories with which we tend to think about and deal with art
works. We are spectators of art works who, sometimes, seek to be or
behave as if we were preservers, not knowing, of course, that this is what
we are doing. This dual response marks, we might now say, our dual
membership: in progressive culture and in aesthetic culture. Unlike Kant,
however, who refused the act of mourning and remembrance, Heidegger's
'end of (great) art' thesis allows for and makes the work of remem-
brance integral to our engagement with works of art. In the recuperation
of the essence of art we become, through remembrance, preservers of art
once removed – preservers of a possibility.

Yet this thesis cannot be quite adequate as it stands, for it says nothing
about Heidegger's approach to modern art; and in the one discussion of a
modern work of art in 'Origin', that of Van Gogh's painting of the peasant
woman's shoes, Heidegger appears to be forwarding the claims that, first,
the painting reveals the true nature of equipment, namely, its reliability;
and secondly, because the painting can perform this cognitive function we
can deduce that the essence or nature of art is to reveal, disclose, bring
into unconcealment the being or general essence of particular sorts of
things. A modern work of art, then, is deployed to reveal the true nature
of art, which, given Heidegger's thesis concerning the end of great art, it
ought not to be able to do; or, at least its doing, if it does, ought not to be
as unproblematic as it is presented to be.

Worse, in 'Origin' Heidegger offers the example of a Greek temple to
illustrate the nature of great art. The choice is governed by his history
of aesthetics where Greek art is the first step, the zero point for Western
reflection on art. The example of early Greek art is unique because there
exists no corresponding 'cognitive-conceptual meditation' (N, 80) on it;
it is, as such, pre-philosophical, pre-metaphysical and pre-aesthetic. Yet

'Origin' is usually read in a manner in which the account of the peasant woman's shoes and that of the temple are construed as paralleling one another. This is untenable. The Greek temple stands at the origin of art, the painting at the end of art; the temple reveals a world, giving to things their look and to men their outlook on themselves, while the painting reveals what the peasant woman knows 'without noticing or reflecting' (OWA, 34); the point of the temple example is to illustrate the worlding powers of a work, while the painting is first introduced in order to help us think ourselves free of the traditional categories of the thing.

Given the differences between the temple and the painting, it might seem most appropriate either to consider them as functioning as contrasting possibilities within the conceptual economy Heidegger is proposing – illustrating, as it were, the difference between works and great works; or to consider the example of the shoes as exhausted with the demonstration of how the equipmental character of equipment requires a mode of accounting that goes outside the terms of the metaphysics of the thing, while offering a possibility as to the true nature of art, a possibility which is finally revealed in the account of the temple, thus making otiose the original inference drawn from the painting. Both proposals require that, in one way or another, the account of the Van Gogh as revealing, more or less, the essence of art be withdrawn. Neither proposal, however, is acceptable. Heidegger nowhere withdraws his account of the Van Gogh as illustrating the nature of the art work (which, again, is oriented toward great art only (OWA, 40)), as one might expect him to do if the example were there solely for a strategic purpose; and worse, near the end of the section 'The Work and Truth' (OWA, 56), he explicitly parallels the way 'truth happens' in the temple's standing and in the Van Gogh painting. Neither correctly represents anything; rather, both allow the 'which is' as a whole – world and earth in their counterplay – to attain to unconcealedness. If 'truth happens in Van Gogh's painting' then a modern work of art, a work of genius, is ascribed the same (or a deeply analogous) truth potential, a potential for unconcealment, as a work of great art.

How can we bring the contrasting and paralleling aspects of Heidegger's accounts of temple and shoes together? More precisely, how are we to regard the happening of truth of an art work at the end of art? And this question is the question of the value, meaning and truth of art for 'whether and how an era is committed to an aesthetics, whether and how it adopts a stance toward art of an aesthetic character, is decisive for the way art shapes the history of that era – or remains irrelevant to it' (N, 79)

A hint as to how we might approach this question is provided by Heidegger's remark at the beginning of his discussion of the shoes that he intends to disregard the possibility that differences relating to the history of being may be present in the way that equipment *is* (OWA, 32). This

remark should not be too quickly passed over since the central effort of 'Origin' is to demonstrate that such differences cannot be disregarded; or even better, that metaphysics, including, as we shall see, *Being and Time*, *is* this disregarding, this forgetfulness; and hence the being of equipment is always provincial to what transcendentally stamps it. As such, Heidegger's apparently casual remark must be regarded as central to the strategy governing the essay as a whole: the essay will disregard epochal stamping in order to illuminate what regarding it is, a regarding that a modern work of art brings to light. Hence what Heidegger's remark directly suggests is that the account of the painting, although going beyond traditional categories of the thing and so of aesthetics, as in its own way did *Being and Time*, does not thereby install our understanding of the work in the truth of being. Rather, despite its critical surpassing of the traditional metaphysical categories of thing, equipment and work, the account of the painting is nonetheless 'metaphysical', just as *Being and Time* remains metaphysical, bound to the vision of truth as presence (even if what is there made present is ecstatic temporality). Surreptitiously, 'Origin' is a double reading of the categorial pretensions of *Being and Time*.

In order to understand what this might mean, and in order to comprehend the happening of truth in the Van Gogh, the painting must be put into its place, our place, in the age of technology, where the end of art is a consequence of the epochal legislation of the essence of technology. Further, it is only in virtue of the quite specific characterization of technology that Heidegger offers that the *privileged* nature of (non-great) art in modernity can be understood. Heidegger's analysis of technology is his characterization of the progressive culture of modernity; and it is through the analysis of art and technology as forming a unity in difference that Heidegger spells out the critical relation of aesthetic culture to progressive culture.

For Heidegger technology is nothing technical; it is not to be understood in terms of the domination of means – end reasoning over other forms of reasoning, although this may be one of its consequences; nor is it to be understood in terms of the kinds of instruments and modes of co-operation required by them that come to dominate production in the technological era; nor can technology be understood as a product of a secular hubris harnessed to an unconstrained desire for mastery over nature without and within. To understand technology, to grasp the essence of technology, is to see what gathers these diverse phenomena together as manifestations of the same. To do this is not to regard these phenomena as effects of some central, locatable and identifiable cause. Rather, since the history of being is the history of the essence of truth, of the modes in which things appear as being what they are, it is to grasp

these phenomena as coefficients of the technological way of presencing men and things, that is, to comprehend technology through its transcendental schematization of experience.

'Challenging' is the revealing that rules in modern technology, for in it everything in the world is 'challenged', transformed, readied, stored, ordered and secured so as to be at our disposal, to be immediately at hand, indeed, to stand there just so that it may be on call for a further ordering (QT, 17). Because everything appears as there to be challenged does not entail that it is we who arrange things thus, that the challenge is something we create or bring about. Such an anthropological humanism supposes that the possibilities of bringing things to unconcealment, the modes of world-disclosure, are themselves at our disposal, that men can *decide* what is to be real and what not. This illusion, the utter oblivion of being, the belief that there is only man and not being, is itself clearly a reflective effect of the essence of technology. For Heidegger, only to the extent that man for his part is already challenged can the ordering revealing of the challenge occur; hence the Kantian belief that we transcendentally legislate is an effect, *Kantian transcendental legislation standing to technology's legislation as production to creation (a creation which institutes the schema of production – the Kantian 'assault' on the thing).*

Heidegger denominates the essence of technology, the challenging claim upon man, *Ge-stell* – variously translated as 'enframing', 'the com-positing', '(universal) imposition'.[23] It is *Ge-stell* that claims man so what is always already comprehended, actually or potentially, does so in terms of the ordering and securing of technological revealing.

Although, from the beginning, Western thought on art has been aesthetical, in modernity, in the era of aesthetics in its usual extension, there is no more great art. Although from the beginning of Western metaphysics there has been an oblivion of being, in the epoch of technology that oblivion attains a kind of completion. If there is a place where these two streams of argument come together it is in Heidegger's analysis of the fate of *poiesis*; and it is equally in this analysis that the historical placement of art in relation to technology is articulated.

Starting from a consideration of Plato's *Symposium* 205b, Heidegger contends that for the Greeks every occasion in which something passes over from absence to presence is *poiesis*, a bringing-forth. Even *physis*, nature's orderly bringing things from concealment to unconcealment, is *poiesis*. Equally, Heidegger reminds us, the Greeks considered *techne*, a term intended to cover both craft skills and the fine arts, a kind of *poiesis*, but a *poiesis* of a distinct kind, namely, one which involves a state of the soul possessing truth. *Techne* is a knowledge of things that come into unconcealment neither by nature nor through necessity, but through human activity. *Techne* is a mode of poetic revealing, being a mode of *poiesis* and of truth (*aletheia*).

Ge-stell, Heidegger claims, drives out every other possibility of revealing; above all, it cancels, blocks, 'that revealing which, in the sense of *poiesis*, lets what presences come forth in appearance' (QT, 27). *Ge-stell*, the essence of technology, is *techne* without *poiesis*; it reveals not by bringing forth, but rather by regulating, securing, transforming; it legislates making (production) without createdness, reducing creation to production. Because *Ge-stell* drives out all other forms of revealing and, fundamentally, conceals itself as a mode of revealing, it provides or invokes no conception of being proper to itself. *Ge-stell*, through its concealing of revealing, lacks a word for being, a word that, while obeying the logic of presence governing Western metaphysics would nonetheless exceed it because being originary, like the great work of art, it would reveal a mode of being's way of holding sway in concealment.[24] More simply, technology realizes, in the form of the 'standing reserve', the constant presence, the making of all things potentially or actually present, that has been the dominant drive of all metaphysics; but this realization is accomplished precisely through the collapsing of the difference between the transcendental and the empirical, eternity and time, the differences that marked, in forgetfulness, the ontological difference between being and beings, presencing and presence. It is because technological revealing can invoke no word of being, because it sees man everywhere and being nowhere, because it is a refusal of being, it becomes the completion of the oblivion of being and is hence distinguished from all previous modes of revealing. For Heidegger, the cancelling of *poiesis* by technological revealing entails the attaining of the limit of being's withdrawal, and hence the complete etiolation of its powers and possibilities of presencing. *Techne* without *poiesis* is like determinate judgement without reflective judgement, the reproductive imagination without the transcendental imagination or, again, production without creation.

Now there is a significant ambiguity in Heidegger's claim that *Gestell* drives out and blocks *poiesis*. On the one hand, it could mean that *Ge-stell* as a mode of revealing is the only one such whose very nature itself involves a refusal of *poiesis*. On the other hand, it might mean that because in its nature *Ge-stell* drives out *poiesis* it therefore, literally, banishes all other modes of revealing into non-existence. In the first case what is at issue is the character of a centre, a dominant mode of presencing, whose effects and relations to the periphery require analysis and elucidation. This would be like analysing the relation between determinate and reflective judgement. If the latter proposal were the correct interpretation of Heidegger's thesis, then there would be a centre without a periphery – determinate judgement without reflective judgement. In the first case, questioning would probe the way the centre holds sway, how it centres itself and sustains its dominance; in the second case, where the possibility of decentring could come from the centre alone – for there is only the

centre – questioning would have to focus on how that decentring could take place.

In 'The question concerning technology' Heidegger attempts to think the overcoming of *Ge-stell* through the use of the familiar rhetorical figure of an extreme position revealing (engendering, conditioning, soliciting) its opposite: the moment of the greatest danger, when so perceived, is whence the saving power grows (QT, 28). Given his reliance on this figure, it sounds as if Heidegger accepts the second understanding of *Ge-stell*'s refusal of *poiesis*; however, the conclusion of the essay speaks decisively against such a univocal and unequivocal construal of the technological epoch.

> Because the essence of technology is nothing technological, essential reflection upon technology and decisive confrontation with it must happen in a realm that is, on the one hand, akin to the essence of technology and, on the other, fundamentally different from it.
> Such a realm is art. (QT, 35)

It is precisely because technology, *techne* without *poiesis*, refers back to a *techne* that covered both technical production and art that we are now entitled to regard technology and art as akin yet different. What is puzzling is that Heidegger says nothing to justify the difference. Rather, he merely asks whether the fine arts are called to poetic revealing; whether such revealing in some sense lays claim to the arts so that they can foster the growth of the saving power. To these questions Heidegger responds: 'Whether art may be granted this highest possibility of its essence in the midst of the extreme danger, no one can tell' (QT, 35).

This agnostic diagnosis is troubling in two respects. First, because in referring to the 'highest possibility of its essence', a possibility realized perhaps only in ancient Greece (QT, 34), Heidegger lapses into an atemporal essentializing of fine art; that is, his contrast fails to make direct and essential reference to the history of art since the Greeks in considering the possibility of fine art playing this critical role. This contravenes the very idea of epochal history. If art were to be able to play a critical role surely it would be because of something more specific to its history than its ancient linking with technical production. What has happened to the identity and difference of art and technical production since then? Perhaps it is not a matter of sheer accident or taste that Heidegger for the most part refers us to Romantic poets and fails to engage with the questions of artistic modernism as such. At least the Kantian distinction between progressive and aesthetic culture gives us a current if unanalysed difference with which to work, one which, as we have seen, points relentlessly in the direction of the problematic of modernism.

Secondly, however, it begins to look very dubious whether Heidegger

could provide the sort of specification that would make his reference to art have point. After all, it is because the essence of technology is nothing technical, nothing empirical, ubiquitous through its hiddenness, that Heidegger is forced to gesture toward another mode of revealing in order to spot the danger. But, and here is the trouble, without art, without the identity and difference of art and technology in modernity, *there is no danger*; there is only technology. It is no accident that technology only comes into view *as* technology and as epochal when Heidegger shows that 'The Rhine', as figured in Hölderlin's hymn by that name, is not present in the landscape; it is available there in no other way than as an 'object on call for inspection by a tour group ordered there by the vacation industry' (QT, 16). *Without the contrast of the two Rhines there is not even technology.* Which is only to say that in order to place the present we require some vantage point 'outside' it, some place marginal or peripheral to it, from which to perceive it. Art was to be that point. Without art as the counter-point to technology neither the question of being nor the history of being can be opened.[25]

One might argue that in attempting to consider the question of art in abstraction from Heidegger's various and numerous considerations of language we abstract from the core of his concern with art. This cannot be correct, for the whole force of Heidegger's thesis that 'language itself is poetry in the essential sense' (OWA, 74), and thence his commentaries on Hölderlin, for example, only come into view and take on significance through a thinking of the togetherness and opposition of art and tech-nology. Of course, Heidegger can read a poet like Hölderlin and find in him a *representation* of the contrast between an age in which the gods were still active and our age in which they have fled, a contrast between a dwelling place and abstract space, between unconcealment and truth, but in so far as these or analogous accounts are offered art remains aesthetic: an imaginative projection of other possibilities of thinking experience. Heidegger cannot think modernity through art without thinking the meaning of art in modernity, thinking, then, how non-great art is more than aesthetical. If such an excess beyond aesthetics is implicit in *modern art*, what is required of philosophy is to underwrite it, to give back to art the transformation of cognition that it first makes possible.

In saying all this I do not intend to deny that the art and technology nexus (or whatever other conceptual apparatus we might use to analyse progressive culture) has something like the kind of significance Heidegger attributes to it; or even to deny that some sort of epochal history is central for the bringing of that nexus into relief. On the contrary, I have been pressing the virtues of Heidegger's historical radicalization of the implicit critique of modernity found in Kant's third *Critique*. What I am querying is Heidegger's way of construing modernity in terms of the essence of technology; and hence the form of the technology and art nexus he offers.

If art does (or might) play the critical role Heidegger suggests, it is not for the reasons he suggest. The evident force of Heidegger's critical analyses does not derive from the framework, or history, that informs them; the juxtaposition of art and technology, and with it the distinctions between production and createdness and the like, do begin to articulate modernity, but for reasons that as yet remain opaque.

vii Earth, World and Alterity: The Polis as Art

At the end of the previous chapter I suggested that Kant's third *Critique* suffered from a refusal of memory, a refusal to mourn, to acknowledge the past whose loss sets critical philosophy's aesthetic theory into motion. One pertinent way of reading the claims with which I ended the last section would be to say that Heidegger's articulation of the art and technology nexus in 'The Question Concerning Technology' – the very nexus that provides theoretical backing, gives force and point to Heidegger's claim concerning the closure of metaphysics and hence opens up the history of being – is overwhelmed by an exorbitant memory and mourning. Immediately prior to his questioning of the possibility of art providing a counterforce to technology, of inhabiting the greatest danger and 'turning' it into a saving power, Heidegger says:

> In Greece, at the outset of the destining of the West, the arts soared to the supreme height of the revealing granted them. They brought the presence (*Gegenwart*) of the gods, brought the dialogue of divine and human destinings, to radiance. And art was simply *techne*. It was a single, manifold revealing. It was pious, *promos*, i.e. yielding to the holding-sway and the safekeeping of truth.
> The arts were not derived from the artistic. Art works were not enjoyed aesthetically. Art was not a sector of cultural activity…
> The poetical brings the true into the splendor of what Plato in the *Phaedrus* calls *to ekphanestaton*, that which shines forth most purely. The poetical thoroughly pervades every art, every revealing of coming to presence into the beautiful. (OWA, 34)

Heidegger's is not a backward-looking utopia, a hope for a return to past times and past gods; but to concede this is not to concede that Heidegger's philosophical memory is not submerged in an exorbitant mourning. One can refuse memory, refuse the call of the past, or heed it too well; a past that is never present and a past that is always present both involve a failure to negotiate, to acknowledge properly, the role of the past in the present. When the past is refused, it will determine the present blindly through that refusal, dooming us to repeat what is partial and broken: the

pathologies of progressive culture. When we remember too well, the past overwhelms the present as a place of action. In both cases we are deprived of a future and caught in an endless present, but differently. When memory is refused, we are conscious of only the continuance of present actions without source or origin; when remembering too well, we are conscious of the inability to act, of the lack of possibilities in the present. If the memory of the 'radiance' of ancient Greece is an achievement over utter forgetfulness, and it is, it is here equally a problem, a halt; a 'radiance' so sublime that the present cannot be seen at all, or at best seen only indifferently, under the ubiquitous and anonymous sway of the essence of technology. Between the full presence of the past and the empty presence of the present nothing intercedes: this is the long epoch of metaphysics. Caught between two presences, the 'radiant' and the empty, neither present nor past is known, and potentiality becomes locked into unmoving actuality. This is the cost of Heidegger's reductive philosophy of history, one that sees the present only in terms of the eschatological realization of the metaphysics of presence, leaving no room for a way of judging the losses and achievements of modernity.

It might be thought that this claim is too strong, that Heidegger is doing no more than turning our attention toward the Greek past in order to retell the history of metaphysics in a manner that would allow the potentialities for presencing in the present to be released. This is certainly the intention behind Heidegger's attempt to demonstrate the shift that 'essence' undergoes in technology. Nonetheless, this defence must fall short so long as the critical significance of modern art remains suppressed. As we have already seen, Heidegger's suppression of artistic modernity is at one with his refusal of autonomy, the transgressive freedom of modern subjectivity. But this raises a technical problem for Heidegger's analysis, namely, how is he to comprehend the respective roles of artist, spectator and work in artistic creation? In other words, Heidegger and Kant agree on the nature of the exemplary work, on what it achieves and how that achievement establishes itself; where they disagree is on how 'subjects' are connected to such works.

In the 'Addendum' to 'Origin' Heidegger concedes that the essay's analysis fails adequately to relate artist and work, and this failure tokens a dislocation of being and beings whereby the former comes to dominate the latter. So although Heidegger stresses that 'Being is a call to man [or: needs man] and is not without man' (OWA, 86), nonetheless in the movement of establishing an alterity sufficient to desubjectivize art, and hence write the riddle of art in terms not dependent on subject/object dualism, Heidegger so stresses the role of the work and of being that they take on the role of subject. Only if it were undecidable whether artist or work were responsible for the setting-into-work of truth would the structures of subject/object dualism be transcended. Heidegger's failure here is worth

detailing, first because it is endemic to his position and remains the most perspicuous source of his refusal of subjectivity; and secondly because it is equally the precise place in his work where the question of art and politics is posed.

The difficulty to which Heidegger points in the 'Addendum' occurs, ironically, in one of the strongest lines of thought in the essay. For Kant, remember, the judgement of taste 'demands' agreement. In attempting to ground this demand we discovered that the neutralized, disinterested subject was inadequate to the task; and further, as we pressed the claims of genius, work and sublimity against the claims of taste it became increasingly obvious that it was the object of judgement that was making demands upon the judging subject. Heidegger's account is a reinscription of sublimity within the terms of the historicality of truth, where the relation between taste and sublimity is rewritten in terms of the difference between art and 'great art'. For Heidegger, again, the work of art is an address;[26] its address occurs through a 'thrust' which is *ungeheuer*: enormous, colossal, monstrous, awesome, extraordinary – sublime. After describing what great art accomplishes, Heidegger asks 'Why is the setting up of a work an erecting that consecrates and praises?' (OWA, 44); and responds, 'Because the work, in its work-being, demands (*fordern*) it'. Heidegger's strategy, then, is to provide an analysis of great works that short-circuits the role of artists and audience, letting the demands, calls and addresses that occur here occur through what is intrinsic to works themselves. The thrust of works engenders a displacement, a holding and engendering of both producers and consumers; works figure and exemplify originarily their createdness, and engender (an awe-full) respect and love. In the Nietzsche lectures Heidegger calls this entanglement of love and respect 'rapture'; in thinking this entanglement he uses Rilke's first 'Duino Elegy' as his guide: 'For the beautiful is nothing but the beginning of the terrible, a beginning we but barely endure' (N, 116).

Central to any such account would be the displacing of (subjective) disinterestedness – that in virtue of which a work is regarded for its own sake and not for any ends external to it – into the work itself, thereby grounding its autonomy, its being, so to speak, an end in itself. This, of course, is a standard thesis of German Idealist aesthetics: the inwardness and depth of the work of art, its having 'soul' in Kant's sense, is what draws the spectator in and grounds disinterestedness. Heidegger identifies this autonomy as a work's 'self-subsistence', a 'closed, unitary repose of self-support' (OWA, 48); this is a work's work-being, whose two essential features are the setting up of a world and the setting forth of earth. Works are a strife between world and earth. The terms 'world' and 'earth' are intended as non-metaphysical replacements for what has been traditionally thought in terms of form and matter, and recall Nietzsche's distinction between the Apollonian and the Dionysian.

World is not to be construed as an object before us, but rather as the disposition of men and things with respect to one another in virtue of which they possess the kind of place, duration and worth they do or can have. It is the 'ever-nonobjective to which we are subject so long as the paths of birth and death, blessing and curse keep us transported into Being. Where those decisions of our history that relate to our very being are made, are taken up and abandoned, go unrecognized and are redis-covered by new inquiry, there the world worlds' (OWA, 44–5). To be 'transported into Being' is to inhabit a world and find a sense in one's activities that is made possible elsewhere than through those activities themselves. To act 'historically' is to act in a manner that perspicuously responds to the non-objective conditions of the possibility of experience; it is, we might say, to remain attendant to the totality *qua* totality, to the categorial *qua* categorial, and hence to the way in which the categorial totality gathers and distributes particulars and kinds, giving to each its place.

Works set up world, but in order to do so they must employ some work-material: stone, wood, colour, language (word), tone – collectively 'earth'. Works use materials without using them up; works rest upon and set themselves back onto the earth, but in so doing reveal the earth as earth, that is, earth is recognized in works as a fundament for their possi-bility. What is so revealed and recognized is that, although capable of being set forth in an endless variety of ways, the earth itself cannot be finally, once and for all, revealed. The earth for Heidegger is precisely that which is by nature undisclosable. Stated positively: 'The earth is essentially self-secluding' (OWA, 47). The earth, then, as a non-historical principle of transcendental opacity, a principle of reserve, thematizes an aspect of what Kant's conception of genius thought through the concept of nature.

Earth is 'by nature undisclosable, that which shrinks from every dis-closure and constantly keeps itself closed up'; the elements of the earth, although belonging together in a mutual accord, always rehearse a 'not-knowing-of-one-another' (OWA, 47). Now this claim may sound as if Heidegger were attempting to make what is usually called nature (but, remember, includes language) incapable of being completely cognitively objectified; hence, salvaging some cognitive privilege or possibility for works against the claims of science and technology. And it is certainly the case that the claims of reason cannot be restricted unless they arise from, lean and depend upon, what they cannot acknowledge. Because art works can acknowledge, indeed thematize, their material basis, every achieve-ment of art is simultaneously an acknowledgement of dependency. And if what is so acknowledged is the non-foundational ground for any world, and since for a world to be world requires its being related to that ground, then art works can rehearse the entanglement of every world with earth

in a manner that escapes the claims of reason (and is suppressed by technological presencing).[27] But to say this, to acknowledge a source of world and reason beyond the control of reason, is just to say that truth, what is revealed by the light of reason, what a world makes visible, is neither self-sufficient nor self-grounding: untruth, what is not revealed but conditions revealing, is a component of truth itself. Because the metaphysical tradition tended to think of absence as a defective mode of presence, and thought of truth in terms of presence (and self-presence), untruth was necessarily thought of as a temporary, contingent and in principle avoidable defect. Once, however, the absential dimension is shown to be an unmasterable and hence not fully objectifiable or presentifiable component of how things can be present, then untruth (absence) can no longer be conceived as external to or a simple lack of truth (presence).

World disclosures are finite, so with each world disclosure there must also occur two concealments. The first concealment is of what lies beyond that world, hence concealment functions here as a limit of knowledge that is equally its condition. The second concealment relates to truth and error in their ordinary sense. Heidegger calls the first sort of concealment 'refusal', and the second sort 'dissembling'. Truth happens, is an event, because worlds are the products of works; but the unconcealedness that works provide in setting forth a world always and necessarily is accompanied by the double concealment of refusal and dissembling. Untruth – concealment, limit, refusal, withdrawal, dissembling – belongs to the essence of truth.

Heidegger's hypothesis is that self-secluding earth is the 'source' of the untruth that makes truth possible. Because Kant thought the horizons of human thought to be unchanging, he thought what Heidegger terms the earth through the concept of the thing-in-itself, what both must and cannot contribute to human knowing. Kant, we might say, wanted to keep untruth external to truth while simultaneously recognizing that the limits of knowledge were also the conditions for its possibility. The Copernican turn instantiates the finitude of human cognition without accepting the consequences of that instantiation. Heidegger's recognition of the historicality of truth allows and requires him to think truth and untruth together. The concealment, the limit and the condition, essential to all unconcealment, is revealed *in* the setting forth of self-secluding earth in works.

It is the place of the earth as being revealed 'in' works 'as' self-secluding that structures and troubles Heidegger's account. This 'in' and 'as' mark the subjectivizing, the activation, the empowering of the work itself; an empowering that occurs in response to Heidegger's desire to identify the event of unconcealment with presencing as being. Works are a strife between world and earth, concealment and unconcealment, presencing and withdrawal. For Heidegger this strife is not the mere

complementarity and incommensurability of these two attributes of works, but a personified, and empowering, battle:

> In essential striving...the opponents raise each other into the self-assertion (*Selbstbehaupttung*) of their natures. Self-assertion of nature, however, is never a rigid insistence upon some contingent state, but surrender to the concealed originality of the source of one's own being. In the struggle, each opponent carries the other beyond itself. Thus the striving becomes ever more intense as striving, and more authentically what it is. (OWA, 49)

'Self-assertion' and 'authenticity' should recall us to the abysmal self-determination, the radical autonomy of the working of genius. In this passage we can perceive the literalizing of our figural identification of being and genius, the genius of being. Only now this identification is more difficult, more than the marking of a shared philosophical problematic, for here the abysmal risk of taking up the burden of human significance is displaced *into* works, the elements 'striving' within them, and the question of presencing *as such*. Heidegger appears to regard these two moves as required in order to acknowledge a non-foundational ground in a manner that secures its role historically (for each and every world) and metaphysically (for worlds as such). By personifying the elements in works Heidegger displaces our entanglement with these elements. If 'essential striving' occurs among the elements of works, will it not follow that our relation to what is 'essential' becomes passive, and thus a return to knowing/contemplating/representing as grounding our being-in-the world? And would not such a return also be a return to subject/object dualism, as well as marking an evasion of what taking up the burden of human significance might entail?

What we cannot avoid noticing is how Heidegger rethinks the indeterminacy and schematizing work of the (autonomous and originary) transcendental imagination of the third *Critique* in terms of the 'rift' (*Riss*), and further links the work of the rift with the createdness of the created work, its 'that it *is*' *überhaupt*. Briefly,[28] Heidegger employs the semantic network sedimented in *Riss* to suggest the complementary incommensurability of earth and world, their identity in difference; and that the complementarity of their incommensurability gets revealed through the 'basic design', the 'outline sketch', the *Riss* or schema the work produces or is. The rift is an active indeterminacy, a difference, and a marking-unifying in virtue of which the rift as unpresentable condition can be thought. The rift, then, spreads out to qualify earth and world, their unity and difference, and their co-belonging in strife. In general, of course, Heidegger is attempting to describe the work-being of a work in a manner that explicates concealment as an essential, conditioning

component of the work, that can become manifest, figured if not presented, in a work through the work itself. The final prizing of the work as the condition that presents its conditions is there to spell the difference between hermeneutic and transcendental inquiry, although it is arguable whether the progressive-regressive movement of transcendental reflection is so very different from Heidegger's form of hermeneutical inquiry. Again, Heidegger is not offering a transcendental analysis only in the sense that: (i) what is transcendental is not formal or utterly distinct from empirical items; and (ii) what is transcendental cannot itself be made present or perceptible.

A good deal of the burden Heidegger places on the rift, as well as its connection with the transcendental imagination and transcendental schema, comes out in this passage where Heidegger is discussing Dürer's remark: 'For in truth, art lies hidden within nature; he who can wrest it from her, has it.'

> 'Wrest' here means to draw out the rift and to draw the design with the drawing-pen on the drawing-board. But we at once raise the counterquestion: how can the rift-design be drawn out if it is not brought into the Open by the creative sketch as a rift, which is to say, brought out beforehand as a conflict of measure [world] and unmeasure [earth]? True, there lies hidden in nature a rift-design, a measure and a boundary and, tied to it, a capacity for bringing forth – that is art. But it is equally certain that this art hidden in nature becomes manifest only through the work, because it lies originally in the work. (OWA, 70)

The rift as indeterminacy is an anticipation; there is, we might say, a rift in nature that anticipates it as resource, design (form, figure, shape, *Gestalt*) and self-closing ('boundary'). The rift is the potentiality for the schema that reveals both world and the rift in nature as the potentiality for that world. Which is to say that we have no access to earth as the non-foundational ground for worlds other than through what is revealed in works. The freedom of the transcendental imagination appears here as the '*creative* sketch', which Heidegger immediately draws back into the rift, and the conflict of measure and unmeasure. Again, while the interplay of art and nature repeats Kant's qualification of genius as that through which nature gives the rule (measure) to art, Heidegger quickly sublimates nature into the work. Each acknowledgement of the essential ground-lessness of autonomy *and* the alterity of nature as unmasterable ground gets displaced into the work itself.

The pressure on Heidegger to make this displacement derives from the desire to keep being and human being intimately connected without reducing creation to subjectivity. And, again, this cannot be untoward if the act of creation is more than an intentional doing, more than producing

in accordance with an existing plan. But in Heidegger the consequence of this strategy is not merely to make creators and preservers dependent on the work (OWA, 71), but in so doing to make the work an address posed to 'some alterity and not posed by man for man'.[29] And the consequence of that is to make the 'otherness' of the 'recognition of self in otherness', which is still here the governing and gathering gesture, the movement of coming into presence itself. This is why Heidegger interprets the createdness of works not in traditional intentionalist terms that would note a work's origin in human productive activity; but rather, in ontological terms where that 'a work *is* at all rather than is not' (OWA, 64) is the happening of the work, what makes it remarkable. *Hence what is (figuratively) brought into the open by a work is that there is something rather than nothing, that is the ultimate source of its sublimity; and only in virtue of its connection with this (figuratively concealed) revelation can a work open a world.*

To be sure, since we do not determine the sheer existence of the world through our activities, then if the being of things matters with respect to truth, works can only figure worlds if they do definitively transcend their producers. Heidegger is appending this thought to the valid thesis that some works, especially, for us, the autonomous works of artistic modernism – works Kant considers to be products of genius because they exceed the previous determinations of art history – can only function by engendering their own conditions of reception. Which is but another way of saying that modernist works create the community that can acknowledge their significance *as* works of art. In this case, as we have already seen, works really are in a strange way community-creating. Heidegger folds this conception of works over the great works of the past, with the consequence that the 'as' of 'as art' is doubled in order to figure the being of the world as such, its 'that it exists at all'. *Hence the createdness of the world as a whole is finally thought through immanently.* This is certainly the ultimate displacement of creation myths. But it is just this radicality in Heidegger's account that troubles it. In order to manage an ultimate displacement of the productivist paradigm he must first take up the case of the exemplary human creation – the work of art – and then displace the site of human beings in the creative act. Heidegger hence deals with the real inadequacy of standard conceptions for the understanding of action by transferring the problematic attributes of subjectivity into the object, and then, through the relay the work represents, into nature itself. Nature becomes earth which rewrites *physis* as the process of manifestation. Worlds thus become manifestations, or modes, of nature.

At B 181 of the first *Critique* Kant states that schematism is an 'art concealed in the depths of the human soul, whose real modes of activity nature is hardly likely ever to allow us to discover, and to have open to our gaze'. Everything in the sentence is correct for Heidegger except the

placement of this art in the human soul: schematism is an art hidden in nature; this art, implicit in nature, only becomes actual in the work; and while the work would not be without creators and preservers, it is the work that 'makes creators possible' (OWA, 71). Works schematize experience; their double 'as' structure offering both a figure of world and a figure of the event of figuration. *Schematism is Ereignis* (the appropriative event): what gives being, the event of unconcealment. The price for this transformation is that the motivating force for considering the forgotten question of being, namely, the overcoming of the reduction of the being of things to presence in order to set free their alterity or otherness, becomes squandered in the alterity of being itself. How could acknowledgement of the absential conditions for presence secure the alterity of things, an alterity the meaning and significance of which remains utterly opaque on this account, without our respecting and heeding it? But if being creates the conditions of its own reception, in concealing and revealing, then all responsibility is removed from us.

In displacing the traits of human subjectivity into works in order to avoid subjectivizing their creation, the burden of human significance, a burden that is now without limit or ground, is lifted from the shoulders of human beings and given over to being – something that is evident from the comparison of the Heideggerian and Kantian versions of the creation of exemplary works (even if one concedes that Kant's incendiary dialectic promotes a frenzied autonomy). Of course, a certain 'left' Heideggerianism might want to dispute this thesis by claiming that the real goal of Heidegger's thought is not the truth of being (and the being of truth) but rather to think 'an original gathering which does not abrogate variety, but unifies what tends apart in a way that preserves difference within unity'.[30] What is being thought here is a non-impositional or non-dominating synthesis of the manifold – which is just, as we shall see, Adorno's way of thinking about the autonomous work of art. And Heidegger does say things like this:

> If we have grasped the fundamental meaning of *logos* as gathering and togetherness, then we must take notice and keep firmly in mind that: gathering is never a mere rounding up and heaping together. It maintains what is striving apart and against one another in their belonging-togetherness. Nor does it let them decline into dispersion and collapse…It does not allow that which reigns throughout to dissolve into an empty indifference, but by unifying opponents preserves the extreme sharpness of their tension.[31]

So the strife in the work of art becomes a general characterization for the relation of elements in a totality that can then be projected onto a community itself. And, indeed, in *An Introduction to Metaphysics* Heidegger

figures the *polis* as a site structurally homologous to the work of great art; better, it becomes clear in this work that what Heidegger was considering in his account of great art in 'Origin' was the Greek *polis: the polis is the Greek work of great art.* The passage in question is worth quoting in its entirety:

> No longer *poros*, but *polis*, is named; not all paths to the realms of beings, but the basis and locus of the *Dasein* of human being itself, the junction of all these paths, the *polis*. One translates *polis* as state or city-state; which misses its full meaning. Rather, *polis* names the site, the *Da*, wherein and as which *Da-sein* is as historical. The *polis* is the site of history, that *Da, in* which, *through* which, and *for* which history happens. To this site of history belong the gods, the temples, the priests, the festivals, the games, the poets, the thinkers, the rulers, the council of elders, the assembly of people, the army and the fleet. All this does not first belong to the *polis*, is not political, because of entry into relation with a statesmen and a general and the business of state. On the contrary, those named are political, that means, at the site of history, in so far as there are, for example, poets *alone*, but then really poets, thinkers *alone*, but then really thinkers, priests *alone*, but then really priests, rulers *alone*, but then really rulers. *To be*, however, here means: as the powerful ones, to use power and become outstanding in historical being as creators, doers. Out-standing in the site of history, they become equally *apolis*, without city and site, alone, homeless, without expedient in the midst of beings as a whole, equally without statute and limit, without structure and order, because they *as* creators must always first found all this.[32]

The *polis* is the site of history, that is, the site in virtue of which a community has a specific historical identity and thus destiny. Here, then, the temple that was historicizing in 'Origin' becomes itself a moment in the larger work that is the *polis* itself. And what makes the elements of the *polis* political is their remaining steadfast 'at the site of history'. The 'political' thence denotes not matters of government (the legislation, execution and judgement of laws, say), but the creation, formation and sustaining of the historical identity of a people as being the people it is, the creation or re-creation of their categorial being in the world, their way of taking up and sustaining the burden of human significance.

It might now be tempting to consider the aloneness of the members of the *polis* as that which allows them to enter into conversation with one another in order to co-create a community whose essence is more than what any one individual contributes. And this would be plausible if we thought Heidegger was attempting to bind Kantian and Aristotelian

terms. Again: does not the 'without end' structure of genius align it to
praxis, and does not the non-subsumptive cognition of reflective judge-
ment recall us to *phronesis*? Would not the Kantian idea that we must
respond to an autonomous work autonomously and that the spirit of
genius is radically opposed to the spirit of imitation give force and gener-
ality to Heideggerian aloneness, underlining his contention that 'creators
must always first found all this'? Are not these creators more like auton-
omous beings than Nietzschean noble beings? Would not such an assump-
tion explicate the connection between the *polis* and democracy, where
democracy figures the thought that the burden of human significance is
our responsibility, but a responsibility that *we* can satisfy only if each of us
acts *alone*, autonomously? Is it not then through these thoughts that we
arrive at the conception of the *polis* as world, in the strong sense, whose
being is political, where the idea of the political refers to some conception
of historically finite transcendental legislation?

Certainly with these thoughts in mind it would not be difficult to
understand Heidegger's emphasis on the work of art as a way of high-
lighting, and restoring, the ancient priority of *praxis* over *poiesis*, doing
over making, creation over production; with the proviso that praxis is only
revealed in something made, poetically.[33] For Kant, I suggested, this
amounts to the thesis that freedom *appears* only in the created thing, the
work of art; and only in the alterity represented by the created work can
we spectators be summoned to our freedom. Kant's emphasis on
communicability in the judgement of the work of art would then be a dis-
tant echo of the fact that for Aristotle the domain of *praxis* and *phronesis*
was one of *doxa*, opinion, not demonstrable knowledge. Pressing these
thoughts, we might now conjecture that reading the inner identity of the
Greek work of great art and the *polis* through the lens of the work of
genius allows us to perceive that transcendental legislation in its various
traditional philosophical formulations – from the Platonic ideas, to God's
creation, to the cogito or the Kantian legislation of understanding and
reason – in each case suppresses a more immanent and essentially *political*
categorial gathering, where, again, what makes this legislation political is
its historical finiteness. If this were the case, that is, if the unsaid of the
Greek *polis* were its being *retrospectively* a work of great art, then it would
follow that the metaphysics (of presence), which is the object of
Heidegger's concern, is the suppression of the human vocation for free-
dom first released in modernity and thematized in the modern work of art.
Genius – or better, the principle genius represents, namely, that the
human vocation for freedom is realized only when the effort to act
autonomously, to take up the burden of human significance originarily, is
made – is the release and historical realization of the meaning of *praxis*.
Genius imprints onto the Greek *polis*, which knew neither history nor cre-
ation in the modern sense, its excessive character as figuring political

praxis as transcendental legislation – a legislation that is necessarily, as creative, schematizing and originary, groundless. Only as a work of art understood through the self-transgressing freedom of genius can the meaning of the *polis* be understood. And only in terms of the genius-being of the *polis* can we understand Heidegger's employment of great art as exemplary for the question of being and history.[34] Heidegger's relating of art to history and community releases the political significance of modern art through his comprehension of the 'aesthetic' features of antique politics.

Correlatively, aesthetic culture figures a radically democratic political culture, a culture that exists now only aesthetically because the productivist logic of progressive, technological culture is the suppression of the ethical: practical knowing and willing. Hence, the burden of historical existence gets decided apart from the historical community in the mechanisms of societal reproduction demanded by the logic of the progressive (productivist) culture. History is made, produced, behind the backs of men – by *Gestell.*

Eerily, this argument would make Heidegger's destruction and double reading of the tradition an almost Feuerbachian or Marxian fable of projection and (re)appropriation, with the anti-humanist or anti-subjectivist twist that the creations of freedom transcendentally exceed and ground the subjectivity from which they 'originate'. Of course, that twist turns, twists, the axis of the fable: (re)appropriation occurs through dispossession; we come closer to our estranged essence as political beings through distancing, through the acknowledgement that modern (transcendental) subjectivity, which appears as what is most near, as our true self, is in fact what is most metaphysically distant. And what makes this a plausible hypothesis is the view that all the moments of the logic of the classical account of externalization, reification and reappropriation depend upon a logic of production. This leaves uninterrogated, and unknown, what institutes alterity, why our fate is tied to exteriority, how what is other than self can ground it; all we have is a *that* such is the case, with the being of genius and the genius of being still locked in an unfathomable dance. Nonetheless, such an argument might well be taken to represent a certain 'left' Heideggerian perspective.

But it is not Heidegger's. Aloneness for him figures the distance between those who are still mired in the everyday, in chatter, and those who can respond to the sublime address, who can listen in order that the destiny of a people can become manifest. The account of great art releases a thought active in Heidegger ever since §74 of *Being and Time.* Note, above all, the final sentence of this passage:

> In finite liberty *Dasein* takes on the impotence (*Ohnmacht*) of its being-yielded up to itself and it becomes clairvoyant with respect to the contingencies of the situation that is revealed to it. Now if

Dasein, subjected to destiny, exists as a being-in-the-world; if by virtue of this it exists essentially in being-with others, its advent is also an advent-with (*ein Mitgeschehen*), it has the sense of something destined (*Geschick*). By this we intend the advent of the community, of the people. What is destined does not simply result from the sum of individual destinies, any more than being-with-in-reciprocity in a single world and in the decision-resolved (*Entschlossenheit*) for certain determined possibilities, destinies find themselves already channeled. In communication (*Mitteilung*) and in combat the power of what is destined is merely liberated.[35]

Freedom is the resolute *passivity* and *impotence* that allows what has prepared itself for the longest time to become liberated; communication, at best, facilitates that liberation. 'Origin' emphatically underlines this thought: 'The resoluteness (*Entschlossenheit*) intended in *Being and Time* is not the deliberate action of a subject, but the opening up of human being, out of its captivity in that which is, to the openness of Being' (OWA, 67). Only the schema of the sublime address allows the resolute individual to be 'brought under law'; hence, again, preserving 'as knowing, is a sober standing-within the extraordinary awesomeness of the truth that is happening in the work' (OWA, 67–8). Heidegger, desperate to avoid the 'from the inside out' logic of subjectivity and production, can only invert it: '*Existenz* is out-standing standing-within the essential sunderance of the clearing of beings' (OWA, 67). All effort is towards the suppression of will, towards being in a position to respond to what addresses us emphatically and absolutely from without.

It is precisely because he conceives of freedom as only to be freed for a destiny always already sent that Heidegger must suppress his fundamental reliance on the modern experience that connects freedom and history. His misery is that only something like creation, whose emphatic instance is given in art, is adequate for the purpose of bracketing the claims of the logic of production. But creation in the sense required is indelibly tied to the modern experience of freedom and subjectivity. What makes art puzzling, enigmatic, is just that art works are intentional items, albeit ones that cannot be saturated by any intentional description of their coming to be. Nonetheless, the effort of creation can be precise in its orientation. Further, communication becomes important, more than an aid to liberating a destiny, only if human plurality is already established. But plurality, whatever else it means, must refer to the distinction between genius and imitation, however overdrawn that distinction may be in Kant, and however enigmatic the idea of an audience of genius may be. For what that idea entails is both that the work of genius is idle until succession – further works that acknowledge its exemplarity – is evidenced; and that succession must itself be a work of free judgement since what gives back to the exemplar the determinacy it possesses are its successors. Exemplary

works are thus de facto answers to the paradox of legislative authority, that is, the paradox as to how to put the law above man and thereby establish the validity of man-made laws. This paradox is but the most striking version of the paradox of finitude, namely, how can what is man-made, and hence empirical, be simultaneously transcendental and authoritative? If one insists that what is man-made is merely empirical, or what is transcendental is necessarily atemporal, or a priori or formal, then this paradox has no solution. Heidegger, despite himself, accepts the terms of the paradox, and thereby denies the solution exemplary works yield. What they demonstrate is the falsity of the either/or of: either inside out (subjectivism), or outside in (objectivism). Heidegger is forced to opt for objectivism the moment he consigns genius to the logic of modern subjectivity.

If we now look again at Heidegger's description of the sublime *polis*, it hence becomes clear that it does not describe a democratic auto-institution of a people, but their formation, their aesthetic education through the work of art or what is sufficiently like the work of great art to be thought of in terms of a sublime address. This is why *polis* should not be translated as state or city-state, of what directly pertains to the political; the state and the political are founded or grounded in the world, in the categorial legislation released by the schematizing of works, indeed, the 'openness of Being' itself. And since the knowing of the world as a whole is philosophical knowing, then the state is grounded in philosophical cognition – and not political *praxis* or judgement, these being grounded in the original insight into the being of the world as a whole. Although greatly deferred, Heidegger here repeats the fabled Platonic suppression of the political with which we began this study.[36] Heidegger's aestheticization of the political, his figuring of the *polis* in the image of the work of great art, is hence hardly benign. By suppressing the moment of freedom through which the work of art can model the creative dimension of history, its self-othering, the analogy between art and the state makes the whole of the state a sublime instance submerging its members. Under these conditions, the aestheticization of the political devolves from the realization of the meaning of politics to its utter abandonment.

The question of the political is intimately related to the question of art because the latter is consistently oriented toward the question of community: at first weakly in terms of the ambiguous status of the 'universality' of the judgement of taste, and then radically in the community – creating of the work of genius. These aesthetic or artistic communities provide alternative conceptions of solidarity to those on offer in contemporary progressive culture. And this matters, the thought of accord or *sensus communis* matters, because the modern belief that lies behind liberalism has proved idle, namely, that the world of everyday affairs, the world of family and work, of culture and leisure, are able to pick up the burden of human significance left vacant with the disappearance of religious belief. The point is not that we require a transcendent domain

beyond everyday life; it is rather that the claims of ordinariness have not proved self-authenticating. Hence the liberal strategy of vacating the public world of ethical substance for the sake of private goods, interpreted broadly as the goods of secular existence, has in fact quickened the disintegration of meaning, the rush of nihilistic decay.[37] Only a substantial political culture is now capable of providing the orientation that could release everyday life, mundane reality, allowing it to escape the futility ascribed to it by the religious tradition. Heidegger understood perfectly the sense in which 'accord' is a question for us, how the path of finitude must be provided with a public meaning if ordinariness is to escape futility. Thus it is that in his Nietzsche lectures Heidegger makes justice the point of convergence between art and truth (Niii, section 21), albeit a convergence which in its Nietzschean form so heightens the place of the will that Being, transfigured ordinariness, is suppressed. Nonetheless, it is art's transfigurative power, the work of genius, that sustains the possibility of transfigured ordinariness in modernity.

In marrying art, schematism and *polis* Heidegger unlocks the implicit radicality of the theory of genius while simultaneously providing for a non-Hegelian interpretation of the *polis* as a work of art. By his very unKantian detachment of genius from freedom and his all too Kantian transcendental construal of schematism Heidegger suppresses the political at the moment of its (re)appearance. Heidegger thus misreads the political implications of art. Because he wishes for the re-institution of the Greek experience of the *polis*, but fails to acknowledge what the modern contribution to the meaning of it is, what would make a re-institution more than merely a dull imitation, he aestheticizes the political. Modern art and aesthetics are not a mere refuge for the Greek *polis*, they liberate a meaning in it not heretofore present. Neither an aestheticization of the political nor a politicized aesthetic could respond to the dilemma of modernity, a dilemma best encapsulated in the thought of the *duality* between these two, what causes that duality and thus makes either an aestheticization of politics or a politicization of aesthetics appear as authentic responses to it. This is not to deny what has now appeared as the driving contention of this work, that philosophical consideration of the meaning of art in modernity becomes the thought of a certain absent politics; a thought entailing that, in a manner of speaking, art and aesthetics are the unsaid of modern politics, its speculative other.

viii Aesthetic Alienation

Throughout this chapter I have been insisting that art and aesthetic discourse as they are for us now are what provide the critical vantage point that opposes and reveals the reign of technological presencing, and through this revelation the history that locates this reign as the sup-

pression of finite transcendence. I have nowhere denied that such a van-
tage point and history are provided by Heidegger's essay. This commits
me to the claim that Heidegger's strategy in 'Origin', his manner of
enjoining the art and technology nexus there, does not rely upon the
specifics of the linkage established in the later essay, 'The question con-
cerning technology', namely, the identity and difference of *techne* and
poiesis, and the inversion trope of 'greatest danger/saving power'.

The central question posed by 'Origin', as well as by the Nietzsche
lectures on art, is whether we can engage with art in a manner that is not
aesthetical, in a manner that transcends the circumscription of art in
'pleasure' and outside cognition and ethics. Indeed, as we saw in the first
section of this chapter, Heidegger is committed to the thesis that aesthetic
perception exceeds itself towards 'what has proper worth in itself' (N,
109). In pointing to the Greek temple Heidegger is pointing to another
conception of art, and asking whether, however dominated and repressed,
art does not make an analogous claim now. It is in and through the
acknowledgement that such an extra-aesthetical claim is being made – that
art is not identical with itself in terms of its categorial inscription as
merely aesthetic – that it is thrown into critical juxtaposition with the
regnant (progressive) culture, the ruling economy of presence that reduces
creation to production, presencing to presence. Heidegger's argument
must go this way since the claim, say, that the Greek temple revealed a
world must remain idle for us now so long as nothing in our world
corresponds to it. While the Greek temple may still stand, 'the world of
the work that stands there has perished...World-withdrawal and world-
decay can never be undone' (OWA, 41). On its own, all the example of the
Greek temple reveals is that, once upon a time, art works were more than
aesthetic objects. Unless there is 'more' to Van Gogh's painting than what
an aesthetic regard can make of it, then there exists nothing to pose
against the claims of truth-only cognition and technological presencing.
How, then, does aesthetic perception exceed itself?

A nature poem by Hölderlin, the painting of a pair of peasant shoes by
Van Gogh: something in Heidegger's presentation and deployment of
these works claim, solicit us to a mode of revealing we cannot validate,
sustain or even in a sense fully understand. They lure us to another scene
of revealing, but one we cannot inhabit. There is a temptation to put this
thought in familiar terms: art works offer possibilities of understanding
phenomena that are not now realized; hence art is fictional because it deals
with imaginatively conceived possibilities. Although Heidegger's thesis at
first sounds like this, and in 'Origin' is intended to so sound, he is in fact
attempting to deny just such a thesis since its operative conception of
'mere possibility' depends upon making actuality (presence) prior to and
independent of what makes it (transcendentally) possible. It is just this
reduction of possibility that reduces 'aesthetic' cognition to taste.

What, then, are we to make of the claims of the Van Gogh and the

Hölderlin? Does the end of great art entail that these works have only 'object-being', being as objects for aesthetic consciousness; or, despite the passing away of great art, do they not possess some 'work-being' as well (OWA, 41)? Heidegger concedes to the Van Gogh that as a work it belongs 'uniquely within the realm that is opened up by itself' (OWA, 41). What is the meaning and being of such a realm which is neither an epochal world nor a realm of the imagination, a fantasy world? In *Truth and Method*, Gadamer too seeks to redeem art from the clutches of the aesthetic.[38] According to Gadamer, aesthetic consciousness feels itself free to accept or reject art works, and, at bottom, although we might challenge or dispute aesthetic judgements, their autonomy guarantees that neither reason (logic) nor moral consciousness can justifiably force us to alter such a judgement. However, aesthetic consciousness, our self-consciousness of ourselves as being free to accept or reject art works on the basis of aesthetic judgements, belies a more basic experience whereby, once seized by the claim of an art work, we no longer feel ourselves free to accept or reject the work on *our* own terms. Gadamer's point here could be that disinterestedness, say, exposes us to a work the experience of which transcends mere liking. In fact he regards the nature of the claim at issue as stronger. Following Heidegger he contends that art works from earlier times were not created for *aesthetic* acceptance or rejection. Our consciousness of art – aesthetic consciousness – is, Gadamer states, 'always secondary to the immediate truth claim that proceeds from the work of art' (PH, 5). Aesthetic judgements *alienate* us from this fundamental, cognitive engagement with art works. The experience of aesthetic alienation is the experience of the gap between an original truth claim by a work and an aesthetic response to that claim; it is the experience of the *gap* between solicitation and refusal, between the lure of the work and the uninhabitability of the space invoked. To experience that gap is to experience a work's excess to aesthetics. My claim is that an appropriate valuing of art as critical of dominant culture lies in the gap and in the experience of aesthetic alienation, an experience (of defused createdness) that reverberates in Heidegger's thinking.

Let us consider again Van Gogh's painting. It solicits and claims us, but how? In the first instance as revealing the 'truth' of some phenomena, that is, in the manner invoked by Heidegger's phenomenological recounting of the picture – a re-counting we shall question later. It is not important for Heidegger's analysis that his re-counting should work for us as an account of the Van Gogh; what is important is that we should be able to conceive of a painting or poem which claims us in accordance with the kinds of significances that Heidegger's account displays. There are two natural but naive critical responses to such an account. The first is epitomized by Meyer Schapiro's critique of Heidegger on Van Gogh; it treats the account as if it were a defence of one representation charac-

terization of the painting in opposition to other possible characterizations, and disputes Heidegger's interpretation accordingly.[39] However inadequate and inappropriate such a critique is, it does reveal how thoroughly representational and aesthetic considerations dominate our understanding of art, and how difficult it is to alter the terrain of aesthetic discourse. Schapiro's critique unintentionally reveals the art work's susceptibility before the sway of the centre, the hegemony of progressive culture over aesthetic culture.

Closer to the bone would be the criticism of Heidegger's account as a naive romanticizing of the peasant world where men, things and nature engaged one another, and *were* together, different to the way that men, instruments and nature engage and interact with one another now. Significantly, this same charge can be levelled against Heidegger's famous discussion of the hammer in *Being and Time* (section 15ff). In both cases a claim about the nature of equipment is offered that relocates the item from representational space – as an object before us to be viewed – to a circuit of praxis as its intrinsic place, a dwelling *place* as opposed to indifferent, geometrical *space*.[40] In both cases, it might be claimed, there is something archaizing about Heidegger's approach. Instead of providing access to a 'true' account of equipment (or space), in both cases Heidegger can be seen as referring us back to an earlier form of understanding and practice; to be, precisely, valorizing a representation of a past possibility; and hence to be proposing a past rural ideology as his critique of the present. Surely, hydroelectric dams or assembly line robots are not instruments in the same essentialist sense that Heidegger proclaims for the hammer and the peasant woman's shoes; the essence of equipment has changed since then. And if this is so, then the mere presentation of a past conception of equipment must remain critically vacuous, a stroll in a pleasant imaginary world. Part of the critical thrust of 'Origin' is to tease us away from both this conception of world and from its sanguine representation of things ('We believe we are at home in the immediate circle of beings. That which is, is familiar, reliable, ordinary. Nevertheless...' (OWA, 54).

Thus when Heidegger says he will offer his analysis of the nature of equipment without consideration as to whether that nature might be subject to alternation, *he is explicitly admitting the legitimacy of this criticism of both accounts*. His gesture of freeing the consideration of equipmentality from history is there for the sake of drawing an analogy with the procedures of *Being and Time*, and hence with the hammer example. His contrasting of the Greek temple that discloses a world with the painting that tells us only what the peasant woman already knows distinguishes the ahistorical, albeit temporally constituted, revealing of *Being and Time* from the epochal revealing of the history of being. Heidegger's self-critique of the metaphysical posturing of *Being and Time*, and his critique of any ahistorical, revelational theory of art, occurs by means of the displacement

that the account of the Van Gogh suffers as a result of its being contrasted with the Greek temple. For the Greek temple, for a Greek tragedy or medieval cathedral, perhaps for the *Divine Comedy*, it is intelligible to us that these works did give things their look and men their outlook – or might have done so, in a sense Heidegger never fully clarifies; but this is something that cannot plausibly be said for Van Gogh's painting. It belongs to the end of great art.

Why, then, does Heidegger invoke the painting in terms consanguineous with the cognitive regime of bringing to unconcealment? How does the Van Gogh exceed aesthetics (and hence how does *Being and Time* exceed metaphysics)? Because, although the cognitive claim itself of the modern art work is shown to be defective – the painting is no Greek temple – the claiming itself of the art work is not representational (of what is actual or possible), hence the work is not a production but still a *creation*, a *work*. It is its present and substantial createdness now which, as defused, invokes a past possibility of revealing that *is* the claim of the work upon us. In other words, what we are attempting to elicit is the nature of the claim that a modern art work makes upon us. How does it proclaim itself, authenticating its sway on our lives? One answer has been eliminated: through disclosing a world (past, present or future). But seen from afar, it does not seem wrong to say that the work enacts a world disclosure it cannot deliver; it lives in its (necessary) failure to attain its ownmost possibility of revealing; hence its createdness, that which makes it a work and not product, entwines earth and world as the constitutive elements that constitute the *being* of works. The sense of ideality, fictiveness, the imaginary that haunts art works, is not a function of their contents (peasant worlds, ideal futures, etc.) but of their 'form', of their being art *works*; it is past and future possibilities of art itself which is the source of the work's claim upon us. Their failure to reveal a world, or to reveal only what is already known, their lack of cognitive power, their exclusion from questions of truth, is hence the source of their power, their negative cognition.

It is a moot question whether Heidegger's way of analysing the Van Gogh will deliver us over to the kind of claiming here broached; after all, his reason for choosing the Van Gogh was to invoke an example that would allow him to repeat the hammer example, to allow him to guide us from the accomplishments and failures of *Being and Time* to the new vantage point of epochal history. Hence the modernity of the Van Gogh can only come into view in retrospect. Further, there is no denying an element of rural ideology haunting Heidegger's philosophical imagination. Nonetheless, the contrast between the Greek temple and the painting is pressed, and a vision of the end of great art presented. As such, what we learn is what the Van Gogh cannot do; but in urging a parallel with the Greek temple we are also being told that that failure is constitutive of the

painting's remaining power of revealing. Perhaps this is what is claimed when Heidegger states, with clear reference to Hölderlin, 'In a world's worlding is gathering that spaciousness out of which the protective grace of the gods is granted or withheld. Even this doom of the god remaining absent is a way in which the world worlds' (OWA, 45). How else could the *absence* of a god, the absence of an acknowledgement of the absential dimension of all presence, be revealed as a historical predicament than through a work's essential default upon its essential possibility as work? If it were not a work's default upon its essential possibilities that were revealed, then the work would be one of great art, and technology not the eschatological fulfilment of the history of being.

Modern art works, works of genius, thrive on their own essential impossibility, on their failure to be works of great art, to disclose a world; and they can do no other, for that is where art is. Hence through them we come to experience the sense of the periphery *as* a periphery, and thus the meaning of the sway of the centre. The art work solicits in remembrance and anticipation of a power, a potentiality of art. This potentiality, when treated as a present actuality – the presumptive truth-claim of the work – conceals the actual meaning of the work, its work of remembrance and anticipation. When this work is accomplished the present is brought to presence in its specificity: the impossibility of great art is the historical fate of art under the sway of technology. If Heidegger's scheme were in working order, he could then say: technological revealing reveals without letting what presences come forth into appearance; its refusal of *poiesis* is the consignment of art to the periphery and hence the alienation of art from its origin. It is a neat and elegant formulation, but false. The alienation of art from truth is more complex and quite other than what Heidegger announces. It is Derrida's achievement to demonstrate precisely how only as a fully modernist work can Van Gogh's painting accede to the role Heidegger needs it to have for his reflections to begin. But once given that status, once modernity receives its reflective comprehension through the works of artistic modernism, a deep transformation of the Heideggerian project occurs.

3

The Deconstructive Sublime:
Derrida's *The Truth in Painting*

i Art, History and Language

The riddle of art does not belong to the epochal history terminating in the utter oblivion of being termed *Gestell*. This history is not our history, the history alienating art from truth. But what if the question of history, the claiming that would lead to the construing of history in philosophical terms, were itself constitutive of metaphysics (as presence), were itself a function of what generates the alienation of art from truth? What if the very idea of a philosophy of history belongs to metaphysics because the questions 'Which history? Whose history?' are conditioned by concepts – say, the concepts of end or purpose on the one hand, and/or the concept of a (collective) subject on the other – that can only be interpreted metaphysically? Is the gesture of seeking such a history so collusive with the metaphysical domination of art that it could never achieve a space in which art could question truth, question history? If the Arendtian judgement, traced in the introduction, is correct that the philosophy of history enters as a suppression of judgement, then must not a judgement against it be particular? An event? An act? A work?

A question of the 'ownership' of history forms one of the central lines of argument in the 'Restitution' essay that concludes Derrida's *The Truth in Painting*. Derrida is interested in questioning the collusive connection of art and history, an interconnection that naively assimilates the art/nature duality to the history/nature duality, and assimilates both of these to the *physis/techne* (nature/production) distinction. This leads Derrida to suggest that 'if the philosophy of art always has the greatest difficulty

in dominating the history of art, a certain concept of the historicity of art, this is, paradoxically, because it too easily thinks of art as historical' (TP, 21). The reason for this situation is that the concept of history is transformed in its two usages: art's historicity is incompatible with the history of art of the sort that would efface itself in art's coming into possession of its essence as art. Derrida will argue that art's historicity is dependent on those moments that interrupt it, that is, on something like the nature of historicity implied by the above analyses of Kant and Heidegger.

But there is a further reason for turning to Derrida at this juncture. That reason lies at the intersection of one of the elements of Heidegger's procedure for reading the texts of the tradition, and a difficulty he concedes concerning the argument of 'Origin'. The history of being, which is the forgetting of being, is conditioned by and equivalent to the withdrawal of being, to being's self-displacement by the metaphysical terms that have dominated the history of philosophy: *idea*, *energeia*, *actualitas*, will. Epochal history is not the history of epochs dominated by the concepts of metaphysics, but the 'destiny of Being in whose sending and the It which sends forth hold back with their self-manifestation... Epoch does not mean here a span of time in occurrence, but rather the fundamental characteristics of sending, the actual holding-back of itself in favor of the discernibility of the gift, that is, of Being with regard to the grounding of beings.'[1] Since the words of being, which is what the terms of metaphysics are for Heidegger, are 'answers to a claim which speaks in the sending concealing itself',[2] then it follows that the texts of the tradition require a double reading. To repeat what was said earlier: first, a text must be read in a manner that reveals how the words of being organize the text toward presence and self-presence; then those same terms must be re-read as exceeding presence, as exceeding the reduction of presencing to presence, and hence as answering to the concealing of what gives presence. Texts' excess beyond presence is the 'unsaid' of those texts, the concealment or absence in the event of disclosure. Without a double reading – revealing how each formation of being, each way being is stamped (*Seinspragungen*) is, as seen from the *Ereignis*, a withdrawing of the sender in favour of what is sent – the texts in question could not be said to belong to the history of being. In other words, fundamental metaphysical concepts *are* withdrawals of being. Hence the necessity for double reading.

This procedure for reading, for double reading, is a (if not the) cornerstone of Derrida's practice of deconstructive reading. With a difference. Although Derridean practice also focuses on concepts in accordance with which texts organize and close in upon themselves, totalize themselves, and exceed that closure, reveal whatever can never be accommodated by metaphysics, and hence what conditions both its possibility (of meaning)

and impossibility (of being equal to itself, undivided); nevertheless, Derridean practice is not governed by the history of being, that is, by the idea of a destining. While Heidegger is clear in denying that destining is either contingent or necessary, brutely empirical or governed by an immanent teleology; he nonetheless claims that 'what is appropriate shows itself in the belonging together of the epochs. The epochs overlap each other in their sequence so that the original sending of Being as presence is more and more obscured in different ways.'[3] But this entails that the destining is the *representing*, in different and ever more obscure ways, of the original withdrawal of being. And hence that the logic of representation, which is the central carrier of the metaphysics of presence, governs the very destiny and destining that is to reveal its displacement.[4] And it is precisely this representational construal of the progressive occlusion of the withdrawal of being that entails Heidegger's exorbitant mourning, his inability to finish mourning the life and death, presence and absence, of being in the experience of ancient Greece.

This is not to deny that the object of deconstruction, most broadly and acutely construed, is the metaphysics of presence, but only that: (i) the otherness or alterity presence refuses and dominates is not being or presencing as such, and hence not either another word for being, or for what gives being; and (ii) the necessity of or for deconstruction cannot be an eschatological necessity, grounded in the thought of the technological epoch as representing the utter oblivion of being, that grounds Heideggerian double reading. Derrida's gain in distancing himself from destining is that he is free to engage with the heterogeneous determinations of the metaphysics of presence without committing himself to a thinking of what *essentially* governs and lies beyond epochal history; his loss is that the grounds for engaging in double reading have also disappeared.

This disappearance, perhaps, opens up onto another gain. It concerns the 'Addendum' to 'Origin' where Heidegger concedes that the relation of being and human being is not adequately thought through in the essay; and that this failure has something to do with his failure to conceive adequately of artist and work as equiprimordial, co-responsible; that in the setting-into-work of truth it remains 'undecided but decid*able* who does the setting or in what way it occurs' (OWA, 87). This decidability entails making one of the terms subject (active and productive) and the other, therefore, object (passive). Since subject/object dualism, which requires representation and sets it in place, is a central strand in the metaphysics of presence, its overcoming is possible only if a point of *un*decidability can be demonstrated to be constitutive for both presence and absence, the same and the other, identity and difference. But the Derridean terms that come to displace Heidegger's words for being, words again which function as guarantors of presence and simultaneously mark

a withdrawal or withholding of being, are precisely undecidable in this sense. These terms – hymen, *pharmakon*, *supplement*, *differance*, etc. – are what, locally and textually, constitute the possibility of the ideal and desire for presence in a text, and hence the impossibility of its realization.[5] They become plausible displacements of and substitutes for words for being if we regard the Derridean word 'text' as a translation (and displacement) for the Heideggerian word 'being'; a translation and displacement required, on the one hand, by Derrida's critical refusal of the destining that grounds explicitly Heideggerian double reading; and, on the other hand, by Derrida's taking seriously and literally Heidegger's focus on language as the unique repository for thinking being. Although intended for other purposes, the following passage from Maurice Blanchot elegantly states how the reforming of the Heideggerian conception of language is to be thought. What Blanchot designates as Mallarmé's conception of language, as opposed to Heidegger's, seems to me to fit Derrida exactly.

> One could indicate that the attention borne to language by Heidegger, and which is of an extremely pressing character, is an attention to words considered on their own, concentrated in themselves, to such words held to be fundamental and tormented up to the point where, in the history of their formation, can be heard the history of being, – but never to the relations of words, and still less to the anterior space presupposed by these relations and whose originary movement alone makes possible language as deployment. For Mallarmé, language is not made of words, even pure words: it is that in which words have always already disappeared and this oscillating movement of appearing and disappearing.[6]

What torments the language of metaphysics is not secreted in semantic history; consequently, what torments metaphysics can no longer be a unitary phenomenon.

The next two sections of this chapter will seek to analyse Derrida's reading of 'Origin'. What that reading demonstrates is how art exceeds metaphysics and makes it possible not generally or universally but textually, specifically: it is Van Gogh's painting of the shoes that does this work in Heidegger's essay. Hence, Derrida realizes, presents and demonstrates, the meaning of art as the art of genius, previously only asserted by Kant and Heidegger. Moreover, Derrida's analysis demonstrates why that characterization of art has come to be realized only with the arrival of artistic modernism, even if it has belonged to art throughout its history. This epistemic privileging of artistic modernism – which is what lies behind Derrida's 'interest' in Mallarmé, Valéry, Artaud, Joyce, Sollers, Jabès and Van Gogh as opposed to, above all, Hölderlin – is equally an embarrassment to Derrida since it assumes a philosophy of history, a

revealing of the meaning of the past through the achievements of the present. All Derrida can do with this embarrassing fact is to distract the reader from its presence. It nonetheless remains to haunt his analyses. That haunting is the focus of the remainder of the chapter, where Derrida's reading of Kant is interrogated. At issue in that interrogation is not only the question of a suppressed history but the question of what has been suppressed in that history. Deconstruction, I will argue, is itself modernist, interruptive; the aesthetic figure of interruption is the sublime. The provocation of my reading of Derrida will be the claim that deconstruction is the production/discovery of the textual sublime.

On the trail of this provocation some obvious questions arise. Is the modernist sublime simply the (aesthetic) figure of what resists presence, phenomenolization, the figure of figurality, or does it refer to a more emphatic alterity? If the latter is not the case, how are we to understand why the interruption of the tradition matters? Is understanding to be displaced before an ethical act, an act exhausted in its interruption of totality, so that deconstruction would become an ethical witness to the devastations of metaphysics, a face frozen in dumb horror? And even if this were to be the case, would that horror and silence be comprehensible? Emerging here for another time is the way in which the aesthetic figures the categorial duality between knowing and right action, truth and goodness.

ii Painting without Truth

At its commencement the logic of 'Restitutions of the truth in pointing (*pointure*)' appears straightforward enough. Derrida's reading of 'Origin' is occasioned by an essay of Meyer Schapiro's, 'The still life as a personal object', which contends that Heidegger's attribution of Van Gogh's picture of the old shoes with laces to a peasant woman is false; the shoes are not those of a peasant but of a city dweller, indeed they are Van Gogh's own shoes at the time he was living in Paris. Whose shoes are they? A peasant woman's or the city dweller Van Gogh's? This question very quickly broadens out into the question 'Whose history?' Schapiro dedicates his essay to the memory of his friend Kurt Goldstein, who had first called his attention to Heidegger's essay. Goldstein fled Nazi Germany in 1933, having been released from prison on condition that he leave the country. He arrived in New York in 1936, after a one year stay in Amsterdam, to teach at Columbia University, where Schapiro was already teaching. Derrida regards the dedication of Schapiro's essay a matter far from extrinsic to it or to the debate with Heidegger over the ownership of the shoes:

> And who is going to believe that this episode is merely a theoretical or philosophical dispute for the interpretation of a work or the

Work of art?...In order to restitute them, Schapiro bitterly disputes possession of the shoes with Heidegger...who is seen then, all in all, to have tried to put them on his own feet, by peasant-proxy, to put them *back* onto his man-of-the-soil feet, with the pathos of the 'call of the earth', of the *Feldweg* or the *Holzwege* which, in 1935-36, was not foreign to what drove Goldstein to undertake his long march toward New York...There is much to discharge, to return, to restitute, if not to expiate in all this. (TP, 272–3)

For Schapiro at least, but maybe not for him alone, there is a matter of history and politics here. Does the painting 'belong' with or to 'the common discourse of the common enemy' (TP, 273), or does it belong with or to the victims, the nomads, émigrés, the city dwellers, the discourse that resists, or stands for what resists, Nazi Germany? Whose history? How does Van Gogh's painting fit into the revolutionary, aestheticized politics of 'Origin'? Would a different reading of the painting undermine its political trajectory?

'I owe you the truth in painting and I will tell it to you,' says Cézanne in a letter to Emile Bernard. To owe the truth is to acknowledge a debt, to place oneself under an obligation. To whom is the debt owed, and how does one pay it? How is truth conditioned by an anterior debt? What is the debt that it can be returned 'in truth'? In painting? Above all, we must now say, in a painting of a pair of out-of-work, out-of-service, untied shoes; shoes doubly without use: untied and painted. The use of the shoes, the cognitive employment of them, depends on their being out of use (TP, 283), their uselessness immediately and immanently reflecting the painting's Kantian 'fineness', its being purposive without purpose: 'It's a question of knowing what revenue is still produced by their out-of-service dereliction, what surplus value is unleashed by the annulment of their use value: *outside* the picture, inside the *picture*, and third, as a picture, or to put it very equivocally, *in their painting truth*'. This surplus value, Derrida goes on to suggest, is bound, or appears to be bound, to who the shoes fit, as if 'it's a question of what ghost's step, city dweller or peasant, still comes to haunt them...[or] a question of knowing whether the shoes in question are haunted by some ghost or are ghosting/returning (*la revenance*) itself' (TP, 258–9). Heidegger and Schapiro both seek to halt the painting's 'without purpose'; Derrida will seek to restitute, recover and confirm the painting's 'fineness', to make his judgement of it properly aesthetical.

The ghosting, the ghost-effect of the untied shoes, matters since both Heidegger and Schapiro, albeit differently, find the shoe's detachment intolerable (TP, 283); and hence for both, although differently, finding the subject, the I, that fills the shoes is connected with the truth of the painting and hence the truth of painting. Returning the shoes to the subject

then connects with the truth of painting and, for Heidegger, the truth of truth.

Derrida lights upon Schapiro's essay not because he believes that its criticism of Heidegger is correct (although it is not false either; the ownership of the shoes will remain indeterminate); on the contrary, the very character of Schapiro's critique operates within the framework of truth-as-representation (TP, 312–14) that Heidegger is in the midst of (radically) putting into question when the example of the shoes is introduced. And at a certain level that makes Schapiro's criticism naively inappropriate. At a certain level, and hence not altogether so; for Heidegger's attribution of the shoes to the peasant woman is itself pre-critical, falling below the level of the critique in 'Origin' of representation, expression, reproduction, and above all the place of the subject, the *subjectum*. After all, Heidegger's attribution of the shoes to the peasant woman in part licenses Heidegger's ideologically loaded description of the shoes, with its embarrassing, heavily coded, 'poetics of the soil' (TP, 345; see also 262, 292), the earth, ground. Derrida sights in this language of soil, earth, ground a still active desire for restitution operative in Heidegger despite, and in the midst of, his critique of the subject.

The subject, *subjectum*, as a fundamental definition of being in general, is a translation/transformation of *hypokeimenon*; but this Latin translation of the Greek word occurs, according to Heidegger, like other such translations, 'without a corresponding, equally authentic experience of what they [the Greek words] say'; and this lack of experience inaugurates the rootlessness, 'the absence-of-ground (*Bodenlosigkeit*)' of Western thought. Hence, even if Heidegger's discourse is not bound to the Cartesian subject, and hence to filling the shoes with a subject as the determinant of the truth of (the) painting, nonetheless a logic of restitution and return informs his argument; the out-of-service shoes need to be returned to their owner (subject) just as the out-of-service, rootless language of Western thought needs to be returned, restituted. The desire for restitution, to return to the subject and the 'ground' experience preceding all subjectivity, reveals a desire for a certain presence.

Derrida connects this (ground) desire for a return to the ground with Heidegger's tracing of the essence of the usefulness of the shoes as conditioned by an anterior reliability (*Verlässlichkeit*), a reliability that is anterior to and a condition of not just the usefulness of any product, but equally (and as a consequence) anterior to and a condition of the elaborate metaphysical/conceptual system of form and matter. The reliability of products stems from or engages with their fundamental belonging to earth and world, a belonging that forms a preoriginal contract that is the 'ultimate condition of the concrete possibility of any *reattachment*' (TP, 353). Reliability marks an original belonging or attachment which conditions and makes possible all other (later?) detachments and returns. Heidegger

laces up the shoes, restitutes them, preoriginarily, even, perhaps, meta-physically: 'This essential and 'full' reliability makes possible – restitutes – not only the most 'critical', the 'profoundest' going-back behind the philosophemes of matter–form, of usefulness, of production, of subjec-tivity, of objectivity, of symbol and law, etc., but also the most naively archaic regression into the element of ingenuous truth...' (TP, 354–5).[7] In highlighting the metaphysical desire for presence in Heidegger, Derrida is obliquely putting us in mind of that other preoriginary logic of belonging in Heidegger, namely, that of *Ereignis*, the event of appropriation prior to both being and time in the late Heidegger. Elsewhere, Derrida contends that Heidegger can make Nietzsche's concept of will 'belong' to the his-tory of metaphysics only by capturing it ahead of time, by reducing history to the event of Appropriation (*Ereignis*). This capturing, Derrida avers, occurs because there is in Heidegger a valuation of the proper, running from authenticity (*Eigenlichkeit*) through appropriation (*Ereignis*), that is never interrupted.[8] The preoriginary tying of the shoes, their fundamental belonging to earth and world, adumbrates the later belonging that ties Nietzsche's 'will' to the history of metaphysics, and ties history up as belonging to being. So understood, history stops being about what occurs in it.

'Restitutions' is a polylogue for n + 1 female voices. In a footnote Derrida quotes an editorial note that accompanied the original publication of (part of) the essay in which it is stated that the essay is a fiction Derrida had narrated at Columbia University in the presence of Meyer Schapiro, amongst others (TP, 272). The 'form' of the essay, its (fictive) fictionality, is lodged against the discourse of belonging (especially a discourse as belonging to a subject). The polylogue cannot return to Derrida, as transcendental subject, author/authority, any more than Van Gogh's painting, despite Schapiro's efforts, as we shall see, can be returned to him. One of the goals of 'Restitutions' is to demonstrate, as was done in 'The purveyor of truth' concerning the missing letter,[9] that a necessary condition of the possibility of restitution and return is the possibility of the letter (shoe, truth, destining) not reaching its destination. This thought is an analogue of Heidegger's making untruth a constitutive compon-ent of truth. Indeed, Derrida's point is the same as Heidegger's, only now extended so as to include, more overtly than does Heidegger, commu-nicative meaning. The possibility of meaning failing to be communicated cannot be understood aright if failure is always external, mechanical, causal or by-the-way. If this were presupposed then the inner connection between indeterminacy, underdetermination and possibility (in its onto-logical as well as logical sense) would all have to be surrendered; and with them, perhaps freedom as well. If this is so, then the possibility of non-arrival (of meaning, truth, etc.) belongs to the (syntactical) structure of possibilities governing arrival such that 'it never truly arrives there,

[and]...when it does arrive, its possibility-of-not-arriving torments it with an internal drift' (TP, 364; one of the voices in fact quoting Derrida's 'Purveyor'). This 'internal drift' is Derrida's way of marking the fact that a certain (sense of) contingency, a certain (sense of the) possibility of failure must (logically) accompany all cognitive and communicative success. The finitude of human cognitive and linguistic activity must cling (constitutively) above all to those places where it seems to have been overcome.

One of the recurrent motifs aiding this demonstration is the female voice's reiterated question of what makes any of the protagonists (including the other voices) so sure that the shoes form a pair, just as male and female form a (metaphysical) pair, since the presumption of the shoes being a pair restricts the economy of questioning that generates the shoes' ghosting effect, that allows the question of ownership to be a question as such (TP, 282, 374). The logic of non-arrival applies with equal force to the shoes being a pair: 'No more than a letter, a pair is not indivisible' (TP, 364). Acknowledgement of the internal drift that would make even a pair of shoes not a pair (under the condition, for example, that each of a pair, left and right, are drawn from a different pair – in which case it would be difficult for the question of whether this were 'truly' a pair to get a footing, which is Derrida's point) breaks, or better, conditions the truth contract between Heidegger and Schapiro, making it secondary, an effect. The pair/non-pair doublet provides here, we might say, the indeterminate condition for determinate claims about the shoes and who might fill them.

An argument of this sort is visible in 'Restitutions'; but what has been said so far fails to amount to the detection of a structure of double reading organizing Derrida's text. Let me pursue a hypothesis. It begins with the fact that in our treatment of Heidegger we said of the Van Gogh that it represented a work of art drawn from the end of art, from the time of the closure and gathering of the history of being, from modernity. Implicitly that meant for us, although not for Heidegger, that Van Gogh's painting belongs to the practice of artistic modernism. Nothing we said there about the painting, however, gave support to that presumption; the evidence for it was drawn from epochal history and not the history of art: the art of the epoch of technology belongs to the end of great art. In his essay, we want to claim, Derrida is attempting to restitute Van Gogh's work to artistic modernism, to *painting*, where painting is conceived of as a practice adjacent to and constitutive of the possibility of the truth discourse that occurs on and around it without ever being in or captured by it. Painting, or rather 'painting', is anterior to, conditioning and limiting, the discourse about truth and painting (as metaphysically constituted), the desire for restitution, without being reducible to this discourse. 'Painting' is the (excessive) gift that produces the desire for restitution, but to which no restitution is possible. Our debt is to 'painting', and not to the preoriginary reliability of earth and world, the preoriginary 'contract'

between products and earth and world proposed by Heidegger. Van Gogh's painting of the shoes forms the place in 'Origin' that both allows its discourse of truth, grounding and return, to occur, and is the 'other' forever exceeding its place and role there. The painting 'frames' Heidegger's essay in a language that will become more perspicuous later: it is inside and outside it, opening the essay to its possibility while dividing it from itself. Van Gogh's painting of the shoes, which is an illustration never quite either necessary or redundant within the economy of Heidegger's argument, is the frame and supplement of it. An indication and an analogy will help this suggestion.

The indication comes from the preface, 'Passe-Partout', to *The Truth in Painting*. There Derrida discusses four senses of the expression 'the truth in painting' relevant to his work. In the first two painting figures as a model for the presentation or representation of truth; truth being the subject matter in these cases and painting ancillary, a way of getting at truth. The third sense of the expression asks after what pertains to picturality proper; what is truth as it occurs in painting as opposed to any of the other places where truth happens? 'Truth in painting' would here mean truth as presented or represented in the pictural 'properly speaking, even if this mode is tropological with respect to truth itself' (TP, 6). Derrida's 'even if' raises a question we shall need to come back to; if truth in painting is tropological with respect to truth itself – is merely metaphorical truth, as is sometimes said – how does this relate to truth in itself? What is truth in itself that it can possess 'merely' metaphorical modes that are not it? Does the metaphorical, tropological sense of truth in painting divide truth (from itself)? Or is the proper of truth such that it makes painting tropological in its truth effects?

These questions and concerns take root in the fourth sense of the expression. 'Truth in painting' might be taken to mean, by means of a doubling or 'parasitizing' of the expression 'in painting', truth *on* the art which is pictural, the truth of the truth (in the third sense of the expression). This sense of the expression insinuates a removal of the gap separating truth as is proper to painting, even if it is tropological, and truth in discourse, language (TP, 7).

What are we now to make of the promise to deliver the 'truth in painting' if the promise is offered by a painter, if the promised restitution is to occur in painting? What now happens to truth when the parasitism between systems is to inhabit just one, painting? Is the truth in painting 'in painting' to be anterior to the difference between truth within and without painting? This anteriority is required because a painting about the truth in painting, a painting about painting, that *is* an allegory of truth in painting, is *first* painting – before, that is, it is or can be an allegory:

> Thus one dreams of a painting without truth, which without debt
> and running the risk of no longer saying anything to anyone, would

still not give up painting. And this 'without', for example in the phrase 'without debt' or 'without truth', forms one of the light-weight imports of this book. (TP, 9).

This dream may be acknowledged as one of the recurrent dreams of modernist art – so Flaubert dreamed of writing a book about nothing, without reference outside itself, without a subject, where the subject would be nearly invisible – the dream of an art that can resist interpretation, resist being reduced to a meaning independent of the work, resist being reduced to its source in history or subjectivity. This is Kant's dream of an exemplary work, a dream that Derrida will attempt to offer back to Van Gogh's painting of the untied shoes, the shoes 'without' use, and also, therefore, without truth.

Let us say, as a way of furthering this suggestion, that the dream of painting without truth coheres with, reverberates with, Derrida's claim in the 'Double Session' that 'there is no – or hardly any, ever so little – literature.'[10] This would be so if literature, like painting, had been subject in both its conceptualization (by philosophy) and its practice, since Plato and Aristotle, to an interpretation of mimesis that proclaimed the priority of the object of imitation over the act rendering that object. The practice, be it of literature or painting, whatever its specific character, was to be cognitively effaced, was the effacing of itself before the object. To the degree to which painting and literature acceded to mimetologism, subjugated themselves to the claims of philosophy and theology, there was no painting or literature: they existed, or feigned to exist, only in self-effacement.

Derrida sees in the writing practices of literary modernism, most acutely in the writings of Mallarmé, the subversion of logocentrism by texts that appear 'to mark and to organize a structure of resistance to the philosophical conceptuality that allegedly dominated or comprehended them'.[11] Literary structures of resistance should not be interpreted, however, in terms of textual practices that presume to capture and exhibit the specifically literary character of works of literature. Formalist practices of writing that attempt to install and sustain the 'literariness' of the literary text, through, say, devices designed to reveal a work's fictiveness and the devices by which this is accomplished, reduce literature to its presumptive 'essence' or 'truth', so once again effacing it. Literarity, and by extension the essentially 'painterly', would form but the obverse side of mimetologism: 'Mimetologism and literarity are the birth and death of literature through philosophy.'[12]

In order to be able to put philosophy, the desires and ambitions of metaphysics, into question, literature must refuse what would define it, capture and shelter it, externally or internally. In speaking of Soller's *Numbers*, Derrida specifies this refusal in terms of a 'generalized putting-

in-quotation-marks of literature, of the so-called literary text: a simulacrum through which literature puts itself simultaneously at stake and on stage'.[13] Rodolphe Gasché has put Derrida's thought this way:

> ...it is by suspending its *being* as literature that literature becomes capable of challenging philosophy's dominant categorization. Literature puts itself between quotation marks *by opening itself to the absolute loss of its meaning*, whether of content or of form...by disclaiming any formal essence as concerns its substance of expression...'Literature' thus acquires a subversive function...not by restoring its specificity at any cost but, precisely, by recognizing that it can effect such a subversion only by hardly being literature. 'Literature' [is] almost no literature.[14]

One might feel here that there is an essential disequilibrium between literature's (or painting's) exposure of itself to the absolute loss of meaning, which exposure reiterates in a different vocabulary the risk Kant demanded of the work of genius, and the almost precious characterization of that exposure as a 'putting-into-quotation-marks'. And this disequilibrium might have its source in the benignly purist way Derrida specifies the question of the relation between philosophy and literature, namely, precisely as an interrogation of mimetologism and essentialism, and hence of the metaphysics of presence in general. Hence while Derrida concedes that it is, for the most part, with 'modern' texts that the 'law of the previous figures' is best comprehended, he does so in a manner that halts or brackets this sense of the 'modern', that is, modernism, as having any fundamental connection with its historical enclosure, modernity.[15] And this would accord with his retraction of historical forms following on from his distancing of himself from the eschatological dimensions of Heidegger's thought. Nonetheless, it is interesting to note that Gasché, in commenting on this moment in Derrida, feels constrained to specify it otherwise: 'Only on the basis of marginality, which modernity represents with regard to the entire tradition, has modernity, as that which breaches that tradition from within, been able to become manifest in the first place.'[16] We will return to this thought of modernity in the Adorno chapters below. Nonetheless, Gasché's mention of 'marginality' should be stressed since the margin, like the spaces between words in Mallarmé's account of language, which is also Derrida's, or the position of the Van Gogh in 'Origin', recall us to the fact that the margin, as opposed to the centre and what centres, is the site of deconstructive reading. Gasché's suggestion is that modernity is at the margin of the metaphysical tradition, its disintegrated *telos*, and modernism is at the margin of modernity. Only in modernism's marginal doubling of modernity, a doubling conditioned by modernity, is the marginality of modernity itself revealed. Derrida

cannot just disavow the philosophy of history if deconstruction is so historically determined in its possibility, if deconstruction is a form of philosophical modernism – philosophy without truth.

At first glance Van Gogh's painting of the shoes seems an unlikely candidate for interrogating philosophy and the philosophemes inhabiting art criticism; it does not appear to risk the loss of meaning, the loss of representational sense, needed to put its own status as painting into question. It is, after all, a painting *of* some shoes. The labour of 'Restitutions' is to restitute Van Gogh for 'painting', even if the painting of the shoes does not specifically, self-consciously, enjoin that for itself.

iii There is Painting

Derrida's argument has three stages. First, the demonstration of the marginality of the picture of the shoes in Heidegger's presentation, its status as a mere 'illustration'. Along with this goes an accounting of the marginality of the marginal, that is, a specification of Heidegger's argument as an attempt to solicit a non-metaphysical comprehension of what is useful, a purposeful product, with an illustration that is doubly useless: a painting, which is a non-utilitarian product, of unworn, out-of-service, untied shoes. Secondly, Derrida attempts to show how it is *in virtue of* the double or even triple marginality of the painting that Heidegger can accede to full or even speculative usefulness, revealing the truth of truth as revealing/concealing, *aletheia*. This stage of the argument, running through the discussion of reliability (*Verlässlichkeit*), does show the precipitousness of Heidegger's designation of the shoes as being a pair of peasant shoes. This precipitousness marks the extent of the validity of Schapiro's criticism. Finally, Derrida will reveal the excess of the painting to the systems of metaphysics – Schapiro's traditional system of subjectivity and representing, and Heidegger's almost non-metaphysical metaphysics of *Ereignis* – while simultaneously reinscribing both painting and systems of thought within the logic of parasitism and trait broached 'the broaching of the origin: that which opens, with a trace, without initiating anything': (TP, 11) in his preface in the fourth sense of the expression 'the truth in painting'.

We can understand better the sense in which Derrida wants and needs to reveal Van Gogh's painting as risking meaning, risking the loss of meaning, if we compare the structure of argument just descibed to his analysis of the master/slave dialectic in 'From restricted to general economy: an Hegelianism without reserve'.[17] Nor is such a comparison an idle search for structural homologies; the language of economics, of surplus value and speculation running through 'Restitutions' draws on this earlier analysis; and much of the point of Derrida's argument is to show how

Heidegger is employing a traditional Hegelian dialectical *Aufhebung* in his use of the Van Gogh. The painting in 'Origin' has the same place in its argument that death does in Hegel's dialectic (and that death does in *Being and Time*).[18]

The internal relation of master and slave, lord and serf, occurs in Hegel's account as a result of a battle for recognition between two presumed self-consciousnesses. The battle occurs as a way of each combatant demonstrating that for it life is not the highest good, that as a self-conscious being it transcends biological existence. Recognition of ourselves as self-conscious beings occurs in the first instance when we risk our biological life in the face of another self-conscious being, another being who can demonstrate independence from the drive for self-preservation and dependence on merely sensible goods.

The direct consequence of the battle is the recognition that natural death would be a cancelling of all meaning, natural and non-natural; and therefore, natural life is a necessary condition of self-consciousness. Further, each combatant comes implicitly or explicitly to recognize that self-consciousness can only be secured in an intersubjective world of mutual recognitions. Hegel denominates this new world of inter-subjectivity 'spirit' (*Geist*); it is a world of social forms and practices within which self-consciousness acts out its (spiritual) life. Biological life is hence superseded by spiritual life; the latter is the truth of the former, its realization and completion. Death, natural death, is hence cancelled and preserved; it comes to signify abstract negativity; it comes to function as a moment in the dialectic where self-consciousness is first formed and learns the terrain in which its destiny is to be decided. Derrida, following Bataille, charges Hegel with covering over the real excessiveness, the absolute, unrecoverable negativity of death on the presumption of the self-evidence of meaning. This presumption entails that nothing must be definitely lost in death, and further reduces death to the notion of 'abstract negativity'. This submission even of death to the rule of meaning is the heart of Hegelian ontology and dialectics. If, however, nothing is ever definitely lost, then there can never be significant risk or sacrifice, 'sacrifice without return'.

> The notion of *Aufhebung*...is laughable in that it signifies the busying of discourse losing its breath as it reappropriates all negativity for itself, as it works the 'putting at stake' into an investment, as it amortizes absolute expenditure; and as it gives meaning to death, thereby simultaneously blinding itself to the baselessness of the non-meaning from which the basis of meaning is drawn, and in which this basis of meaning is exhausted.[19]

Derrida identifies the moment of death, destruction and sacrifice, all that is risked in the risk of life, as the blind spot, the moment of excess around

which the representation of meaning is organized but which cannot itself be truly included in the system.

Van Gogh's risk of meaning (= the risk of life), risking the utter loss of representational meaning, turns on the shoes being out-of-service, serving no end, unworn and unlaced. And it will be through the shoes' suspension of utilitarian purpose (meaning) that Heidegger will be able to reveal, to speculate, a more fundamental meaning and experience, nearly the very one that would restore to language its grounding from out of the root-lessness consequent upon the translation of Greek words into Latin. The shoes 'being-unlaced' appears to 'suspend all experience of the ground, since such experience presupposes walking, standing upright, and that a 'subject' should be in full possession of his/her/its feet!' (TP, 288).

When Heidegger introduces the painting he does so in the context of a questioning of the form/matter distinction in terms of three-fold schema of (mere) thing, (useful) product, and (art) work. The schema, which has a certain privileged status within the tradition, is illusory in its orderli-ness: as if one could get to thinghood (bare, naked things) by stripping purposefulness from the product; or get to works by adding to the product the self-sufficiency, the residing in-itselfness, the dense propriety (TP, 298), of the thing (purposefulness (product) without purpose (thing = product without purpose)).

The form/matter distinction gives useful products a centrality which carries over badly when things and works are introduced. Hence Heidegger's desire to interrogate useful products, to find a way of comprehending them without reliance on the form/matter distinction. In doing so he offers, strictly for the purposes of illustration, 'to facilitate the visual (intuitive) realization' (OWA, 33), and 'by way of accessory aid' (omitted from the translations; TP, 309), a painting of the shoes he wants to (phenomenologically?) describe, a painting, a work, that as work is not at first at issue in the discussion.

The usefulness of the 'accessory aid' is itself , albeit only rhetorically, put into question by Heidegger: 'As long as we only imagine a pair of shoes in general, or simply look at the empty, unused shoes as they merely stand there in the picture, we shall never discover what the equipmental being of the equipment in truth is. From Van Gogh's picture we cannot even tell where these shoes stand' (OWA, 33). The picture does not overtly represent a world, a context of interlocking utilities, and is thus useless for the comprehension of use. It is Heidegger, then, who pretends to have marginalized the picture for the purposes of the argument, and who regards the shoes as devoid of purpose, without ground and out-of-use. 'This uselessness of the useless when it comes to thinking about the useful, this-already-double uselessness only stems for the moment from the being-detached of the shoes, from their being abandoned, unlaced. Heidegger does not speak directly of the exhibiting of the half-loosened

laces, but that's what matters here' (TP, 339–40). The strange motif of the laces, themselves a marginal element of Van Gogh's painting, that forms the governing leitmotif (the guiding thread, the orientation, imaginative projection or schema) of Derrida's essay, their tying and loosening figuring a structure of writing, is revealed as the (dangling) frame of Heidegger's argument. Unlaced, out-of-use, without purpose (like the painting they are in), they yet adumbrate the possibility of meaning, of being tied and knotted, without ever necessitating, requiring, demanding or determining it.

The voice of the polylogue that states Heidegger's dependence on the laces, goes on to suggest that what is at work here is the logic of the cut (to be discussed below). Another voice interrupts, demurring:

> The loosening of the laces is not absolute, it does not absolve, unbind, cut. It keeps an organized stricture. Not a more or less of stricture but a determined (structured) form of stricture...The logic of detachment as cut leads to opposition, it is a logic or even a dialectic of opposition...The logic of detachment as stricture is *entirely other*. Deferring, it never sutures. Here it permits us to take account of this fact: that these shoes are neither attached nor detached, neither full nor empty. A double bind is here as though suspended and imposed simultaneously...Any stricture is *simultaneously* stricturation and destricturation. (TP, 340).

The laces, then, *risk* meaning; but in making meaning a matter of risk, they introduce the possibility of the utter loss of meaning; and for Derrida this determines a structure/stricture of indeterminacy, of play, between univocality and equivocality, meaning and the dispersion of meaning, which never gets tied up, one way or the other. On this account, then, the laces play the role in Derrida's thought that we earlier saw reflective judgement had in Kant; providing the indeterminate grounds for determinate thinking, a grounding that cuts determinacy from its goal, deferring it. But in so doing, at the same time, it provides a form of what might be called groundless grounding, or even 'groundless legitimation'.[20]

Heidegger's tact is, at least here (which is to agree that this is not so everywhere), to leave behind, speculate away the moment of risk. And we might well have had a premonition of this in the way that Heidegger continues the passage quoted above concerning the uselessness of the painting. After having just said that from the painting we cannot even tell where the shoes stand, he peremptorily identifies them: 'A pair of peasant shoes and nothing more' (OWA, 33). The 'nothing more' rehearses a risk that has already been withdrawn. We know this withdrawal of risk has occurred, for then follows Heidegger's speculative 'And yet –', followed by the incriminating passage. However, the passage itself does not end the

matter or show the precise character of Heidegger's feint. And this for the evident reason that the description and the revealing of the equipmental character of equipment in reliability is made without direct reference to the picture – reference being, for Heidegger, itself posterior to the grounding that will occur. More precisely, Heidegger queries whether the picture does reveal all the description of it claims to reveal; better, he questions whether what is revealed in the picture *corresponds* to 'shoes': 'But *perhaps* it is only in the picture we notice all this about the shoes' (OWA, 34). The acuteness of this gesture on Heidegger's part, the suspension consequent upon 'perhaps', is that it breaks with the logic of correspondence, pressing thought back into the picture itself. And this going back into the picture, this cutting off of its representational sense, parallels the move back to ultimate grounds that Heidegger is after: 'Nevertheless, in its genuinely equipmental being, equipment stems from a more distant source [more distant, we might say, than the distance between representation and object]. Matter and form and their distinction have a deeper origin' (OWA, 35). By cutting the picture off from the outside – a gesture licensed by our aesthetic conception of art works as self-authenticating, as articulating fictive possible worlds that can be entered into by accepting works' own terms of reference – Heidegger opens up the possibility of a more distant 'outside' the painting, an outside that is no object at all. The suspension of reference hence opens onto a space forever prior to reference. 'The equipmental quality of equipment was discovered. But how?…only by bringing ourselves before Van Gogh's painting. *The painting spoke.* In the vicinity of the work *we were suddenly somewhere else than we usually tend to be*' (OWA, 35; my italics). Again, Heidegger plays off the aesthetic displacement of the everyday, as recorded in locutions such as 'entering into (the world of) the painting or novel', for purposes that put into question the assumptions of aesthetic and representational 'entering in', the very entering that Kant attempts to secure through disinterestedness and formality.

Nothing in Heidegger's arguments here, as recorded by Derrida, puts into question the curiosities we noted earlier: that the painting reveals what the peasant woman already knows, what she is 'privy' (OWA, 34) to in just wearing the shoes (or is it only in the moment she slips them from her feet?); that the accounting is done irrespective of the historical permutations and alterations that befall products, and that therefore what is revealed here, as opposed to by the temple, is not an historical world, but, more originarily as it were, 'the silent call of the earth' (*überhaupt?*), and that in virtue of which the woman can be 'sure of her world' (OWA, 34). Let us put the problem this way: although Heidegger notes that world and earth exist for the peasant woman *and* 'for those who are with her in her mode of being' (OWA, 34), the painting could not be regarded as the

gathering revealing of that *world* as it is in Van Gogh unless it were counterpointed to the world of the city dweller, unless the marginality, the approaching suppression of that world, were also noted in and from the painting. Derrida's choice of Schapiro's essay would then fall into place, for it would provide the counterpointing absent from Heidegger's analysis, thereby giving back to the painting a historical specificity. This, however, is not what Derrida actually does. On the contrary, his strategic goal is to offer to the painting a place or space that falls outside any normative accounting, and hence outside any attempt to identify the risk that painting takes by identifying its recollecting and interrupting of any specific history. Were Derrida to do that, he would become just another party to the debate between Heidegger and Schapiro.

If Heidegger flirts with the loss of meaning in order to make the tying and reattaching of the shoes all the more firm, then Derrida must find a way of inscribing the double uselessness of shoes and painting that does not lead on to sublation, overcoming, *Aufhebung*; a speculative loss of meaning for the surplus values of originary meaning. How do the uselessness of shoes and painting relate to each other, connect? One of the voices begins to suggest a way: the two detachments should not be regarded as a pair, pairing being a quickly to be surpassed preliminary to full restitution. Rather, the detachment of the one 'marks, re-marks or overmarks that of the other...the shoes with their laces (a little) undone give painting to be remarked' (TP, 342). The logic of the mark or re-mark is one of Derrida's quasi-concepts for the movement whereby transcendental constitution is suggested and withdrawn simultaneously. The relation of mark and re-mark directly parallels the first two moments of transcendental synthesis: apprehension in intuition and reproduction in imagination. As in Kant, so here: what is second (remark, reproduction) is presupposed by what comes first (mark, apprehension); hence the immediacy of the first moment becomes endlessly delayed and deferred.

Re-marking marks the place where a condition of possibility is opened without universality or generality, and hence without transparency. It marks a place of either groundless legitimation or non-legitimating grounding: a groundless ground, a ground that makes possible without securing or determining in the manner of a transcendental ground or origin. A mark, such as the painting, is re-marked by the shoes, which allows the first mark to be the repeatable sign of some signified; only in being re-marked is the first mark first (a mark) − here the mark of (indeterminately: useless/useful) painting. Although the re-marking is what first gives to the mark its possibility of sense, hence the analogy with transcendental grounding, what does the re-marking is detachable from and independent of what it doubles and re-marks. And that detachment, the possibility of detachment that attaches to all re-marking, infects, deflates,

withdraws the grounding security, the reliability, insinuated by the quasi-transcendental movement of constitution provided by the re-marking. In his most elaborated discussion of the mark, Derrida states:

> The mark-supplement (*le supplement de marque*) produced by the text's workings, in falling outside of the text like an independent object with no origin other than itself, a trace that turns back into a presence (or a sign), is inseparable from desire (the desire for reappropriation or representation). Or rather, it gives birth to it and nourishes it in the very act of separating from it.[21]

Derrida rehearses the opening of this desire (for restitution) in what follows.

The shoes *give* painting to be re-marked. Another voice interjects here, 'They give?', that is, you don't really mean to repeat Heidegger's 'It gives', do you? The first voice concedes that it is the Heideggerian locution, idiom, at stake: 'It gives, there is, *es gibt...*'The second voice returns, still worried by the linking of the Derridean re-mark with the Heideggerian '*es gibt*': 'In an obsolete language, one would say!' The first voice does not retreat: 'Is there any obsolete language? Like old outworn shoes, out of use or out of date, in a word–painted language?' The 'it gives' will be returned to since what Derrida intends is its reinscription, a statement of it otherwise, as re-marking. But the second voice, so anxious to get beyond Heidegger and close its ears to reinscription, perfectly takes the bait of the desire for restitution opened by the re-mark. This desire, the allegory of painting, is all the more seductive since it sounds Derridean. Textual, or in this case painterly, allegory is the form of restitution that attaches to deconstructive reading.

> ...the shoes produce a discourse on painting, on the frame, on the *traits*. These shoes are an allegory of painting in painting. Or again: one could entitle this picture 'the origin of painting'. It makes a picture of the picture and invites you not to forget the very thing it makes you forget: you have painting and not shoes under your nose ...painting is originarily this detachment which loses its footing. (TP, 342).

This is far from the dream of painting without truth noted earlier. It is therefore not surprising that the first voice resists this allegorization, resists, that is, the immediate translation of the re-mark into allegory, without denying the allegory since it represents one of the effects re-marking sets in motion.

To place this translation, de-limit it, restore the painting to its 'without truth', its 'it gives', 'there is' painting, Derrida will complement Heidegger's account with Schapiro's. Having noted the (indeterminate)

scholarly grounds for refusing Heidegger's interpretation, Schapiro takes the offensive by withdrawing these scholarly complaints, conceding for rhetorical purposes the legitimacy of Heidegger's attribution of the shoes to the peasant woman, and going on to claim that Heidegger would still be wrong. He would have failed to notice 'the artist's presence in the work,'[22] the 'personal' and 'physiognomic' aspect of the shoes, their facing the viewer *as* the portrait of a face might – all the signs and traces that reveal the shoes as a 'portrait' of the artist, e.g., 'a portrait of the artist as an old thing' (TP, 370). A naive form of expressionist logic informs Schapiro's reading. This naiveté is best understood by the desire for restitution, for identification underlying it. Because that desire is an effect, secondary, identification is always supplementary: 'the demand for reattachment is by definition insatiable, unsatisfied, always making a higher bid' (TP, 368). So Schapiro outbids Heidegger; even if the shoes are those of a peasant woman, they are still Van Gogh's; better, since the logic of part and whole is displaced in Schapiro's interpretation, the shoes express 'his whole presence, gathered, pulled tight, contracted into itself, with itself, in proximity with itself: a *parousia*' (TP, 369).

Schapiro's interpretation stands at the other pole to Heidegger's (thereby reflecting it); in opposition to Heidegger's discourse of earth, ground, etc., Schapiro's offers the language of face and subjectivity. And there is some authorization for Schapiro in Van Gogh's numerous self-portraits, his painting of personal objects, and his identification of his work as a painter with artisanal activity. Schapiro outbids Heidegger, but not without grounds. Finding grounds and circumstances for Schapiro's interpretation, as in showing the extravagance of the desire underlying it, does not entail condemnation or authorization: 'Nobody's being accused, or above all condemned, or even suspected. *There is* painting, writing, restitutions, that's all!' (TP, 371). There is painting, painting without truth; painting suspending its own meaning, risking the loss of meaning; ever excessive, ever non-identical with itself, less than a pair and more than a pair; but also, always restitutions, recuperations, reattachments. 'There is painting' is, then, the reinscription of *Ereignis*; it gives being, beyond ownership, propriety, property and the proper; beyond the chain of neutralizations which return the excessive gift, this painting, to the logic of the same called metaphysics.

iv Interrupting Metaphysics

Painting without truth. Why without truth? What is the gain, advantage, insight produced by locating painting, this painting, in the non-space of the 'without truth'? Perhaps this is a way in: 'Without truth' marks out a space for the other that is not reducible to the logic of the same; only

'without truth' (as correctness, say) can the otherness of the other be sustained. And Derrida's way of handling alterity does manage to present something like a solution to the problem of alterity we noted in Heidegger. In Heidegger the truly other was being, not beings; its otherness guaranteed through its appearing only in self-displacement, in withdrawal. And this, we claimed, caused a difficulty in being's connection with beings; their fate, because somehow secondary, became dirempted from the real fatefulness of fate, the destining of being. Derrida, refusing generality, universality, ultimate grounds, dispenses with the dream of securing both presence and alterity a priori, once and for all. But that dream and desire, and the discursive practices adhering to it, cannot be dispensed with as such; they must placed and accounted for. *The placing and accounting is the continuation of philosophy beyond metaphysics, the continuation of the project of philosophy otherwise.* Derrida, like Heidegger, is on the track of finite transcendence, of a transcendental that is not equivalent to or a proxy for the eternity of ideas; a transcendental, then, that will open the (or a) space of the empirical without, for all that, being opposed (beyond, above or below) to the empirical. Only a groundless ground, such as 'earth', can give things (history, persons, meaning), let them be, without dominating or withdrawing them from their alterity and specificity in the very gesture through which they come forth. De-transcendentalizing the transcendental, however, is not the utter repudiation of it, the disavowal of thinking through 'the conditions for the possibility of...'. Derrida's continuation of metaphysics beyond presence (and hence the axiomatic of eternity) is local, specific, even empirical, but still a continuation, a quasi-transcendental (non-universal) accounting.

The logic of the quasi-transcendental accounting involves a moment that cannot be presented, cannot be phenomenologized; a moment we will rehearse again below for the 'without end' (without purpose) of a tulip. It is the 'there is painting' of Van Gogh's shoes. The non-identity, the otherness, of the painting with the accounts of it – Heidegger's, Schapiro's, the allegorical interpretation of the shoes – is quasi-transcendentally accounted for not in terms of the defeasibility of particular interpretations, nor in terms of the empirical impossibility of saturating the work with concepts, both of which would leave the ideal of truth in place; but rather, in terms of the painting being a condition for what would account for it, as exemplary works are anterior to what would account for them – the parallel is precise. The Van Gogh has this power through its suspension of being and meaning, through the risk of the undone laces, through, that is, the re-marking of the detachment of painting in the detachment of the pair of shoes. That suspension, the originary gift of that work, a gift prior to the exchanges and contracts over its truth, is what necessarily, but also as a matter of fact, cannot be restituted, returned, made present. It opens the hermeneutical circle of which it is

also a part; opening, it is neither inside nor outside the circle. Alterity, the otherness of the other, is in excess of metaphysics, beyond the presence and absence of meaning, without truth; but it is equally, on the basis of a contingently operative necessary condition, what gives metaphysics, presence and absence, identity and difference, the interpretations of the painting and the metaphysical protocols licensing those interpretations. *In modernist art, in Van Gogh's painting, we experience, in however defused a way, a source of meaning exterior to the subject.* Modernist art is the refuge of our experience of generative exteriority, of an authority beyond the sway of mere taste and will.

Deconstructive readings enact a powerful logic; a logic which because not general, not a universal, subsists only in and through its enactment. Thus Derrida's *infinite task*: the otherness of the other, its particularity, its unique probity, is a product of reading, of demonstrating in each case where totality or universality loom, a quasi-transcendental moment that ruins universality (metaphysics) through *the* philosophical gesture of supplying the necessary conditions for the possibility of the item in question. Because the demonstration is local, then nothing secures its 'rightness' other than its rightness 'here' and its analogical iterability. That ability of being repeated, which is just the *fact* of plural readings analogically related to one another, also threatens to ruin the punctuality, the 'thisness' of readings, as if there were an absolute moral demand, an aporetic categorical imperative – 'Read in such a way that you always treat the other (text, person, event) never simply as a means, but always at the same time as end in itself' – sublimely soliciting the act of reading, providing its worth. This suppressed moral demand, the ethic prescribing deconstructive reading, reduces such reading to what it opposes. Further, to the degrees to which double reading is itself a *form* and a procedure, albeit not an algorithm or a determinate procedure, it must collude with metaphysics.[23]

As a first approximation, we might hazard that what is odd about Derrida's practice is his silence on the question of judgement. It is a matter of (aesthetic) reflective judgement again, operating without philosophical guarantees, without firm criteria, without 'reason', abandoned in the face of the other, but wanting all the more to speak, judge, truly, with truth. How can this judgement enter philosophy? In what way does judgement interrupt philosophy and metaphysics? The question of judgement is suppressed in Derrida twice over. First, judgement appears everywhere in Derrida, and yet nowhere, in the guise of 'reading', in what connects, without rules or formalism, without a deconstructive algorithm, formalism and text. The weight of the very idea of reading in Derrida, its seriousness, is the seriousness of judgement. Secondly, more indirectly, judgement is at issue in the privilege Derrida gives to literature and art. If some version of the argument so far is correct, then judgement has been

dismantled, marginalized by the legislative framing of truth-only cognition and categorical reason. Judgement only *appears as* judgement in aesthetics, in art and literature. Aesthetics, art and literature are already posited in modernity as without (theoretical and practical) truth. So the 'without truth' of the 'there is painting' might be thought equivalent to the truth of judgement outside theoretical and practical truth. Such a hypothesis might at least begin to account for why the 'suspension' of being and the risk of non-meaning has first occured in art and literature; why art has been taken to be the other of reason; why, finally, art (or literature) is the supplement to metaphysics, interrupting philosophy for the sake of what it intends: the other – the other that a certain history (but whose?) has abandoned to art.

This hypothesis might help explain Derrida's curious handling of the *Critique of Judgement*. Rather than seeing the third *Critique* as throwing into question the metaphysical protocols of the rest of the Critical system, Derrida reads it as fulfilling the metaphysical ambitions of the system as a whole, as radically exemplifying the metaphysical truth underlying the system; and in so doing repeating Kant's own dehistoricization of reason, the trajectory of which we have been attempting to reverse. Derrida goes on to locate the *Critique*'s disruption of the metaphysics of presence in isolated moments, but most emphatically in the moment of sublimity. As we saw earlier, however, the sublime in Kant itself operates a repression of judgement; a point Derrida is careful to note (TP, 137). A double repression of judgement then, Kant's and Derrida's. What judgement is suppressed in the non-judgement of the sublime? Kant's sublime, but Derrida's as well. *For what is deconstructive reading, the reconnoitring of what cannot be presented in the text but is yet of the text, but the production/ discovery of the sublime moment in each text of the tradition?* And would not this entail that the deconstructive sublime is but a 'higher', more sophisticated repetition of Kant? Deconstruction standing to metaphysics as the third *Critique* stands to the claims of theoretical and practical reason? But then we are returned to our original question: of what is the suppression of judgement, the cutting it off from truth and moral rightness, a suppression? What has been coded so as to become 'aesthetics'? What alterity is lingering there in the aesthetic terms: beauty, judgement, the sublime, *sensus communis*?

Of course, Derrida's handling of the third *Critique* is typical of his treatment of texts, such as those of Heidegger and Levinas, that have a prima facie claim to be regarded as non-metaphysical. In these cases Derrida is anxious to point out the moments of collusion with metaphysics in order to let their departure from the tradition appear less thematically. Further, one should regard Derrida's practice of reading as an artistic practice, as the creation of exemplary works. Derrida 'makes' these works exemplary thought the creation/discovery of their moment of excess, whose quasi-representation in terms of non-concepts is the analogue of the

untied laces. Derridean non-concepts are philosophical dangling laces, and hence mark (or re-mark) the risk of meaning in Derridean practice. And this makes his readings works to be judged, works of genius, rather than philosophical texts of the traditional sort. To interpret Derrida in the traditional way is thus to subsume his texts, to reduce them as Heidegger and Schapiro reduce Van Gogh, to the law of the same. Derrida's texts do not suppress judgement but insist on it, demand it. Deconstructive reading is meant to be compulsive in the same way as a new practice of literary writing or painting is compulsive. In Derrida artistic modernism becomes philosophical, and philosophy becomes modernist. What above appeared as the iterability of Derrida's procedure is but the work of succession, a demonstration *that* a new rule has been won for philosophy.

There is, then, no way in which we can take seriously the 'aesthetic' critique of modernity (progressive culture) without at the same time acknowledging Derrida's achievement. Everything I have been wanting to say in defence of aesthetic modernism is realized in deconstructive reading. The difficulty with his achievement, however, is whether we can understand it. For in aligning himself directly with artistic modernism he by-passes the one question about it that is intransigently philosophical, namely, what does its critique mean in relation to our dominant habits of knowing? By philosophically repeating modernism Derrida reduces philosophy to the marginalized aesthetic, thereby acceding to the alienation of judgement from truth and morality. In so doing he leaves unknown the forces that make the aesthetic marginal, and leaves untransformed the contemporary regimes of knowing. This is the state of affairs that Derrida's reading of Kant exhibits.

In the rest of the chapter I will argue, first, that Derrida follows Heidegger in reducing genius to metaphysics. In so doing he, like Heidegger, dissimulates the questions of freedom and history that are the moments of excess in Kant's aesthetics. Secondly, as a consequence of this dissimulation Derrida ends up keeping the interruption of metaphysics he himself enacts aesthetical, closing it off to its ownmost ethical and political potentialities and significance. Finally, we can comprehend this self-limitation as a consequence of Derrida's desire to secure a certain 'transcendental' safety, a certain ethical sublimity, for the procedures of deconstructive reading – a safety and security that are intended as protection against the inclusion of deconstruction in the guilt of the repressive consequences of metaphysics.

v Framing the Without End of Pure Beauty

Without truth. Without end, purpose, goal, *telos*. Kant's *Zweckmässigkeit ohne Zweck*, finality without end (as Derrida and his translators have it), is a construction too close to Derrida's conception of the 'without truth' for

him not to credit it, not to perceive in it the anticipation or broaching of a transgression of the form of metaphysical closure that reduces the other to the same. Indeed, Kant constructs his analysis of aesthetic reflective judgement precisely in order to provide a non-comprehending, reducing form of judgement. The without end of the object of aesthetic reflective judgement is central to the movement whereby the object gets suspended, bracketed from theoretical and practical concerns. The suspension puts reason out of play, freeing the object from considerations of theoretical truth and moral worthiness. What is significant in Kant's analysis of the without end is that the cut through which it appears does not entail a lack of any sort for the subject; hence its without end does not entail the need or the necessity for the object to be supplemented in any way. No end determines its 'oriented movement' (TP, 87), or our apprehension of it as straining toward the end.

Crediting Kant, Derrida analyses the 'without' (the *sans*) of the without end in terms indigenous to his own thinking:

> The mere absence of the goal would not give it [the experience of the beautiful] to me, nor would its presence. But the trace of its absence (of nothing), inasmuch as it forms its *trait* in the totality in the guise of the *sans*, of the without-end, the trace of the *sans* which does not give itself to any perception and yet whose invisibility marks a full totality to which it does not belong and which has nothing to do with it as totality, the *trace* of the *sans* is the origin of beauty. It alone can be said to be beautiful on the basis of this trait. From this point of view beauty is never seen, neither in the totality nor outside it: the *sans* is not visible, sensible, perceptible, it does not exist. And yet *there is some of it* and it is beautiful. It *gives* the beautiful. (TP, 90)

The purposelessness of pure beauties perfectly installs the idea of how a non-presentifiable absence can condition and make a certain presence possible. This almost perfect homology between pure beauties and the general Heidegger/Derrida account of absence as conditioning presence hence structures the direction of Derrida's account. Thus he continues by assimilating the freedom of free (independent, detached, *vaga*) beauties, say of a certain tulip (CJ, §17, 236), to the model of Heideggerian 'errance',[24] and to his own thesis concerning the possibility of meaning failing to arrive as constitutive of its (possible) arrival. So, for example, he claims that free beauty, the only kind compatible with judgements of pure beauty, 'is an indefinite errance, without limit, stretching toward its orient but cutting itself off from it rather than depriving itself of it, absolutely. It does not arrive itself at its destination' (TP, 93). Although Derrida will come to criticize Kant for terminating this original indetermin-

acy, nonetheless his strategy highlights how an 'aestheticization' of transcendental reflection is constitutive of the form of de-transcendentalizing that he and Heidegger restlessly pursue.

Initially, then, Derrida wants to insist upon the transgressive character of Kant's analysis of pure beauty, its without end and its errance. The tulip is not beautiful from the perspective of knowledge and science; if its parts were seen as contributing to its reproductive powers, its fecundity, as a botanist might see them, then they would not appear as beautiful. Nonknowledge is the point of view which gives rise to the beautiful (TP, 91); from the perspective of nonknowledge 'the seed wanders', it is without goal or purpose. 'What is beautiful is dissemination' (TP, 95). The tulip, Derrida says, is not significant, it is not a signifier, even of a lack. 'Starting from a signifier, one can account for everything except beauty, that is at least what *seems* to envelop the Kantian or Saussurean tulip' (TP, 95). Derrida will go on to contest this seeming lack of signification on the part of the tulip; he will go on to demonstrate how the apparent purity of the pure cut that lets the tulip appear as a pure gift, is already framed within a system that is teleologically oriented toward the Kantian Kingdom of Ends. Derrida's point is not to insist upon what everyone already knows, namely, that the Kantian system has this teleological orientation. Rather, his point is that beauty is not what it initially appears to be in Kant, errant and disseminating, because the system, at a distance and indirectly, 'supplies the course, determines the vagueness (as lack) and gives sense and direction back to errancy: its destiny and its destination' (TP, 117). In brief, Derrida's fundamental strategy in reading Kant is the exact opposite to the one we have been pursuing. Where we have been pressing the claims of beauty and aesthetic reflective judgement against the claims of the system, taking them to be an interruption in what the Critical system intends, Derrida folds that central interruption back into the system for the sake of, or at least with an eye towards, a marginal interruption. Worse, our reading is utterly exposed before the Derridean reading since it has turned on a willingness to *interpret* Kant, to ask after and to urge the claims of the text beyond its own systematics. Interpretation, which requires judgement, is a discourse of truth, of restitution. The powerful formalism governing Derrida's reading leaves his position structurally unexposed – no truth claim or thesis is presented – and in this sense without risk (which is not to deny the intense subtlety and riskiness in Derrida's performances). The space separating our two readings, then, concerns the question of risk and exposure, of the place of risk in the question of otherness, and the exposure (risk) of self in the face of the other in the question of meaning. What, to return to the question of art, is it that the risk of the loss of meaning risks, signifies, opens and closes? The nature of the sublime will be the place of this contestation.

Before getting there, however, let us quickly sketch the two steps

whereby Derrida folds the interruptive movements of Kant's aesthetics back into the system, the without end of pure beauty and the anti-mimetic, self-transcending character of the work of genius.

Two elements within Kant's analysis adumbrate the recollection of pure beauty back into the system, permit its apparently errant character to be determined. On the one hand, free beauty, which all pure beauties must be, is not all of beauty, but only one type of beauty; the other type being dependent beauty. This immediately qualifies the paradigm of free, pure beauty, placing its errancy within a larger context, a broader framework of the beautiful. On the other hand, like every modern aesthetics, although 'beauty is always beautiful once', aesthetic judgement being the non-subsumptive judgement of unique items, the judgement itself drags the singularity of the term judged into the domain of universality. This dragging is the paradox that every aesthetics must face: Derrida is not contesting the existence of the paradox, only Kant's way of solving it.

Kant's solution is bound up with the first element, the distinction between free and dependent beauty. What requires the introduction of dependent beauty into Kant's account is, again, man, for the beauty of man can never be without the concept of an objective finality, the end, the concept of freedom, which determines his being as a man. Further, as demonstrated by the example of Kant's claim that horses too can only be considered in terms of the concept of the objective finality governing them, their being (essentially) *for* man, his system presupposes, and is organized by, the thesis that man, being an end-in-himself, is the final end of nature, that the 'whole system of ends is oriented by him and for him' (TP, 107). So Kant says that man is the being upon earth 'who is the *ultimate end* of nature, and the one in relation to whom all other natural things constitute a system of ends'. When man is satisfied by means of nature and its beneficence, his end is determined as happiness. When man's freedom is the issue, his 'aptitude and skill for all manner of ends for which he may employ nature both external and internal' (CJ, §83, 430), his end is determined as 'culture'. The orientation towards man's happiness and culture orient, give place and meaning to, the things of nature and society.

The concept of end adheres to man, is non-detachable from him. Further, unlike other dependent beauties, man is capable of the ideal of beauty. It is through an understanding of the ideal of beauty, and its role in constituting the possibility of universality for aesthetic reflective judgements, that Derrida demonstrates how pure beauty gets oriented and framed.

Again, judgements of taste cannot be determined by concepts, there are no criteria in accordance with which one can make valid, universally communicable, judgements concerning the beautiful. The prerequisite for universality can only be sustained by empirical examples that appear

'weak indeed and scarce sufficient' (CJ, §17, 232) to raise the presumption of a 'deep-seated and shared' ground for accord. Only certain *exemplary* products of taste will be able to fill this role. Because taste is formed through interaction with particular products, there redounds to taste a certain historical, cultural, pragmatico-anthropological character; and this parallels the connection between exemplarity and historicality we traced earlier in the analysis of genius. While the (partial) constitution of taste through exemplary products enjoins an horizon of historical productivity, the exemplar can give itself as an example 'only to the extent that it signals, empirically, toward a structural and universal principle of accord, which is absolutely ahistorical' (TP, 109). This simultaneous opening and closing of the historical horizon is made even more complex because the notion of exemplarity here is bound up with 'free' production. Taste cannot be produced through imitation; hence the highest model of taste is a 'mere idea, which each person must beget in his own consciousness' (CJ, §17, 232), employing it as a model to estimate everything which is an object of taste. Derrida fastens our attention on the paradoxicality of this thesis:

> There must be a pattern but without imitation. Such is the logic of the exemplary, of the autoproduction of the exemplary, this metaphysical value of production having always the double effect of opening and closing historicity. Since everyone produces the idea of taste, it is never pregiven by a concept: the production of the idea is historical, a series of inaugurations without prescription. But as this production is spontaneous, free at the very moment when, by its freedom, it rejoins a universal fund, nothing is less historical. (TP, 109–10)

Two questions emerge from this claim. First, how does the 'universal fund' close off the historicality opened by the series of inaugurations, exemplary productions, without prescription? What curtails, halts, suspends historicality at its moment of inception? Secondly, if what is at issue here is a closing off and delimiting, then what is refused in the manner of the Kantian closure, whose removal would reopen the horizon of historicality? If exemplary production is the production of freedom by the means of freedom, then what of freedom is denied by the Kantian analysis? One would naturally expect that the answering of the first question would lead to some answer or engagement with the second question. Derrida answers the first question twice over without engaging the second. Freedom is refused by Derrida in the very manner that he displaces Kant's delimiting of it. More precisely, Derrida invokes an errancy, a non-determination, of man that falls short of, is less than historicality, less than the production of freedom by means of freedom. The basis for that refusal in Derrida is his association of the autoproduction of freedom with

the self-presence of the producing subject with itself, with, that is, some version of the metaphysics of subjectiviy as self-presence. Derrida's refusal becomes less compelling, however, if the opacity we have already seen in Kant and Heidegger to be an ingredient in exemplary production, its 'without rules', can be upheld. What if autonomy is, to borrow a term from Derrida, a kind of gift?

Reason's indeterminate idea is of a maximum accord between judgements. Since this maximum cannot be represented by concepts, it must be sustained by singular presentations, by the ideal of the beautiful. An ideal of beauty is not, however, compatible with free beauties since nothing would connect them with the rational idea of a maximum accord between judgements. In order for there to be such a connection between an idea of reason and a singular presentation, the presentation must be one of an object possessing an objective concept of finality. And within the Kantian schema only man has an unconditioned end, a fully objective concept of finality. There is no beauty in general, beauty as such, neither free nor dependent (despite these being predicates of beauty); pure and errant beauty is opposed to ideal beauty – opposed through man, who can judge of free beauties because he forms the ideal of beauty. Man 'is not errant' (TP, 111). Because he is no errant, he is never the object of a pure judgement of taste; he 'prohibits a pure human aesthetic because, so that, insofar as the *sans* of the pure cut is effaced in him' (TP, 112). This, Derrida claims, is what is at stake in Kant's Copernican revolution.

To claim that man is not transgressively free in Kant is to claim that human freedom, that which makes man an end in himself, is transparent to itself. And this must be taken as equivalent to the thesis that in Kant's aesthetic writings there is a direct curtailment of the transgressive freedom of genius by reason. Kant contends that the products of genius must appear 'as if free from the constraint of arbitrary rule, 'as if' they were products of mere nature' (CJ, §45, 306). What is the scope of this 'as if'?

In 'Economimesis' Derrida argues that what the artist imitates is not nature; rather, his production will resemble nature because it imitates, not *natura naturata*, but 'the acts of *natura naturans*, the operations *of physis*'. But, Derrida continues, since an analogy has already made *natura naturans* the art of an author–subject, indeed, perhaps, an artist–God, then human action comes to imitate divine action: the imitation of one freedom by another. Behind Kant's overt rejection of mimesis, then, there lies a deeper mimetic structure:

> The poet or genius receives from nature what he gives, of course, but first he receives from nature (from God) besides the given, the giving, the power to produce and to give more than he promises to men…The genius poet is the voice of God who gives him voice, who gives himself and by giving gives to himself, gives himself what he

gives, gives himself the (power) to give (*Gabe* and *es gibt*), plays freely with himself, only breaks the finite circle or contractual exchange in order to strike an infinite accord with himself. (B, 11)

The deep structure of economimesis marks the passage from Kantianism to Hegelianism.

Economimesis represents the ultimate economic frame determining the destiny of the without end of pure beauties, the without concept of judgements of taste, and the without concept of exemplary productions. Derrida presses his cases for this claim – the second thought we want to draw from 'Economimesis' – through a demonstration (referred to in TP, 116–17) that Kant's repeated claim in §51 is false – the claim that his classification of the hierarchy of arts is a mere attempt, non-conclusive, with other systems of classification remaining possible. It is false, according to Derrida, since the deduction is regulated according to a conception of language and the body of man which organizes the fundamental humanism of the whole system. More precisely, the structure of analogy regulating the mimetic encounter between human and divine poetic production has its origin in the *logos*: 'The origin of analogy, that from which analogy proceeds and towards which it returns, is the *logos*, reason and word, the source as mouth and as an outlet' (E, 13).

As we have already seen more than once, the privilege of the human in Kant depends on an inside, an interiority that itself is moral in character. This passage to the interior is announced even in Kant's account of the pleasure we take in natural beauty, where that pleasure is taken as a sign or trace of a regular agreement between nature and our distinterested satisfaction, thus entailing an interest akin to the moral. A moral revenue is hence drawn from the utterly disinterested contemplation of nature; and what mediates between our contemplation and nature is a language of nature. Pure beauties, which signify nothing, are not signifiers, are 'also, and by that very fact, encrypted signs, a figural writing set down in nature's production. The *without* of pure detachment is in truth a language that nature speaks to us' (E, 15).

Kant's positing of the *logos* is violently interjected into the analysis when he contends that beauty in general, whether natural or artificial, may be described as 'the *expression*' of aesthetic ideas' (CJ, §51, 320). Why expression? With what right and on what grounds is 'expression' introduced here? Kant does not say. But it is the introduction of expression that regulates Kant's deduction of the arts. It entails Kant's overt decision, which he takes to be merely convenient, to classify the arts in accordance with the organs of expression in man. Expressive language is the analogical equivalent placing the arts. Hence it does not surprise us to discover that the art that imitates the least, and is thus closest to divine speech, is at the summit of the arts. But what gives poetic speech this

privilege? Derrida is in no doubt: it is the structure (mouth to ear) of hear-ing-oneself-speak, the presence of the self to its self without interruption or mediation, without the possibility of meaning becoming lost or defused along the way. This structure, and it alone, justifies the authenticity, loy-alty, integrity of poetic production. These quasi-moral values derive from the value of full presence and full speech.[25]

> Poetry manages not to deceive by saying that it plays, and what is more its play, auto-affection elaborating appearances without exter-nal limitation...maintains itself seriously in the service of truth. The value of full presence guarantees both the truth and the morality of the poetic...By breaking with the exchange of values, by giving more than is asked and more than it promises, poetic speech is both out of circulation, at least outside any finite commerce, without any deter-minate value, and yet of infinite value. It is the origin of value. (E, 18)[26]

vi Framing the Sublime

Kant's hierarchy of arts does indeed appear to depend upon the value of full presence. Nonetheless, Derrida's general argument is not compelling. First (a small point) because, as he himself states, the introduction of expression is 'violent', inserted, not justified. But violent with respect to what? Only, presumably, the logical and conceptual requirements of the argument to that point; that is, nothing about the claims of free beauties, judgements without concepts, and exemplary production either presup-poses or entails the insertion of expression and the value of full speech, hearing-oneself-speak. A violence, then, against what? Beauty? Freedom? Community? Whatever the exact answer, the violence is against the de-centring of transcendental subjectivity that has governed the analysis to that point; and that should worry Derrida.

Secondly, and more overtly, Derrida too quickly helps himself to God and divine production in his account. The orderliness of nature for Kant is transcendentally constituted, and hence can only be understood from an epistemological perspective. But this entails the inappropriateness of employing the traditional onto-theological distinction between *natura naturata* and *natura naturans*. There can be no *physis* in Kant; such a nature is necessarily pre-critical. So when Kant is tempted to bring God back in, and this at best only regulatively and at worst as an act of meta-physical nostalgia, he does so through a second-level consideration of nature on analogy with human productive activity. Hence an analogy between human and divine production reduces to an analogy between human productivity and itself; but human productivity possesses, even on

the most austere reading, an indelible opacity. Derrida's analysis beautifully delineates the contours of Kant's metaphysical imagination, which is theological, but fails to engage the gap between the requirements of Kant's argument and his much more traditional metaphysical desires. If the desire for full presence haunts Kant's system, its argument is riddled with abrupt halts and opacity: the thing in itself, the spontaneity of the 'I think', etc.

Finally, and most emphatically, the opacity of the human mind to itself in its most fundamental determinations, above all in respect to its freedom, is decisively transmitted into the account of artistic praxis. Exemplary production is, from the perspective of the producer, necessarily excessive to its intentional moment. The validity of original productions cannot be determined through reference to the mind of the artist, but rather is assessed, without rational criteria, through succession (what Heidegger considers under the term 'preservation'). But the fact that the effort of genius to take up the burden of human significance is always conditioned does not entail that our vocation as autonomous beings is thereby infringed upon. The point is rather that *neither* freedom *nor* what conditions it are beyond reflection, beyond what comes of them, beyond whatever stance we might take towards them. We can never possess our freedom nor forsake it; nor can we affirm what gives our freedom unconditionally, nor circumvent it. Or so I shall argue.

As we have already seen, exemplary production/creation is the place in Kant's text where the logic of subjectivity, the logic of self-presence, is most fully and decisively undermined. If the expressivist logic of §51 and §53 are in any sense violent, it is a violence that seeks to tame the incendiary dialectic of genius. Derrida's dropping of the question of exemplarity runs against the actual movement of Kant's argument; but this is not an idle point since although both exemplary works and deconstructive readings rehearse a logic of transgression and groundless legitimation, Kant's equally sustains a logic of recognition, of the discovery of self in otherness. Derrida will insist upon this same otherness while attempting to suppress the moment of recognition, the moment in Kant and Heidegger whereby we are gathered into community. Derrida's route to sustaining this thought involves pressing the claim of the sublime without the corresponding consideration of genius.

Derrida's treatment of artistic production raises a problem with deconstructive reading and any attempt to engage with it. For to make reference here to the exigencies of argument (truth) in opposition to the elaboration and detailing of that argument is to presuppose the discourse of truth, that a text is making a claim about some subject matter outside the text. This is what interpretation is. It is also what deconstructive reading is attempting to avoid. When Derrida says in *Of Grammatology* that 'there is nothing outside of the text', he is calling into question the

presupposition of interpretation.[27] Deconstructive reading wants to traverse texts, in a manner that is neither that of a commentary (which merely repeats and protects the text) nor that of an interpretation (which presupposes a signified outside the text), by discovering a blind spot in a text that exceeds the author's intentions yet governs the logic of the text. In this way deconstructive reading need not decide, what it wants anyway to call into question, between exigencies of argument (= philosophy) and the writing, detailing of that argument (= literature). Despite the flamboyance of his style, Derrida's reading is regulated by a kind of textual ascesis, an asceticism, in virtue of which he hopes to locate a place exterior to logocentrism in order to interrogate it. What happens, however, when this ascesis depends for its operation upon the registering of distinctions, as between what *follows* in a train of argument and what can only be regarded as a forcing of the argument, that automatically puts into play the discourse of truth and interpretation? How else can deconstructive reading continue than by violently suppressing the distinction between truth and violence it enunciates? How could a decision be made here without begging the question?

In order to gain a perspective from which this question can be broached, we need to follow through the readings we are examining. Again, a double reading will seek within a text the moment of excess outside the internal (logocentric) logic of the text that constitutes the possibility of its totalizing action. In *The Truth in Painting* Derrida focuses on the logic of the frame as a way of interrogating the idea that art has an essence, an integrity, in virtue of which it is art and nothing else. He wants, in brief, to throw into doubt the thesis that there is a rigid and unalterable line (frame) marking off what is forever inside art from what is outside art. In the parasitic movement between Van Gogh's painting and the accounts of it, we already have before us an example of the kind of crossings between inside and outside, regulated but without stop, that Derrida intends. Art will always be for Derrida both more than art and less than art; as philosophy will always be both more than (and other than) itself, and thereby less than (and other than) itself. Neither art nor philosophy can correspond to our deepest (metaphysical) desires about them, our desires for restitution, fulfilment and presence.

The question of purity is central to aesthetic reflective judgement. A judgement of taste can only be pure if it is determined by formal considerations alone, without the merest taint of empirical delight in the object being taken; if empirical delight were found, it would interrupt the disinterestedness and impartiality of the judgement. In §14 Kant works through a variety of examples in order to clarify his point. Near the end of his discussion he takes up the question of parerga (ornamentation). These, he states, are 'only an adjunct, and not an intrinsic constituent of the object', which in augmenting the delight of taste do so only by means of

their form (CJ, §14, 226). So it is 'with the frames of pictures or the drapery on statues, or the colonnades of palaces'. However, Kant continues, when *parerga* do not enter into the formal composition of the work, as might be the case with elaborate gold frames, then what we have is 'finery' that, as it invokes empirical charm, subtracts from genuine beauty.

Parerga, even at face value, are conceptually anomalous, being additions to what is already complete without them. If *parerga* do augment what they are added to, how can the original object (argument, demonstration) be complete without the addition – complete in just the sense of requiring nothing else for its completion? One might essay the thought that a *parergon* is not *necessary* for the completion of the object; but won't a merely contingent augmentation throw into question the presumed original completeness? The difference between the necessary and the contingent is undermined by the *parergon*, and just because it is, by definition, neither simply inside nor simply outside the work (*ergon*: 'Philosophical discourse will always have been *against* the *parergon*' (TP, 54)).

Parerga, in so far as they do augment a work, reveal a lack or absence in the work, intrinsic to it; but the lack or absence is of nothing else than the parergon, which nonetheless remains exterior to the work. The 'internal structural link which rivets' parerga to the lack in the interior of the *ergon*, reveals that lack as 'constitutive of the very unity of the *ergon*' (TP, 59). Once the logic of the parergon is acknowledged, the task of knowing what belongs to the inside of a work and what belongs to the outside becomes incompletable, epistemically impossible.

Frames represent an exemplary instance of parergonal logic. Frames stand out against two grounds: in setting off the work they merge with the general background; while in setting off the work from the general background they merge with the work. Frames disappear in two directions. 'There is always a form on a ground, but the parergon is a form which has as its traditional determination not that it stands out but that it disappears, buries itself, effaces itself, melts away at the moment it deploys its greatest energy' (TP, 61; for Kant's attempt to frame the third *Critique* see TP, 71ff).

If frames put everything to work, even if in so doing they impose themselves in a manner of apparent exteriority, then the frame can neither be framed nor done away with. Deconstruction is the deconstruction of gestures that seek an ultimate, non-impositional frame, and of those that dream the simple absence of the frame (TP, 73). Deconstruction works the frame, is neither inside nor outside metaphysics.

What moment, then, breaks with the frame of the aesthetic? Where in Kant's aesthetics is its framing acknowledged (the ultimate frame supplied) and surpassed? According to Derrida, the borders of the aesthetic are broken, severely infringed upon, in the sublime. Derrida deploys the

example of the colossal (CJ, §26, 253) as his point or orientation: 'The colossal excludes the parergon. First of all because it is not a work, an *ergon*, and then because the infinite is presented in it and the infinite cannot be bordered' (TP, 128). But this is too simple, for in order for what is infinite, without borders, to show itself, be presented, it must accept determination, framing, of a sort.

In Kant what is properly infinite is reason, the thought of which is called upon in the face of what defeats the imagination's power of apprehension and comprehension. The judgement of the sublime is aesthetic, again, because 'it represents, without being grounded on any definite concept of the object, merely the subjective play of the mental powers (imagination and reason) as harmonious by virtue or their very contrast' (CJ, §27, 258). If there truly is a play of mental powers, and not a mere movement from one to the other, than the object whose presentation exceeds the powers of the imagination remains on stage. Or so Derrida intends to read Kant. For only by making this assumption can he consider the question of the sublime to be a question of presenting the unpresentable. Which is not to say that he is unaware of the peculiarities of Kant's account; on the contrary, what intrigues Derrida is the way in which the sublime announces itself in the sensible, and the sense in which this announcement must be aesthetic and subjective:

> Unlike that of the beautiful, the principle of the sublime must be sought in ourselves who *project* (*hineinbringen*) the sublime into nature. There is an effect of the colossal only from the point of view of reason. Such is the *reason of the colossal*, and such is its reason that no presentation can get the better of it. The feeling of the colossal, effect of a subjective projection, is the experience of an inadequation of presentation to itself, or rather, since very presentation is inadequate to itself, of an inadequation of the presenter to the presented to itself, of an inadequation of the presenter of presentation (TP, 132).

The awkwardness of this, marked in the twistings of the final sentence, is derived from the fact that the external objects announcing the sublime are not themselves sublime; and yet, if the judgement of sublimity is not to be reduced to a causal sequence through which we are awakened to the infinity of reason within us, then there must be in what is presented an inadequation, an excess that is (also) the excess of reason, its unpresentability. In brief, Derrida is attempting to read the harmony of reason and imagination 'by virtue of their very contrast', not as a causal ordering of the imagination and reason with respect to each other, but as their inner articulation.

Derrida construes the ordering argument to be Hegel's reading of the

sublime. In it what is without measure is the infinite idea, which does not let itself be adequately presented, and so transcends whatever contingent condition of representation attaches to it. The object announcing the infinite idea, no matter how large, has a measurable size, however large (TP, 133). Kant's conception of the sublime, in contrast, sets out from the object, lets the announcement of infinity, of the unpresentable, begin with it (TP, 133). Derrida's reading of the sublime intends a 'Kantian' critique of Hegel, a defence of the Kantian sublime against the Hegelian infinite idea.

What wants explanation here is what it is about the colossal that defeats measurement; in virtue of what does it transcend its own presentation? To press this search is, for Derrida, the error; any account of that in virtue of which the colossal defeats measurement will, a fortiori, involve presenting, conceptually capturing, that which is the defeat of all presenting and capturing. It would be the dream of reframing, the refusal of all parergonality (TP, 145), a thought underlined in Derrida's text by being presented, like the whole of the Kant essay, at the border of two unjoined, and themselves slightly detached, corners of a frame.

Sublimity is but the working of the frame, of what is neither inside (presentation) nor outside (without size/cise, and unpresentable). 'The cise of the colossus is neither culture nor nature, both culture and nature. It is, perhaps, between the presentable and the unpresentable, the passage from one to the other as much as the irreducibility of the one to the other' (TP, 143). Deconstruction, the working of the frame, is sublime. It produces/discovers the sublime. What was the work of reading 'Origin' but the demonstration that Van Gogh's shoes were sublime, neither within nor outside representation, but the continual passage from one to the other? Sublimity, the figure of what is without figure, is the figure of deconstruction. And yet...

Kant's sublime is a movement, a scene and a drama, a narrative of sorts. Derrida, as we shall see below, notes the elements and moments of this narrative; only, of course, to de-narrativize its movement, reduce it to another movement, that of framing, the logic of the *parergon*. Yet the narrative is there. A vivid version of it occurs in Kant's *Anthropology from a Pragmatic Point of View*:

> The sublime is that *greatness* in size or intensity which inspires awe (*magnitudo reverenda*): it simultaneously invites us to approach it (so as to make our forces equal to it) and deters us by the fear that in comparison with it we shall shrink into insignificance in our own estimation (thunder over our head, for example, or a high, rugged mountain). When we are in a safe place, the gathering of our forces to grasp the appearance, along with our anxiety about not being able to grasp the appearance, along with our anxiety about not being

able to rise to its greatness, arouses *astonishment* (a feeling that is agreeable because it continuously triumphs over pain)...So the sublime is not an object for taste. It is rather, the feeling of being stirred that has the sublime for its object. But when an artist exhibits the sublime to us, by describing it or clothing it (in ornaments, *parerga*), it can and should be beautiful, since otherwise it is wild, coarse and repulsive, and so contrary to taste.[28]

The parergon of the sublime is beautiful art, the clothing, framing of the monstrous ('greatness that is contrary to the end'). But the sublime itself stands in a curious relation to Kant's aesthetic: both a moment of it, formally analogous with the logic of beauty; and outside it, a function of a logic that belongs to morality rather than aesthetics. And this must raise the suspicion that the sublime too is a parergon, a clothing or aestheticization of an experience that without aesthetic refinement, the refinements of aesthetic sublimity, would be 'wild, coarse and repulsive', threatening, an occasion for fear and dread. Kant's drama, despite itself, represents another scene, another space or place of confrontation and testing.

The drama, unfolding as a drama only from a distance, from 'a safe place', is of a battle deferred, framed; or better, it is the imitation of a battle without its violence. The 'safe place' is the condition for what unfolds being a drama; safety being the distancing and aestheticizing of the fearful threat occurring. The sublime object *is* not a source of fear; rather it is *represented as* a source of fear. If dynamical nature were a real source of fear, then our judgement upon it could not be aesthetic (CJ, §28, 260–1). But this distance is not that of an absolute spectator for whom the spectacle is provided; the spectator who frames the threat is also an actor in the drama, indeed its protagonist.

While the representation of the object as fearful and threatening is a central ingredient in the drama, we must not rush to it. In order to feel the fear and the threat we must be in some proximity to the sublime object; it must have already come on the scene, perhaps inviting us in some way to approach. Without the invitation, the lure, the object's interruption of our narcissistic self-complaisance could not occur. We are 'invited' to approach the other in order to 'make our forces equal to it'. There is, then, a test of our forces; and what is thereby tested is what our *forces are*, who we *are*, our *being*. Testing must raise us to an insight into our forces, into our nature and being. So something of the other invites us to approach it, and deters us. We are threatened, fearful; we might shrink into insignificance; that is, the other threatens us, threatens, at least, our sense of bodily integrity; hence it awakens us to our sensible being and the indeterminate vulnerability consequent upon our being sensible beings; we are threatened to the limit of sensibility. In the test our mortal being is revealed as mortal; but, at once, we also learn what cannot be confined or

reduced to mortal being, to life and the drive for self-preservation. Hence, our vulnerability will be accepted and refused; and that refusal will be ambiguous between a justified denial (we are always in excess of our merely sensible being) and complete self-denial (we *are* not sensible beings, but self-legislating, autonomous creatures projecting ourselves onto a sensible screen). So: 'Attraction/repulsion *of the same object...* Double bind. There is an excess here, a surplus, a superabundance which opens an abyss (*Abgrund*). The imagination is afraid of losing itself in this abyss, and we step back' (TP, 129). The stepping back is the framing of the threat and the mastering of it; equally, the stepping back is the aestheticizing of the threat, making it no threat, only a representation, a fiction. The safe place is the place of reason, whose transcendence beyond all sensible threat is assumed from the outset (CJ, §29, 265). *Hence the apparent transition from imagination to reason is made through the determination of reason.*

The sublime halts the easy play of beauty and introduces an abrupt seriousness: 'A violent experience in which it is no longer a question of joking, of playing, of taking (positive) pleasure, nor of stopping at the 'attractions' of seductions. No more play (*Spiel*) but seriousness (*Ernst*) in the occupation of the imagination' (TP, 128). The seriousness of the narrative is a direct consequence of the threat, the threat the 'imagination' feels at the prospect of losing itself, being defeated, slayed. Here the imagination not only includes our sensible constitution generally, imagination and sensibility, as it does throughout the third *Critique*, but equally stands in for and assumes the position of our bodily being in general (as is arguably the case in the first *Critique* as well). Only on this assumption does it become comprehensible why determining the imagination's measure of the threat to itself is the measure of the body: 'The primary (subjective, sensory, immediate, living) measure proceeds from the body... Things must come to a relationship of body to body' (TP, 140–1; and for the measure of the body: CJ, §26, 252). So the test is a contest, a struggle between two bodies, each exceeding itself, being more than body; and in that excess threatening the other (body, that is more than body).

At first glance, Kant's battle appears to be the primitive battle between man and nature, with the experience of the sublime rehearsing nature's objectification, our becoming, both practically and theoretically, masters and possessors of nature. But this suppresses the inaugural moment, the moment of invitation and seduction, and the place of reason in that starting place, as well as the body-to-body standard of measurement. We assume ourselves to be self-conscious beings and desire to have validated and confirmed that sense of ourselves as transcending our natural determination. Only a completely circular confirmation would arise from Kant's uninterpreted account of the confrontation. Real confirmation can come only from another self-conscious being, a being whose sensible being and

its comportment invites, draws us in. And this is the significance of the fact that the imagination uses nature as 'a schema for ideas' (CJ, §26, 265; §53, 326) in the experience of the sublime; only if nature has ascribed to it the infinity of reason can its threat be sufficient for its overcoming to signify our transcendence of our natural determination. So the battle is of body to body, of bodies both in excess of themselves. And that excess in the body of the other is fearful, threatening to reduce us to mere bodies and thence to vanquish even that. But this is a drama in which we are both actors and spectators; so, because there is a safe distance, the distance of the aesthetic, we master the other (the sublime object), at a distance, in imagination. The sublime, Kant says, is the counterpoise of the beautiful 'because our effort and attempt to move to a grasp (apprehension) of the object awakens in us a feeling of our own greatness and strength'. That mastering of nature within and without (CJ, §28, 264) is our pleasure, the pleasure of dominating (our fear, if not its object) of finding ourselves more than what threatened from the measure of the body – threatened to reduce us to mere bodies, or worse, threatened our bodily existence, which we are forever more than and forever bound up in.

This would be serious, a matter of life and death, again but for the safe distance, a safe distance which frames the battle, lets it play, be a play, just as art frames the naturally sublime, ornamenting it, making it tasteful, acceptable, to be hung on the library wall or read in vivid iambics. Art is the supplement of the sublime, its parergon; and the sublime is the frame, the parergon of the life and death struggle, the originary battle constitutive of the truth of self-consciousness. Within the narrative of the sublime is secreted the continually reiterated and suppressed account of the origin of self-consciousness in the experience of the threat of a violent and sudden death: Descartes's confrontation with the evil genius, the threat of violent and sudden death in Hobbes's disorderly (sublime) state of nature, that same threat by the sovereign in the second Critique, and finally the awakening to authenticity in being-toward-death in Being and Time.[29] But in each of these cases we also find a suppression of the very alterity through which self-consciousness is confirmed. So the sublime other (evil genius, disorderly nature, sovereign) becomes, as the sublime does in Kant, the mere contingent occasion for self-possession. Yet these occasions have weight, matter, only in and through the ascription to the other of what is discovered as a consequence of its threat; the threat is only a threat through what it always already has given: self-consciousness. From the outset, the violent discovery of self-consciousness in modernity has received an aesthetic framing, making safe its presentation as a representation always already narratively controlled. With this the political constitution of subjectivity becomes safely framed; the freedom of self-consciousness theoretically/aesthetically legitimated almost before it has emerged.

Must not this be said not just of Kant's sublime, but also of the deconstructive sublime, of deconstruction as sublimity. Does this reading then make deconstruction also a parergon, a framing, of seriousness, of the life and death struggle?; its play, serious like that of the imagination, the introjection and literary/philosophical, textual writing of that other scene, the scene of the other? In asking this question we must remember that the safe place constitutive of sublimity, its aesthetic distance, is a product of the framing of reason. *It is reason that constitutes the approach of the other in modernity into an aesthetic scene of the sublime.*

vii Sublimity or Tragic Politics?

Certainly what is most odd about deconstruction as a heterology, a pursuit of alterity, of what is other to the *logos*,[30] is how that otherness is marked in terms of the textual operation of non-concepts that both open and limit the discourse of philosophy. Sublimity in Kant is curiously analogous, since it too concerns the attraction of the other, but writes that other in terms that defeat our comprehension of what that attraction, seduction, lure might be; and further, makes equally difficult an understanding of why that other cannot be present as other, why it exceeds our grasp, and does not fully appear. Alterity and sublimity intersect with each other, represent each other, take us into the place where the other, which in its radical alterity never appears, appears.

Could the attraction of the other be our desire for its body? Not just that, for the other is more than its body; its attraction is of its body in the manner in which it is exceeded. Our body too is such a site, a space of presenting (expressing?) a forever non-appearing inside, interiority, outside. What cannot appear in itself, what cannot be made present (without the thought of its being simultaneously absent) is our autonomy. As we have already seen, the exemplary work as the creation of freedom is both a product of freedom, presupposes it, and that through which freedom appears. And when freedom does thus appear it does so in some determinate form, some particular configuration that is not freedom itself. The mark of freedom not appearing is the transcendental opacity, the tain through which and against the background of which freedom is given and reflected in the exemplary work. So, on the one hand, there is the freedom that produces/creates the work; and this presupposed freedom might lead us to consider non-appearing freedom as the ontological condition for appearing freedom. Yet, on the other hand, we *receive* our freedom from the work; where the freedom received is not a mode of it, but the thing itself, that in virtue of which we can act freely.

And this tells us about the desire for the other, for its freedom also is not present or immediate. Hence the lure of the other, its attraction,

exceeding its embodiment, is its autonomy, its self-consciousness; which appears only in its non-appearing, its remaining always in excess of whatever form or configuration is given it. So in desiring the other we desire its freedom, which can only be its recognition of our freedom. Kant's account of the sublime is the *parergon* of the life and death battle for pure recognition; and the moment of sublimity itself, the moment of pleasure triumphing over all pain both real and potential, our drive for self-preservation and what can threaten it, is the Master's moment, the moment when self-consciousness is affirmed in its transcendence of sensible being while the heteronomy of reason, the other *in* self-consciousness, reason as the voice of the other in the subject, is refused. This is the ambiguity of the Kantian sublime: it both recognizes the other as self-consciousness in the use of nature as a schema for reason, and refuses that recognition in framing the battle into a self-confirming aesthetic scene. This play of recognition and non-recognition exactly duplicates the master's recognition and non-recognition of the slave. The experience of the sublime is that of the approach of the other, where the framing of the scene and the interplay between reason and imagination in it reveal that other to be the human other. Thus, to think radical alterity is to think the autonomy of the other; autonomy being the otherness of the other, that in the other that can never be made immediately present. That, at any rate, is the hypothesis I want to pursue, above all because it explicitly responds to what we saw was the fault line in Heidegger's aestheticization of the political.

Derrida's way of pursuing the sublime, of suppressing its narrative and figural structure, elides the question that has been the centre of his analysis of beauty: errancy, judgement without concept, auto-production – the submerged question threading its way through Kant's aesthetics of freedom and historicality. Parergonal logic accedes to a certain historicality by means of its setting in motion an indeterminacy that halts logocentric closure; but it does so in the absence of freedom and autonomy. Yet it is autonomy that is both threatened and triumphant in the drama of the sublime in Kant. Now we can make some headway with Derrida's avoidance of the questions of autonomy and historicality in his ultimate working of the frame of the aesthetic if we register the thought that for him autonomy, as it is in Kant, is but another version of auto-affection, of hearing-oneself-speak. The structure of auto-affection consists of '"giving-oneself-a-presence", of mastering all exteriority in pure interiority, by assimilating and idealizing it, by mourning its passing'.[31] Throughout both 'Economimesis' and *The Truth in Painting* Derrida persistently tells us that in analysing beauty and aesthetic judgement we are on the track of the work of mourning. For example, 'It is in poetry that the work of mourning, transforming hetero-affection into auto-affection, produces the maximum of disinterested pleasure' (E, 18). Or: 'Of the par-

ergon – get one's mourning done. Like the entirely-other of hetero-affection, in the pleasure without enjoyment and without concept, it provokes and delimits the labor of mourning, labour *in general as* labor of mourning' (TP, 79–80). Auto-affection, as an operation of idealizing the other, thereby making the other fully introjectable and masterable, is like the labour of mourning as described by Freud.[32] In so-called succcessful mourning the other is assimilated, idealized and interiorized. Since this interiorization is also memorization, then mourning is the work of interiorizing memory – *Errinerung*. As interiorizing memory, mourning succeeds only as the suppression of the otherness of the other.

Derrida uses the image of mourning as a paradigmatic image of labour (as opposed to creation) in general. Thus we are to understand the full implication of the 'assault' on the thing by the metaphysics of production, which for Derrida is metaphysics as such, through the cannibalistic intro-jection of the wholly other, the dead other, by the mourner. Derrida contends that the work of genius, the act of freedom by means of freedom, is the act of idealizing the other, of refusing the other's alterity, its death. Equally, my original analysis of Kant's account of sublimity can now be regarded as claiming that it illegitimately transformed hetero-affection into auto-affection. Conversely, parergonal logic, as the delimiting of auto-affection, limits the act of mourning, lets one acknowledge the death of the other as other, as both part of me and as forever different from me, and move on. And, again, the sublime represents just that non-idealizable other. Derrida's practice almost everywhere involves demonstrating the limits of interiorization, the moment of materiality or withdrawal (what cannot be idealized or interiorized) that conditions the act of idealization, the act of sense making or meaning, that denies in its essential movement what makes it possible.

For Derrida, then, autonomy and auto-affection are the paradigmatic forms of the metaphysics of presence; and the deconstructive sublime is the introduction of an irreducible heterogeneity that both delimits and constitutes the possibility of self-consciousness. The difficulty, then, is this: in tracing the sublime we have discovered that the sublimely other is the autonomous other, and that the scene of the sublime, its narrative, is of the life and death battle between two autonomous selves. This yields Derrida a point of proximity to and distance from Hegel. And, as we have already seen, Derrida distances himself from Hegel on the grounds that in the Hegelian battle, the battle for recognition where the self discovers itself other to itself, the ultimate non-idealizable heterogeneity, death, is *Aufhebung*; dialectical sublation, then, is the ultimate labour of production and mourning, the ultimate cannibalism and assault.

And yet. The Hegelian analysis directly concerns the question of auton-omy (the chapter on self-consciousness is subtitled 'Of dependent and independent consciousness'), and the opening of self-consciousness to

historicality, to its own historicity. This is not the place to engage in a detailed reading of Derrida on Hegel's dialectic of master and slave, which I have begun to attempt elsewhere.[33] Rather, in deference to the question of sublimity, I want to focus on his handling of the question of risk, that is, the removing of the parergonal frames that represent the 'safe place' of Kant's and Derrida's discourse of the sublime.

Again, what Derrida objects to in the Hegelian account is the way in which all loss, all sacrifice, is amortized, fed back into the system, profited from. Speculation speculates on death and gains from it. In *Glas*, however, in the course of repeating this line of argument against Hegel, Derrida acknowledges that the *logic* of the battle, especially in the early Hegel, does not have this characteristic. The risk of life is real:

> In effect I can make an attempt on others' lives – in its singularity – only in risking my own. To posit oneself as consciousness supposes exposure to death, engagement...'When I go for his death, I put into play my own proper life.' This putting...must, as every investment, amortize itself and produce a profit; it works at my recognition by/ through the other, at the posit(ion)ing of my living consciousness, my living freedom, my living mastery. Now death being in the program, since I must *actually* risk it, I can always lose the profit of the operation: if I die, but just as well if I live. Life cannot stay in the incessant imminence of death. So I lose every time, with every blow, with every throw. The supreme contradiction that Hegel marks with less circumspection than he will in the *Phenomenology*.[34]

Ignore the question of circumspection. What is the contradiction? It is in accordance with the same logic that states that if the non-arrival of meaning is a condition of arrival, then in a sense even when meaning arrives it is fraught with its potential of not being there. This now becomes: if risk is real, then the possible loss of life and meaning is constitutive of self-consciousness, tormenting it with an enduring drift. Death, loss, haunts Hegel's system; shadows it abidingly. As soon as the risk of life is included, then that risk, and its possible result – death – must adhere to the system. Risk and death are cancelled *and* preserved. Derrida states this explicitly: 'Absolute appropriation is absolute expropriation. Onto-logic can always be reread or rewritten as the logic of loss or of spending without reserve.'[35] Derrida intends this statement to entail an inviolable either/or: either the dialectical overcoming of death – absolute appropriation; or spending (risking) without reserve – absolute expropriation. Yet if the logic of the one can *always* be reread or rewritten as the logic of the other, implying the essential indeterminacy of the logic in question, then the either/or collapses: there is never either absolute appropriation or expropriation, but always only a movement between them. That Derrida

appears to generate the conditional logic of finitude from the mutual can-
cellation of two absolutes might suggest that, as in Kant, finitude is being
comprehended as failure, as the non-correspondence between us and an
infinite ideal. Let us ignore this possibility for the present and ask again:
what is the contradiction?

If there is a contradiction here, it is not in what is said by Hegel or
Derrida. It is rather a contradiction between what is said and a presump-
tion, let us call it the standard reading of Hegel, that what is said intends
the opposite of what it says. The risk of death for the sake of recognition
rehearses a structural moment of self-consciousness. Its aim is not to dem-
onstrate that self-consciousness is constituted in and through the recog-
nition of the other, an autonomous recognition that, because autonomous,
is forever beyond the will of the self; the demonstration is of the con-
ditions through which that dependence becomes recognized, and its truth
attained; recognition does not constitute the relation between self and
other, the heteronomous conditions for autonomy, but acknowledges it.
Autonomy, independence, is the (forever excessive) 'gift' of the other; it
depends on the other's free recognition; and it is because the other's
recognition of me cannot be willed, demanded or obligated by me that
I am dependent on the other. Indeed, Hegel takes great pains in the
Phenomenology to emphasize the *asymmetrical* structure undergirding
mutual recognition: recognition of the judging self by the evil self does not
directly or immediately bring forth recognition from the judging self; the
confession of guilt by the evil self, its moment of coming into its relation
to the other, is left hanging.[36] Recognition is always a risk, an exposure of
the self to the other; and being recognized always a gift. This asymmetri-
cal structure is directly analogous to the relation between artist and work
in the creation of exemplary items. So the risk of life, like the risk of cre-
ation, is conditioned: an action done for the sake of freedom. One risks in
order to be at risk. Risk is the acknowledgement and activation of finitude;
risk is the self-conscious act of self-dispossession; and disinterestedness is
but the aestheticization of risk in a passive mode, the exposure of subjec-
tivity to what solicits and confirms it (beyond itself).

The exteriority of the self to itself, its being itself only in and through
absolute otherness, as a self-consciousness, as an autonomous being, opens
the horizon of historicality; history being the manifold forms and battles
for recognition, for independence, freedom. And this too Derrida knows:
'...the ethical body must incessantly repeat the spiritual act of its upsurge,
must always be reborn, must always recall itself to its name and its free-
dom.'[37] Always.

So Derrida knows that even when Hegel tells the story of Antigone he
is telling the story of this upsurge, the risk and the interruption of history
that makes it possible. Only the story of Antigone is different; unlike the
master and slave of the original upsurge and interruption (which is a

phenomenological abstraction for Hegel, ahistorical and structural in status), she dies. 'Nothing should be able to survive Antigone's death. Plus nothing more should follow, go out from her, after her. The announcement of her death should sound the absolute end of history. A glaze(d), virgin, sterile transparency. Without desire and without labour.'[38] This vision of Antigone parallels exactly the 'comical' perception of death in the *Phenomenology* presented above: death must not be allowed to mean, to be a source of meaning, a means toward meaning. 'Properly' speaking, death is the cancellation of meaning, its annihilation.

But can it be? Can the other on whom we depend vanish utterly, without 'trace'? Has Antigone no mourners? Does no one recognize her, her life and her death? Is her death sheer nothingness, absence, without shadow or echo? In saying this is Derrida posing an absolute, *unconditioned* exteriority against Hegelian interiority? Antigone dies. She sacrifices herself, accepting her (tragic) fate. We are overwhelmed with pity and terror, as the spectator on the scene of the sublime is overwhelmed with terror, fear, anxiety and a dissolving moment of pleasure. In the sublime too there is a sacrifice, but a safe sacrifice, a sacrifice that is an *anamnesis* of that sacrifice of self for the sake of the ethical totality, the sacrifice and risk that could never know profit or restitution, the sacrifice that is the acknowledgement of self in otherness, the fatefulness of that. The sacrifice of the imagination for the sake of reason, the suppressed moment of the other in us, is other than this: safe (TP, 130–1). Derrida would like to attribute this law of sacrifice to Hegel too. But it is not Hegel who prescribes and calculates Antigone's death, her sacrifice. Indeed, from the very beginning of his career Hegel opposed considering sacrifice in terms of an act of expiation for sin, as an act to be performed in order to gain some recompense. For him, sacrifice is the essential practice of folk religions; it is an act of love and gratitude. There is no reason to believe that he changed his view when he came to consider the fate of Antigone; the dignity he shows her derives from his perceiving her sacrifice as an act of love ('I was born to share not hate but love', line 523), which is a recognition of the ethical totality to which she belongs. To calculate her sacrifice, to treat it as an investment – for the sake of, say, eternal salvation – would be to deprive it of the ethical force that prohibits its subsumption under Christian and Kantian ideas and ideals of expiation and recompense. (Creon, conversely, in detaching law from love, structurally sets life against death, consciousness against memory: 'Then go down there, if you must love, and love/the dead. No woman rules me while I live', lines 524–5.)

Hegel acknowledges Antigone's death, mourns it and delimits that mourning by acknowledging it as constitutive of his fate and ours. The *Phenomenology* is indeed a work of memory and mourning; we are not done mourning Antigone, acknowledging the dependence of our discovery

of freedom and the meaning of freedom on her sacrifice. The sublime is the recognition and non-recognition of that fate; an *anamnesis* that remembers, repeats an earlier violence, but idealizes it, makes it safe, and hence forgets what it is remembering and repeating; and in that forgetting, that non-recognition, refuses to mourn or remember, refuses death.

As Philippe Lacoue-Labarthe reminds us in his pointed analysis of the sublime's subjectivist repetition of tragedy, Aristotelian pity and terror were not psychological notions, but political concepts. 'Pity refers to what the modern age, under the name of compassion, thinks of as the social bond...: terror refers to the risk of the dissolution of the social bond, and the pre-eminent place of that first social bond which is the relation with the other.'[39] Terror belongs to the 'first social bond', the relation to the other, because the other represents a conditioned absolute power over the self, a power which if not recognized (the conditional moment) and acknowledged, becomes an alien force, a blind fate, acting against it. All recognition is risk, and all risk sacrificial; but there is no law of sacrifice. Which is why terror belongs both to the first social bond and to the risk of the dissolution of the social bond.

A refracted echo of the refusal of tragic politics is dimly perceptible in Kant's own writings. It does not seem wrong to say that for him the fundamental perspectives designated by the beautiful and the sublime correspond to the perspectives of the philosophy of history and politics respectively.[40] The philosophical historian, in asking the question whether the human race is constantly progressing, must, in order to answer that question, take up the 'disinterested' stance of the 'spectator'. From this perspective the great revolutions of past and present (it is the French Revolution which is the immediate focus of Kant's analysis), with all their 'atrocities' and 'miseries', appear as a 'game' to such a degree that while no sensible man could contemplate their repetition, even if success were guaranteed, they nonetheless find 'in the hearts of all spectators (who are not engaged in this game themselves) a wishful participation that borders closely on enthusiasm, the very expression of which is fraught with danger'. The philosophical historian takes up the stance of the aesthetic observer in order to transform what is empirically ugly and monstrous into beautiful 'historical sign(s)' that reveal the unfolding teleological progress of the race. It is that stance that blocks the expression of the enthusiasm that is fraught with danger — the danger of real participation. Those same events, when surveyed from the perspective of the 'Ideas of human justice' fill the soul only with 'horror'.[41] Kant's refusal of the 'suppressed' political is given by this extreme separation of the beautiful and the sublime, the historical and the political: revolution can be affirmed only as an aesthetic phenomenon corresponding to the framing of the beautiful; in its reality, in its true terror, it is always contrary to the dictates of morality — morally, we must be horrified by the executions of

the French monarchs. To act against given law is necessarily to act against reason. Tragic politics thus becomes an impossible site of action in Kant; nor is this surprising if action must be lawful. The political and tragic sublime, the sublime of a tragic politics, becomes merely aesthetic in Kant, and the aesthetic sublime a 'safe' morality of reason whose safety is an aestheticization of the politically sublime, that interruption of history for the sake of another history, the repeated upsurge of the ethical body that recalls it 'to its name and its freedom'.

Sublime fear and pleasure are subjectivized, internalized versions of a political reality that can no longer be lived, of the risks of a political and historical life that are foreclosed and refused; in part legitimately, since without the foreclosure of Greek ethical and political life self-consciousness and freedom could never have become part of our self-understanding; but also illegitimately, since the form in which self-consciousness becomes manifest involves a disavowal and occlusion of its grounding conditions. The sublime is the historical fate of a tragic politics whose oblivion – caused by what historical forces? – is constitutive of the modern predicament, the predicament of modernity. A predicament rehearsed and repeated, sedimented and forgotten, in the sublime, Kant's sublime, and the deconstructive sublime. Our need to remember and mourn is profound.

To be sure, deconstructive readings enact, perform, the sublime interruption of the texts of the tradition; in those readings the phenomenal grasp of the imagination is sacrificed, deconstructed, in order that hetero-affection can be acknowledged. Deconstruction is the sacrifice of mastery, the work of self-dispossession. Further, Derrida would have no direct reason for contesting my reading of Hegel; it represents a precise mirror image of a significant element in his reading of Levinas.[42] The issue concerns the meaning of the aesthetic sublime, its interpretation, or better, the need and the necessity for interpreting it, knowing it, comprehending it. Let me concede that the price of 'knowing' the sublime as the sedimented memory of a tragic politics reduces its heterogeneity, gives it and the history of which it is a part an impossible unity. It does not follow from this concession that this history is not necessarily implicated in what gives deconstructive readings their force, that the aesthetic and deconstructive sublime is not *also* this history. Interpreting the deconstructive sublime is discovering its (Hegelian) substantiality. In conceding that this substantiality suppresses the alterity of the subjectivity it informs, the fundamental aporia of subject and substance is revealed. It is their belonging together and incommensurability that inscribes our predicament: what gives meaning and force to deconstructive readings, the efforts of aesthetic modernism, is a history that can only be comprehended in a reflection complicit with what has driven political praxis into the precincts of the aesthetic. That *complicity*, confessing it, is the

acknowledgement of the impossibility of philosophical clean hands, *an acknowledgement of guilt and responsibility beyond the confines of the will.* This complicity and guilt is the key to Adorno's reading of the modernist sublime. In absolutizing Antigone's death, in ignoring its conditioned and purposive character, Derrida inters her life with her death, prohibiting the appropriation of her act, the mourning that is both love and guilt. In its fidelity to the claim of the aesthetic sublime, which we shall see is not a structure of originary withdrawal and hence not beyond innocence and culpability, deconstruction makes this predicament unknown and unknowable. It is that refusal of self-consciousness, of sacrifice and guilt, that keeps the sublime interruption of metaphysics aesthetic.

The aestheticization of the sublime installs us in a condition we cannot recognize; to repeat our original reading of Kant in a different way, it disavows its own historical conditions of possibility, which is our history (a history, we shall want to say, that must be construed in order that it can be denied). This makes the other determining us, the very history which turns tragic politics into the sublime, unknown. Derrida appropriates this unknowing, transcendentalizing it, making it the unknowable condition of presence. He repeats and regularizes, in the form of double reading, the unknowing of the aesthetic sublime.[43] To be sure, this unknowing, because it also acknowledges the law of dependence, has the capacity to unsettle whatever system of law that would attempt to totalize experience. So Derrida says: 'deconstructions have always represented...the at least necessary conditions for identifying and combating the totalitarian risk...'[44] The totalitarian risk is the risk of the coming into being of a totalitarian regime as a consequence of principled, metaphysical totalization, even the principle of freedom. On this account no discrimination is made between 'good' and 'bad' acts of totalization since *qua* acts of totalization all entail the same risk. A rigid duality between totality (history as evil) and what interrupts it (the aesthetic/deconstructive sublime as ethical innocence) is thereby generated, with the consequence that all possibilities of aporetic totalization are eliminated. In Derrida, reason does not limit itself, become self-limiting, through recognition of what conditions it, but is blinded.

Derrida fails to ask after the possibility whereby the necessary conditions for undoing the totalitarian risk, by virtue of their unknowing, simultaneously prohibit what would transform society. What if, to be more precise, the necessary conditions for combating the totalitarian risk prohibit a democratic politics that takes that risk by departing from liberalism's (illusory) agnostic stance towards the question of the good life? What if the necessary conditions for identifying and combating the totalitarian risk denude political action of *risk* by instantiating liberalism's prepolitical scepticism concerning the possibility of knowing the good, and hence of political knowing in general? What if, then, deconstruction's

necessary conditions for combating the totalitarian risk amount to no more than the *aesthetic* interrogation of modernity? Non-knowledge may be able to protect us from a future totalitarianism; but can it aid us combating the present?

In the name of what, then, does Derrida refuse labour and mourning, grief and struggle, risk and history? It is not the risk of death, the struggle with the other for the sake of recognition, that opens history for Derrida, but the 'there is', 'it gives' of the gift. 'So the gift, the giving of the gift, the pure *cadeau*, does not let itself be thought by dialectics to which it, however, gives rise. The giving of the gift understands itself here before the for-(it)self, before all subjectivity and objectiviy.'[45] The gift gives prior to risk or exposure. Without the possibility of loss intervening, the *pure* gift is given. There is painting.

I have been suggesting through my references to Derrida's infinite task – but also: his twisting away from the historicality of genius, the unconditionality of death and the gift for him, his providing a defence of the Kantian sublime against the Hegelian, his reading of the sublime in Kantian moral terms, his registering of an absolute duality between history as totality and its ethical interruption – that Kantian morality, a morality without knowledge, is anchoring his practice of reading; that for him, as for Kant, what is truly sublime is the moral law as the beyond of representation (which it is and is not for Kant). This is equally Derrida's self-description:

> I have on several occasions spoken of 'unconditional' affirmation or of 'unconditional' appeal. This has also happened to me in other 'contexts' and each time that I speak of the link between deconstruction and the 'yes'. Now, the very least that can be said of unconditionality (a word that I use not by accident to recall the character of the categorical imperative in its Kantian form) is that it is independent of every determinate context, even of the determination of context in general. It announces itself as such only in the *opening* of context. Not that it is simply present (existent) elsewhere, outside of all context; rather, it intervenes in the determination of a context from its very inception, and from an injunction, a law, a responsibility that transcends this or that determination of a given context. Following this, what remains is to articulate this unconditionality with the determinate (Kant would say, hypothetical) conditions of this or that context; and this is the moment of strategies, of rhetorics, of ethics, and of politics. The structure thus described supposes both that there are only contexts, that nothing *exists* outside context, as I have often said, but also that the limit of the frame or the border of the context always entails a clause of nonclosure. The outside penetrates and determines the inside. This

is what I have analyzed so often, and so long, under the words 'supplement,' 'parergon'...This unconditionality also defines the injunction that prescribes deconstruction.[46]

Derridean unconditionality repeats the *duality* of the beautiful and the sublime, the duality that separates history as nature (which becomes in Derrida 'text' or totality) from the demands of morality, the moment of sublime alterity. The moment of alterity gives and ruins transcendental understanding in Kant's sense because it follows the path of the primacy of practical reason, a primacy required by the supreme authority of the moral law. As the 'fact of reason' the moral law affects reason from without while being its grounding condition. Thus the self-affection of reason whereby reverence/respect/fear (the affective responses to the sublime address) for the moral law becomes operative, appears, is simultaneously a work of hetero-affection. *The 'yes' of respect is the re-mark of the original (non-appearing) 'yes' of the moral law itself.* It is that re-marking, that reproduction prior to original intuition, that ruins transcendental self-consciousness as self-presence. Kant simply took inadequate account of the fact that the affective states that make the moral law available in the first place by virtue of their secondary character prohibit those states from being consequences of a self-affection. The self is opened to its possibilities as self by what does not belong to it. Moral law and reverence/respect are the two essential moments of the 'schematism' of the ethical.

In so far as Derrida keeps the logic of beauty and the sublime separate he registers the categorial diremption of truth and goodness; and this he must do in order to sustain a 'non-sceptical' overcoming of truth as what can be presented. *Truth beyond truth (as representation) is not unconcealment but unconditional affirmation, yes and yes-yes.* What Derrida does not tell us is how it is that this unconditionality – which, remember, 'defines the injunction that prescribes deconstruction' – has come to be revealed as prescriptive for us now (at the closure of metaphysics?); or even, how it is that this unconditionality as the law of deconstruction is acknowledged as law other than through de facto reiteration.[47] The point is not just that, as Hegel has it, faith without insight is blind (a blindness perhaps too unnervingly close to Heidegger's affirmation of unconditional affirmation in the 30s), but that this faith is itself invisible in Derrida, not a judgement but the condition of judgement, the practice of reading that deconstruction is. Conversely, Antigone's sacrifice of mastery is grounded in law, her act, the love of law, revealing law as the work of love.

Unconditional affirmation must leave the site of tragic politics foreclosed. Derrida inverts the Platonic hierarchy, making the moral (or ethical in Levinas's sense) prior to knowledge and truth, following the path implicit in the primacy of the practical in Kant required by the supreme

authority ascribed to the moral law. In this inversion of Plato, which as an inversion retains the Platonic structure, politics remains as before: only hypothetical or conditional, a question of strategies and rhetorics. And history remains a kind of cave. Derrida's unconditional affirmation provides a weak insulation of sublime alterity from the immanence of history. It is this that grounds his (transcendental) forgetfulness, that licenses his refusal to mourn Antigone and his assumption of the role of a philosophical Creon, prohibiting Hegel from commemorating Antigone – letting her factical death determine the movement of his speculative reflection – as Creon prohibited Antigone from burying Polyneices.

Derrida's deconstructive sublime intrigues the interruption of history, but leaves its deformations and reformations subordinate as strategies and rhetoric. Within this scenario *failure* is no longer intrinsic to action, risk not quite so risky, and the burden of human significance, history and its struggles, always already sheltered within an unconditional affirmation. Can we acknowledge the sublimity of the moral law aright if we do not acknowledge Antigone's role in the history that precipitated its arrival? That it arrives as it does through our remembering of her? A memory always subject to the powers of forgetfulness, that stays alive only in virtue of the struggles that do remember and will not forget? Is not Hegel's gesture thereby political? Must we not acknowledge that at the very moment that politics becomes a historical site, then along with political praxis and judgement we require a political memory? That politics can only be historical by first being commemorative? And finally, that it is only in virtue of a political memory that the duality between (private) morality and (public) politics can be overcome?

What I have referred to as the 'safety' of the aesthetic sublime is the moment of unconditional affirmation. Of course, this is not the safety of transcendental knowing: it does not give us reality as a knowable whole; and hence it does not lead to or entail mastery or the suppression of alterity. Its safety is its exclusion of radical failure, a failure that would be co-constitutive of the 'it gives'. If radical failure were to adhere to the gift, then each gift would also be a negation responding to a condition of lack. In fact I shall claim that the notion of the (transcendental) gift must be dropped; nonetheless in phrasing the matter in terms of the conditions for radical failure (as opposed to transcendental 'safety'), a possible site for lack and negation is provided.

The pattern of the deconstructive sublime draws on the waters of modernism in order to transform Kantian morality, transform the categorical imperative into the unconditional gift, the gift of painting. But Van Gogh's painting is not a sheer gift, but a historical creation, an intervention and interruption of history, risking the loss of meaning *for the sake of* another meaning, another sense of what meaning and truth in painting

might mean. Derrida's dream of painting without truth is not quite Van Gogh's: his sublime, as we shall see, is a historically conditioned response to a certain conception of beauty. Thus his praxis is more knowing than Derrida allows: it engages the history of painting, and the history of which painting is a part, for the sake of another history whose potentiality is recognized and not recognized in the history of the present. The risk of the loss of meaning, a risk never fully recuperable, is for the sake of the other, for spiritual life, done in the face of the other, exposed.

4

Constellations of Concept and Intuition: Adorno's *Aesthetic Theory*

Adorno's philosophy is also a heterology, a search for the non-identical (with its concept) other. Like Derrida, Adorno regards idealism as the quintessence of philosophy, the devouring rage at all that is different from the self. Idealism is the 'belly turned mind'; even 'the august inexorability of the moral law was this kind of rationalized rage at non-identity' (ND, 23). Because it is idealism that represents the fulfilment of metaphysics, what Adorno terms 'identity thinking', then the overcoming of idealism requires an overcoming of the standpoint of the devouring subject: 'our aim is total self-relinquishment' (ND, 13). Negative dialectics and aesthetics are the two roads to self-relinguishment. The goal of the former is 'to use concepts to unseal the non-conceptual with concepts, without making it their equal'; this it can accomplish only by changing the direction of conceptuality, giving it a 'turn toward non-identity', which is the 'hinge of negative dialectics' (ND, 10, 12). Traditional philosophy thinks of itself as having an infinite object: God, being, the absolute. It is this belief that makes such philosophy particular and finite. Heidegger was correct in seeing that philosophy reduced its 'object' to a particular, a thing, thereby giving it the hope that the infinite might be captured, mastered through concepts. But in phenomenologically turning the philosophical thing into an infinite non-thing, nothing, the event of appropriation, Heidegger remained within the ambit of traditional philosophy. The substance of the changed philosophy sought by negative dialectics 'would lie in the diversity of objects that impinge upon it and of the object it seeks, a diversity not wrought by any schema; to those objects, philosophy would truly give itself rather than use them as a mirror in which to reread itself, mistaking its own image for concretion' (ND, 13).

Unlike Heidegger and Derrida, Adorno does not regard the search for non-identity as a continuance of transcendental philosophy beyond metaphysics. If traditional philosophy made itself finite, particular and conclusive, by reducing the infinite to a thing, then a changed philosophy, accepting its abandonment to things and history, would instantiate a 'bad' infinity (ND, 14). This bad infinity is for both Derrida and Adorno a kind of post-Hegelian Kantianism; however, while for Derrida this Kantianism represents the forever-to-be-repeated interruptive work of reading, for Adorno it is the not-yet arrived utopia of the concept.

Now Adorno avoids continuing the path of transcendental philosophy through a double acknowledgement of what transcends the concept. On the one hand all concepts, even the philosophical ones, refer to nonconceptualities 'because concepts on their part are moments of the reality that required their formation, primarily for the control of nature' (ND, 11). Even if the formation of concepts by the nonconceptual must be grasped conceptually, hence making that reflection complicit with what it is seeking to overcome, it remains the case that it is not concepts themselves that block non-identity but their formation, which is equally the formation of the subject employing them. This nonconceptuality, however, is not a quasi-transcendental item, such as *Gestell*, but the order and ordering of modern societies. For Adorno it is capital that now performs the crucial work of formation.

Secondly, and here again more like Heidegger than Derrida, Adorno conceives of the present as a kind of quasi-eschatological fulfilment of past history: 'Universal history must be construed and denied...No universal history leads from slavery to humanitarianism, but there is one leading from the slingshot to the megaton bomb' (ND, 320). Without a philosophy of history the present would be reduced to sheer actuality without potentiality, the principle of identity would be a blind fate forever ready to swallow non-identity, and the work of philosophy reduced to forever hinting at what eludes it.

Nonetheless, despite the *moments* of transcendence Adorno builds into his argument, they remain non-decisive precisely because they are complicitly conceptual, acts of philosophical mastery and domination. Unless some concrete intimation of non-identity existed, some experience of non-identity possible, then reflection's work would be indistinguishable from phantasy; or better, there would be no reflection. Adorno does not rule out the possibility of radical failure. Reflection does continue, we are solicited by the non-identical, but nothing guarantees this state of affairs. For a complex of historical reasons, modern, autonomous art categorially performs (or performed) this work of solicitation.

Adorno's aesthetics attempts dialectically and speculatively to weave together the experience of modern art as the suspension of identity thinking (in this he is like Derrida) with the moments of transcendence that

would allow us to comprehend it in order that a practical judgement upon the present may be had. In this chapter I want to immanently follow through Adorno's reinscription of the categories of aesthetics in accordance with the dictates of artistic modernism, saving his treatment of the modernist sublime, and hence his relation to Derrida, for chapter 5.

i Reinscribing Aesthetics:
Modernism, Autonomy and Synthesis

Adorno submits that 'art and art works are what they may become' (AT, 491; SAT, 533). 'Art,' he says, 'is different from empirical reality. Now this difference itself does not stay the same; it changes because art changes' (AT, 3). History transforms certain cult objects into art, and disfranchises other works previously considered art. As a consequence, philosophical reflection on art – what Adorno calls 'aesthetics' without, in so doing, committing himself to any typically aesthetical views on the nature of art – should take as its starting point the most recent artistic phenomena, rather than the other way round as is the case with history-of-ideas approaches to art. However, the most recent artistic phenomenon, modernism, is a reflective and critical form of artistic practice whose vocation is bound up with an insistent interrogation of the nature and meaning of art. Hence *Aesthetic Theory* opens with the corrosive problematic of modernism firmly installed: 'It is self-evident that nothing concerning art is any longer self-evident, neither in itself, nor in its relation to the whole, not even its right to exist' (AT, 1; SAT, 9).

Modernism is bound-up with the autonomy of art from its earlier cult functions, its belonging to societies whose norms were firmly metaphysically or theologically underwritten. Art participates in the disenchantment of the world, albeit not unequivocally; it extends the destruction of all natural boundaries, all 'given's' and all foundations that Marx claimed was the civilizing work of capital. 'The ground of modernism is both the absence of a ground and the explicit normative rejection by modernism of a ground, even if there were one' (AT, 34). Art's will to autonomy, its forsaking of grounds (that, anyhow, have disappeared or been withdrawn) and its normative rejection of them, forces art to negate not only previous artistic styles and practices, but equally tradition itself. This negation has a twofold structure. On the one hand, the negation of tradition is motivated by the search for what would make a work of art purely and just art and nothing else, without of course ceasing to be art (by becoming, say, pure decoration).[1] In so far as tradition is a sedimentation of previous answers to the question 'What is art?', and in so far as those sedimentations include heteronomous determinations of art, then it is only through a critical engagement and reflection on tradition

that art can achieve autonomy. On the other hand, since the very attempt
to achieve autonomy presupposes that there is an essential nature proper
to art, that what is inside and outside art can receive a determinate answer,
then this project as a whole was doomed to failure. As Derrida showed,
the essentially inner nature of art can only be grasped through its relation
to the outside; the relation between what autonomously belongs to art and
what is heteronomous is an internal relation. Hence the prosecution of the
search for autonomy becomes just the negation of the tradition, that is,
the negation of all that art *has been* determined to be. In this way the his-
torical search for autonomy is transformed into a purely, and apparently
therefore empty, temporal adventure; art is forced into a paradoxical
search for novelty. Paradoxical because the concept of modernism, so
defined, is privative, 'indicating firmly that something ought to be negated
and what it is that ought to be negated' (AT, 30); without, however, there
being a comprehensible terminus to this quest. The negatively defined
search for autonomy through novelty defines achievement as the attain-
ment of novelty; which is equivalent to saying that only what is future,
what is not-yet, is art. Hence art cannot be realized. This is what Adorno
means when he says 'The new is the longing for the new, not the new
itself. This is the curse of everything new' (AT, 47; see also 246–7, 339).
Because the new of artistic modernism is conditioned by its critical func-
tion, it stops being a truly historical category, a category spelling histor-
icity, and becomes an 'invariant', which is its weakness (AT, 383). In so
far as novelty identifies history's not unfolding, it is no longer novelty but
the sign of the rigidification of history.

Taking insufficient account of the fact that 'achieving' novelty, if only
for a moment, is the achievement of something, this familiar story is too
severely formal, too one-sided and abstract, even if this abstraction itself
defines the limit of modernism's critical engagement with modernity.
Adorno calls the temporary achievement of novelty 'non-identity'; non-
identity, at this juncture, defining the case in which a work is art but in a
manner not positively defined, determined or legislated by the tradition.
Non-identical works are art without being what art has been. Such works
are extensionally equivalent with Kantian works of genius; they negate
previous accounts of what it is to be a work of art and make enigmatic
original sense. Adorno's thesis is that we can only understand the claim of
art, the cognitive claim of aesthetic culture in modernity, if we can capture
and comprehend what the claim of non-identity is. In claiming that the
search for novelty can be substantively reformulated as the search for
non-identity, Adorno is not suggesting that this project is any less para-
doxical than its formal equivalent: 'the new wills (*intendiert*) non-identity'
in willing its rejection of grounds and departure from tradition; but, 'by
willing, [art] inevitably wills identity. To put it differently, modern art
is constantly practising the impossible trick of trying to identify the

non-identical' (AT, 33). Non-identical works only succeed to the extent that they exceed their intentional ground.

Such an abrupt valorization of aporetic modernism appears illegitimate; the privative concept of modernism is abstract, and as such provides the non-identical itself with only an abstract and privative sense. Adorno agrees. He regards art's will to novelty as the 'aesthetic counterpart (*Signum*: sign, token) to the expanding reproduction of capital' (AT, 31; SAT, 39); modernism is the critical principle of modernity in art, and less. The abstractness of the will to novelty reveals the commodity character of art (AT, 336); it is this abstractness, the very restlessness of capital itself, this production for the sake of production, that gives to modernism, in its earliest theoretical articulations in Baudelaire, 'a fatalistic ring. The new is intimately related to death' (AT, 31). As privative, modernism must foreswear grounds and positive ends; but because only privative this revocation of grounds becomes an increasingly empty gesture, a futile radicalism.[2]

Sometimes Adorno will attempt to redeem the abstractness of modernism directly; for example, he argues that abstractness in art signals art's withdrawal from objective reality on the grounds that nothing remains of the objective world save its death's head: 'New art is as abstract as the real relations among men' (AT, 45). For a thought like this to have force, which after all offers to art only the status of a deferred mimesis, Adorno needs to give substance to the deferment; and more, to tie together art's autonomy and deferment into a more than privative concept of the non-identical.

Adorno's central strategy for establishing such a connection runs through the Kantian anatomy of art; the Kantian analysis of art is true, but not as a metaphysics of the experience of art, but rather as a social inscription of the historical fate of art in modernity. Adorno takes Kant's characterization of aesthetic judgement to be a characterization of modern and/or modernist art itself, a move anticipated in Kant's own account of art works where, by a kind of contagion, the already established analysis of aesthetic judgement as judgement-like without actually being a judgement, as being a mimesis of judgement, infiltrates the characterization of works of art as being exemplary, and hence rule-governed-like, without there actually being any rule which is the one exemplified in the work. Perhaps the best inaugural way to get at Adorno's thought here is to say that he is struck by both the proximity and the distance between aesthetic reflection on the one hand, and judgement (the work of understanding) and practical reason (autonomous legislation) on the other hand; that it is as if aesthetic judgement involved a mimetic, and hence illusory, relation to these 'proper' activities of mind, and hence was being solicited, invited, to judge and to legislate while at the same time being prohibited from so doing. The proximity is a mimesis, while the illusion reveals the distance

that makes the mimesis not the real thing, not really judgement or practical legislation. The juncture of proximity and distance, mimesis and illusion, is the index or symptom of a difficulty; hence it is not aesthetic reflection as such that is problematic, but rather its curious doubling of understanding and practical legislation; a doubling that we saw in chapter 1 to be the issue in Kant's attempts to legitimate transcendentally aesthetic reflection. Transcendental legitimation for aesthetic judgements could only be had if they were subsumed under either understanding or reason; but the proximating subsumption could only succeed at the cost of undermining aesthetic judgement's difference and autonomy from understanding and practical reason. And, again, all this is quite integral to the strictly Kantian problematic of aesthetic judgement, whereby it is to form a bridge across the abyss separating understanding from practical reason, mind from nature, is from ought.

One way of putting this point is to say that the autonomy and heteronomy of each of our cognitive faculties is made difficult and problematic by the unresolved autonomy and heteronomy of aesthetic reflection; a difficulty that directly infects the presumptive valorization of autonomy over heteronomy. And this has been the leitmotif of our reflections throughout. So Heidegger's historical and epochal inscription of aesthetic autonomy challenged Kant's refusal of history and memory, while revealing art's modern and contemporary alienation from truth. Simultaneously, we contended that the glaring splendour of the object of remembrance in Heidegger seemed provocatively disconnected from our current predicament, a disconnection that was repeated in the failure of Heidegger to provide an account of the connection between art and technology sufficient to explicate the possibility of the former being a locus for thinking the latter. And this certainly suggests the possibility, to be prosecuted below, that Heidegger's exorbitant remembrance of Greece is also a refusal of memory, a screen memory for something worse.

Derrida, in contrast, lets his accounting be governed more fully by the exigencies of Kant's text and its inner problematic; and this leads him to reveal the immanent collapse of art's claim to autonomy, and further, the dependency of the autonomous inside on the heteronomous outside. Nonetheless, we could not help but note that that demonstration failed to account for its own discovery; hence the claim for autonomy and its collapse ended by being an index only of itself – a demonstration of the closure of the metaphysics of presence without either the history of being or the epochal inscription of technology. Derrida's distancing of himself from Heidegger leads him to forgo history, and so leave unknown what enjoins presence (even more than it is unknown in Heidegger). From our present vantage point we might well suspect Derrida too of a refusal to know and to remember.

Further, in the case of both we saw how their various attempts to

undermine, limit, or go beyond aesthetics came to be marked by a dis-
tinctly and avoidably Kantian element. And this should lead us to the
suggestion that while each, differently, was correct in their desire to de-
aestheticize art and aesthetics, their sense of what is wrong, of what our
situation is, is mistaken; but mistaken in a very precise way, for if it is
indeed Kantian conceptual figures – genius, *sensus communis*, the sublime –
that return to haunt their endeavours, then, in a sense to be elaborated,
our actual situation must itself be more Kantian than the stories of tech-
nology or the metaphysics of presence can reveal or accommodate. And
this is just the hypothesis that Adorno pursues; his strategy of reading
Kant's aesthetic categories as the historical categories of modern art is just
the attempt to comprehend historically the aporiai of Kantian aesthetics,
which is coeval with the aporiai of the Kantian system as whole, without
transcending or dominating the configuration of the categories of mod-
ernity with categories drawn from elsewhere.

Here is a prima facie unpromising remark for surveying the Kantian
constitution of art: 'Aesthetics cannot hope to grasp works of art if it treats
them as hermeneutical objects. What at present needs to be grasped is
their incomprehensibility (*Unbegreiflichkeit*: inscrutability)' (AT, 173;
SAT, 179). The most natural assumption about works of art for us is that
they require interpretation, deciphering, that there is, as Gadamer would
insist, a play of familiarity and strangeness, of knowing and unknowing in
our original confrontation with a work. And that would appear to entail
that what is required is interpretation. It is, however, equally the case
that modernist works of art often function through carefully designed
strategies for refusing, or at least halting, the work of interpretation.
Further, it is generally held that an interpretation of a work is never equal
with it, that, at best, interpretation allows the work to be 'experienced',
allows the interaction between spectator and work to take place. And that
would appear to be equal to the claim that interpretation is for the sake of
what is not commensurable with or reducible to interpretation. This is what
Adorno says: art works are waiting to be interpreted. To deny this claim,
to assert that nothing in art requires interpretation, 'would expunge the
line of demarcation that separates art from non-art' (AT, 186). Adorno
also claims, however, that 'the better one understands an art work the
more may it remove the enigma concerning some dimension; the less,
however, does it illuminate the enigma which is constituting the art work'
(AT, 177; SAT, 184). What happens to the constitutive enigma we will
discuss below. For the present it is sufficient to note that a work opens
itself up to interpretive reason because 'its enigmatic quality is a
deficiency, a condition of want' (AT, 186).

One way of collecting these thoughts together would be to say that
hermeneutical reflection on art works does not conclude with a subsump-
tive judgement, that the work of interpretation is judgement-like, but does

not actually issue in a judgement (except, perhaps, the non-subsumptive judgement: 'This is beautiful'). Entailed by this would be the thesis that what is specific to works of art is their quite distinctive form of incomprehensibility; an incomprehensibility that becomes manifest or prominent at the final moment of interpretation. That incomprehensibility is a consequence of art's distance from its proximate constitution by reason and understanding.

'To be sure,' Adorno states, 'works of art are like judgements in that they, too, effect a synthesis. But art's synthesis is non-judgemental' (AT, 180). Works of art unify their diverse elements by means of their forms; but the operation of these forms provides *less than* the unity accomplished through conceptual synthesis. Generally we take it that concepts subsume particulars under themselves; they insist that one (unique) thing is the same as another. And only so, says Kant, can we think; thinking is the recognition of individuals (intuitions) in accordance with what they are not *qua* individuals, namely, the same as other individuals, and hence different from themselves. The work of understanding is to bring intuitions under concepts, identifying individuals in terms of their (universal) properties or, in the application of sortals, in virtue of those same properties.

Nothing appears untoward in this. However, Adorno contends, we cannot comprehend the kind of claim that works of art make if we accede to this view, believing that things could not be otherwise, that this is all cognition, knowing and judging, can be. The initial evidence that ordinary conceptual comprehension and its extension in science is, somehow, untoward, not the final story, is provided by our acknowledgement that art works, in accordance with their inner dynamic, resist subsumption, identification, explanation – the brute subordination of the particular to the universal.

...the painter paints a picture rather than what it represents. Implied here is the idea that every work of art spontaneously aims at being identical with itself, just as in the world outside a fake identity is everywhere forcibly imposed on objects by the insatiable subject. Aesthetic identity is different, however, in one important respect: it is meant to assist the non-identical in its struggle against the repressive identification compulsion that rules in reality. (AT, 6; SAT, 14)

Conceptual domination, the repression and squandering of particularity and sensuousness, as we will see more fully below, as evidenced by technological rationality and capitalist social relations, is caused by the regimentation of reason by the drive for self-preservation under conditions of social domination until, finally, only instrumental reason and its

correlatives (inductive and deductive explanation, the correspondence theory of truth, etc.) are regarded as possessing cognitive worth.

The thesis that art is not simply different from conceptual understanding (and practical legislation) but a protest against its present formation derives, again, from the logic of distance and proximity governing the constitution of art in relation to understanding and reason. Evidence that such a logic indeed governs art would be provided by an account showing that art's autonomy from the demands of judgement and practical reason is enforced, that is, that art contain a heteronomous moment, that its autonomy is for the sake of heteronomy, its incomprensibility is for the sake of the concept, for the sake of reason and cognition. It would be true to say, however, that such evidence is not immediately forthcoming. After all, once art had established its autonomy from religion and its redemptive truths, once it was secularized, 'it was condemned, for lack of any hope for a real alternative, to offer to the existing world a kind of solace that reinforced the spell (*Bann*) autonomous art had wanted to shake off' (AT, 2; SAT, 10). Autonomous works, in positing well-rounded totalities entirely on their own, provide solace either by creating the false impression that the world outside art is equally well-rounded, or by appearing as a counter-realm to the non-unified world outside. Such impressions given off by autonomous works, and the corresponding views about art that follow from such impressions, fail to acknowledge the deficiency, the want and wound of art.

That failure of acknowledgement, the wound of autonomy, is for Adorno the point of departure for modernist art, where modernist art is understood as the critical, reflective comprehension and continuation of the project of modern, autonomous art. True art must challenge its autonomous essence (autonomously), must, that is, acknowledge that its capacity to produce wholes is grounded in its distance from empirical reality, and hence acknowledge its wholeness as illusory. 'They are riddles (enigmas) because they deny, as fragmented, what they really want to be' (AT, 184; SAT, 191). We are familiar with this tension extrinsically through the various attempts by art throughout this century to infiltrate itself directly into the real world, to break down the barriers between art and life. These attempts have failed.[3] Hence the dilemma art finds itself in today: 'If it lets go of autonomy it sells out to the established order, whereas if it tries to stay strictly within its autonomous confines it becomes equally co-optable, living a harmless life in its appointed niche' (AT, 337).

To comprehend modernist works of art is to comprehend the motions of this dilemma, the symptoms of the wound of autonomy, as an internal constituent of art works, indeed as constitutive of them, and hence constitutive of the claim works make. But since this claim is a historical claim it

follows that its establishment must be intensely problematic since, if autonomy is a wound as well as a condition for art's claiming, then art is a critique of what lies outside it. However, the only evidence offered for things outside art being such as to make autonomy a wound is the wound itself; that this, and this alone, is art's historical fate. Equally, however, this is the strength of the thesis; if art's autonomy is a wound, if art's autonomy inscribes an antinomic space, then this offers the best evidence we can have that the world outside art is disfigured by its repression or exclusion of what art works exemplify, of what their illusory wholeness is an illusion of.

ii Synthesis, Illusion and Non-identity

Art works are synthetic wholes; they synthesize a manifold; 'they have an immanent synthetic function which is to bring unity to the diffuse, non-conceptual, quasi-fragmented materials in artistic products' (AT, 423; SAT, 453). This unifying endeavour is the work of reason in art, art's logicality and conceptuality, and hence the sense in which art works are judgement-like. Nonetheless, art works are not judgements, and this in part because their syntheses occur through the medium of artistic 'form' rather than through concepts, propositions and syllogisms. Form is the central aspect of art, it is 'the law that transfigures empirical being (*des Seienden*)' (AT, 207; SAT, 216). The goal of this transfiguration is to render consistent and articulate the diffuse particulars that are a work's content (even though form itself is but sedimented content). But this is to say too little, for the kind of unity or wholeness after which art works seek is one in which the elements (particulars) composing the work are not determined, made determinate by the form synthesizing them. In Kant's terms, this is to say again that form must offer the opportunity for the imagination to survey an aesthetic idea, while not dominating the material in a manner that would engender closure or subsumption. And this again points to the question of works' incomprehensibility, their providing 'sensuous truth' (CJ, §51, 322) rather than conceptual truth. What does this incomprehensibility signify?

For Adorno everything turns on form's proximity to conceptuality in terms of its synthesizing function, and its distance from conceptuality in its restraint, its not subsuming the elements of a work in it or under it, and hence its not providing for conceptual determinacy or closure.[4] The simplest assumption as to why non-subsumption might be valued and desired is that something gets lost or repressed in subsumption (and in practical legislation, which in Kant is also a work of subsumption). Adorno contends that at present the dominant relation between universal and particular, theoretically and practically, is one whereby individuals are

subsumed under universals. Understanding, both theoretical and practi-
cal, is taken to be equivalent to subsumption, the mastery of individuals
by bringing them under concepts and laws. What is lost through such pro-
cedures is the sensuous particularity of the individual in itself. Sensuous
particularity has been lost to us by the way in which theoretical and prac-
tical reason have come to be understood as subsumption; and further,
once coming to be so understood, how they have managed to order and
arrange the social world in accordance with the dictates of that under-
standing. And this thought relates directly to the claim in chapter 1 that
Kant's difficulties arose from his reductive construal of what was and what
was not sense-perceptible.

The inexponible character of aesthetic representations, the unintelligi-
bility of works of art, derives from the fact that sensuous particularity has
been excluded from the work of theoretical and practical reason. However,
if theoretical and practical reason cover the possibilities of cognition, if
what it is for an object to be cognitively significant is for it to be either
conceptually understood or to figure as an element in an act of practical
reflection, where practical reflection is taken to operate in accordance with
generalizable procedures, then sensuous particularity cannot be cognitively
significant. The exclusion of sensuous particularity from practical and
theoretical comprehension, in virtue of what theoretical and practical
reason have become, entails its silencing, the impossibility of determinate
practical or theoretical judgements about it.

Aesthetic syntheses become a protest against this state of affairs if and
only if it can be demonstrated that to view things in accordance with their
sensuous particularity but non-judgementally is not a static accomplish-
ment of the progress of art, but a situation that art attempts to transform.
In other words, it is to claim that we misunderstand the achievement of
non-identity if we understand it in terms of a critical modernism that
regards the question of art as one that is purely internal to art, say a ques-
tion about the essence of art, and not thereby a question of what art is not.
The internal project of achieving non-identity in art is art's negotiation
with what has been art and with what is not art; or better, what art has
been, formally conceived, fails to be non-identical because the works of
the past become past by becoming discursively saturated; to become an
element of the tradition is to become known, cognized, subsumed. So the
rejection of tradition is a battle with cognition for the sake of (an other)
cognition. This accords with the thesis suggested at the end of chapter 1,
that aesthetic culture is significant through its power of resistance to pro-
gressive culture. We could make progress in this thesis if we could come
to regard art's illusory status as substantial and problematic in a way dis-
connected from traditional representational renderings of the problem;
that is, if we could come to regard illusion now as a historically engen-
dered and fully signifying feature of art works. However, this thought can

carry conviction only if it is attached to the account of artistic syntheses that Adorno's transformed Kantian story has been eliciting.

Adorno is relentless in his treating of art works as synthetic products with conceptual and intuitive moments. However, central to his transformation of Kant is his equally relentless reinscription of the terms of the synthesis, of what concept and intuition can be regarded as being. Adorno's point in figuring artistic practice as synthetic products while trans-figuring the terms of that synthesis is to reveal how the theoretical forms 'concept' and 'intuition', which now jointly inscribe the unreflected categorial determination of sense-perceptibility, are themselves the products of a history, are produced forms and hence sedimented histories, whose current mutual exclusiveness and interdependence requires reflection. Art *is* this reflection, which is what makes art philosophical and reflection on art always a 'second reflection' (AT, 490; SAT, 531), since in art synthesis has taken a different direction than in the world outside art; a direction in which what has been excluded from pure cognitive and practical syntheses gets reinstated. The transfigured terms of synthesis are this reinstatement, however aporetic and/or illusory that reinstatement might be.

Concept and intuition are rewritten by Adorno as form and content, spirit and mimesis, form and expression. In each case what is at issue is a questioning of the possibilities for comprehending the relation between universal and particular, where it is agreed from the outset that cognition is a synthesis, that there cannot be cognition without conceptuality. Further, Adorno concedes that as things stand the intuitive moment concerns visuality, sensuousness, particularity, immediacy and contingency; while the conceptual moment refers to meaning, language, mediation, universality and necessity. Because Adorno regards the constitutive components of artistic practice and aesthetic reflection in terms of universal and particular, and further conceives of their relation in terms of synthesis, his operative understanding of the problem of art is everywhere cognitive, a question of reason, rationality, judgement and knowledge. What Adorno challenges in the traditional view is that the duality of concept and intuition is closed and unmediated, that the moment of intuition always and everywhere lacks meaning (sense) and significance, and the moment of conceptuality lacks (sensible) givenness and materiality. On the contrary, it is just the *rigid* separation of concept and intuition, universal and particular, that Adorno sees art as questioning.

However, moving now in the opposite direction, although art is a reflection on the fate of sense-perceptibility, this does not entail that its work is narrowly epistemic. Art, as a social institution, as a form of social practice, has been determined by both internal and external factors in its role of engaging with the question of sense-perceptibility. Hence those determinations equally spell out an account of the fate of sense-

perceptibility outside art, that is, in non-artistic social practices, and in the operative rationality of those practices. In brief, to speak of the fate of sense-perceptibility is necessarily to speak of the fate of reason and rationality in modernity.

Now we have already seen that Kant attempts to explicate the difference between art and cognition (theoretical and practical) by insisting that in art the intuitive moment is primary over the conceptual moment. That primacy, captured in the thesis that aesthetic ideas are inexponible representations where thought is bodied forth to the senses, nervously reiterates the standard comprehension of concept and intuition at the very moment it is being thrown into question. If it is indeed an *idea* that is being bodied forth to the senses, then bodying forth cannot be brutely intuitive. The suggestion that art alters, say, the balance between intuition and concept, in fact hides the reinscription these terms are undergoing; a fact hidden by Kant's absorption of art into his faculty-based theory of judgement. Nonetheless, because we employ the language of concept and intuition as it is formed outside art in order to understand what is happening in art, we are naturally led to consider art as demanding a dominance of the intuitive: art ought to aim at visuality, a writer should 'show' what is meant rather than telling.

> The desideratum of visuality seeks to preserve the mimetic moment of art. What this view does not realize is that mimesis only goes on living through its antithesis, which is rational control by art works over all that is heterogeneous to them. If this is ignored, visuality becomes a fetish. Actually, the mimetic impulse also affects the process of conceptual mediation. *Concepts are indispensable to art as they are to language, but in art they become something other than shared characteristics of empirical objects.* To argue that concepts are interspersed with art is not the same as claiming the conceptuality of art in general. *Art is as little a concept as it is an intuition (Anschauung); and just for that reason does it protest against their separation.* Moreover the intuitivity of art differs from empirical perception (*sinnlichen Wahrnehmung*: sensory awareness) because it always points beyond empirical perception to spirit. Art is a vision of the non-visual; it is similar to a concept without actually being one. It is in reference to concepts, however, that art releases its mimetic, non-conceptual potential... *The falsehood opposed by art is not rationality per se but the fixed opposition of rationality to particularity.* (AT, 141–2, 144; SAT, 148, 151; my italics)

Success in sustaining this claim, in making good the thesis that the modernist work of art halts and overturns the definitional duality of concept and intuition, and hence the opposition of rationality to particularity, requires that we reconceive what these moments are.

Let us begin with the concept of mimesis, one of the most difficult in Adorno's œuvre. First and foremost it is necessary to insist that mimesis is a critical reinscription of intuition, of the role of particulars in cognition. In making use of mimesis Adorno relies, in a way he rarely openly acknowledges, on the semantic associations embedded in the term. Mimesis refers to particularity; but as a form of and refuge for mimetic behaviour mimesis construes the question of particularity as a relation, namely, of one particular to another. In Kant intuition refers both to the particular referred to in a judgement and the relation to that particular. So Kant introduces his concept of intuition this way: 'In whatever manner and by whatever means a mode of knowledge relates to objects, *intuition* is that through which it is in immediate relation to them, and to which all thought as a means is directed. But intuition takes place only in so far as the object is given to us' (A 19). If in judgement a particular is brought under a universal, if an individual uses a concept to appropriate a particular with respect to his cognitive and practical interests, in mimesis the situation is otherwise: one particular (the subject) appropriates another particular (the object) by likening itself to it. So one takes on the ferocity and power of the lion, in order to better hunt it, by likening oneself to it. That example, however, is not quite apt, for Adorno wishes to distinguish mimesis from magic. Once the distinction between mimesis and magic was made, then mimesis 'took on the appearance of a residue: it is as though it has long since lost its function which was tied up with biological layers of human life' (AT, 453).

'Mimetic behaviour does not imitate something but assimilates itself to that something. Works of art take it upon themselves to realize this assimilation' (AT, 162). Mimetic affinity is the primitive form of sympathy and compassion, which play a large role in Adorno's 'ethics'. And as an act of compassion is neither randomly contingent nor universally legislated, but rather the precise undoing of the duality presumed by those alternatives, so mimetic activity is modally anomalous. Mimesis is appropriation without subsumption; in it the appropriating subject likens herself to the object, reversing conceptual appropriation; it is a relation of particular to particular. In art this amounts to a nonconceptual affinity between a subjective creation and its unposited other. (What this amounts to for Van Gogh's shoes we shall see below.) This affinity is what gives mimesis title to be recognized as a form of cognition. As cognition, mimesis acknowledges the sensuous particularity of the other without dominating it. 'What mimetic behaviour responds to,' Adorno states, 'is the *telos* of cognition, which it simultaneously hinders through its categories' (AT, 80).

Of course, mimetic behaviour presupposes conceptual discrimination, the capacity to distinguish the characterizing features of the other. But Adorno never meant to deny mediation or conceptuality. In thinking the intuitive moment in terms of a mimetic potential he is, rather, calling into question the necessity of construing the appropriation of particulars as

subsumption and domination. Mimesis is never pure, never an immediate relation of particular to particular. Mimetic activity is always shaped by spirit.

Spirit, too, is a strange category in Adorno, elaborating elements from idealist aesthetics. As mimesis reinscribes intuition, so spirit reinscribes concept. If we consider conceptual articulation as that in virtue of which what is not meaningful is rendered significant, then Adorno's opening specification of spirit should not surprise us: 'The spirit of works of art is their plus or surplus – the fact that in the process of appearing they become more than they are' (AT, 128; SAT, 134; 'plus' and 'surplus' are the translator's elaboration). In explicating this plus or surplus, that through which a thing transcends its sensuous materiality and hence signifies, Adorno attempts to connect two apparently disconnected thoughts. On the one hand, spirit is not a separable item over and above materiality and sensuality, but rather their configuration, their form of togetherness, their synthesis; 'it transforms them into a handwriting' (AT, 129). And this connects with a structure that Adorno deploys from Hegel's *Logic*, namely, that of appearance and essence. Works of art appear, they are phenomenal beings; but what appears is essence, not as something below or under appearances and separable from them, but as their 'law of form' (AT, 138).

If Adorno stopped here his conception of spirit would be idealist since essence in idealist logic, as it is usually interpreted, refers back to the synthetic activities of the subject; this would make the law of form governing synthesis the work of the subject. But spirit is the law of form, not form itself. It is form that is 'the non-repressive synthesis of diffuse particulars' (AT, 207); as such, form 'is the consistency of artefacts that distinguishes them *qua* art from mere existents, no matter how antagonistic and disjointed that consistency may be' (AT, 205). While form, thus conceived, 'is a repository for all quasi-linguistic (*Sprachähnliche*) qualities of art works', it should not therefore be construed as opposing content, as in impositional theories of conceptual and categorial articulation; form is itself 'a sedimentation of content' (AT, 208, 209; SAT, 217). To claim that art is a sedimentation of content, a becoming form of elements that were content, is to claim that in art the logicality, the kind of conceptual consistency exemplified in works, is not a true logicality; art's logic still harbours 'an archaic unity of logic and causality' (AT, 199); which is to say, that in art the difference between purely logical or conceptual forms and empirical contents fails to hold. For unproblematic examples of this consider the temporality, the structures and modes of temporalization, in modernist novels or music; or the connecting of sound and sense, or sense and spacing, in modern poetry; or, more directly still, the spatializing, space-making, features in the work of a sculptor such as Anthony Caro. Art's rejection of abstract conceptuality, art's being abandoned to aconceptuality, is what engenders art's concern for visuality, its concern

for particularity and the non-identical. And Adorno will characterize this concern as spirit, in art, discarding its natural medium and becoming manifest in its opposite – materiality (AT, 173).

Spirit refers, then, to what gets articulated in the non-repressive synthesis of particulars through form. This 'what' will lead the question of spirit to the question of the truth of art, to be taken up in chapter 5. Now in saying that spirit pervades art as its truth content, Adorno is aware that he is still tied to an unwanted idealist conception, namely, that which conceives of the beautiful in art as the sensuous appearance of the Idea, where the Idea is the rational idea of self-determining personality. For Adorno, such a conception hypostatizes the course of spirit, making it subsumable under a logic external to it; aesthetics 'is not some application of philosophy but is philosophical in itself' (AT, 135). And this entails that spiritualization in art – although partaking of spiritualization generally, that is, partaking of the movement of rationalization, the immanent sense of that rationalization – that spelling out of the growth of consciousness, cannot be read off of a pre-formed logical system, but must rather be elicited from the historical determinations of art.

Adorno's precise referent in this claim is to the thesis that spiritualization is rationalization, the becoming of form as separable from its immersion in nature and hypostatized transcendence, and hence as what a priori ought to dominate, subsume and articulate, sensuousness and particularity. But this is not what has happened in art; art's participation in spiritualization has reversed its movement outside art. Adorno denominates this double movement the 'dialectic of spiritualization': 'On the one hand, spiritualization as the constant expansion of the mimetic taboo in art, which is the native soil of mimesis, is busy dissolving (*Selbstauflösung*) art. On the other, spiritualization is also the mimetic power that helps art works achieve identity with themselves, discharging all heterogeneity and thus reinforcing their image character' (AT, 136; SAT, 142). Spiritualization precipitates the autonomization of form, which is but another version of the sedimentation of content: the making of natural, theological (religious), metaphysical and related forms that once determined art from the outside into artistic forms as such. Art's participation in spiritualization, which here means first humanization as disenchantment, is its becoming autonomous, making traditional forms into art forms. In art, however, this movement is double: disenchantment entails the continuance of the mimetic taboo; but in this continuance the art work attempts to rid itself of externality, to become purely immanent. The consequence of this is an immersion in materiality, and hence a release of the mimetic potential whose repression spiritualization has enforced. So Adorno can conclude: 'By means of spiritualization, which is the radical domination of art patterned after the domination of nature, art corrects the real domination of nature' (AT, 166).

Where one might hestitate in this account is over the claim that what is

released is a mimetic potential, that the concept of a mimetic potential adequately transcribes the artistic transformation of intuition. The reason for this hesitancy is that there is an apparent tendentious line of argument running through Adorno that suggests that the mimetic relation, whose demise is the direct object of enlightened rationalization, should be reversed. It is here assumed that mimesis represents an independent, archaic form of cognition that survives only in art. Where this thesis goes wrong is in giving to mimesis a substantiality and independence it does not possess. Again, the question addressed by the concept of mimesis is that of the role of the particular in cognition; and one of the mistakes Adorno is attempting to denote through the employment of the idea of mimesis is that cognition, conceived of as subsumption, is innocent. However, there is no direct way in which we can simply see that subsumption is domination (other than through tracking down the negative effects of the operation of a presumptively neutral cognition, which would still leave unanswered the question why those effects should be the consequence of cognition itself and not, say, a certain application of what has been attained in it). For Adorno, the artistic modification of concept and intuition, when it succeeds in particular works of art and is critically comprehended, is the establishment of the thesis that theoretical and practical subsumption is domination.

In order, then, to further ramify the meta-critical transformation of intuition in art, Adorno goes on to partially identify the mimetic moment with expression. Expression, for Adorno, is not of either artist or object; on the contrary, expression is the 'gaze' of the art work, an 'objectification of the non-objective, (AT, 163), and of the 'non-subjective in the subject' (AT, 165). The conjunction of these two, the non-objective and non-subjective, leaves only what has been left out of the process of the mutual formation of subject and object, what rationalization has rationalized out of subject and object. The initial implausibility of this thesis receives correction when it is noted that Adorno ties the notion of expression, or better, focuses it, not on the obvious representational features of works, but rather on the formal characteristics of harmony and dissonance.

Harmony, unity, would be the triumph of spiritualization, the realization of the drive for non-violent synthesis. But what is being conceived of when this classical model of a realized work is proffered? What is the idea of success presupposed by this ideal of complete integration? And if this really is an ideal, how are we to make sense of its modernist rejection (without falling into naive romanticism)? It is at this juncture that the problem of illusion, for the sake of which we began this train of analysis, re-enters.

Works of art are illusory because they give a kind of second-order, modified existence to something which they themselves cannot be.

They are appearance, because at the end of a creative process the non-existent for the sake of which they exist is imbued with at least a discontinuous, intermittent kind of life. Art, however, can no more achieve the identity of essence and appearance than can our knowledge of reality. The essence that passes into appearance both shapes and explodes the latter. (AT, 160; SAT, 167)

The essence that should appear is the inviolable meaning of a sensuous particular: a thing's being and being-thus. But if essence did appear, if the gap separating essence and appearance were to close, then art works would not be illusory at all, but real things. If their syntheses were cognitive, then they would not be works but statements. If works of art were real unities their syntheses would be (real) theoretical or practical products. But throughout we have seen that we can only conceive of works on the basis of a logic of approximation and distance; their synthetic activity must be likened to theoretical and practical synthesis without being it. Exploding appearance underwrites works' antinomic status.

However else artistic illusion may have been thought, or indeed have been, prior to art's becoming autonomous, illusion now refers to the distance between art and empirical reality, where empirical reality is defined in terms of the kind of activities producing it and the forms of our knowledge of it. To employ a wildly over-simplified formulation, this entails that the synthetic achievements of modernist works of art are of what cannot be achieved in empirical reality. But this entails that works of art are not 'in' empirical reality – they stand at a distance from it; but if not in empirical reality, then, in a sense, not 'real' things at all. 'Illusion is not a formal but a substantive characteristic of works of art. It is the vestige of an injury that art seeks to undo (*revozieren*)' (AT, 157; SAT, 164).

Harmony, then, as an image of resolution and completion, of a dissolution of all that is heterogeneous to artistic form, becomes the mark of illusion, of the pretense of works being what they are not – real things. 'Harmony presents something as actually reconciled [i.e. the unity of rational form and sensuous particularity] which is not. In so doing it violates the postulate of appearing essence which the ideal of harmony aims at' (AT, 161). Illusion is injury because it registers the distance between art and empirical reality, and hence the consignment of non-violent synthesis to a domain independent of and marginal to the central domains of societal reproduction, that is, to the domains where real synthetic activities take place. This, and this alone, explicates the antinomy of autonomy, namely, that if art lets go of its autonomy it becomes immersed in and dominated by the forms of synthetic activity against which it is protesting; while if it remains within its autonomous realm it stays harmlessly independent, and hence socially idle (AT, 337).

Within art the sign of this antinomy, the marker for the fact that illusion is substantial and an injury, is present in the refusal of achieved harmony, that is, in dissonance. 'Dissonance is the truth about harmony. Harmony is unattainable, given the strict criteria of what harmony is supposed to be' (AT, 161). Dissonance, fragmentation, and the like spell out art's self-consciousness of its illusory character, of what harmony aims at and necessarily cannot achieve. Hence the desire for dissonance is a component of the revolt against illusion reflecting art's discontent with itself. Dissonance, however, is the same as expression, art's breaking through and acknowledging its illusory character, however illusory that breaking through is. If artistic synthesis, despite itself, is a counter-movement to the progress of rational synthesis; if art works aim to acknowledge what has been left behind in the progress of rationality, then art's injury is double: it is the injury of illusion, and the injury of what that illusion is for. What that illusion is for is at issue in the transformations that critical theory works on the terms constituting the achievement of reason's progress: concept and intuition. Expression, as the equivalent of dissonance, is another name for intuition. 'Expression,' Adorno states, 'cannot be conceived except as expression of suffering' (AT, 161; see also AT, 21). Suffering is the truth of intuition as the unsubsumable other of the concept.

iii Without Purpose

Form and content, spirit and mimesis, form and expression together constitute a 'constellation' around concept and intuition. This constellation of concepts does not attempt theoretically to replace what is originally thought through concept and intuition; rather, the constellation reveals the field of historical and social determinations that have been excised from the original terms of the analysis. Constellations are non-subsumptive reorganizations of a conceptual field; they unlock and 'decipher' the 'sedimented history' of an object that has been lost through subsumptive thinking (ND, 164–5). Constellations take the place of systematics. Constellations are philosophical 'compositions'; as such they are the philosophical equivalents of modernist works of art. We shall return in the next chapter to this likeness between philosophy and art, which strongly echoes the analogous likeness we have already seen at work in Derrida.

Thus far we have concentrated our analysis on the problem of synthesis, on Adorno's constellative reinscription of synthesis and intuition, on the question of theoretical synthesis. Another, more direct, version of Adorno's interrogation of the substantiality of illusion and its connection with the inscrutability of art works is to be found in his reflections on the transformation of practical synthesis in art. Here, too, Adorno wants to

point to the underlying social truth of Kant's hypostatized theoretical formulations.

In discussing Kant's formula that aesthetic reflection regards objects as internally purposeful without an external end over and above their internal ordering, it was noted how the non-subsumption of works to external ends had the consequence of making works analogues of ends in themselves. And it was in virtue of this analogue status that aesthetic reflective judgements could at least begin to claim universality for themselves; the very regard of an aesthetic object as not for any end or purpose external to itself, the disinterested gaze of the aesthetic attitude, offered to that regard a ground for claiming objectivity for itself. This connection between the lack of an external purpose and objectivity is in Kant's theory parasitic on the distinction he draws between relative ends, that are particular, and ends in themselves, Kant's version of ultimate ends, which ground claims to universality. Kant uses the formula 'purposeful but without a purpose' as a way of establishing his version of normative objectivity, namely, the link between ends in themselves and universality. This linkage, since it bespeaks just the sort of subsumptive thinking he is writing against, is of no interest to Adorno (but see AT, 18).

What does strike Adorno about Kant's formula is how it captures the becoming autonomous of art, that is, the very movement that led Kant to attempt to establish a new philosophical subject matter, namely, aesthetics (its novelty an adumbration of the figure of novelty it will generate). If, in the first instance, aesthetics reflects the disarticulation of beauty from truth and goodness as categorial systems, where the rise of modern science had already disarticulated truth and goodness (rightness), the consequence of that disarticulation was the autonomization of art itself. Hence what was played out in Kant's system in categorial terms and faculty psychology is worked out by Adorno in the more emphatic terms demanded by subsequent history, namely, art's autonomy. This is an important matter to which we shall have to return. Nonetheless, it explains the oft-noted homology between Kantian aesthetics and modernist art.

What requires elaboration in the Kantian 'purposive but without purpose' thesis is why being without purpose should approximate the norm of end-in-itself; and why that status should be accorded to *art*, to *things* that are works. According to Adorno, art used to be part of a praxis that sought to affect reality; subsequently, when rationality came to the fore, art had to go its own way, acknowledging that its presumptive praxis was an exercise in self-deception (AT, 202). Rationalization and disenchantment deprived art of its purposefulness; aesthetic judgement is a blurred reflection of this historical event. The ascription to works of art of a purpose hence came to signify the fact that they were dynamic totalities whose moments existed for the sake of the whole, while the whole had the purpose 'of fulfilling the moments or redeeming them negatively' Conversely, works were

purposeless because they fell outside the means–end relations and structures constituting the empirical world. These characterizations acknowledge that 'the relation between aesthetic and real purposiveness (*Zweckmässigkeit*) is a historical one: the immanent functionality of art works was determined by external conditions' (AT, 202; SAT, 210).

What remains unsaid in this account is why that apparently neutral articulation of art's purposiveness should so resiliently, and enigmatically, call attention to itself. To specify what remains unsaid here, reference again must be made to conditions external to art, namely, to what has become of practice outside art. Autonomy is but another term for art's purposelessness. Adorno reads autonomy as double: both as art's loss of a (direct) social purpose, and as art's refusal of the kind of purposiveness that has come to dominate society. Roughly, in a manner I shall return to shortly, Adorno's conception of modern societies is an amalgam of the Marxian and Weberian analyses, that is, Adorno reads the universal domination of use–value by exchange value as societal rationalization, and societal rationalization as a necessary condition for the domination of use–value by exchange value. Capital exchange relations just are the rationalization of economic life, the reduction of economic activity to means–ends rationality freed from extra-economic and extra-means–ends rational considerations. The universalization of exchange relations entails, as matter of social fact, the fungibility of all particulars, the principle that all things can be exchanged for other things. Nothing is irreplaceable, nothing an end-in-itself. Hence societal purposefulness comes to mean exchangeable, *having a price*. Which, of course, is precisely how Kant inaugurally specifies the distinction between relative and absolute value, autonomy and heteronomy, means and ends, in his 'modern' reformulation of the distinction between praxis and poiesis:

> In the kingdom of ends everything has either a *price* or a *dignity*. If it has a price, something else can be put in its place as an *equivalent*; if it is exalted above all price and so admits of no equivalent, then it has a dignity.
>
> What is relative to universal human inclinations and needs has a *market price*; what, even without presupposing a need, accords with a certain taste – that is, with satisfaction in the mere purposeless play of our mental powers – has a *fancy price (Affektionspreis)*; but that which constitutes the sole condition under which anything can be an end in itself has not merely a relative value – that is, a price – but has an intrinsic value – that is, *dignity*.[5]

The 'fancy price' of taste refers to the fact that having taste alone, however valuable, does not entail that its possessor has dignity. In that sense, the possession of taste is of relative and not absolute worth.

Our interest, however, was not in the purposeless play of the imagination, but in the purposelessness of works. Adorno directly connects art's purposelessness with, on the one hand, works being illusions (apparitions, non-existents), and, on the other hand, with that feature of works grounding their resistence to exchangeability:

> Non-existent apparition attaches to individual being; it represents, i.e. stands for, the unsubsumable. Thus, apparition defies the ruling principle of reality, which is the principle that all things can be exchanged for other things. By contrast, the appearing or apparition is not exchangeable because it is neither a torpid particular being, replaceable by other particular beings, nor an empty universal, subsuming and levelling specific beings in terms of some common characteristic. Whereas in the real world all particulars are fungible, so the pictures of art stretch out to everything for an other, which it would be, emancipated from the schemata of imposed identifications. By the same token, art – the *imago* of the unexchangeable – verges on ideology because it makes us believe there are things in the world that are not for exchange. Art must, through its form, on behalf of the unexchangeable, conduct the exchangeable to a critical self-consciousness. (AT, 122–3; SAT, 128)

Purposelessness can insinuate the idea of an end-in-itself only against the background of exchangeability. However, that purposelessness would lack substance if art works were not (apparently) synthetic wholes, products of a praxis that was akin to the transformative, productive practices outside art but for the fact that no 'really' usable thing is produced. Art works are exchangeable, purely so; but their form 'conducts' consciousness to an awareness of what lies beyond exchange.

Art works are particulars claiming us beyond our ability discursively to place them; they are, or more precisely appear, as excessive with respect to the regimes of empirical practice in virtue of which exchangeability reigns. This is what Adorno means when he claims that what is social about art is not its overt political or ideological stance with respect to reality, but its inner dynamic that puts it in opposition to society: 'Works of art are plenipotentiaries (*Statthalter*: envoies) of things beyond the mutilating sway of exchange, profit and false human needs' (AT, 323; SAT, 337). Art works refer us to use values, or to what use values might become, in opposition to exchange-value, through their empirical uselessness. Of course, as we shall see later, uselessness can register aesthetically only to the degree to which works' being without purpose approximates to a state of self-determination.

Three clarifications are necessary before we can proceed. First, in speaking of illusion, apparition, non-existence, Adorno is not engaged in

an ontological analysis of works; on the contrary, Adorno is refusing the ontological problematic of appearance, reality and illusion and offering in its stead a historical analysis. But this displacement is not a reduction of one form of questioning to another; rather it attempts to reveal how the original question can assert itself. Hence Adorno contends that the question whether the non-existent apparition *qua* appearing entity exists or is just an illusion prompts philosophical reflection, and *that prompting is the authority of works* (AT, 123). Philosophy, we might say, is now dependent upon the 'moment' of art for calling forth the sort of reflection that was once, presumptively, philosophy's.

Adorno directly connects art's cognitive authority with its purpose-lessness. The purpose of art is retained as an 'in-itself' feature of art works once their external purposiveness has evaporated. It is just this that makes art works enigmatic, that they attain to purposefulness, to meaning, despite (and because of) their evident lack of meaning. What becomes of art once its external purpose is gone? 'The enigmatic quality prompts art to articulate itself immanently, acquiring meaning by giving expression to its glaring lack of meaning [or: attains emphatically a meaningless meaning]. If this is so, the enigmatic quality is not final (*Letztes*); rather, every authentic work also suggests a solution for its insoluble riddle' (AT, 185; SAT, 192). That art develops the capacity, for however long, to insinuate the idea of non-identity occurs through the characteristic features of artistic production under conditions where art is deprived of social meaning. That deprivation we designate in art's becoming autonomous. Art would not be enigmatic if things were otherwise outside art. Art's purposiveness without purpose is enigmatic because purpose has itself become purpose-less, production for exchange without end, while artistic practice itself still has the idea of the 'work', a praxial production, before it. Art's enigmatic quality is the modern equivalent of wonder 'in the presence of the other' (AT, 184), the claim of the other (beyond exchange and subsumption) which it was philosophy's to instil. How Adorno works through this dependence of philosophy on art we shall examine in more detail in chapter 5.

Secondly, because Adorno regards the question of illusion and purpose-lessness as historical and social he can provide them with a set of social resonances that would be barred from an ontological analysis. In particular he connects art's afunctionality with a whole range of pre-artistic phenomena — fireworks, circuses, magic, festivals, etc. — that were themselves promises of happiness, reminders of what spiritualization was for but forgot. For example: 'The afunctionality of works of art has something in common with the superfluous tramps of all ages, averse as they are to unmovable property and sedentary civilization' (AT, 121). For Adorno this pre-artistic moment clings to art, hence explicating both the childish expectation that attaches to our anticipation of engaging with art works, and art's exposure to the moment of silliness, fatuity, kitsch (AT, 174–5).

Finally, and most importantly here, Adorno does not regard art's opposition to empirical reality – the opposition that it possesses as a consequence of its afunctionality – as entailing that art is not collusive with what it criticizes. Adorno registers this collusion and culpability in a variety of registers. Most significant amongst these is his contention that art's appearance of being in-itself purposeful is a *fetish* directly conditioned by the fetishism of commodities. More precisely, Adorno conceives of art works as absolute commodities: '[autonomous works] are social products which have discarded the illusion of being-for-society, an illusion tenaciously retained by all other commodities. An absolute commodity rids itself of the ideology inherent in the commodity form. The latter pretends it is being-for-other whereas in truth it is only for-itself, i.e. for the ruling interests of society' (AT, 336). Art's being a commodity is both a condition for its aesthetic substance, its capacity to be a vehicle of cognition, to be elaborated below, and the condition for art's ideological social status, its illusory appearance of being independent of the conditions of material production. Art works cannot help continuing the work of repressive reason since they 'contain the moment of synthesis which helps organize a totality' (AT, 423); and further, by pretending that this is not so through their existence in a separate domain, which they must preserve for the sake of their critical moment, their 'practical impotence and complicity with the principle of unmitigated disaster' (AT, 333) becomes painfully evident.

Art works are impossible objects: if aesthetic praxis were really transformative, then art works would be (practically or cognitively) 'true', that is, art objects would be worldly objects, not meaningless but meaningful, not purposeless but purposeful; if, on the other hand, they were mere objects or artefacts, they would be either just things or meaningless but purposeful. Works are meaningful, they enact a synthesis, but not discursively true; they are purposeful but without a practical purpose. Their meaning is a semblance of truth without domination; their purposelessness an image of use–value that cannot be exchanged. Their purposelessness is their form of resistance to exchange – a form that is harassed and subject to defeat. Their nonconceptual form is their form of resistance to identity thinking – a form that is harassed by the desire for meaning, for example in engaged or committed art, and by the will to interpretation. The autonomy of art is the plus, the surplus, the excess, the non-identical which allows identity thinking to continue unharassed. Art is the remainder, the result of the exclusions which allowed enlightened rationality and an autonomous economy to centre themselves without the encumbrances of the claims of sensuousness or teleology (the submersion of use–value by exchange value). In this way the Kantian thought that aesthetic awareness mimics the unifying work of conceptual judgement without however actually bringing the art object under a concept becomes both a conception of artistic practice, of how artistic form is to deal with its materials,

and a statement about the socio-historical predicament of art rather than an a priori account of it.

Three questions arise at this juncture. First, how does artistic practice relate to practice outside art? What connects and separates artistic and empirical practice? Secondly, what licenses Adorno in employing the Kantian analysis of art as a key for a social inscription of art? And thirdly, what are the philosophical repercussions of that reinscription? We shall take up the first question directly, saving our answer to the second and third for chapter 5.

iv Art, Technology and Nature

Earlier we argued that Heidegger's way of linking art and technology is inadequate to the task of explicating their unity and difference in a manner that would explain the possibility of art being a countermovement to technology. Adorno consistently regards the connection between art and technology as a direct one: autonomous art, especially as realized in modernist art, is just rationalization in art; and the rationalization of art is just the unleashing of aesthetic forces of production from social purposes external to art. Artistic technique hence becomes the repository of artistic purposefulness once social purposefulness has been rationalized out of art (AT, 308). Adorno's thought here is that aesthetic rationalization entails aesthetic nominalism: the revocation of ready-made principles of artistic production. In the absence of unequivocal aesthetic universals technique enters as a direct determinant of artistic production, progress and judgement: 'Technique alone guides the reflective person into the inner core of art works, provided of course he also speaks their language...Technique is the defineable figure of the enigma of works of art. It is rational but non-conceptual, permitting judgment in the area of the non-judgmental' (AT, 304). Indeed, such is the sway of technique in modern art that much of the dialectic of purposefulness and purposelessness can be played out through it. As aesthetic nominalism releases technique as a central determinant of aesthetic practice, the critical edge of technical innovation becomes eroded. Hence the purposefulness of technical innovation itself becomes purposeless:

> Art's indispensable rationality, encapsulated in technique, works against art. It is not that rationality has a deadening effect on the non-conscious, on the real substance of art or whatever (on the contrary: it is technique that enables art to appropriate the non-conscious); but that a consistently rational and elaborated work, because of its absolute autonomy, would tend to level the distinction between art and empirical being, assimilating itself to commodities

without directly imitating them. It would be indistinguishable from perfectly functional creations except in one respect: it would have no purpose, and that would speak against it. (AT, 310)

Adorno summarizes this point succinctly : 'While technique is the epitome (*Inbegriff*) of the language of art, it also liquidates that language' (AT, 310; SAT, 323).

For Adorno 'artistic forces of production are not *per se* different from social ones. The difference lies in the constitutive turn, by the former, away from real society' (AT, 335). The turn away, the absenting itself, from real society, again, is both discovered – the 'magical' conception of art as transformative practice is self-deceptive – and determined by the collapse of the social a prioris which sustained artistic practices as moments of a totalizing social praxis. The 'disenchantment' of art (tendentially) deprives it of grounds and purposes external to those immanent in its technical unfolding. Artistic progress is not reducible to technical progress, any more than this is the case outside art; but in modernity technical progress becomes a determinant of artistic progress as a whole. And, for better or worse, artistic modernism has made progress in art a determinant of art history. The technical moment, the unity and difference of technology in art and society, can better be brought into focus if we return to a consideration of the Van Gogh.

In an interpretation of Van Gogh that departs markedly from Heidegger's, Fredric Jameson claims that we ought to recognize as the background and raw material of Van Gogh's painting generally 'the whole object world of agricultural misery, of stark rural poverty' where fruit trees are 'ancient and exhausted sticks coming out of poor soil'.[6] Against this background,

the willed and violent transformation of a drab peasant object world into the most glorious materialization of pure colour in oil-paint is to be seen as a Utopian gesture: as an act of compensation which ends up producing a whole new Utopian realm of the senses, or at least of that supreme sense – sight, the visual, the eye – which it now reconstitutes for us as a semi-autonomous space in its own right...

Jameson goes on to present Heidegger's interpretation of the peasant shoes, claiming that it needs to be completed

by insistence on the renewed materiality of the work, on the transformation of one form of materiality – the earth itself and its paths and physical objects – into the other materiality of oil paint affirmed and foregrounded in its own right and for its own visual pleasures.

It is noteworthy that, like Heidegger, Jameson abstracts his account of Van Gogh from the history of painting itself, and further fails to integrate fully his proper appreciation of Van Gogh's foregrounding of the activity of painting and the materiality of paint into either his own or Heidegger's account. As we saw earlier, central to progress in modernist art is its negation of the tradition informing it. If we take these points into account, three consequences follow.

First, Van Gogh's concern for some old shoes or a chair was less a willed transformation of a peasant object world than a continuation of the process of questioning the relationship between the (technical) activity of painting and its subject matter. More precisely, Van Gogh unmasked the parasitic authority that past art had attempted to claim for itself through its treatment of august events, person, and the like (AT, 214–15). Secondly, then, art's authority, its value, now has to be recognized as integral to its practice, as a consequence of the transformations it has wrought upon its subject matter, no matter how ordinary. Finally, however, because art's authority has become formal, has become a matter of its forms of working, then the foregrounding of itself, its calling attention to the materiality of the paint and its application to the canvas, functions as a revocation, a cancelling of the (Utopian) transformation, the bestowal of autonomous dignity, which that very same painterly act has achieved. Art's autonomous power to transform its now ordinary (democratized) subject matter, perhaps to wrest it from the domination of commodification and exchange equivalence, was realized at the precise moment that it came to recognize its real powerlessness with respect to the object world. Its transformations were henceforth to be consigned to an autonomous domain whose very distance from empirical reality, the world of commodity production, was the price it was to pay for its authority. What had been (marginally) asserted and recognized in previous painting was now established in the paintings of Van Gogh in a way that made regression difficult. Thus the moment of Van Gogh parallels the place of Flaubert in the history of the novel, where secular narrative's previous lack of reliance on established plots, a priori values, and given, ahistorical forms, came to self-consciousness through the foregrounding of the transformative power of writing itself.[7]

With these thoughts in mind, it is now possible to begin to comprehend the nature of the *risk* involved in Van Gogh's painting. At bottom, this risk is his willingness to let the authority and claim of his painting stand upon nothing more than his performance, the act of painting itself. This risk, however, is quite different from Manet's, about whom one might be tempted to say similar things. In Manet each brush stroke is emphatically also a moment of representation, so that painting and representation appear as if magically entwined: brush strokes become flowers. For Manet technique is still magic and power: his performance. If we ask how Van

Gogh's painting offers back to ordinary things their dignity, their non-identity, then one must point to the way in which, in reaction to Manet perhaps, Van Gogh revokes the magical aspect of technique by emphatically underlining it. The paint and the strokes come to have an almost autonomous representational function. It seems almost as if Van Gogh's paintings could survive as non-representational works, which is just how his successors interpreted them. But this moves too quickly through the paintings. What is marked by the appearance of the possibility of the paintings having their representational aspect revoked, is the separation of the material and representational moments. What this separation accomplishes, however, is the setting up of an *affinity* between configurations of paint-on-canvas and the representing object. It is the inner affinity between paint-on-canvas and painted shoes, and not either the laces or the phenomenological/representational character of the shoes on their own, that draws the integrity of the shoes from their intentional object and into the canvas, their painted being: the autonomous dignity of the painting offers autonomous dignity to what is therein painted. In brief, Van Gogh sets up an internal mimetic relationship between painting and representation as a means of producing the mimetic relationship between painting and world; that internal mimesis is what provides the work with its 'depth', its 'in-itselfness'. Van Gogh's canvas becomes a kind of transcendental space in which the 'affinity of the manifold' (A 113) is established, but established not through transcendental laws but through the unfolding of the material itself. This internal mimesis between the visible strokes of paint on canvas and the representing thing is precisely what Adorno means by art being an objectification of mimesis (AT, 165; Williams's 'red wheel barrow' rehearses a similar affinity amongst words, work and thing).

Van Gogh's successors were right in thinking that he risked the authority of his paintings on their material and technical dimensions; by overlooking the internal mimesis in his works, however, they misunderstood the place of the traditional representational function at work. In relation to Manet, one might say that Van Gogh rehearses a technical overcoming of the determination of painting as technique. Technique is the explicit means through which the mimetic impulse is released. But if this is so, then Heidegger's and Schapiro's analyses of the shoes can be joined. Art is mimetic only as objective expression. The best model of expression, Adorno contends, is to think of it in terms of 'ordinary things and situations in which historical processes and functions have been sedimented, endowing them with the power to speak' (AT, 163). The shoes express the suffering of their historical milieu through their insistent paint-on-canvas being. The value/meaning of the painting as paint-on-canvas and the value/meaning of the shoes, in virtue of the work's internal mimesis, stand or fall together. Such was Van Gogh's risk and radicality;

it was a risk and radicality firmly rooted in modernism, and hence incommensurable with Heidegger's conception of works.

For Adorno the achievements of modernism undermine the tradition's self-understanding of itself; and this should suggest to us that modernism comments upon Heidegger's conception of great art. Adorno defines what he calls 'affirmative art' as works that claim their qualities to be those of being-in-itself beyond art. Affirmative art belongs to art's past. Although not all affirmative art is great art in Heidegger's sense, arguably all great art is affirmative art. About affirmative art Adorno writes:

> In the perspective of the present, the affirmative works of the past are less ideological than they are touching. After all, it is not their fault that the world spirit did not deliver what it had promised. Their transfigurations were too translucent to arouse real resistance. What makes them nevertheless evil is not ideology, but the fact that their perfection monumentalizes force and violence. These repress-ive connotations are brought out in adjectives like 'engrossing' or 'compelling,' terms we use to describe great art. Art neutralizes force as well as making it worse; its innocence is its guilt. The new art with all its blemishes and fallibilities is a critique of success, namely the success of traditional art which was always so unblemished and strong. The new art has its basis in the inadequacy of that which appeared as adequate... (AT, 229; SAT, 240)

Hence, Adorno will claim that what guarantees the authentic quality of modern works of art is 'the scars of damage and disruption inflicted by them on the smooth surface of the immutable' (AT, 34). Prior to mod-ernity the sublimity of works, what made them engrossing and compel-ling, might well have opened a world, but the worlds opened, and by extension opening itself, were entangled with force and violence, with all that now makes us regard those worlds as lacking justice. That violence must now adhere to the sublimity of those works for us. As we shall see, modernist sublimity is the re-marking of that earlier violence, and thus a retreat, which is a kind of advance, from the kind of affirmation of pre-modern works. Affirmation, which is continued in the Nietzschean mode, is violence and guilt.

Adorno continues the path of this reflection into a critique of classicism, where he states that the 'real barbarism of ancient times – slavery, geno-cide, the contempt for human life in general – has left virtually no trace in art from classical Athens forward. Art has kept all of this out of its sacred precincts, a feature that does nothing to inspire respect for art' (AT, 231). As we shall see shortly, the direct consequence of this critique of classi-cism and great art is an altogether different conception of the object of artistic memory.

The conception of history and memory at work here draws heavily upon the writings of Walter Benjamin while departing from the messianic elements in Benjamin's thought. Adorno's remarks here are a clear echo of the seventh of Benjamin's 'Theses on the Philosophy of History', in which he critiques the idea of effective historical consciousness, as the passive/progressive transmission of tradition through history, by reference to the fact that the continuity of tradition can be established by barbarism as well as culture.[8] Thus: 'There is no document of civilization which is not at the same time a document of barbarism. And just as such a document is not free of barbarism, barbarism taints also the manner in which it was transmitted from one owner to another.'[9]

Adorno rests the authority for his critique of success not on a presupposed moral standpoint, nor on messianic vision, but on art itself, on the development of the formal work of art. The formal and technical means of modernist art is its rational element, its unleashed forces of production: '...art is part and parcel of the process of the disenchantment of the world...It is inextricably entwined with rationalization. What means and productive methods art has at its disposal are all derived from this nexus' (AT, 80). If technical production outside art, the sovereignty of means–ends rationality, spells domination, in art it is the means of resistance to domination. 'Art works oppose domination by mimetically adapting to it. If they are to produce something that is different in kind from the world of repression, they must assimilate themselves to repressive behaviour' (AT, 404). That assimilation is the reign of technique and the mastery of aesthetic materials through technical form. Because of the dominance of this moment in modernist art such art is 'rational'. 'Art is rationality criticizing itself without being able to overcome itself' (AT, 81; see also 403).

Technological domination, which is at one with capital in demanding the fungibility of all individuals, is, most literally, mastery over nature (within and without). Because Adorno regards art as a countermovement to rationalized domination, he is sensitive to the traditional claims for natural beauty. Nonetheless, these claims cannot be taken literally, in part because nature is not yet what it appears to be, a state that will continue until nature stops being defined exclusively in opposition to history and society (AT, 97). Hence the appreciation of natural beauty cannot be literally what it thinks itself to be; at its best it represents 'the recollection of a non-repressive condition that may never have existed' (AT, 98). Such a remembrance, which is formal and social in character, underdetermined as it is by the causal conditions necessary for a 'real', psychologically or factually transmitted memory, must hence be constituted from elsewhere than direct aesthetic cognition of nature.

Art cannot be an imitation of natural beauty because as an appearing quality such beauty is itself an image. Art 'imitates neither nature nor

individual natural beauty. What it does imitate is natural beauty in itself'
(AT, 107; SAT, 113). Natural beauty is defined by its undefinability, by
its resistance to conceptual determination: 'What the beautiful in nature
does is testify to the precedence of the object in subjective experience.
Natural beauty is perceived alike as authoritatively valid and as incom-
prehensible (as a problem asking for a solution)' (AT, 104–5). The auth-
oritative validity and incomprehensibility of natural beauty *restates and
states originarily* the duality of the authentic work of art in its authoritative
validity and incomprehensibility, an incomprehensibility, however, that is
not absolute but a particular historical formation which itself means and
signifies. The law governing the formation of this incomprehensibility can
be known; knowledge of this law is what separates Adorno from the
unknowing, the beyond of knowledge, of Heidegger and Derrida. Nature
in itself is the historically and artistically produced model to be imitated
by art; it is the 'mediated plenipotentiary of immediacy' (AT, 91). Natural
beauty's exemplary status is a corollary of the domination of nature,
of nature's preponderance and non-existence. In claiming that works
of genius appear as if natural, traditional aesthetics acknowledges the
exemplarity of natural beauty and the preponderance of nature, while
simultaneously masking the appearance character of the former and the
scarred physiognomy of the latter. Yet both acknowledgements are necess-
ary if the self-determining, and hence proleptic transparent freedom of the
act of genius is to be harmonized with its opacity. The opacity of the work
of genius is the opacity, and non-existence, of natural beauty at one
remove. The freedom that opposes itself to nature, that seeks to master
and dominate nature conceptually (in science) and practically (through
technology) can gather itself only in appearance, in art; and that appear-
ance form of freedom must refer itself to repressed nature for its authority
and validity. Freedom thus survives only as sheltered, as art; which is a
corollary of the fact that the 'beautiful in nature is history standing still
and refusing to unfold' (AT, 105).

 This is why works that seek to imitate nature's beauty directly, forget-
ting its derived status and the non-existence of what nature appears to be,
strike us as kitsch; such works ignore the scars that domination has left on
nature for an appearance taken as reality. That is the source of their
sentimentality. In opposition to kitsch, technological art, art that sur-
renders itself to technique, setting itself against subjective intentions (but
remember that technology itself is but congealed subjectivity: AT, 62),
does so in order to produce a non-intentional, nonconceptual and non-
significative language. This language, which is the modern analogue of the
language of nature, seeks to portray the potential meaningfulness of nature
(AT, 89, 99). Hence,

> thoroughly *thesei* and human, the work of art is the representative of
> what is *physei*, what is more than mere subjectivity, a thing in itself

in the Kantian sense. The identity of the art work with the subject is as complete as the identity of nature with itself ought to be...On and through the trajectory of rationality, mankind becomes aware through art of what rationality has erased from memory. (AT, 93, 99)

Adorno instances the works of Paul Klee here.

Now what rationality has erased from memory is overdetermined and ambiguous in Adorno's theory. The difficulty in being clear derives from the fact that, on the one hand, the idea of 'artistic memory', be it in Heidegger or Adorno, is always as much formal as substantial; and, on the other hand, because the memory in question is constitutive and formal it can operate without psychological recognition, without, that is, being noticed as a memory of anything. This is to say that some portion of the experience of art, of the beauty of art and nature, is constituted by an element which is properly memorial in character but is typically either ignored or conceived of differently.

One line of thought explored by Adorno derives from an attempt to comprehend the act-like nature of works, their sense of being something momentary and sudden despite the fact of their being actualized as durable products. Adorno speculates, and this is the most speculative line of interrogation operative in *Aesthetic Theory*, that since works are 'set in motion by patient contemplation', then their act-like nature reveals that 'they are truly after-images of prehistorical shudders in an age of reification, bringing back the terror of the primal world against a background of reified objects' (AT, 118). The survival of the prehistoric shudder is meant by Adorno as the direct complement to his account of originary repression in *Dialectic of Enlightenment*.

There he and Horkheimer argued that the successful implementation of instrumental reason revenges itself upon the reasoner. They contended that a condition for subjugating external nature by reason is the repression of internal nature; the inhibition and domination of drives and desires is a condition for the successful employment of discursive reason. Further this same repression of inner nature precipitates the formation of the individualized self or subject; so each victory over external nature is paid for by a defeat of inner nature and a strengthening of the self as subject, a strengthening which is, of course, also a defeat. The sacrifice of the self for its own sake – which is figured in the imagination's sacrifice within the Kantian sublime – is quixotic since the repression of inner nature entails the distortion and eventual occlusion of the purposes for the sake of which the domination of external nature is undertaken. What in capitalism is exemplified by the domination of exchange–value over use–value, a domination which systematically voids the teleological rationality of our productive activity, is, Adorno says, 'already perceptible in the pre-history of subjectivity'. He continues:

> Man's domination over himself, which grounds his selfhood, is almost always the destruction of the subject in whose service it is undertaken; for the substance which is dominated, suppressed, and dissolved by virtue of self-preservation is none other than that very life as functions of which the achievements of self-preservation find their sole definition and determination: it is, in fact, what is to be preserved. (DoE, 54–5)

The shudder released by the work of art, the experience of the modernist sublime, is the memory of the experience of the terror and strangeness in the face of threatening nature. Shudder is the memorial experience of nature's transcendence, its non–identity and sublimity, at one remove. But, as such, it is equally a memory of the libidinous desires that were repressed in the face of primal nature. Shudder is a memory, an after-image, 'of what is to be preserved'. 'Consciousness without shudder is reified. Shudder is a kind of anticipation of subjectivity, a sense of being touched by the other' (AT, 455; SAT, 490). Shudder is the address of the other; it corresponds to what Gadamer would identify as strangeness in the object of understanding, and what Heidegger thinks of in terms of the claim of being. Above all, shudder is the terror of the sublime in Kant, a terror made safe by the retraction of the object as its source.

Even if we feel uneasy about Adorno's speculative anthropology, it nonetheless points to something that does seem constitutive of our experience of art, namely, how art provides a *reminder* of what is repressed in the advancement of reason and technology. That reminder is, again, formal: it has no empirical object, although it does have an intentional object. It is equally more than retrospected longing. It contains the repression as well as its object, the cruelty of reason (in artistic forming and its advance) and what that reason dominates (art's material moment, which is formed nature). Indeed, it is precisely the entwining of these two moments in the work of art that is the source of the memory. Again, dissonance, the technical production of the failure of production, expresses the suffering of the non–identical at the hands of reason. But the legitimacy of attributing a memorial dimension to modernist works is just this same, formal, critique of success. If the claims of sensuous particularity, non–identity, lack validity and worth outside art, a fact that art can register only negatively and in the mode of illusion, then art can experience that claim only as something that has *come to be* lost or repressed (even if the state lost has never existed). To speak with Derrida, we might say that the claims of sensuous particularity and non–identity appear only as a trace, as a first (mark, apprehension in intuition) always already formed by a second (re-mark, the reproductive imagination). But what appears as a transcendental move in Derrida appears in modernist art as part of the logic of its forms. Art remembers formally, that is, without causal intermediaries,

because its forms (which are themselves quasi-causally formed inter-mediaries), as the example of Van Gogh illustrates, specify the claims of sensuous particularity as something that has been lost or repressed. 'By repressing the agent of repression, art undoes some of the domination inflicted on nature. Control over artistic forms and over how they are related to materials exposes the arbitrariness of real domination...' (AT, 200). The memorial element in art, then, concerns the fate of sensuous particularity; but the fate of sensuous particularity is categorially the fate of sense perceptibility, and materially the fate of nature and the other.

In our original discussion of Kant we claimed that aesthetics, by definition as it were, is constituted by a repression of memory; and when that memorial element surfaced in the writings of Heidegger we questioned its object, whether it was not a screen memory for something worse. That 'something worse' has now surfaced in Adorno's critique of affirmative art, namely, the violence and suffering that have left no mark or trace on the works of traditional art, and worse, have been 'monumentalized' by them. Further, there is an evident inner connection between the failure of world spirit to deliver what it had promised, and Enlightenment's fear that the truth which set it in motion 'is going to be sacrificed in its progress' (AT, 118); that fear is marked by the desire to retain shudder: both the fear and the address of the other.

Shudder is the other side of suffering; the latter is the expression of dominated non-identity, while the former is the experience of that same non-identical other in its primal antagonism to the subject. Sublimity is the aestheticized conception of shudder and suffering, of resistance to self and integrity of the other. And it is at just this juncture that Adorno parts ways with Heidegger and Derrida. Because he surveys history from the perspective of 'world spirit', being, Heidegger sees only its failure, which is the realization of enlightenment and identity thinking. Sensitive to the neediness of this state but denying utterly the real advance of enlightened modernity and thus its promise (of freedom and happiness), Heidegger can but ascribe this neediness and distress to being (and not the lack of freedom and suffering of individuals).[10] This marks the nadir of Heidegger's failure to think being and beings together.

Derrida drops the fatefulness of being, the history of being, for the sake of alterity, non-identity. And like Adorno, Derrida places non-identity at the 'margins' of identity thinking, the outside that conditions and makes the inside possible while simultaneously eluding its grasp (comprehension). But there really is no 'other' for Derrida except in terms of the (transcendentally conditioned) failure of identity thinking to totalize itself, to achieve presence and self-presence. Hence non-identity gets reduced to what cannot be absorbed by reason and identity thinking: madness, vomit, etc. And while this gesture temporarily prevents triumphal history from unproblematically laying claim to the trophies of culture, it equally

prohibits cognition of what the other, underside of culture was and is. The moments of excess in texts are hardly equivalent to the comprehension of those texts as equally documents of barbarism, even if we concede that, perhaps, *differance* etc. are transcendental markers for that other history. If Derrida, then, does not quite side with 'great art', the deconstructive gesture can do no more than interrupt effective historical consciousness while making the law governing that history necessarily unknown and unknowable.

If the other is what gives necessity to deconstruction, nothing marks that necessity. And nothing can mark that necessity because the other is always reduced to 'otherness as such', alterity as such. And 'as such', Derrida conflates absolute otherness, the very idea of otherness, with serious otherness, the claim of otherness, the anticipation of subjectivity released through the touch of the other in shudder and its expression of suffering in dissonance.

Shudder, within which subjectivity is already stirring, without yet existing, is the touch of the other. Adorno continues: 'The aesthetic mode of behaviour assimilates itself to that other rather than trying to subdue it. It is this constitutive orientation of the subject towards objectivity which joins eros to knowledge' (AT, 455). This orientation, which is refracted through art's handling of its materials, allows Adorno to claim that 'art completes cognition concerning that from which it [cognition] is closed off; in so doing, it undermines its [cognition's] univocality *vis-à-vis* knowledge' (AT, 80; SAT, 87). Shudder and mimesis are different aspects of the same moment. Through them there occurs a joining of eros to knowledge which is art's articulation of ethics and knowledge.

Shudder, as dissonance (AT, 124), is staged, aestheticized, sublime fear. It is the affective acknowledgement of the otherness of the other. Unlike Kant, Adorno does not transpose this fear into pure morality, which is the revenge of nature on subjectivity for its repression; nature returns in Kant as the force of reason turned against the nature it was to release as happiness. Rather, Adorno approaches fear aesthetically, mimetically in his sense of the term. He thus underlines what Kant retreats from: that sublime fear is not just fear in its naturalistic sense, but also awe and respect in the face of the natural other. The disentangling of fear from awe and respect, which have their origin in fear, is one, thus far distorted, accomplishment of spiritualization.

Shudder, and the awe and respect that follow upon it or are intermingled with it, come from the non-identical other. So-called disinterestedness is not an unconditioned product of subjectivity; on the contrary, shudder in the face of sublimity conditions the aesthetic space labelled disinterested by interrupting, through fear, awe and respect, the self-aggrandizing narcissism, the reification, of rationalized subjectivity. Plausibly enough, only something that contains this moment of fear can accomplish this interrup-

tion, fracturing our interested gaze and opening us up to what is other than subjectivity in its petrified state. Shudder, then, is the generation of distance and angle with respect to the other: fearful awe is the affective 'spacing' of the other as at a 'distance' from us and as 'above' us. Height and distance represent the affective geometry of non-identity.

We have already seen this geometry at work in chapter 1 in our discussion of Kant on love and respect, the formal joining of beauty and sublimity. Adorno links eros (aesthetically: mimesis) and shudder here as we entwined love and respect there. What complicates this story, and what we failed to say then, is that Kant does allow the unity of love and respect to be exemplified; he labels their union 'friendship'. Kant's identification is troubling because he acknowledges and fails to acknowledge both that friendship is not yet and that even if it were to exist it would nonetheless contain a moment of non-identity (asymmetry) within its reciprocal (symmetrical) structure. Of course, he reads these moments of difficulty, historical absence and aporia, straightforwardly as departures from the *ideal* of friendship. But his account says otherwise. First, because he produces his analysis as a commentary on Aristotle's aporetic statement of the concept of friendship: 'My dear friends, there is no such thing as a friend.' Secondly, because in the course of attempting to provide friendship with a firm moral moment he must acknowledge that it 'is something so *delicate* (*teneritas amicitiae*) that it is never for a moment safe from *interruptions*... '[11] Kant conceives of these interruptions as generated by emotional friendships' lack of a firm moral ground. However, were this ground to be present, then the entwining of love and respect that friendship is meant to exemplify would be undermined.

Because he fears the fragility of friendship that follows on its lack of an a priori basis, and so the interruption into subjectivity that friendship manifests, Kant must equally eschew the sensible, non-categorical conditions that make social life possible: good-naturedness, mutual love and respect, affability and propriety, sociability, gentleness, etc. These, Kant says, are 'only *outworks* or by-products (*parerga*), which present a fair illusion of something like virtue, an illusion which also deceives no one, since everyone know how to take it.'[12] Such illusions of virtue are 'small change; yet they promote the feeling of virtue itself by [arousing] a striving to bring this illusion as near as possible to the truth'. We do not need to repeat Derrida's parergon argument to see that here Kant is casting as illusion the sensible expression of virtue in favour of its non-appearing reality (however otherwise truly deceptive the appearance of virtue can be).[13] What is striking for our purposes is the fact that now sociality appears only in the domain of illusion, an illusion that becomes in time the substantive illusion of the work of art.

Sociality sensibly redrawn as aesthetics is manifest in shudder and mimesis; shudder, again, marking the non-identity of the aesthetic object,

and mimesis the comportment of artist and spectator (AT, 203). Because aesthetic behaviour has a mimetic moment, mimesis now clearly the heir of disinterested delight, Adorno can regard the affective geometry of non-identity as proto-cognitive, as the return of the link between eros and knowledge. But Adorno's point in making this claim is to reveal the affective geometry at work in rationalized cognition as well: it is constructed from a position where the subject is 'above' the object, subsuming the object under it, its cognitive desire squandering the distance between subject and object, deriving pleasure from mastery and control. At best, subjective reason manifests an indifference to the object; at worst, it manifests a rage at the object – the rage realized in idealism. The reversal of this pattern of knowing requires a different comportment to things, a comportment we experience in art where dissonance marks the object's being sublimely raised up to address us from a height; its incommensurability with given conceptual regimes provides it with a distance from the claims of rationalized subjectivity; its interruption of interested subjectivity allows us to approach it mimetically, lovingly, as we might approach the needs and concerns of friends and fellow citizens had any such existed.

For Adorno there is a question about truth, in the emphatic sense, because there is an issue, other than the failure of the traditional project of philosophy, at stake in non-identity. Adorno wants to raise the question of truth because the other matters, is suffering. And it is this suffering other that is figured in the modernist work of art, an other forgotten by great art and by philosophy.

> Surely it would be better for art to vanish altogether than to forget suffering, *which is art's expression and which gives substance to its form. Suffering, not positivity, is the humane content of art.* If the art of the future were to become positive once again, one would be justified in suspecting that negativity had not been obliterated. This suspicion is ever-present, just as ever-present as the real danger of relapsing into negativity; for freedom – the freedom from, among other things, property – cannot be owned for ever. It is difficult to imagine what would become of art as historiography if it wiped out the memory of accumulated suffering. (AT, 369; my italics)

Arguably, the history of being and the anti-history of deconstruction portend the erasure of this memory. For Adorno, in contrast, 'the need to lend a voice to suffering is a condition of all truth.' He continues: 'For suffering is objectivity that weighs upon the subject; its most subjective experience, its expression, is objectively conveyed' (ND, 18).

5

Old Gods Ascending:
Disintegration and Speculation
in *Aesthetic Theory*

i Rationalization, Differentiation and Categories

Throughout our reflections we have consistently discovered that a certain thought of modernity is required in order to understand the problem of art. Even in Kant we saw the necessity of making reference to a pre-critical time in order to place aesthetics, to generate an understanding of art and aesthetics that was discrete and distinct from the understanding of theory and (moral) practice. This necessity would obtain even if one demurred from the memorial hypothesis and regarded pre-critical time as premised upon categorial confusion, on an amphiboly of the concepts concerned. But it is not just some account of modernity that is required in order to understand the problem of art, but a quite particular thought of modernity, namely one which takes the Kantian categorial differentiation between truth, moral worth and aesthetic reflection as its guiding thread. The recoil and revenge of the antinomies and aporia of Critical philosophy back onto the analyses of Heidegger and Derrida certainly make it appear as if metaphysics is too broad a conceptualization of what troubles aesthetics, even if one were to concede that at least the structural displacements gathered together under the idea of the metaphysics of presence are pertinent. Hence Adorno too is concerned with the metaphysics of presence, with the reduction of difference to identity and the other to the same. Identity thinking is another name for metaphysics. However, the overcoming or displacement of identity thinking *as such* is not attempted by Adorno; rather, he focuses on a specific formation of identity thinking, namely, that at work in Kant's Critical philosophy.

What, then, grounds Adorno's choice of Critical philosophy as the guiding thread for the analysis of modernity which would explain the power of Critical philosophy to recoil on the thought of analyses which attempt to by-pass it, leap over it towards a more encompassing philosophical comprehension of the tradition? An evident premise of Adorno's procedure is that the question of what a correct account of modernity is makes a difference because the structures of modernity condition our thought about it; which is why a recoil occurs when the specificity of modernity is ignored by philosophers. If the recoil is Kantian, then the operative assumption is that modernity itself is Kantian in some sense. At first glance, it is far from obvious how Adorno could accept this thesis given the role of Marxian theory within his work; a role which appears to make capital exchange relations quasi-causally responsible for the domination of identity thinking within modernity. Before this charge can be answered, we need to examine, if only briefly, the outlines of Adorno's understanding of identity thinking. This understanding is best had by looking again at the central lines of argument governing his and Horkheimer's *Dialectic of Enlightenment*.

According to Adorno and Horkheimer, enlightenment is from the very beginning anti-enlightenment; indeed, even prior to the commencement of the overt strategies of enlightenment, the myths against which enlightened thinking comported itself were themselves implicated in the strategies of identity and repetition, mastery and domination: 'Myth intended report, naming, the narration of the Beginning; but also presentation, confirmation, explanation' (DoE, 8). Myth succumbs to enlightenment, while enlightenment inevitably reverts to myth. This reversion or engulfment of enlightenment in myth, enlightenment's becoming 'animistic magic' (DoE, 11), is consequent upon its adoption of the 'principle of immanence, the explanation of every event as repetition' (DoE, 12), which is the principle of myth itself. What allows this dialectic to escape the charge of factitiousness, the charge of being premised upon a fragile and simplistic rhetoric of inversion, is Adorno's and Horkheimer's contention that the fatalities of reason are premised upon and have their foundation in the drive for self-preservation; a drive for mastery and control which governs, in differential ways and to different degrees, with greater or lesser effectivity, the logics of myth and reason. What has come to be called instrumental reason, the reduction of cognition to means–ends calculation and hence to instrumentality, is grounded in the anthropological foundations of the human species. We understand the rationality of instrumental reason by revealing its place within the human condition, within, that is, the anthropogenesis of human cognition. We come to understand the irrationality of instrumental reason when we see how a (legitimate) part of reason came to be taken for the whole, and how that historical metonymy involves a distortion of that in the service of which it

operates. Hence what might appear at first as a rhetorical strategy is in fact a work of detection, a genealogy of reason that allows us to glimpse the rough contours of mastery and domination beneath the glimmering surface of mythic play and epic wanderings.

As we saw in the previous chapter, the central trope here is the introversion of sacrifice, the sacrifice of desire for the sake of its realization. This repression of desire gives over to what it was sacrificed for, namely cognitive domination, a natural force. The return of the repressed provides reason with a force of fatefulness equivalent to what it opposed. Kantian, autonomous subjectivity, which at first sight appears as the rejection of instrumental rationality for the sake of some higher reason, hence comes to appear in the light of genealogy as the crystallized perfection of the suppression of inner nature. Happiness, the elimination of suffering and the satisfaction of desire and need, become a detached postulate of what the realization of autonomous reason ought to provide. Happiness ought to be proportional to merit and worth; but it lacks an independent claim upon reason. Categorical rationality's logical indifference to ends thereby comes to echo exchange–value's logical indifference to use–value. Categorical rationality is hypothetical rationality as an end in itself; and transcendental subjectivity the reification of subjectivity determined by its 'own' rationality. Transcendental subjectivity is a moment of objectivity at the heart of the subject; only, since it really is objective and not subjective, it works against the claims of the subject.

To enlighten reason about itself, which is what genealogy intends, requires a demonstration to the effect that what now appears as the whole and quintessence of reason is only a distorted part of reason; even if it, the part, is all we have available in order to make this demonstration. But this partiality has not yet been demonstrated. Two features of our situation militate against the possibility of a direct demonstration. First, the historical fact that discursive reason as it is now is instrumental rationality; which is what genealogy demonstrates. Secondly, logically, we take the minimal unit of rational thought, the concept or, what is the same, the sign-unit, as essentially or by their nature subsumptive, as either cognitively (realism) or volitionally (nominalism) equating different items, marking the different as the same. The logic of identity, which Adorno wants to argue is a logic of domination and suppression, appears internal to the very nature of the concept. The concept in its purity expresses nothing but a rejection of immediacy, a rejection that makes possible the separation of the actual (the given) and the possible, the given in terms of its characteristics, its powers and potentialities. Adorno in no way demurs from this thesis. What he denies is that the mediational powers of the concept entail, in and of themselves, the present formation of discursive reason.

Again, Adorno employs a genealogical approach in order to make his

point. Despite the potentialities built into the negativity of the concept, its capacity to negate the given as given, a crucial moment in its history, which for want of a better name can be called 'Platonism', marked it off for a different destiny:

> The universality of ideas as developed by discursive logic, domi-nation in the conceptual sphere, is raised up on the basis of actual domination. The dissolution of the magical heritage, of the old diffuse ideas, by conceptual unity, expresses the hierarchical consti-tution of life determined by those who are free. The individuality that learned order and subordination in the subjection of the world, soon wholly equated truth with the regulative thought without whose fixed distinctions universal truth cannot exist. (DoE, 14).

Note that Adorno's target here is not conceptual thought as such, but the regimentation of it into universality, deduction, system and correspon-dence; in other words, those features of our conceptual system that spell out its eventual rejection of historicality. The moment of the original tri-umph of instrumental rationality is a moment of domination. Although there are numerous mediations missing from this account concerning who and under what conditions conceptual domination perpetuated and deepened real domination, it remains the case that it allows us to perceive the rough outlines of how representational thinking is immanently bound up with domination; and further, how the coercive aspect of represen-tational thought is the moment of the identity. That linkage lays the foun-dations for the indirect, structural domination of modernity.

Conversely, Adorno is emphatic in not identifying the moment of domi-nation with the concept itself. As he clearly states some pages later: 'what is abandoned [by subjective or formal rationality] is the whole claim and approach of knowledge: to comprehend the given as such; not merely to determine the abstract spatio-temporal relations of the facts which allow them to be grasped, but on the contrary to conceive of them as superficies, as mediated conceptual moments which come to fulfillment only in the development of their social, historical, and human significance' (DoE, 26–7). Conceptual thought in the form of subjective reason betrays the mediational powers of the concept because it institutes a second immedi-acy as its goal, a making present of the world in universal truth; and hence forfeits the inner impulse of cognition to know what is other as such, in its alterity, which, in accordance with the inner character of conceptuality itself, involves actuality and potentiality. Negative dialectics, the pro-duction of constellations, is precisely the attempt to conceive of things as 'superficies, as mediated conceptual moments which come to fulfillment only in the development of their social, historical, and human signifi-cance'. It is these positive and negative aspects of the concept that struc-

ture Adorno's critical enterprise, and make it political from the outest. It is not metaphysics but a violent historical metonymy that is at issue; and analysing the fulfilment of that metonymy in modernity forms the essential background to Adorno's aesthetic theory.

Adorno conceives the structure of the modern economy and state, and their relation to one another, in Marxist terms. The Marxist analysis demonstrates how, at the societal level, the logic of identity achieved and sustains its hegemony. However, he reads the logic of the development of modernity in terms of a Nietzschean genealogy of reason, or, what is the developed sociological equivalent of that comprehension, in terms of rationalization. With Max Weber, Adorno conceives of 'the institutional framework of the capitalist economy and the modern state...not as relations of production that fetter the potential for rationalization, but as subsystems of purposive-rational action in which Occidental rationalism develops at a societal level.' [1] Although Adorno supports Marx's analysis of modernity, he demurs from the philosophy of history in which Marx places his account on the grounds that it follows the path of identity. Rationalization explains and comprehends, however aporetically, the precise historical metonymy that Adorno and Horkheimer attempt to reveal genealogically in *Dialectic of Enlightenment*.

If at the societal level rationalization involves the differentiation of the capitalist economy from the modern state, at the cultural level rationalization also involves a progressive differentiation, a becoming autonomous of the value-related spheres of activity; which entails and is entailed by their progressive formalization and grounding or value intensification (*Wertsteigerung*). The two reciprocally conditioning sides of cultural rationalization, differentiation on the one hand and formalization and value intensification on the other, rehearse as a moment of the logic of cultural development the reflective self-interrogation of Critical thought. It is no accident then that Weber should see this process of differentiation as revolving around the Critical triad of truth (knowledge), right and goodness (law and morality), and beauty (art and taste); or, in the material mode, science and technology, individualistic ethics and formal law, and autonomous art. *Critical philosophy is modernity's philosophical comprehension of itself*, a point recently underlined by Habermas:

In Kant's concept of a formal and internally differentiated reason there is sketched a theory of modernity. This is characterized, on the one hand, by its renunciation of the substantial rationality of inherited religious and metaphysical worldviews and, on the other hand, by its reliance upon a procedural rationality, from which our justifiable interpretations, be they pertinent to the field of objective knowledge, moral-practical insight, or aesthetic judgment, borrow their claim to validity.[2]

Hence Rationalization involves the becoming and the 'making conscious [of] the *internal and lawful autonomy* of the individual spheres', but this process does not occur untroubled according to Weber, for by becoming autonomous these spheres 'drift' into 'tensions which remain hidden to the originally naive relation to the external world'.[3]

For Weber the tension, the clash, is between 'the religion of brotherliness' and the 'orders and values of this world';[4] or, to state the same in more mundane terms, between the binding character of community itself, what the young Hegel called 'life', and the terms, cognitive, practical and artistic, in which that bindingness relates to itself and to the external world. Now the ground for my translating 'the religion of brotherliness' as the bindingness of community is that Weber consistently deploys the former expression as the background assumption against which Occidental rationalization is understood. If 'the religion of brotherliness' is not so translated, then the full aporia of modernity sketched by Weber collapses: the binding force of community is at one with its immanent intelligibility – only ethical substantive rationality is capable of sustaining a rational *life*; rationalization spells the end of both community and intelligibility. The religion of brotherliness is Weber's *sensus communis*; only against the background of the lost *sensus communis*, ethical life, does differentiation appear as fragmentation, and rationalization spell out a kind of metonymy. Because Weber does not adequately theorize the categorial features of the religion of brotherliness, he tends to see rationalization as fragmentation but not as the triumph of part for whole.

Weber's aporetic construction depends upon more than a simple collapse of the meaningfulness of life consequent upon secularization; rather, that collapse must derive its force from the relation between differentiation and what gets differentiated. Rationalization tokens a double movement: a real increment in rationality, and a corresponding and simultaneous loss of meaningfulness (the worth of activities in the separate spheres) and intelligibility (the cognitive connection of value-related spheres of activity with one another): 'culture's every step forward seems condemned to an ever more devastating senselessness.'[5] 'Senselessness' here equals the consequences of autonomization.

> If anything, we realize again today that something can be sacred not only in spite of its not being beautiful, but rather because and in so far as it is not beautiful...And, since Nietzsche, we realize that something can be beautiful, not only in spite of the aspect in which it is not good, but rather in that very aspect. You find this expressed in the *Fleurs du Mal*, as Baudelaire named his volume of poems. It is commonplace to observe that something may be true although it is not beautiful and not holy and not good. Indeed it may be true in precisely those aspects. But all these are only the most elementary

cases of the struggle that the gods of the various orders and values
are engaged in.[6]

Each value-related sphere asserts itself for itself and against its rivals.
Kant's presupposed and postulated unity of reason becomes the much
more equivocal 'unity of rationalization'; a unity whose truth is differen-
tiation. This differentiation entails a new polytheism, a polytheism with a
difference, for unlike the old polytheism our gods are disenchanted: 'Many
old gods ascend from their graves; they are disenchanted and hence take
the form of impersonal forces. They strive to gain power over our lives
and again they resume their eternal struggle with one another.'[7] Kant's
Critical philosophy, in virtue of its inevitable failure to harmonize the
three Critiques, comes to represent and explicate this new polytheism. It
is not a peaceable division of labour that Kant offers us, but a battle of the
gods.

 Weber construes the autonomy of art in the same formal manner as does
Adorno, namely, as involving a reflective, inward turn which allows it to
develop in accordance with its own inner logic (*Eigengesetzlichkeit*), an
inner logic which Adorno identifies with the rationalized forms at art's
disposal. In accordance with his new polytheism, Weber regards the
development of this inner logic as a self-contained enterprise; indeed, as so
self-contained that for him none but formal questions about art are appro-
priate. Aesthetics cannot question the meaning of art, but only, given its
existence, the necessary conditions for the possibility of that existence.
Aesthetics can only be a transcendental discipline just as sociology can
only be an empirical discipline; neither is in a position to pose the
questions of meaning or intelligibility. And since all other disciplines work
under the provisions of their godhead, they too are barred from asking the
questions of meaning or intelligibility. For Weber, there is no substantive
unity among the various disciplines, and each discipline must remain
blind to the significance and worth of its endeavours. Hence, 'aesthetics
does not ask whether there *should* be works of art.'[8] But this assertion rests
upon a gross oversight; in practice artistic modernism persistently asks
that very question, answering proleptically the existential–historical
question of its very being. So, again, Adorno's *Aesthetic Theory*, in full
regard of its dependency on modern art, begins: 'Today it goes without
saying that nothing concerning art goes without saying, much less without
thinking. Everything about art has become problematic: its inner life, it
relation to society, even its right to exist.'

 On Weber's view, each differentiated domain, as a consequence of the
autonomy of the logic governing its practices, necessarily operates a policy
of non-interference with respect to other cultural domains; nor is any
domain in a position to interrogate the worth or the intelligibility of either
its own or other sphere-specific practices. Value-intensification entails the

sublimation of the questions of worth and intelligibility into the logical prosecution of the rationality of each separate cultural practice. But this trajectory of enlightened rationality short-circuits to the point of occlusion the self-reflection which provided, and continues to provide, the impetus and motor of rationalization. To enlighten Enlightenment about itself, about its own irrationality, is to continue the self-reflection of enlightened reason against its curtailment in the differentiated value spheres. Such is the reason, against 'reason', constituting Adorno's philosophical project.

This project is aporetic since no value sphere has been historically empowered to engage in a reflection on reason in its state of dispersion. What distinguishes art from other domains of culture is that such a reflection on reason in its dispersion is a precipitate of its rationalization; but a non-discursive precipitate, and hence not immediately recognizable as a reflection. Art's cognitive dimension appears as non-cognitive; this is another aspect of its resistance to enlightened rationality, its presumptive unintelligibility. Modernism continues the process of disenchantment and the 'straining toward maturity', but in forms that appear irrational, even childish, from the perspective of a rationality 'too narrowly conceived of in terms of a pragmatic instrument'. If art were not 'rational', an obeying of laws and logic proper to its own domain, if it did not contain its own standards of rigour and technical achievement, if there were not possibilities of comprehending the unfolding of that logic and rigour in art's historical development, then art could not open up a perspective on rationality outside itself. 'Such irrationality in the principle of reason [the irrationality of the fetish of means into end] is unmasked in the avowedly rational irrationality of art and at the same time in its modes of behaviour' (AT, 64; SAT, 71). For Adorno, the fact 'that art has a critical edge in relation to society is itself socially determined' (AT, 48; SAT, 56). That critical edge is given over to art, however briefly, through what rationalization outside art excludes. Tracking aesthetic rationalization thus becomes a tracing of the remnant of a knowing that history has left behind.

Modernist works of art are cognitive and rational, but not in ways that are either directly recognizable or discursively recuperable without remainder. 'Art works talk like the good fairies in tales: if you want the unconditioned, it will be bestowed to you, but only *unkenntlich*, indecipherably. By contrast, the truth of discursive knowledge, while unveiled, is precisely for that reason unattainable' (AT, 183). Adorno credits the Enlightenment with having been aware, however obliquely, that what 'reason wants to seize without veil tends to vanish' (AT, 124); that is, reason's attempt to grasp the other in its alterity and particularity without remainder, to fully appropriate the other to itself, leads to the recognition that something always gets left behind in the progress of rational cognition. Adorno usually identifies this remainder as the Kantian thing-in-

itself; the concept or idea of things-in-themselves is the acknowledgement of the limits of a reason that because it emanates from the subject can but constitute the object in its own image, impose itself on the object, and thereby leave behind the object in its own 'heteronomous' integrity. The connecting of instrumental reason with self-preservation provides the link that justifies the identification of Copernican reason, reason and rationality as emanating from the (transcendental) subject, with instrumental reason. Cognition's assault' upon the object, as Heidegger has it, derives from a historically comprehensible restriction of reason rather than from some remote destining of being. If we can recognize in Heidegger's discourse on technology a second-order, transcendentalized presentation of what is best understood in terms of Weberian rationalization, then the difficulties we have previously noted in Heidegger's position fall into place.

From the perspective of modernism, enlightened reason reveals itself as instrumental reason, means–ends rationality; because instrumental, then therefore as subjective; because not the whole of reason, therefore as particular; and because it claims to represent the whole of reason, indeed it appears in practice as the whole of reason, then therefore irrational. Such a reason 'needs spurious irrational enclaves and treats art as one of them'; that is, art performs the same sociological role that is performed by the Kantian idea of the thing-in-itself in philosophy. And like the paradox that reverts onto philosophy when the the thing-in-itself is noted, the same occurs when the complex of art, reason and society are brought into consideration: one cannot enter into the rationality of modern society without taking cognizance of artistic 'irrationality', art's excess beyond societal rationality; but when art is acknowledged, one cannot remain within the confines of societal rationality. So Adorno continues: 'Even so, art is the truth about society in the sense that in its most authentic creations the hidden irrationality of a seemingly rational world is brought to light. In art, denunciation and anticipation are syncopated' (AT, 124; SAT, 130).

ii Disintegration, Sacrifice and Truth

In so far as universal and particular diverge (because subsumption sets them into opposition with each other), there is no freedom (AT, 62; SAT, 69). That lack of freedom is overt and particular in the original act of real and conceptual domination; it becomes implicit and universal when the domination of concept over particular is realized in rationalized modernity. All that is left of freedom is self-reflection (with which it began); and all that is left of self-reflection is art. Freedom has become the thought of freedom; the work of genius the sustaining of that thought. It is the radical attenuation of freedom in art that so easily permits freedom

to be dropped from what art reflects. Further, the remnant of freedom is all but indistinguishable from that of the autonomous subject propounded by modernity. A substantial illusion of freedom, that of the autonomous subject, intersects with an illusion of substantial freedom in the work of modernist art.

What Aristotle and Hegel specified with respect to ethics, namely, that a good man could exist only in a good society, is how Adorno conceives of freedom – but with more cause given that individual freedom cannot be comprehended outside the changing configurations of the social (universal) and the individual. Freedom requires a 'free' society (ND, 299). To imagine a subject's 'non-identity without sacrifice' (ND, 281) to the social universal is to conceive of the absolute, or what Adorno thinks of as reconciliation: Utopia. Hence the concept of 'utopia' figures Adorno's understanding of reconciliation.

Given that the divergence between universal and particular, concept and intuition, serves as a measure of unfreedom, this would appear to entail that art should seek a harmonious synthesis between these two elements in order to figure the idea that reconciliation, and hence freedom, are (still) possible. Such a view is wrong-headed because it simplifies the elements falling under the headings of 'universal' and 'particular'. This is why Adorno contends that 'art should not and cannot be schematically reduced to the dichotomy (*Polarität*) of mimesis and construction' (AT, 65; SAT, 72).[9] If Adorno identifies construction with social universality, and expression, the most prominent specification of intuition in art, with the (helpless) individual, giving him thereby a false sense of importance, he does not believe that one can understand art from a juggling of these categories. On the contrary, their dominance would lead to making consistency and 'uncompromising elaboration and integration' the test of aesthetic authenticity. But this is not the case. To see this requires recognizing the importance of truth content over consistency, for only on that presupposition can we understand how an artist is able to mobilize, risk, the moment of disintegration, the moment when, like Prospero, the artist puts down his magic wand, having traversed the field of integration, and releases into the work what cannot be integrated in it. Late Beethoven marks the commencement of this self-conscious pushing of integration beyond itself in modern art (AT, 67).

Adorno's short way with this thought is to say that 'the highest products of art are condemned to fragmentariness [the developed form of disintegration], which is their way of confessing that even they do not have what the immanence of their form claims (*prätendiert*) they have' (AT, 133; SAT, 139). The immanence of form, which is but another conceptualization of autonomy, is what permits and requires works to secure their authority, an authority which is now 'aesthetic', immanent and autochthonous. Immanent form, then, is what grounds the possibility

of works being purposive within themselves without having an end beyond themselves. The goal of securing immanent validity represents the original impulse governing the historical development of autonomous, rationalized art. It is the rationalization of art. Nor is it difficult to see how the criteria of integration, consistency, harmony, closure, elaboration (articulation) and the like fall out as direct corollaries of this conception of art. Equally, however, it is just these rationalized aesthetic ideals that secure for art criteria of validity that are autonomous from standard concepts of truth and moral rightness. As such, aesthetic beauty becomes the aesthetic mode whereby the separation of spheres is legitimated. *The (still) aesthetic challenge to these criteria of artistic worth hence represents, not just the transformation of the concept of validity in art, but necessarily refers to normative concepts left behind by the rationalization of art.* Adorno's defense of modernism and his attempt to direct aesthetic theory back to the questions of truth and cognition are different sides of the same argument.

Disintegration, recognition and acknowledgement of the heterogeneous materials which aesthetic integration is for, curtails the claims of formal beauty. Like Derrida, Adorno regards sublimity as the inheritor of the claim of art; but not sublimity as Kant characterized it. Rather, the Kantian sublime anticipates the logic of disintegration that befalls art after Kant; that is, the movement from integration to disintegration that governs the unfolding of art from its traditional autonomous shape to modernism is best understood in terms of a diachronic movement within art that leads from beauty and taste to the sublime. 'Works that transcend their aesthetic shape under the pressure of truth content occupy the place that aesthetics used to reserve for the sublime' (AT, 280; SAT, 292). Sublimity has tended to function as what transcends truth-as-subsumption, and hence as a counterforce to a fully cognitive conception of art. Adorno reverses this argument, seeing autonomous beauty as the marker for aesthetic validity without truth and goodness, and the modernist sublime as the (still aestheticized) attempt to generate a moment of 'truth' beyond beauty. This forms the precise point of contestation between Adorno and Derrida. For both the sublime marks the site where the claims of identity and presence are resisted; for both sublimity is the figure of an alterity that eludes conceptual capture. However, for Derrida the deconstructive sublime, as a generalized philosophical reinscription of the aesthetic sublime, corresponds to a reinscription of the transcendental, the place where it is realized and ruined at once. While for Adorno the sublime remains an overt and explicit creature of aesthetic discourse; his constellative reinscription refers the sublime to an emphatic conception of truth in opposition to all transcendental structuring and destructuring. *The philosophical reformation of the concepts of aesthetics, in accordance with the transition from beauty and taste as constitutive of 'aesthetics' to sublimity as*

the overcoming of 'aesthetics' from within, is the determining historical gesture of Adorno's aesthetic theory. Its validity depends almost wholly on his identification of 'aesthetic' art as the rationalized, disenchanted form of art in modernity, and modernist, sublime art as its critical extension. It is equally this connecting of 'aesthetic' art and Kant-style aesthetics with rationalization that underwrites the modernist sublime's reflective inter-rogation of 'aesthetic' art as forming a critical interrogation of rationaliza-tion as a whole.

Despite the fact that the modernist sublime is a traversing of the field of the aesthetic in the direction of cognition, it is still subsumption, spiritualization as subjective domination, that is to be overcome here. Which is why nature, both as dominated and as a force resisting subsump-tion, continues to reverberate within Adorno's aesthetics. More precisely, the opposition between art and nature, beauty and the sublime, becomes an internal constituent of art works themselves – the interaction between the integrative (constructive) and disintegrative (mimetic/expressive) moments of the work – as spiritualization progresses, incorporating into works elements incapable of being accommodated by the productive imagination. The integration of a disintegrative moment into works forms the core of Adorno's understanding of the *risk* of meaning – because of the risk of everything that has been recognized as constituting aesthetic validity – taken by modernist works. That risk is historically conditioned: it is not possible always or everywhere; it is the unique risk that opens the exchange between art-in-its-historical-being-and-meaning as what has been rejected, and what is preserved in autonomous art. Modernist works

> polarize spirit and material, only to unite them again. Their spirit is unable to depict itself in sensuous terms and their material seems incompatible with the unity of the work. The concept 'work of art' is no more applicable to Kafka than is that of the religious. The material, and especially...the language, becomes desolate, trans-parent, naked. It imbues spirit with a quality of second-order abstraction. Kant's doctrine of the sublime, understood as an emotion, describes more properly the kind of art that trembles (*erzittert*) by suspending itself for the sake of a non-illusory truth content, while simultaneously being unable to slough off its illusory quality as art. (AT, 280; SAT, 292)

Sublime, modernist art is the kind of art that suspends itself, that is, suspends its constitution by the aesthetics of the beautiful, for the sake of what does not fit the discourse of beauty, the discourse of representation and illusion. This suspension is common to both Adorno's and Derrida's understanding of Van Gogh. Derrida, again, sees it in the untied laces; Adorno would see it in the internal mimesis between shoes (spirit) and

brush strokes (material). Both see it as the suspension, and interruption, of 'art' as an already constituted domain. Derrida comes upon that reading of Van Gogh through its relation, and resistance, to the discourses of Heidegger and Schapiro; Adorno comes by it through cognizing the history sedimented in the painting. Derrida restores, restitutes, the sublimity of the Van Gogh from out of its capture by Heidegger and Schapiro, while Adorno attempts to unleash its original appearance. In revealing the conditionedness of Van Gogh's painting, Adorno, on my reconstruction, reveals what its failure would historically mean, and how that failure can be inscribed into the possibilities the work itself releases.

Accomplishing the traversal of the field of integration for the sake of a non-integrated truth content is possible only through the continuation of the rationalization process within art, that is, through an intensification of the formalist trajectory. This intensification of formalism appears in modernist art aesthetically as cruelty. Cruelty, as the emergence of naked form in works, repesents a countermovement to the spell of beauty: 'Cruelty is a result of the self-reflection of modern art, which despairingly realizes that it would find itself in the role of a henchman of the powers that be, if it were not cruel but conciliatory instead' (AT, 74; SAT, 81). The movement of disintegration hence works through integration; the more integrated works are, the more purely formal their intent, the more disintegrated, heteronomous, are their constituent elements taken separately (AT, 78). It is this state Adorno has in mind when he states that 'art is true to the extent to which it is discordant and antagonistic in its language and in its whole essence, provided that it synthesizes those diremptions, thus making them determinate in their irreconcilability' (AT, 241; SAT, 251). Determinate irreconcilability is the Adornoesque equivalent of Derridean indeterminacy. While the latter designates a place of collision between the desire for presence and its absence, the former designates an illusory escape from heteronomy, and by extension an image of self-determining spirit. After all, if the disintegrative moment corresponds to a risk whereby works are released from subjective control, the rule of construction, then they must take on the appearance, illusion, of 'meaning' autonomously: 'art is an empirical existent determining itself as spirit' (AT, 471; SAt, 511). Determinate irreconcilabilty elaborates the finality–without–end aspect of works to the point where they image freedom and autonomy; they are the illusory appearing of freedom. Modernist works in their sublimity thus realize what was posited but not actual German Idealist aesthetics of the beautiful: freedom in appearance.[10]

Conversely, the idea of beauty as harmonious integration of parts to whole comes historically to appear as the utter pacification and subjugation of its constituent elements: 'aesthetic reconciliation proves fatal for the extra-aesthetic other' (AT, 77; SAT, 84). The 'extra-aesthetic other', which is always an element in art, resists pacification, unfreedom and

death in the disintegrative moment, the moment of exploding appearance
and indeterminacy (the laces, the brush strokes). For both Derrida and
Adorno this moment has a similar logic: re-mark and mimesis. It is
through the workings of this logic that sublimity comes to serve as 'the
counter-image of mere life' (AT, 281; SAT, 293). However, it remains
unclear why re-marking should have this power to form a counter-image
of mere life if it does not have at least some of the attributes of mimesis.
Alternatively, it is unclear why re-marking should matter in its securing
of alterity unless a counter-image to mere life is formed. This is the
juncture where alterity as 'it gives painting' confronts the alterity of self-
determining spirit, where quasi-transcendental constitution confronts the
indeterminate exchange between illusion and truth. In attempting to
decide between these two accounts we might ask whether the untied laces
could play the role Derrida attributes to them if they were not a part of a
Van Gogh painting, where painting is suitably foregrounded. Is the logic
of mark and re-mark too distant, because too transcendentally syntactical,
from the phenomenon it grounds in comparison to the logic of illusion and
truth, mimesis and construction?

Through its holding together of the moments of integration and
disintegration modernism acknowledges its participation in domination in
the same gesture in which it attempts to specify and twist free from it.
Twisting free occurs through self-implication, twisting more fully into and
becoming an element of what it is criticizing. There is no outside position
for art to twist into; hence, it is only through a structured immersion, the
continuation of rationalization, that art realizes its distance from mere life.
Modernist works themselves accomplish this end through tracing the his-
tory from beauty to sublimity, from taste to truth. Each modernist work
must represent the moment of beauty it could have had but forwent.
Because beauty has been available but resisted, this tracing is equally an
ethical gesture.

> Initially hostile to expression, the formal nature of beauty half
> triumphantly transforms itself into a kind of expression wherein the
> menace of domination of nature is wedded to a sense of yearning for
> the defeated victims of that domination. Thus this expression is one
> of grief about subjugation and its vanishing point, i.e. death...The
> grief that art expresses results from the fact that it realizes unreal
> reconciliation at the expense of real reconciliation. All that art is
> capable of is to grieve for the sacrifice it makes, which is the self-
> sacrifice of art in the state of powerlessness...While the idea of works
> is modelled on immortality and eternal life, the road to that desti-
> nation is strewn with the annihilated life of particulars. (AT, 77–8;
> SAT, 83)

Art's sacrifice of itself, which is its grief, is formally its disintegrative movement; hence also its attempt to overcome the autonomously beautiful: 'For the sake of the beautiful, there cannot be a beautiful any more: because it has stopped being beautiful' (AT, 79; SAT, 84). Art stops being beautiful, or better, beauty stops being beautiful when its harmony and tranquillity appear as synonomous with the very forces that make art a counter-image to mere life in the first instance. It is equally this grief that requires the suppression of that other grief over paradise lost: 'Authentic works must wipe out any memory trace of reconciliation – in the interest of reconciliation' (AT, 333; SAT, 348).

Art's grief and social culpability (AT, 208), and its attempt to atone for its culpability, are but the ethical face of its becoming 'conscious of the non-identical in [its] midst' (AT, 194; SAT, 202). We have already noted the place of sacrifice in the logic of the sublime. Adorno's account hugs the shoreline of the Kantian sublime while transforming it: what was the sacrifice of the imagination for the sake of reason becomes the sacrifice of the material equivalent of the unifying work of the transcendental imagination, i.e. aesthetic beauty, for the sake of the truth (reason) that would redeem it. Only a logic of this kind can explain the ethical weight we are wont to ascribe to the risk taken in modernist works. The risk of meaning is more precise than Derrida allows: it is the risk of aesthetic beauty. And the risk matters as risk because of what it departs from. The sacrifice of beauty, however, is ethical in another sense because it is not innocent, an innocence that would adhere to it from the perspective of re-marking and quasi-transcendental constitution. Derrida's Nietzschean affirmation, 'it gives' loosens the historical guilt attaching to the painting, 'untying' the painting from its historical locale as well as its deriving its power to interrupt history from what has made that history one of suffering. It thereby makes the painting's gesture transcendentally ecstatic rather than historically tragic. By making the modernist sublime's sacrifice historical Adorno locates its interruption of history for the sake of another history within a historical field of forces capable of transformation. But transformation is possible only through the guilt of participation in what has already formed history against non-identity. Without the confession of guilt, which is equally the denial of unconditional affirmation, the deconstructive sublime is guilty a second time; it is the beautiful soul of modernity.

For Adorno, Van Gogh's painting is an illusory Antigone; but it is the work's capture in an illusory domain, and hence in a domain quite other than the tragic political space of ancient Greece, that determines the character of its ethical act. Can we understand that act as other than marking the absence of a political community? The Van Gogh can succeed only through the dissolution and transformation of the very structures that allow his painting to be. The deed of the painting summons up just the

self-determining spirit that Antigone's deed exemplified and required from the Greek *polis*. Her deed, like his, transgresses the boundaries constituting the relevant domain of practice because that domain does not preserve but squanders the very life it seeks to support. Both deeds rehearse an exchange of recognition and non-recognition, and of a clash between apparently autonomous spheres (religion and state, art and empirical life). Non-recognition (as death and illusion) always involves the suppression of the self-determining spirit expressed in the ethical deed. Both deeds arise from the margins of their respective social worlds: Antigone's from the margin of family and woman, Van Gogh's from art. In both cases the sphere in question is the locus of a suppressed sensuous particularity and of a solidarity (political love) lost to the world. Political love is what underlies the sacrifice at work in both cases: of life and beauty (the illusion of life). Confession, the admission of culpability, stems from love; that is what makes art the rose in the cross of the present; it sacrifices willingly, affirming the world, the lives contorted in it, in the only way that can acknowledge what has been distorted. That is art's painful pleasure, its pleasured pain. The 'joy' or affirmation in sacrifice derives not from future recompense, but from its acting out of love of the world as it is.

In both cases, then, the validity and autonomy of the marginalized sphere is illusory. Van Gogh's painting cannot say what transformation of the spheres of modernity would redeem its sacrifice, any more than Antigone could. What Hegel attempted for Antigone, Adorno is attempting for the modernist sublime. The analogy between their efforts presents the possibility that more than an analogy is at work, that Adorno is repeating the Hegelian work of speculation, that he too is remembering Antigone. He mourns Antigone because that is what the grief sedimented in the modernist sublime expresses. The moment of Antigone is the moment when the recognition occurs that only a community of 'free' subjects could realize the potentiality for ethical life implicit in the duality between religion and *polis*. The moment of the aesthetic sublime is the moment when the 'harmony' between art and empirical life is realized to be a disharmony, a conflict in which the marginalized sphere is not an integrated moment in the totality but the refuge and repository for what empirical life rejects. Now we have neither free subjects nor an ethical community, only the illusion of both in art. The modernist sublime is a tragic art. As tragic but *only* art, in a way that ancient tragedy was not, it must figure both the excluded other and the community that would recognize it. In its grief art becomes the stand-in for a politics that has never been.

It is important to recognize all the elements at work in the structures we have been outlining – aesthetic (from beauty to sublimity, and from integration to disintegration); cognitive (from taste to truth); and ethical

(risk and self-sacrifice; culpability and grief) – when summoning forth Adorno's best known statement of this position: '[Modern art] has taken all the darkness and guilt of the world onto its shoulders. Its entire happiness consists in recognizing unhappiness; all its beauty consists in denying itself the semblance of beauty.'[11] *The trajectory of Adorno's account is to weave together within the modernist sublime a reunification of the categorial spheres dirempted by Kantian modernity. The modernist sublime is a regathering of beauty, truth and goodness: beauty beyond aesthetics, truth beyond subsumption and goodness beyond categorical worthy action.* In this regathering we are no longer sure where, say, sublimity ends and truth or ethical risk begins; Adorno's dialectical transformation of the categorial structures of Kantian modernity achieves the sought-after unity of the three spheres in the only way possible, namely by surrendering the drive for hierarchy and (categorial) subsumption.

Again, what makes this possible is the sacrifice of beauty, which is equally the sacrifice of reason since the sacrifice of beauty is the sacrifice of the constructive moment, where the constructive moment is the sedimented moment of aesthetic rationalization. Aesthetic beauty is subjective reason in art. That is why reason and truth remain at the centre of Adorno's account. It is thus important to keep the logic of disintegration in mind when attempting to articulate Adorno's account of truth in art. That account does not concern some general or a priori conception of aesthetic truth; rather it is the articulation of what is claimed by the disintegrative moment, the moment of modernism, against the claims of the autonomously beautiful. Adorno's theory of truth, then, relates precisely to the historical fate of aesthetics since Kant, the constitutive norms of aesthetic validity for autonomous art.

iii Truth or Communication?

The cognitive element of art is tied to the historical emergence of the modernist sublime; an emergence that must be seen against the background of the 'aestheticization' of art consequent upon its rationalization into an autonomous sphere. Earlier we denominated the discursive silencing of art, that occurs in virtue of its diremption from rationalized truth and morality, 'aesthetic alienation', the alienation of art from moral and epistemic reason. Adorno's *Aesthetic Theory*, which involves a certain aestheticization of theory as well as being a theory of the aesthetic, offers an alternative analysis of the phenomenon of aesthetic alienation.

Although it is natural to presume that Adorno's conception of discursive silencing is keyed to modernist music generally and the work of Schoenberg in particular, hence supplying silence and discursive incomprehensibility with a conspicuous and rather prejudiced point of reference;

in fact, Adorno generally links his analyses of modernism and the modernist sublime to the writings of Samuel Beckett, to whom *Aesthetic Theory* was to be dedicated. So, for example, epistemically, which is to say, in terms of art's character of being illusion and semblance, in terms of its '*suggestion* of meaning amid a general loss of meaning', (AT, 222; SAT, 231; my italics),[12] we find: 'aesthetic transcendence [the truth claim of the modernist sublime] and disenchantment [the claim of aesthetic formalism which is the consequence of rationalization] achieve unison in the speechlessness that characterizes Beckett's work' (AT, 117; SAT, 123). Ethically too Beckett's work forms the paradigm of art caught by the logic of culpability and sacrifice.

> By following the dynamic of self-sameness to the end, art works assimilate themselves to the non-identical. This is the stage of development mimesis has reached today. Reconciliation as method or mode of conduct is discernible at the present time in those works which have abandoned the traditional idea of reconciliation, works where the form prescribes inexorability. Such unreconciled reconciliation in the form, however, has as a condition the unreality of art, which keeps threatening to invade and ideologize them...By their very a priori assumption or idea, if you prefer, works of art become part of the context of culpability. When they succeed they transcend blame, only to find themselves having to atone for trying to escape. Every work is a 'desecration of silence' (Beckett) wishing it were possible to restore that silence. (AT, 194–5; SAT, 202–3)

The presence of silence (absence), which pervades Beckett's work, is provided by Adorno with a rigorous sense. Aesthetically, silence is the direct result of art's rationalization into an autonomous sphere; cognitively, aesthetic silence is doubled or repeated in the formal claim of the work beyond aesthetic claiming – the silence of the modernist sublime; and ethically silence signifies the innocence departed from by art's necessary participation in rationalization, domination and subjugation of the non-identical other, in the very aesthetic act, the only one available to it, through which it registers its dissent from rationalized domination. Aesthetic silence is both a historical fate and a form of refuge, a position to be criticized and the condition for that critique being lodged. Which is why critique always recoils on itself, why, that is, critique is impossible without sacrifice. Silence must be given voice, suffering expressed: the risk of meaning is always a coming-to-presence, being present. What Adorno says of Benjamin's philosophy holds for art as well: philosophy and art can be more than 'bustle' only where they run 'the risk of total failure' (ND, 19). Is the risk of *total* failure applicable to the re-marking of the untied laces?

Can total failure be thought within a transcendental philosophy? Does not unconditioned affirmation block the spectre of failure?

The entwinement of the value spheres of truth, goodness and sublimity (alias beauty) in silence, for categorial reasons the only way they can now be entwined, is the categorial and historical claim of the modernist work. Since aesthetic silence is the result of rationalization, it is what modernist (enigmatic) silence opposes; and since ethical silence is parasitic on epistemic silence, then the ultimate validity of the modernist work turns on the validation of its epistemic claim. However, since art's capacity to register this claim turns on its a priori concept or idea, the concept or idea of sensuous particularity, it follows that no fully discursive validation of art's claiming is possible. What is equally evident, however, is that art's categorial self-consciousness, and its reflective displacement of enlightened categorial articulations, only register if they are discursively, philosophically, interpreted. Adorno too, then, like Derrida, must attempt to generate a logic of parasitism, a logic of interaction between art and philosophy. And for him too art exceeds philosophical discursivity. Adorno's parasitic logic, however, is not transcendental but dialectical and speculative; or rather, Adorno must be thought of as opposing a dialectical and speculative account of the relation between art and philosophy to a parasitic one. The stronger account of the relation between art and philosophy in Adorno derives from his perception of the stronger claim the art work makes, on the one hand; and the fact that the claim is more historical and concrete on the other. For Adorno, the art work does not withdraw from positive meaning but interrogates it through risking another (always illusory) positivity. He does not pursue the idea of continuing transcendental reflection beyond metaphysics, beyond identity thinking; rather, for him philosophy 'lives on (ND, 3), in part consumed with criticizing its constitutive desire and cognitive drive for identity, and in part as a second reflection upon what of itself interrupts identity thinking and subjective reason – art.

This reading of Adorno is not beyond challenge. Consider, for example, his project for a modernist philosophy,[13] or the aestheticization that theory undergoes in *Aesthetic Theory* where fragmentation, the upsetting of logical subordination and the use of rhetorical figures all play an essential role. Against the background of his vision of modernism's dying, to be discussed in the final section, all these factors point to a project whereby philosophy mimetically assimilates itself to its (dying) object. This would make Adorno's theory the dialectical twin of Derrida's. Yet the moments of positivity in Adorno, however aporetic they may be, point to a version of aporetic speculation (which leaves unquestioned how aporetic or non-aporetic Hegel's own conception of speculation was) as expressing the inner movement of his thought; and only this conception is adequate to meet the challenge, if that is the correct word, of deconstruction.

Art critically and categorially interrupts identity thinking. Philosophy, which possesses that capacity for interruption only weakly and derivatively, needs art for the sake of its claims to non-identity, as art needs philosophy in order to elaborate what it alone can accomplish: 'The object of aesthetics determines itself as indeterminable (*unbestimmbar*), negative. That is why art needs philosophy to interpret it. Philosophy says what art cannot say, although it is art alone which is able to say it: by not saying it' (AT, 107; SAT, 113). Art and philosophy stand to one another as intuition to concept, particular to universal. But the concept does not here raise the intuition to itself; aesthetic truth is not sublated into philosophical truth in Adorno. On the contrary, because it is sensuous particularity that has become dominated by the reign of subjective reason – instrumental reason and capital exchange relations – which entails the silencing of non-subsumptive knowing and judging; and because the distortion incurred by discursive knowing through its separation from non-subsumptive knowing only categorially appears from the perspective of non-subsumptive knowing, it follows then that philosophy is provided with its evidence and force by art. *Aesthetic Theory* is the tracing of the possibility of art being the saying of what philosophy can no longer say. It hence inverts the relation between art and philosophy (because it is philosophy in its autonomous mode that has ended: ND, 3) which had been the theoretical centre of Hegel's account of the death of art. Because there has been no progress in the consciousness of freedom, because there has been 'no progress in the real world', art remains the place of our consciousness of needs, *das Bewusstsein von Nöten* (AT, 297; SAT, 309). Art remains a place of mourning for Adorno, but the grief it expresses is not over an ideal past or its own passing; rather, art mourns over its participation in rationalized domination (and the victims of that domination) that has left it the repository of our consciousness of needs.

Two elements, then, are involved in Adorno's theory of truth in art: first, he must elaborate an account of the modernist sublime as having a truth content that transcends autonomous aesthetic claiming; and secondly, he must provide an account of how that claiming is articulated philosophically. What troubles both accounts is that art's truth content is not representational, not a truth claim about some straightforwardly empirical subject matter, *but a categorial truth claim, a claim about art and the nature of truth (reason) in modernity*. The full oddness of Adorno's position becomes visible when we ask why art requires philosophical elucidation. Why shouldn't art criticism, interpretation and commentary, remain the vehicle through which art reaches discursive articulation? A criticism of Adorno's position on this matter has been forcefully lodged by Albrecht Wellmer:

> The attempt to unravel the truth content concealed in the work of art is for Adorno nothing but the attempt to rescue the truth of art,

which would otherwise be lost. *What*, however, is rescued here through conceptual articulation is the polemical-utopian concept of art as such – art's relation to reconciliation as something which is knowable: it is a truth *about* art and not the truth content of the particular works of art. It is only because for Adorno the two levels of 1) an analysis of the *concept* of the truth of art and 2) the appropriation of each concrete truth of art, coincide, that he has to conceive of aesthetic knowledge as philosophical insight and the truth of art as philosophical truth. (TSR, 106).

Wellmer is correct: Adorno's account does turn on making the truth about art overlap with the truth content of particular works. Hence against Adorno Wellmer offers an account of art as providing a transformation of perception, a transformation that must be perceived and recognized 'not in the way that the truth of a statement is recognized, but in the way a face is recognized' (TSR, 107). Wellmer's often delicate analysis (TSR, 107–10) allows him to maintain a distinction between aesthetic validity and cognitive truth while exploring how the former can be taken up in the latter through the intermediary of a transformed subjectivity, a 'real expansion of the borders of the subject' (TSR, 103). Hence while Wellmer concedes that truth, truthfulness (aesthetic validity and authenticity) and normative rightness are bound up in the work of art, they are so bound up only metaphorically; however, the work of art, as a symbolic construct, is at the same time an object of experience, an object for an embodied subject active in a complex world, in which the three dimensions of truth (cognitive, aesthetic and moral) are unmetaphorically linked (TSR, 109).

For Wellmer, whose account is a recognizable categorial extension of hermeneutic criticism, modernism differs from traditional art only in degree; in it the moment of the transformation of perception through aesthetic experience 'becomes increasingly dominant' (TSR, 108). This, however, leaves out of account how reflective and problematic modernist art is, how much it does concern itself with the *question* of its own nature and purpose, a questioning that proceeds precisely through the suspension of aesthetic meaning. To the degree to which that question is dominant, to the degree to which the achievement of autonomy involves a continual artistic interrogation into the nature and place of art in modernity – an interrogation accomplished through a continual critical dialogue with tradition and the history of art – and to the degree to which artistic achievement involves a reinscription of the borders of *art*, to that degree the truth content of particular works of art do overlap with the truth about the nature of art. To be sure, even in a work like *Endgame*, which involves an overt reflection on the relation between meaning as it continues in art, in the 'refuge', and its lapse outside art, there exists as well a reflection on certain 'subject matters': subjectivity, familial ties, the claims of nature, etc. However, the claims about these subject matters take their place

within the work by continually being drawn into the orbit of the work's categorial self-reflection.[14] And this is as it must be if the distortions of these existential structures is a consequence of rationalization and its distortion of categorial articulations. Modernist art cannot be art unproblematically; each modernist work is a differentiated response to the questions 'What is art?' and 'Why is art?'; a response that in turn reacts on whatever apparent subject matter with which the work itself deals.

Wellmer's refusal of modernism's self-reflective character, his refusal to acknowledge the nature of the risk of meaning enacted by modernist works, has its proximate cause in his assumption of the validity of the Habermasian version of Critical Theory. His general line of argument turns on the thought that the Adornoesque paradigm of reconciliation ought to be replaced by the Habermasian vision of dialogical relationships between human individuals in a liberal society, that is, the image of the non-violent togetherness of the manifold imaged in authentic art works properly pre-figures an uncorrupted intersubjectivity, a 'mutual and constraint-free understanding among individuals who come to a compulsion-free understanding with themselves – sociation without repression'.[15] The reason proffered as to why we ought to make this substitution is that the philosophy of consciousness within which Adorno works restricts the comprehension of rationality to instrumental rationality; thus it cannot actually name or analyse what is destroyed through instrumental reason. Mimesis as a figure of what is lost suggests 'a relation between persons in which one accommodates to the other, identifies with the other, empathizes with the other',[16] but can do no more. Hence what is other than instrumental reason remains opaque to rationality, and a liberated society becomes simply the other of this society. This is Adorno's 'abyss (*Abgrund*) between praxis and happiness' (AT, 17–18; SAT, 26). Alteration to a communication-based theory allows the rational core of the mimetic achievements of art to be unlocked in terms of communicative rationality. 'This utopian projection,' Wellmer argues, 'does not describe the "Other" of discursive reason, but its own idea of itself. Because this utopian projection remains attached to the conditions of language, what is at issue here is an inner-worldly – in this sense "materialist" – utopia' (TSR, 99).

What is significant about autonomous art, then, is again its functional capacity for altering intersubjective relations and releasing the communicative potential repressed by capital's intrusion into artistic distribution and reception. Wellmer's defence of a hermeneutical account of artistic cognition, and his refusal to engage with modernist artistic production with its categorial self-reflection – which does not directly image a nonviolent togetherness of the manifold, but includes an emphatic moment of dissonance – is required by his acceptance of the Weber–Habermas thesis that the categorial separation of truth into knowledge, moral rightness

and aesthetic validity represents *the* cognitive achievement of modernity. Wellmer is sufficiently 'materialist' in his approach to acknowledge that were artistic production distorted in the way that the institutionalization of art distorts its relations of distribution and reception, then his defence of categorial modernity would collapse. And with that collapse there would follow as well the collapse of Wellmer's and Habermas's defence of a continuist conception of historical change from capital to its successor social formation. Nothing, however, speaks in favour of the elision of modernist artistic production from consideration; and nothing that Habermas or Wellmer say about artistic modernism supports the hypothesis that it does not involve categorial self-reflection, an interrogation into the nature and purpose of art in modernity that questions its inclusion within an autonomous sphere of validity.[17] On the contrary, the concession that in modernity artistic relations of distribution and reception become distorted, deformed, is unintelligible unless artistic production is included. One cannot sustain an account of an alteration in reception without that account coming to infect artistic production. And, of course, everything Adorno says coheres with the traditional materialist idea that production is primary over reception. If there is an aporetic moment in modernist art, that moment stems from the changed position of artistic production. Nothing Wellmer says directly challenges this thesis.

Wellmer and Habermas want to preserve a core of reason and rationality that remains untouched by rationalization. This is the neo-Kantian moment of their thought. Their fear is that were there to be a reintegration of spheres then power and reason would again become fused; 'mere' ideology and truth could no longer be contrasted as such. Hence they too want an unconditioned affirmative moment. Truth's entanglement with power, which is indeed what keeps domination on the political and historical agenda, is what allows truth to matter. Truth discriminates against untruth; that is truth's non-tolerance. Truth's lack of tolerance, its entanglement with power, is politically the non-detachability of justice and goodness. If justice does not judge, it cannot be good. Universalism (justice) without goodness thus lacks historical force, and thereby repeats the violence it would oppose. Communicative rationality is not bad *per se*, any more than harmony or unity in works is; but in keeping communication pure, in the norms of communicative rationality, Habermas and Wellmer remain bound to the logic of beauty, a logic of illusion that does not recognize itself in its non-identical other. It thereby forfeits the non-identity it would promote. Communicative rationality is another beautiful soul.

Aesthetically, the consequence of their acceptance of such a (quasi-transcendental) core is the presumption that modernism is an unequivocal cognitive advance beyond the tradition when viewed from the angle of artistic production. Not only is the attempt to insulate artistic production

from its institutionalization in a separate art world misguided; it makes opaque the connection between developments in artistic form and art movements that made the fact of institutionalization paramount, such as the Avant-garde. That opacity is but the reverse side of the attempt to protect enlightened reason in the form of communicative rationality from contagion by the destructive forces of modernity. Such protection cannot be had (AT, 109); worse, the emphasis on communication, however important it might be, displaces the central roles of reflective judgement, creative praxis and sublimity which, we have been arguing, provide the real contours, the categorial anticipations, of an intersubjectivity worth having.

iv Truth and Speculation

If art cannot directly escape its autonomized placement in modernity, then it can transcend that placement only through the employment of the very artistic forms that render it autonomous in the first instance. And this is equivalent to saying that modernist works must force the concepts of aesthetic validity to surmount themselves towards truth. Aesthetic validity thus becomes different to itself in its modernist guise. By means of aesthetic validity, then, modernist art must insinuate its desire to be more than art; it must include within itself a moment of anti-art, a moment in which art is risked for the sake of what art promises (AT, 464). The traditional substance of art, that is, those elements of art that account for the possibility of aesthetic validity, are collected under the heading of 'illusion'. Illusion, again, qualifies or brackets a work's appearance of being a thing-in-itself. If a work were a thing-in-itself it would be a worldly object, unsupported by the bracketing of meaning and purpose constitutive of the aesthetic sphere; the self-sufficiency of works, engineered through form, is itself the form upon which illusion rests (AT, 425). Which is why one cannot comprehend the illusory character of art without at the same time investigating the categorial determinations of art, that is, the categories constitutive of aesthetic validity as opposed to those constituting epistemic and moral validity. What is real or illusory is always a categorial matter. Which is not to deny that art works are real things; their real *and* illusory distance from what is considered empirical existence institutes their antinomic character. The avant-garde exchange between art works and real things is the passage through illusion in its autonomous signification.

Aesthetic truth is the 'transcendent dimension of illusion in which illusion transcends itself'. The truth of works of art is neither their meaning nor the intention behind them, but 'the truth we gain through the medium of art' (AT, 398; SAT, 423). Because the truth of art is what

occurs 'through' the medium of art, truth is not an element or component of works: 'Art moves towards truth. It is not directly identical with truth' (AT, 394; SAT, 419); 'truth content is not one factual given among others in a work' (AT, 398; SAT, 423). To suppose the contrary of this view would entail letting illusion, which is substantial in art, be true as such. This would make all art works affirmative. Because the medium of art and the medium of illusion are united in art, the cognitive element of works cannot be directly or immediately immanent to them. This thesis, however, is not equivalent to the idea that works have 'implied truths', or to the thesis that the truth of works is the truth of a possibility. Both implied-truth theories and truth-of-possibility theories are designed in order to explain how art works can have a cognitive element while simultaneously granting the validity and hegemony of standard accounts of truth-as-correspondence and rationality. So implied-truth theories allow the truth of works to be true if and only if the propositions implied by the works are (standardly) true. Art works are thereby deprived of any internal cognitive dimension. What is worse, it remains unclear why, in accordance with implied-truth theories, aesthetic 'rightness' provides good reasons for considering the propositions implied by works as candidates for empirical consideration. Replying to this difficulty involves demonstrating that aesthetic forms are simultaneously social forms; but once this move is made, the character of the separation between aesthetic and empirical rationality presupposed by implied truth theories collapses.

Truth-of-possibility theories acknowledge works as acts of practical reason; for them the internal consistency of works is a mark in them that the 'imagined' possibilities inscribed or portrayed by the work are real possibilities, ones 'worth' considering. Such theories are sub-categorial. The possibilities they acknowledge accept the categorial terms of reference operative in empirical reality as providing the initial conditions for the imaginative investigation of the work. As a consequence, they cannot provide an account of the relation between the internal consistency of an aesthetic performance and an act of practical cognition. Indeed, such theories provide no account of the idea of aesthetic consistency, but rather take some form of artistic realism as their norm, and simply construe a work's performance as an act of practical reflection. In brief, both types of theory are reductive, taking truth and reason as properly fully discursive and disallowing the thought that the non-discursive moment of works can itself be cognitive.

Nonetheless, as we shall see, Adorno's position is akin to both implied-truth theories and truth-of-possibility theories. The similarity to the former is evident in the way he connects artistic practice and philosophical interpretation; while the similarity to the latter is invoked when Adorno employs works as indexes of categorial potentialities latent in artistic practice but not elsewhere (for the time being) in modernity. For all that,

the centre of Adorno's endeavour is to sustain the cognitive significance of works' incomprehensibility, their moment of non-discursive cognition (AT, 476).

Sustaining the moment of non-discursive cognition can be understood in terms of sustaining the cognitive significance of illusion, where, again, illusion must be interpreted as the (illusory) unity of an aesthetic performance. Thinking this possibility involves perceiving the riddle of art, a riddle which is to be understood but not discursively untied.

> A metaphysics of art today has to centre on the question of how something spiritual like art can be man-made or, as they say in philosophy, merely posited, while at the same time being true...To ask how an artefact can be true is to pose the question of how illusion – the illusion of truth – can be redeemed. Truth content cannot be an artefact. Therefore every act of making in art is an endless endeavour to articulate what is not makeable, namely spirit. (AT, 191; SAT, 198)

Like Heidegger, and unlike the Marxist he is supposed to be, Adorno always denies that truth can be understood as something made or produced. Indeed, for him the metaphysics of production is the metaphysics of identity thinking since made or produced truth 'duplicates the subject, however collective, and defrauds it of what it seemingly granted' (ND, 376). Transcendental subjectivity, as responsible for the *constitution* of the necessary conditions for the possibility of experience, is thereby the fulfilment of the metaphysics of production; and negative dialectics the attempt to 'use the strength of the subject to break through the fallacy of constitutive subjectivity' (ND, xx). The question of spirit is equally a question of creation for Adorno; but the question of creation is not transcendental since there has never been either a subject or an object that could be 'first': 'the subject is never quite the subject, and the object never quite the object; and yet the two are not pieced out of any third that transcends them, (ND, 175). The desire for a non-reflective third, what transcendental affirmation must always be, either repeats the logic of production or aestheticizes the historical totality (or both). Only through acknowledging the lack of a transcendental third can historical success and failure achieve full immanence.

What is not makeable, spirit, is the intelligible structure of recognition of non-identical others. Spirit, recognition, cannot be willed or posited. This limit of volition is one we have seen before in other guises: in the uptake of works of genius, in the relation between beings and being, and in the deconstructive refusal of the problem of freedom and autonomy. Each acknowledges in their own way, a limit to what can be achieved through rational, self-determined action in its subsumptive or produc-

tionist guise. Each insists on a moment of heteronomy. Art is for all a matrix of this problem since art works are intentional products whose significance transcends what is intentionally posited in them. Modernist art's inscription of that problem is unique in that it raises that moment of art into the centre, making it the constitutive claim of works. This occurs as a consequence of art's placement in society, which is why this claiming can be detected in artistic practices (surrealism, Dada) and theories (such as institutional theories of art) whose immediate claims are quite different.

As we have already seen, Adorno's theory differs from those previously examined in seeing in modernist art the goal of redeeming the promises of the Enlightenment, above all the promises of freedom and happiness. Further, the very fact of a radicalized aesthetic domain, that is, a domain in society enacting in an illusory mode the historical self-determination of a free society, is taken as a register of the gap between the idea of freedom and its reality. It is from this theoretical constellation that Adorno derives the thesis that the process enacted by every art work is a 'model for a kind of praxis wherein a collective subject is constituted' (AT, 343). Elsewhere he puts the matter this way: 'Enshrined in artistic objectification is a collective We. This We is radically different from the external We of society. It is more like a residue of an actually existing society of the past. The fact that art addresses a collectivity is not a cardinal sin; it is a corollary of the law of form' (At, 338; SAT, 353). The law of form in autonomous art addresses a collectivity because in it empirical (material) form and logical form are not opposed; a form that is quasi-empirical, which is as much material and sensual as conceptual, is one whose meaning is context-dependent, and thus a form that can mean only if it is *our* form. Adorno's We is the direct descendent of Kant's *sensus communis*; its character as a 'residue' refers to art's memorial moment, while its enactment of the constitution of a We specifies both what it does and what it adumbrates. It highlights the heteronomous moment in the constitution of a people, a moment in irreconcilable conflict with Kantian moral autonomy and liberal, rights-based, political theory. Art works rehearse the moment wherein praxis entwines with meaning.

There is, then, a perhaps surprising internal connection between what Adorno wants to say about illusion and truth on the one hand, and what needs to be said about the limits of intentional action on the other. What provides for the confluence of these two items, which one might have thought to be a desideratum for a general theory of art and the aesthetic if one were possible, are the processes of rationalization conjoined with the form they take when harnessed to capital exchange relations. The separation of spheres of validity and the tendential instantiation of universal fungibility make disenchantment entail the suppression of autonomy, an autonomy whose categorial inscription lives on in artistic praxis. The two converge through the divergence between universality and particularity as

demands; fungibility is an illusory acknowledgement of both universality and particularity. Enlightened modernity acknowledges the claims of non-identity in principle but not in fact. *Pace* Heidegger and Derrida, the historically developed domination of the different by the same is the suppression of human freedom; although the freedom suppressed is, of course, not equivalent to the full idea of autonomy and self-determination inscribed by the tradition. That notion of freedom suppresses the moment of heteronomy that is a condition and not an external constraint on autonomy. That is what the concept of recognition, spelled out at the end of our discussion of Derrida, is intended to be a recognition of.

The truth of modernist works, which is again their critical surplus beyond traditional autonomous art's conception of aesthetic validity, transcends traditional aesthetic rightness in direct proportion to the capacity of works to transcend their formal construction. In order to make that construction speak against itself a work must aesthetically dissolve previous modes of aesthetic ordering. The dissolving, disintegrating agents are: self-reflection, irony, parody, dissonance, fragmentation, montage, etc. Because this dissolution is 'aesthetic', because what is involved here is an act of self-overcoming by art, through the risk of 'self-relinquishment', and because what is to be overcome is fundamentally a categorial distortion of cognition requiring a rigid juxtaposition of rationality and particularity, then the consequence of modernist artistic reflection must be a cognitive claim by the work that cannot be itself discursively redeemed. So the redemption of illusion is not equivalent to a discursive redemption of the work, but rather the philosophical reflection on the claim of the work that allows it to be recognized as a cognitive claim. Aesthetics in the Adornoesque mode, in the first instance, does not restitute the truth of art works themselves but *that* a truth claim is what is being made. Aesthetics installs modernist works, by transforming the discourse of aesthetics through them, in an aporetic space in which the self-surmounting of aesthetic validity can and must be understood as lodging a claim to truth. The claim to be registered, however, is still the claim of the work itself.

Works claim us beyond our capacity to redeem them discursively. In Adorno's writings this thesis is given an austere reading pertaining only to the claiming of works belonging to the modernist sublime. The austerity of Adorno's account turns on the fact that the truth of modernist works is restrictedly the truth of a negation: 'No truth in works of art without determinate negation; today aesthetics has this to expound' (AT, 187; SAT, 195); or, 'Actually, only what does not fit into this world is true' (AT, 86; SAT, 92). To say either of these two things is just to say: (i) that a work does claim our cognitive attention; and (ii) that the claiming transpires through the (aesthetic/sublime) negation of all previous modes – forms – of aesthetic ordering. In so far as a work accomplishes these two tasks, it appears as meaningful otherwise, that is, as meaningful

in a way not sanctioned by what has been recognized as meaningful, cognitively significant, heretofore. The work, then, appears as excessive to rationalized meaning, but nonetheless meaningful; it interrupts what we had till now considered as providing the grounds for recognition.

In so far as modernist works perform a determinate negation of the tradition, then they become the condition for the possibility of future discourse on art. In this respect Derrida's account of the relation between the Van Gogh and the discourses surrounding it is correct. Derrida's version of the 'it gives' is, of course, a straightforward logical extension of the theory of genius. What Derrida's account fails to do is explain how a work comes to acquire that grounding relation to what would conceptually dominate it except to say that as a condition it withdraws from cognition. Derridean scepticism is the direct consequence of its continuance of transcendental philosophy. While determinate negation fails as a general account of the possibility of historical truth – for Adorno 'dialectics is the ontology of the wrong state of things' (ND, 11) – it does match the historicity of artistic modernism.

Adorno's austere presentation of truth content is parasitic on what he regards as the austerity of modernist art in its formal ambitions. At the centre of this austerity is the linking of the process of aesthetic negation, and the consequent claim of the work that survives through and despite that process. The complex process of aesthetic negation inscribes the area where critical attention can still find a place for itself. The resultant claim is the enigma of the work, its incomprehensibility or silence, which calls forth philosophical reflection while remaining beyond discursive redemption (AT, 177). What entitles Adorno to employ the idea of 'determinate negation' is that authentic works are neither sceptical nor resigned; they do more than abstractly negate the terrain of their activity. Rather, aesthetic negation is the condition constitutive of such works being works; as works, still and despite everything, they 'end up having a similarity to meaning…Art is illusion in that it cannot escape the hypnotic suggestion of meaning amid a general loss of meaning' (AT, 221–2; SAT, 231). The silence and/or meaninglessness of modernist works is meaningful and determinate, albeit not determinable, because they remain *works* despite and in virtue of their negations; and in so doing they intimate a potentiality for meaningfulness incommensurable with the tradition's determinations of what might count as positive meaning. The determinacy of works of art is their lawfulness, their obedience to the demands of form; their not being commensurable with demands of discursive determination is their being without law. Determinate irreconcilability is Adorno's reinscription of lawfulness without law.

Because aesthetic negation involves a continuance of rationalization and disenchantment into art, carrying 'the empirical process of the disappearance of meaning into the traditional categories of art, negating them

concretely and extrapolating new categories from nothingness', and because in so doing it recapitulates and reflectively articulates that empirical process, then the successful accomplishment of that activity involves a tracing of the history of meaning and an engagement with 'meaninglessness in its historical genesis' (AT, 220; SAT, 230). It is this connection of aesthetic negation with history and historicality that explains how works can carry out the fully cognitive task of inscribing historical actuality and potentiality. The 'potentiality for meaningfulness' released by modernist works is not to be identified with the postulation of an imaginatively conceived possibility, that is, it is not equivalent with what is logically possible given initial conditions; rather, it specifies a historically real if suppressed potentiality. As such, what Adorno claims for modernism, and what expounds it, accords at least in part with what has been thought to be involved in a critical theory of society. Further, his account of modernism best explains the pre-theoretical intuition that modernism stands in a particular critical relationship to society in virtue of its implicit historical self-consciousness. Modernism is, formally, the enlightening of enlightenment about itself.

Modernist art calls forth philosophical reflection because it concerns the categories, aesthetic and non-aesthetic, of meaningfulness. The truth content of modernist works is a critique of rationalized truth. Since that is the only conception of truth available, no presently operative conceptual material can succeed in redeeming the truth content of these works. What speaks for these contents is aesthetic necessity; that necessity is one provided by the works themselves: 'Works of art are their own standard of judgement. They themselves stipulate the rules they then follow' (AT, 243, SAT, 254). This necessity is experienced through the 'sheer weight' of works' 'hermetic unity and the certainty of [their] being-thus-and-only-thus' (AT, 114; SAT, 121); or: 'The mark of authenticity of works of art is the fact that their illusion shines forth in such a way that it cannot possibly be prevaricated, and yet discursive judgement is unable to spell out its truth' (AT, 191; SAT, 199). The truth of a work cancels the moment of illusion; if illusion were not cancelled, then what works non-discursively say could not be true. Equally, however, because aesthetic necessity is negative and incapable of discursive articulation, the truth of works are exposed and fragile. Adorno takes this predicament to be the inverse of the predicament facing philosophy; because it is conceptual, its determinate negation of the tradition ends up stating truths, which hence affirm the tradition. Adorno's philosophical practice, however, belies his conception of it.

What is at issue here is the precise status of Adorno's claims about art, and hence the status of his most exposed concepts, utopia and reconciliation. Can an austere account of these be made that would be compatible with the austerity of his conception of truth in terms of determinate

negation? In his critique of Adorno, Wellmer half perceives the austerity of determinate negation, but interprets it in traditional terms as a secular version of negative theology. Taking his lead from the discussion in 'Fragment on Music and Language', where Adorno takes the language of music – which can be regarded as a metonymy for the language of modernist art as a whole – and discursive language as philosophically exemplified to be 'torn halves' of an integral language that would be able to manifest the absolute, Wellmer comments:

> The language to music and discursive language appear as the lacerated halves of 'true language', a language in which 'the content itself would become manifest' as Adorno puts it. The intrinsic idea of such a language is 'the figure of the divine name'. The aporetic relationship of art and philosophy sublates a theological perspective: art and philosophy combine to form a negative theology. (TSR, 93–4)

In carrying this thought forward into the antinomy of art itself, Wellmer urges the thought that art must show itself to be the 'Other' of unreconciled reality. It can accomplish this task, it can only be 'true' in this sense, by revealing reality

> *as* unreconciled, antagonistic, fragmented. But it can only do this by letting reality appear in the light of reconciliation through the non-violent aesthetic synthesis of the diffuse – a synthesis which produces the appearance of reconciliation. This means, however, that an antinomy is carried into the *very interior* of aesthetic synthesis: aesthetic synthesis can, by definition, only succeed by turning against itself and calling its own principle into question – it must do this for the sake of truth which may not be had except by means of this principle. (TSR, 95)

Wellmer is not altogether clear in specifying wherein the problem with Adorno's account lies for him. It might be contended that Adorno *presupposes* the standpoint in virtue of which reality appears as fragmented. But this cannot be correct since even for Wellmer the perspective of reconciliation is a *result*, the achievement of determinate negation, the 'negative' of a presumed negative theology. Perhaps, then, the objection lines in what is revealed: 'what art makes manifest is not the light of redemption itself but *reality* in the light of redemption' (TSR, 94). But this cannot be the source of difficulty either since the idea of reconciled reality is even more emphatically present in the Wellmer/Habermas scheme, in the idea of communicative rationality and the ideal speech situation, than it is in Adorno.

In fact, for Wellmer the crucial objections to Adorno are those already

canvassed, namely, his discontinuist conception of historical change, for
which the concept of 'utopia' is a marker, and his apparent maintaining of
a philosophy premised upon the model of the producing subject rather
than communicative relations, relations of intersubjectivity. However,
Habermas's and Wellmer's strong conception of historical continuity relies
on two dubious assumptions: (i) that the categorial differentiation of mod-
ernity must be accepted; and (ii) that the idea of communicative ration-
ality is a quasi-transcendental condition for all linguistic practice. Clearly,
(ii) presupposes (i) since it presupposes Habermas's progressive philos-
ophy of history; but (i) is just what Adorno's entire project calls into
question. And, as we have just seen, it is not true that Adorno's theory
operates on the presumption of a single or collective subject 'making'
reality. For Adorno too reality must be linguistically mediated; where
language, at a given time, represents the sedimented achievements of a
community. Because for Adorno there is no extra-historical (or tran-
scendental) space from which reality can be perceived, linguisticality and
intersubjectivity never appear as such, in their own name; rather, language
and intersubjectivity are always bound to the actualities and potentialities
of a given historical community. This is so even for art: 'Paradoxically, art
has to attest to the unreconciled while nevertheless tending to reconcile;
this is possible only through its non-discursive language. In that process
alone does the We concretize itself' (At, 241; SAT, 251). Adorno does not
lack a conception of historical potentiality; rather, his utopian, discon-
tinuist conception of historical change derives from his analysis of the
categorial deformations of modernity coupled with his emphasis on the
heteronomous moment in the constitution of social freedom. Spirit can-
not be made or produced; hence historical change that would release
the promises of enlightened modernity cannot occur through rational,
means–ends calculated action. To claim that Adorno maintains a concep-
tion of a self-producing collective subject misses one of the central points
of his argument.

Terming Adorno's practice a secularized version of negative theology
also seems exactly wrong. In negative theology, at least as traditionally
understood, the most adequate predicative analysis of God is achieved
strictly through the negation of predicates which would limit Him: He
is neither spatially nor temporally locatable, neither sensible nor non-
sensible, etc. Negative theology turns on discriminating the finite and the
infinite though a negative comprehension of the finite; and does so for
the sake of summoning the mystery of God in a manner that would not
reinscribe Him in 'other' finite categories. Nothing like this is true of
Adorno's procedure.

The similarity between Adorno and negative theology stops at the point
where what is termed the 'absolute' can be gathered only as a result of
negations; for Adorno these negations are determinate and not abstract.

Because these negations are determinate the result is finite. Wellmer is correct in what this result allows, namely, the comprehension of reality *as* fragmented. *The whole work of Adorno's philosophy is for the sake of the appearance of this 'as'.* The point of this procedure, which takes its orientation from the movement and characterization of elements of reality itself, is to avoid legislating or positing, in the manner of a Kantian transcendental 'ought', the 'other' of this socio-historical reality. What is other is revealed in terms of the historically dynamic actualities and potentialities of the present. Potentiality appears with the 'as' of 'as fragmented'.

Further, it can hardly be said of Adorno that he leaves the other of this historical formation utterly indeterminate. What is repressed by identity thinking and the social mechanisms that concretize it is sensuous particularity. Only in virtue of the subsumptive model does the individual appear as the starting point of social practice and not as an – individualized – achievement. Collectivity, the We, fails to appear in its own name in modernity. This entails making alterity and heteronomy a limit rather than a condition for autonomy. The most salient categorial structure sustaining this perspective is the separation of the validity spheres of truth, moral rightness and beauty. It is as a consequence of this categorial deformation that the rigid juxtaposition of particularity and rationality occurs. The previous epistemic unity of reason and particularity, as exemplified by Aristotelian *phronesis*, reappears in modernity paradigmatically as aesthetic reflective judgement (AT, 203). Hence the discursive rationality of modernity and its non-discursive other, when viewed from the perspective of the development of the sphere in which non-identity thinking survives, appear as 'torn halves of an integral freedom, to which, however, they do not add up'.[18] What makes Adorno's analysis appear abstract is its level of analysis: it deals strictly with categories.

Adorno's writings are strewn with propositions to the effect that two items, in each case one signifying the moment of (social) universality and the other the moment of particularity, belong together but at present stand opposed to each other, such as philosophy and art, rationality and particularity, the art of the culture industry and autonomous art, philosophy and sociology. Hegel termed propositions of this sort 'speculative propositions'; they state a unity of identity and difference. Because Adorno construed the concept of unity here as stating an identity accomplished through the subsumption of the individual under the universal, he consistently interpreted his conception of negative dialectics as departing from Hegel at just this point.[19] Whether he was right or wrong about Hegel is here beside the point. He employs what is clearly a version of speculative propositions that do *not* return to the principle of identity criticized. On the contrary, because Adornoesque speculative propositions, which properly are the entire system of demonstrations that allow them to

appear, result not in a statement of true identity (A=B), but in an 'as' that elicits a 'belonging together' of the items in question, a belonging that is perceived through their state of diremption, the result is aporetic: difficulty is comprehended as difficulty but not transcended.

Formally, speculative propositions assert the identity and non-identity of the terms linked by the copula.[20] But subject and predicate grammatically are subject and substance materially. Thus all *reflective* elucidations of sedimented substantiality (such as the recovery of the tragic politics within the aesthetic sublime) and all dialectics of mimesis and rationality are incipiently speculative. Speculative propositions are most easily understood as forms of essentialist predication where the relation between subject and predicate is set into motion as a consequence of the discovery that the so-called predicate is the content, the reality, the substance of the subject – the subject cannot be comprehended without it. Subject and predicate exchange positions when what initially appeared as an attribute comes to stand in the subject position – a position that is then discovered to be in its own way ineliminable. Now in this experience of the undermining of the stability of the subject position, the experience that the grammatical subject must be turned towards its substantiality, the reading subject's progress from subject to predicate is 'checked' and 'suffers' a 'counterthrust'. The 'loss of the [grammatical] subject' experienced in the reading of speculative propositions is equally the loss of the reading subject to itself. *Speculation is self-dispossession.* The reading subject can only come to itself by losing itself, by coming to recognize itself, its substantiality, in what was an external other, a contingent attribute perhaps predicable of a substantial subject. Reading speculative discourse forces the reading subject to give up its external position with respect to what is being read about in precisely the same way that the abstract subject position of the grammatical subject is overcome by its attributes. Speculation, then, draws the reading subject into what is being read about; thus the representational relation is dispersed. Self-implication is realized in the self-reflection of speculative thinking.

Speculation is *reflective* self-dispossession. It is the work of reflective distancing that draws the subject *into* the ethical totality of which it is a part. That totality is the subject's 'own', which is why it is responsible for what does occur and has occurred in it; and not its 'own', it neither 'belongs' to nor is it within the control of the subject. In speculative reflection the ethical position of the subject is revealed to be non-identical with the subject's will. That is why all speculation is tragic: the deed that fractures the ethical whole (including, for example, the collective deed of capital appropriation) is the subject's deed, a deed for which it is responsible, even though it is not its intentional act. Speculative truth is tragic recognition: philosophy's abstract universality recognizes its partiality and culpability in the exploded essence of works; and they, in turn, seek the

universality they struggle against. It is because the unities that speculation reveals destroy presumed innocence by entangling the subject in a world beyond will, that it cannot be viewed as suppressing non-identity. On the contrary, only if the subject is categorially responsible for a world it has not willed can non-identity be preserved. But how else than through speculation, through a reflection that traces the constitution of the subject in the world, is the relevant 'ownness' of world to self now to be elicited?

Against the grain of Adorno's own statements about his practice, I am claiming that non-identitarian truth appears *twice* in his theory. On the one hand, the truth content of particular works of art is their claim to cognitive attention in excess of the categories and concepts which presently exhaust cognitive significance. This claim is categorial or re-flective because its claim is that meaning and truth is possible otherwise than how they are conceived of now. If that were all Adorno could place before us his theory would leave unreconciled reality unknown, and, indeed, underline its unknowability. Our fate would be incomprehensible to us. Therefore, on the other hand, he must allow that art itself has a speculative moment, and this speculative moment reaches cognition, in the form of speculative thinking, in philosophy. Philosophy can know and say what art cannot say; but the veracity of philosophy's saying is depen-dent on the truth content of art; philosophy's second reflection follows the historical path sedimented in works. Second reflection thereby becomes a work of narration and memory, thereby supplementing creation with explanation. Such activity does 'do violence to the works, but they cannot survive without it' (AT, 480; SAT, 521).

Philosophy and art overlap, but do not coincide, in the idea of truth content: 'The progressively unfolding truth of a work of art is none other than the truth of the philosophical concept' (AT, 190; SAT, 198). Adorno amplifies this thought thus:

Aesthetics is not something above and beyond art; it has to retrace the dynamic laws of art of which the works themselves are unaware. Art works are enigmatic in so far as they represent the physiognomy of an objective spirit that is opaque to itself at the moment when it bursts forth into appearance...Their enigma is the twilight zone between the unattainable and what has actually been accomplished. (AT, 186–7; SAT, 194).

The 'unattainable' is the categorial potentiality instantiated by the work's aesthetic negation of 'what has actually been accomplished'. The work is enigmatic because of its form: historical potentiality only appears in the incomplete self-surmounting of aesthetic illusion. Self-surmounting, the effort of determinate negation, is incomplete, aporetic, because made in a work of art.

The claim that universal and particular have become dirempted issues from the particular – art; the comprehension of that claim, the unfolding of the diremption of particular and universal, must nonetheless fall to philosophy. Art cannot say the 'as' of fragmentation except by not saying it, which is the law of form in art now; while philosophy must bring that diremption of itself from particularity (art) to conceptual articulation. However, philosophy's mode of conceptual articulation, its speaking speculatively, does not directly betray sensuous particularity, as Adorno sometimes assumes. It is not a betrayal because its speculative truth is neither legislated, posited, nor a reductive statement of fact. It is a betrayal only because it must speak discursively. Speculation is the point where redemption and betrayal speak together. Speculation's statement of the belonging together of universal and particular, of philosophy and art, is what Adorno mystifyingly identifies as the light of redemption. Nonetheless, when he stops using the language of redemption, Adorno invariably reveals the structure of his analyses as the elaboration of a speculative proposition: philosophy and art are one; or autonomous art and mass art represent two halves of an integral freedom, to which, however, they do not add up. There is no conceptual way of demonstrating the fragmentation of modernity without presupposing or merely positing its negation except through the demonstration of the antinomies infecting the opposed moments. Their opposition and mutual belonging are the conclusion of the demonstration.

Speculative knowing does not transgress the demand that utopia, the absolute, must not be represented. What is known is only the present *as* fragmented; the absolute, the belonging together of the separated categorial domains, appears as the negation of their fragmentation. Where speculative cognition appears most vulnerable is in its apparent lack of an ethical moment, an awareness of its complicity with the fate being expounded. But this is a false impression since what is claimed by philosophy is its lack of self-sufficiency. By siding with the concept, against it, philosophy is culpable. Self-consciousness cannot avoid self-implication. Thus what spells the limit to transcendental reflection and ruins it, the empirical moment, ethically implicates the subject in what it would transcend. The reiterated guilt and complicity of art also belongs to its second reflection. Derrida attempts to avoid self-implication by taking transcendental thought beyond self-reflection; Adorno continues the path of self-reflection against the transcendental. Interruption, the gift of 'it gives', is not beyond good and evil, but everywhere implicated in their deformation through identity.

Of course, that philosophy must state its inner insufficiency makes its fate worse, more culpable, than art's; after all, it is sensuous particularity that is repressed and dominated. Nonetheless, the distortion of one moment must equally involve a distortion of the other. To that degree

both philosophy and art are in the same predicament. For both it can be said that 'the unity of the *logos* is caught up in a complex of blame because it tends to mutilate what it unifies' (AT, 267). Adorno considers Homer's account of Penelope unravelling a day's weaving as the most poignant exemplification of this fate.

> The woman's cunning mutilates the artefacts made by her, but in so doing she actually mutilates herself. A seemingly unimportant episode in the Homeric epic, this story points to a constitutive aspect of art, which is that art is unable to bring about the identity of the one and the many, and incorporates this inability as a moment of unity. (AT, 267)

This work of self-mutilation is also that of speculative philosophy; it is the self-mutilating work of *Aesthetic Theory*. In it the inability to bring about the identity of the one and the many is incorporated as a moment of unity, a unity that is a complex of blame.

v Speculation, Art and Politics

The redemption of illusion is the speculative proposition that art and philosophy are one, that they belong together; where their belonging together is not to be construed as a prelude to either an aestheticization of the philosophical or a conceptualization of the aesthetic. What we now mean by the aesthetical and the philosophical refers to a categorial deformation of the relation between universal and particular in modern society. Hence aestheticization would only lead philosophy into the predicament of modernist art; while conceptualization just is the neutralization of the modernist sublime. Philosophy, then, can only speak its separation, its loss of the capacity cognitively to engage sensuous particularity, if it ever possessed such, aporetically.

This is revealed in the analysis of the separation of philosophy's negative dialectic from art's aesthetic negation, that is, in the concept's attempt to overcome itself in the direction of sensuous particularity, and art's attempt to overcome itself in the direction of sensuous reason. But it is art that leads philosophy to an aporetic conception of itself; which is also to say that works of art draw their authority from 'the fact that they call forth philosophical reflection' (AT, 123; SAT, 129). This thesis returns us to our starting point, namely, the claim that *Aesthetic Theory* is primarily concerned with reinscribing Kant's, and modernity's, understanding and social structuring of concept and intuition. For Kant concepts without intuitions are empty, intuitions without concepts are blind; categorial synthesis, the synthetic activity of the transcendental ego, unites concept and

intuition in a judgement. Adorno's analysis initially sounds similar: philosophy without art is empty, art without philosophy is blind. Their unity, however, is speculative and aporetic; and this because the Kantian construal of intuition fails to respect the integrity of sensuous particularity, of the non-identical other. Philosophically, this failure first emerges in the antinomies of aesthetic autonomy in Kant's aesthetics; culturally, this same failure becomes perceptible in the antinomies of the modernist sublime. Revealing the conceptual, linguistic, technical, and generally formal features of art works demonstrates the resources of sensuous particularity that make them capable of temporarily resisting theoretical subsumption. In so far as art is cut off from discursive rationality, however, it can say what it wants to only by not (discursively) saying it. To be able to speak and claim without discursively speaking and claiming is art's strength and misery. It is that which makes art a field of cultural contestation, carrying a weight of cultural significance that stands in inverse proportion to its ability to affect anything.

Throughout this century, this usually inarticulate sense of art's cultural significance has been the spur to attempts, both theoretical and artistic, to draw art directly into politics. From Adorno's perspective, it is evident that art's political moment resides in its refusal of immersion in given political programmes for cultural reform. Indeed, Adorno's defence of this refusal, and his dismissal of engaged art, has been the most criticized element of his theory. Such criticisms overlook the pathos of *Aesthetic Theory*; its summoning up of the critical character of modernist art is made at the very moment when art's capacity to resist neutralization had begun to dissolve: modern art is growing old (AT, 55). This sense of the immanent disappearance of the one domain in modernity that was categorially assigned the task of reflection conditions both Adorno's comprehension of modernism and his continual sense of its dependence on philosophy.

For Adorno the dialectic of modernism was always degenerative. This degenerative tendency was already evident in my original statement of the dialectic of the new. Because the new is produced through negation, art staying always only a half step ahead of the will-to-interpretation of the art-critical community, the desire for the new tends toward stasis. The incessant repetition of the new makes it old; the very sharpness of the dichotomy between identity and non-identity tendentially makes the appearance of the non-identical itself an image of the triumph of identity. The dichotomy between identity and non-identity is the truth of the radical duality between autonomy and imitation in Kant; Kant's incendiary dialectic of genius does not state a metaphysical truth about autonomy and heteronomy, but a social truth about the appearance of freedom in modern societies. Freedom appears only as the revealing of the unfreedom of what lies outside art; but since every appearance must yield to its com-

prehension, our grasping at our freedom through works immediately ruins it. The community of the work, the community of the 'art world' that is gathered through works, is as illusory and as susceptible to neutralization as the works themselves.

Modernism's degenerative dialectic is a dialectic of substance and subject; substantiality is equivalent to the moment of mimesis and expression, and subjectivity is equivalent to the moment of rationalization, construction and technique. Because modernism is rationalization in art, substance remains alive only through the development of its opposite, construction and technique. This is the emphatic aspect of the logic of degeneration: historical substantiality and sensuous particularity become increasingly attenuated through what is meant to sustain them. The nature of this dialectic in painting is implicit in the transition from Van Gogh's internal mimesis between paint-on-canvas and painted object to abstract art's paint-on-canvas. The path from Van Gogh traces the disappearance of substance from art, while the development of abstraction (into the aptly named 'minimalism' that, at worst, conflates materiality with sensuousness, and at best uses materiality as a reminder of a loss of sensuousness) traces an increasing loss of sensuousness. These two losses together come to entail the disappearance of art as a determinate negation of the reified social world: 'desubstantialization of art is not only a stage in the liquidation of art but the logical development of art' (AT, 117; SAT, 123). The path of modern art is from a determinate to an abstract negation of the categorial structures of modernity. But abstract negation contains nothing to inhibit its turning into its opposite; which to a large extent is the fate that has befallen modernist art: it has become the token of what it originally refused.

Some critics have wanted to say that the liquidation of art in modernism is really just the liquidation of Adorno's philosophy of art. After all, modern art has gone elsewhere since the heyday of high modernism; and where it has gone has nothing to do with the notion that progress in art follows the course dictated by the most advanced artistic materials – art's technical forces of production. And it is true that at first glance the thesis of the most advanced artistic materials appears to overlap with the account of modernism as the search for what is truly essential to any particular domain of artistic practice. Both analyses do legislate a linear, quasi-logical course of artistic development. Since the development of post-modernism has refuted the critical vision of art reaching out towards its immanent *telos*, that development can equally be seen as refuting Adorno's philosophy of modernism. Adorno's conception of advanced artistic materials, however, has nothing to do with the search for the essentially painterly, literary, musical, etc. As opposed to Kantian theories of art that regard art's inward turn as continuous with modernity's self-conscious purification of its categorial terms of reference, Adorno regards art's inward

turn, its autonomy, as something forced upon it from the outside by social determinants legislating against what briefly was categorially salvaged in art. Thus when Adorno notes that the liquidation of art is part of its logical development, he is claiming that the very idea of logical development, of a history of determinate negations, is how the triumph of the logic of production appears in the domain of autonomous art. Art's short history of determinant negation is the triumph of the very logic he philosophically opposes: dialectic is the ontology of the wrong state of things. Art's liquidation, the end of (high) art, is its end as a categorially structured and culturally systematic protest against rationalized modernity; the logic of art's unfolding no longer makes it the conscience of a deformed reason. Certainly, no one would want to claim categorial perspicuity for postmodernist art. For Adorno, post-modernism's tendential overcoming of the gap between high art and the art of the culture industry is another version of the triumph of identity thinking because it does not provide for a *substantial* reintegration of universality and sensuous particularity.[21]

Over the past two decades, art's liquidation has led to its critical moment to pass to philosophies, theories, that are themselves self-consciously modernist in their outlook and procedures. Philosophical *writing* has become the attempt to produce texts that are to be *judged* the way works were judged: purposeful histories without external ends (Foucault), interventions in the texts of the tradition that withdraw their referentiality in a gesture that reveals their difference from themselves (Derrida), or fragmentary writing (Adorno).[22] Philosophy has come to disavow its conceptuality through a self-surmounting in the direction of particularity. Philosophical particularism has the goal of making its texts sublime instances, absolute alterities opposed to conceptual exchange relations. Adorno's second reflection explains why these philosophical programmes have come to matter in the way they do, why their particularism appears as somehow necessary and true despite the fact of their leaving 'truth' behind. Philosophy has both autonomously and parasitically been caught up in the logic of modernism. And it is this fact that explains both the compulsive character of these philosophies, why their claiming now is as strong as the claims of modernism were, and their evident fragility.

Even if we ignore the criticism that these philosophies have falsely surrendered the path of self-reflection, that they have willed an unknowing as a condition for their claiming, it remains the case that there is no reason to believe that philosophical modernism is immune to the logic of desubstantialization that led to the liquidation of art. On the contrary, when we consider the movement from phenomenology to fundamental ontology to deconstruction we cannot help but perceive the mimetic moment ('the things themselves', Heidegger's existential analytic, Levinas's phenomenology or, in a different register, Lukács's philosophy of

praxis) as being sustained and liquidated by the moment of construction (Heidegger's poetic thinking, the formalism of Derrida or, differently, Adorno's philosophical compositions). Derrida's formalism and the operation of the degenerative logic of the new in the texts of Adorno are part of the logical development of philosophy and its liquidation. It was the dim figure of the degenerative logic of modernism at work in these texts that led me to the reading of them in terms of concepts drawn from Kant's 'modernist' aesthetics. The antinomies of Kant's aesthetics were the first harbingers of the degenerative dialectic of modernism, a dialectic that came to inform art itself and then returned to philosophy. The dialectic of aesthetic culture and progressive culture first appears as the categorial divisions of the critical system; it becomes the dialectic of artistic modernism, which is repeated at the conceptual level in the unfolding of modern philosophy. A logical history conditions and ruins the categorial protest against it. Which is not to deny that aesthetic modernism really is (or was) the site that opens modernity to its categorial fate and calls it into question.

Aligning philosophical modernism with artistic modernism equally explains why there is a gap between the sensed, implicit radicality of these theories, turning on their formal resources (differance, power, style, etc.) for resisting subsumption and identity thinking, and their explicit and overt apolitical and often culturally conservative character. Their substantiality (Dasein analytic, class consciousness, etc.) was always conditioned by their constructive, rationalizing moment; as the latter overtakes the former substance, with its mediated immediacy, it becomes so attenuated, so lacking in direct 'reference' to what gets left behind through rationalization, that modernist form (the *logic* of deconstructive reading or negative dialectic) asymptotically approaches its opposite. Complicity is unavoidable; however, we are rightly more suspicious of this complicity when it occurs in philosophy since, unlike art, here it represents not only a moment in the degenerative logic of modernism but equally a refusal of self-reflection. However well motivated, that refusal can but appear as an ethical fault.

The duality between formal radicality and manifest neutrality or conservativism in modernist philosophy is heightened by the fact that modernist art's capacity for resistance was in part dependent on modernity's disavowal of its own historicality, its own moment of non-identity. Let me explain. Thus far we have spoken as if modernity outside art truly obeyed an unproblematic identity logic, say the logic of progressive culture, and hence was directly thrown into question by the interruptive logics of modernism. If this were the case, then the only issue facing the modernist sublime would be whether it could manage an interruptive moment. This scenario too easily reduces the logic of capitalist development to rationalization. Capitalist societies are historical; the logic of capital is the

destruction of all *natural* boundaries, all given teleologies. Capitalism's constructive moment, its development of the forces of production for the sake of indefinite expansion, and its consequent drive for universality, entail the radicalization of all contents, all substantiality, into a system whose reproduction requires expansion: all that is solid must melt in the air. Since the end of the last war capital has begun to proclaim, rather than attempt to deny, its power to dissolve all natural boundaries; it has begun to display its own moment of sublimity, its own activity of continual self-transgression, its own ever-recuperated non-identity with itself. The domination of exchange–value over use–value makes capital a vast, non-teleological desiring machine. Non-identity and self-dispossession are as much a part of the logic of capitalist development as they are of the logics that attempt to oppose it.

This is why non-categorially refined conceptions of non-identity, accounts of non-identity that refuse the critical interplay between social modernity and artistic modernism, suddenly appear as even more complicit with the claims of modernity than had the acknowledged culpability of modernist art appeared in Adorno's eyes. Indeed, non-categorially refined conceptions of non-identity, conceptions of non-identity that foreswear dependence on a sociologically informed analysis of modernity, that refuse the burden of self-reflection and the sacrifice of innocence, are complicit with capital's sublimity in a way modernist art was not. Such *theories* of non-identity go under the tag of 'post-modernism'. Post-modernism is a running conflation of the modernist sublime with the sublimity of capital; it fails to separate theoretically capital's non-identity with itself from non-identity proper. Capital's restless, self-transgressive movement is the form through which it continually denaturalizes itself and all that attempts to resist it. However, this self-transgressive movement, which to be sure is a movement opposed to hierarchy and substantial presence, is equally a movement of universalizing fungibility. In brief, capital's synthetic activity is the historicizing of all contents, but that activity itself remains formally constituted, a form opposing and subsuming empirical life. The logic of totality and interruption is the logic of capital, what opens the totality that capital is no thing or idea but the unconditioned affirmation of production, a production that depends on a suppressed creative moment for its continuance. As such, deconstruction can be comprehended as the reflective appropriation of the self-transgressive moment of capital, a mimetic assimilation to it that also repeats capital's intransigent and opaque formality – the formality we first saw in the form of Kant's transcendental unity of apperception. Because intransigent and opaque, the formality of deconstruction, like the form of capital reproduction, blocks the real self-transformative activity that its self-transgressive moment continually *appears* to be intriguing. Capital's unconditioned affirmation cannot be fully distinguished from decon-

struction's affirmation, its 'yes, yes', 'it gives', without knowing and reflection. Once, however, the path of self-reflection is embraced the possibility of discovering an unconditioned opening disappears. If 'first' philosophy can only be pursued transcendentally, then self-reflection spells the end of first philosophy.

Post-modernist art and culture for its part really does attempt to over-come the duality between autonomous art and the mass art of the culture industry, but this is only to say that it is an art which is self-consciously in tune with both capital's self-transgression of all natural boundaries, all presence, and with capital's unnatural naturalism, its formal reduction of particularity to fungibility for the sake of further capital expansion, further self-transgression. Post-modernism, like deconstruction, repeats the Janus-faced ambiguity of capital, emancipatory and dominating at the same time. Hence the confusions surrounding post-modernism concerning its political orientation.

Art is or was a privileged social space for critique because it alone, among the rationally differentiated specialized spheres of practice (cognitive, practical, aesthetic), suffers or suffered that differentiation. Any attempt to mitigate that suffering, for example through keeping art aesthetic or prematurely letting art realize its desire for non-art (the false modernism of post-modernism), mutes the question of non-identity and with it the question of truth. Heidegger and Adorno, the oddest of couples, join forces over the recognition that the questions of modernity, history and truth must be posed together or the question of truth cannot be posed at all. The demand for an emphatic, non-adequation, conception of truth separates their critique from its pragmatist spectral image. It is, of course, truly terrible and terrifyingly ironic, and hateful because this recognition contains an ironic moment, that the human suffering and misery that is both the sufficient and final cause for Adorno's critical engagements, should find its cognitive echo in the marginalized practices of high – bour-geois – art. Modernity's marginality with respect to previous history has entailed that in it the exclusion/marginalization of the art of the victor has been a condition for its reconciled intersubjectivity, which hence puts high art in the position of the victim. This disjunction between the victims of modernity and the art that is the consciousness of their needs is played out in Adorno's theory in the antinomy of engaged content and radical form. Equanimity over this fateful disjunction, which is as much the dis-junction of high art from mass art as it is the disjunction of high art from what it is for, hence equanimity over history's ironizing of fate into irony, can only be had at the price of unconsciousness. This is the political unconsciousness of post-modernism. But that political blindness is neither random nor wilful; it is the constitutive antinomy of art's aesthetic negation of modernity.

What goes wrong, then, with the political interrogation of the cultural

significance of art is that it fails to perceive that significance as dependent on and a marker for an *absent* politics. Implicitly or explicitly, that absence has surfaced in each and every one of the writers examined: in the duality of beauty (as contemplation) and sublimity (as moral law) in Kant; in the end of great art, and the identity of great art and the *polis* in Heidegger; in the tragic politics that is the substantiality informing the sublime in Derrida; and, most formally and most weakly, in the opposition between the community-creating illusion rehearsed by the modernist work and the critique of engaged art in Adorno. Art cannot be directly politicized because art develops as a critical domain only through and in conjunction with the depoliticizing of what has come to be called 'politics'. Each account involved the acknowledgement that substantial possibilities for social transformation have been closed off, and that whatever remains of the impulse for and meaning of historical overcoming has devolved into works and what can be like them. Beauty bereaved, the mourning over beauty's alienation from truth and all that alienation has come to signify, is consummated in the bereavement over the loss of the political. This is the unspoken, the subtext of modern philosophy's entanglement with art and the aesthetic. It remains unspoken because all that can be said about it appears in what is substantial and categorially legitimated in its own right, namely, art and the discourse of aesthetics. Without a genealogy of liberalism, a genealogy that would give historical substance to the fabled suppression of the political offered in the Introduction, politics bereaved remains an abstraction. Yet without the effort to realize art's role as a stand-in for that absent politics, such a genealogy would lack categorial reach. Only as art does the absent political achieve categorial presence in modernity.

In different ways, all the philosophers we have been examining attempt to undo the given hierarchy of universal and particular by using the experience of art as a demonstration of the cognitive significance of sense-perceptibility beyond the limits laid out by Kant's (transcendental) separation of transcendental and empirical; an attempt that is motivated by the failures and successes of Kant's own aesthetic theory. Adorno's advance over the analyses of Heidegger and Derrida can be summarized in two theses. First, if history matters, if history and historicality have become the arena for questions of a suppressed praxis, then both modernity, as the specific formation and experience of universal and particular that is ours, and artistic modernism, as the specific form in which the challenge to that formation takes place, must be given prominence. Modernity and modernism must be thought together or art's challenge to theory will be reduced to a moment of theory. Secondly, Adorno does not refuse the moment of reflection, but attempts to intensify and radicalize it beyond its present standpoint. Philosophical reflection, as practiced by Adorno, is an extension of the reflection implicit in art works themselves.

Adorno's practice of determinate negation and speculative reflection attempts to elicit the precise fourfold departure of artistic reason from subsumptive reason: art's claim for the integrity of unique items against the hierarchical duality of universal and particular; its legitimation of sensuousness (happiness and embodiment) against abstract universality; its legitimation of creative action, genius as praxis, against productive, intentional action; and art's exemplification of concrete knowing, aesthetic reflection as *phronesis*, against subsumptive knowing. Art is the other of reason, but it is not an abstract negation of reason. This practice is difficult because it is a stand-in for an absent politics, a placeholder for it, and hence it is always and necessarily less practical, less 'political' than the reason and praxis it is exemplifying. To politicize art is to employ the rationality it refuses for the sake of the rationality it enjoins.

To claim that art is a stand-in for an absent politics is equivalent to claiming that, speculatively, art and politics are one, that they belong together, and that we can best understand the inability of modernity to unfold, its resistance to real transformation, through the separation of art and politics. We have seen numerous adumbrations of this thought throughout these pages: in the challenge the *sensus communis* offers to the Categorical Imperative, and in Kant's refusal of the memory and history situating the new discipline of 'aesthetics'; in Heidegger's account of the world-founding of the great work of art; in our account of the sublime as a transformed cipher of tragedy and its politics; and in the thesis that modernist works of art rehearse the praxis through which a collectivity is formed. The categorial claim of the speculative proposition that art and politics are one delineates reflectively what has been thought confusedly in the demand for either a politicization of aesthetics or an aestheticization of the political (this latter is arguably one feature of fascism). Only by eschewing an immediate assimilation of art to politics, however, can the true significance of art for politics be comprehended. This was the difficult path pursued by Adorno; but a path that comes clearly into view when we notice, with some surprise, that, unlike Heidegger, Adorno's defence of art makes *no* claims about what the future of art is to be. The aesthetics of the modernist sublime exhausts itself in its speculative comprehension: 'As eminently constructed and produced objects, works of art, including literary ones, point to a practice from which they abstain: the creation of a just life.' [23]

If art and politics are one, and art's challenge to theory is best understood in terms of the fourfold departure outlined above, then the political side of the speculative proposition would need to demonstrate, say in terms of a critical genealogy, that the liberal state, grounded on the precept of equal respect whereby each individual is free to pursue his or her own conception of the good life, operates a fourfold neutralization or evacuation of the political realm. This neutralization occurs fundamentally

through the separation of public and private, relegating the emphatic
claims of particularity, sensuousness and ethical praxis to the private
realm. It thereby leaves the public and political world to concern itself not
with concrete individuals, but with formal or legal persons, generalized
others viewed as bearers of abstract rights and entitlements; not with the
concrete needs and desires of others, but with legal claims of equal respect
before the law; not with praxis concerning the ethical future of the com-
munity as a whole, but with technical actions which will protect the public
world itself and underwrite the possibility of future capital reproduction.
Finally, because political action has become technical, then political cog-
nition is reduced to the investigation of means for achieving already given
ends. In summary, liberal politics is a politics without ethics (a concern
for the good and for happiness), knowledge or praxis. This claim has force
only on the condition that the claims of artistic modernism have force; the
force of those claims being, again, the speculative unity of art and politics.

To see better what is at issue in this speculative proposition, let us con-
sider again the claims of sensuousness. One of the central theses of Hegel's
aesthetics adopted by Adorno is the former's view that aesthetics must be
placed alongside the human consciousness of needs: 'And as long as these
needs persist, art will persist...Speechless by themselves, needs rely on art
to give expression to their being' (AT, 473; SAT, 512). Why are needs
speechless? Needs, desires and wants are speechless because they are
legislatively assigned and restricted to the private realm, an assignment
philosophically underwritten at the beginning of the modern age by
Descartes and Hobbes who restricted knowing to facts, leaving desire to
follow its own course: reason as knowing and contemplation was to be the
slave of the unreasoned ends of passion. In accordance with the apparent
respect the liberal state has for each, the attempt to draw the needs,
desires and feelings of individuals into the public realm would count as an
interference with their autonomy, their right to define the good life as they
please so long as they respect others' right to do the same. This is what
the primacy of right over good in modernity means.

Habermas, who for the most part presumes the correctness of this mod-
ern accomplishment, labels 'aesthetic-expressive'[24] the forms of discourse
in which our need interpretations are thematized, and whose semantic
content defines happiness and the good life. This coheres with the idea
that the good life is a (semi-)private affair, that is non-universalizable and
culturally specific, and hence outside the bounds of either truth or exter-
nal morality (legality and justice in their modern sense). In brief, this
labelling reveals, what our argument to here has been suggesting, that the
privatization of social meaning – what in pre-modern societies was repres-
ented by *ethos* and (popular) religion – is equivalent to the privatization,
the silencing of desire and need; a silencing that becomes harboured
materially in the domestic subject and formally in art. Adorno's thesis that

art must forsake happiness for the sake of happiness is grounded in the thesis that the price paid for generating the conditions that acknowledge each a *right* to happiness is the oblivion of the goal. And this for the precise reason that those conditions are the liquidation (that is, reification) of the self for whose sake the historical journey of modernity has been undertaken. The marker for that liquidation or disintegration, which is obviously sociologically and empirically contestable, is the fate of art and the aesthetic in modernity. Adorno's apparently hyperbolic analysis of modernity, an analysis that cuts across modernity's most sanguine self-pronouncements, only makes sense if it is understood in categorial terms.

Another passage through which a categorial analysis of the relation between politics and art must travel concerns the previously analysed dissolution of *praxis* into genius. Again, the claim here was that *praxis*, as understood by Aristotle, referred to actions done for their own sake, that is, for the sake of ends internal to the action. In its Kantian analysis, genius is free or autonomous action minus the formal constitution of autonomy by the Categorical Imperative. Genius is autonomy without formality. But it is more, for the work of genius is also without external purpose or end; its meaning, as an event, is internal to it. Genius, then, involves a double transformation of *praxis*: first, in accordance with the uniquely modern conception of freedom and liberty, genius transcribes praxial action into the action of interrupting existent meaningfulness for the sake of some other conception of meaningfulness; genius is political praxis become self-consciously historical. Secondly, however, *praxis* reaches modernity only as art, as illusion. Genius is *praxis* historicized and aestheticized.

This latter moment is dealt with optimistically in Kant because he failed to notice that the notion of aesthetic ideas involves the aestheticization of social meaningfulness, the aestheticization of our collective identity and understanding of the good (which is why the 'highest good' in Kant appears as an imaginative projection, a postulate, necessary for but external to the morality subtending it); hence the displacement of *praxis* into art, which makes art's praxis a pseudo-praxis, praxis as illusion and the illusion of praxis, is the consignment of society's historicality within a delimited and non-empirical sphere. This is why art becomes the interruption of social meaningfulness *without* the ability to begin history anew. Art images the idea of collective self-determination that is the presumptive privilege of liberal democracy; but because the latter separates the legal from the ethical, which is but another version of the separation of public and private, it leaves out of consideration any self that might matter in the way of self-determination. Art's pseudo-praxis rehearses self-consciously liberal democracy's blind pseudo-praxis. Nonetheless, art's pseudo-praxis at least gives an idea of what true praxis might be like.

The speculative writing of the unity of art and philosophy is the story

of the difficult praxis of 'aesthetic theory': the aestheticization of theory is
its becoming praxial, incomprehensible in the way that the modernist sub-
lime is incomprehensible; the theoretical telling of this continuation of the
reflective movement of art is the poietic revelation of praxis. Under these
circumstances speculation comes to appear as a form of judgement that
accepts that because of fragmentation what was judgement (*phronesis*) and
praxis are no longer possible. And this, again, is why art works can but
rehearse the praxis that is the constitution of a collectivity. Art and phil-
osophy are praxis and judgement in the absence of praxis and judgement;
they are political or ethical stand-ins for an absent politics. Hence they are
and are not that of which they speak.

It is perhaps tempting at this juncture to think that we might directly
conceptualize in concrete terms, that is, without the indirections involved
in historical reflection and speculation, what has been silenced in the
aestheticization of praxis and social meaning, and in the privatization of
desire and need. In a work that attempts to supplement Habermas's
defence of the standpoint of the generalized other, the standpoint of
rights and entitlements that represent the fulfilment of the moral point of
view, Seyla Benhabib constructs the standpoint of what she calls the 'con-
crete other'. This standpoint requires us

> to view each and every rational being as an individual with a con-
> crete history, identity, and affective-emotional constitution. Our
> relation to each other is governed by the norm of *complementary reci-
> procity*; each is entitled to expect and to assume from the other
> forms of behaviour through which the other feels recognized and
> confirmed as a concrete, individual being with specific needs, talents,
> and capacities. The norms of interaction are...the norms of soli-
> darity, friendship, love, and care.[25]

This standpoint, Benhabib states, has been silenced, even suppressed by
the liberal political tradition. Further, this suppression, she claims, has
been abetted by the social and epistemic exclusion of woman's voice and
activity from the public sphere.[26]

What goes wrong with Benhabib's construction is that she appears
to believe that it can be regarded as 'just' a rational supplement to
Habermas's theory, which is to say, 'just' a supplement to modernity in its
own self-understanding. *Pace* Benhabib, we can no more directly appre-
hend what is tokened by the silencing of woman's voice than we can
directly apprehend the incomprehensibility of the work of art; nor can we,
with any rigour, separate these two silences. They are part of the same
silence. That silence is complex; its elements are: the aestheticization of
praxis and social meaning (religion and *ethos*); the privatization of desire

and need; and the exclusion of the non-identical other (woman, labour, other races, etc.). To construct conceptually the missing standpoint forgets what rationalization has done to solidarity, friendship, love and care. Which is why Adorno was so sceptical about theories that attempted to restore through theoretical decree what history has fragmented and transformed: 'The concept of the person and its variations, like the I-Thou relationship, have assumed the oily tone of a theology in which one has lost faith' (ND, 277). How can we avoid considering the standpoint of the concrete other as but another version of the I-Thou relationship, another liberal political theology?

Art and politics are one; this speculative and aporetic proposition is the volitional analogue of Adorno's governing speculative proposition that art and philosophy are one. The absence of a concrete political programme in Adorno is a direct consequence of his view that the deformations of social life brought about by rationalization have displaced the elements that 'belong' to political life and activity. Hence his approaches to the other are never direct, and rarely made in terms coterminus with the now deformed discourse of the intimate sphere. Rather, he speaks of shudder, mimesis, affinity. Nonetheless, it must be conceded that Adorno's centre of attention fell squarely on the aporia affecting cognition and rationality rather than on the deeply analogous, and deeply entwined, aporia affecting volition.

Perhaps the gradual and continuing dissolution of the modernist sublime and the arrival of a political and theoretical feminism, which is its heir, makes Adorno's preoccupations appear dated. But if feminism is the heir of the modernist sublime, if to think and act in continuance with Adorno's project we must turn away from art and the aesthetic toward gender and race, then this politics and its thinking will of necessity be speculative and aporetic. Speculative propositions are neither statements of fact nor prescriptions. How, then, are they to be understood? Aesthetic judgement, we claimed, was the sublimated and aestheticized remnant of *phronesis*. *Phronesis* could not survive once the social bonds that sustained it disappeared. Autonomous art provided an illusory closure in which *phronesis* could find the support necessary for it. Art works, we might say, are an illusory *polis*, or an analogon of religious community. In thinking our fate now no such illusory support is possible; the 'we' that would sustain political judgement and praxis has disappeared from direct view; 'we' do not know, directly or immediately, who 'we' are. Our 'we' has gone underground, appears only through the theoretical tracing of the fate that has rendered us strangers to one another. 'We' come to know ourselves and recognize who we are only through the mediation of theory. By extension, practical insight into that situation will be equally and necessarily theory mediated. This is the corollary of works of art 'creating' communities of their own: the *sensus communis* as presupposed and yet to be

achieved. Judgement must migrate into theory. Speculative propositions are modernity's theoretical version of what once was *phronesis*, judgement. The continuance of self-reflection beyond transcendental self-reflection, which enacted a suppression of judgement, is the means and mode in which judgement becomes reinstated. We cannot return to judgement directly – the idle hope of modern neo-Aristotelians – since the conditions for it have been erased. Judgement now occurs only in and through self-reflection. Self-reflection is consummated and achieved in the elaboration of speculative propositions that utter our categorial predicament.

To rescue means to love things; this is experienced by consciousness both in terms of the marred figure of what we should love, and what the spell, the endogamy of consciousness, does not permit us to love (ND, 191). This political love, the unity of eros and knowledge, was exemplified in art works in their mimetic moment, and in philosophy's self-relinquishment of itself (identity thinking) in the face of art – which *was* the marred figure of what we should love, and what the spell of consciousness (subjectivity) did not permit us to love. Aesthetic negation and second (speculative) reflection, the movement of self-overcoming in art and philosophy respectively, were the discipline, the law of this love, their lawfulness without law. The law of love and the love of law are the 'more' subjectivity necessary for the overcoming of subjectivity.[27] The propositions stating the unity of philosophy and art, and art and politics, were this self-relinquishment and its comprehension, both love and law. Perhaps what is required now is the writing of new speculative propositions tracing the fate of subject and substance; perhaps philosophy and woman are one, and politics and woman are one. Since these speculative propositions would be neither statements of fact nor prescriptions of what ought to be, then we must acknowledge that such speculative thinking would be, as such, a form of political insight, political wisdom, *phronesis*, and a praxis. In our acknowledging this we would not be (just) following an inference or obeying an obligation; rather such an acknowledgement would be difficult, aporetic – an anxious act of political love.

Notes

Introduction Aesthetic Alienation

1 Jürgen Habermas, *The Philosophical Discourse of Modernity*, tr. Frederick Lawrence Cambridge: Polity Press, 1988), p. 95.

2 By post-positivist philosophy of science I mean, for example: Thomas Kuhn, *The Structure of Scientific Revolutions* (London: University of Chicago Press, 1970); Imre Lakatos, 'Falsification and the methodology of scientific research programmes', in *Criticism and the Growth of Knowledge*, ed. I. Lakatos and A. Musgrave (Cambridge: Cambridge University Press, 1970); Dudley Shapere, *Reason and the Search for Knowledge* (Dordrecht: D. Reidel Publishing, 1986). For the sort of categorial implications of these pre-supposed in my claims see: Gerald Doppelt, 'Kuhn's epistemological relativism: an interpretation and defense', *Inquiry*, 21 (1978), esp. p. 41.

3 The phrase comes from Gadamer; see below, chapter 2, note 37.

4 See J. Habermas, 'Philosophy as stand-in and interpreter,' in *After Philosophy: end or transformation*, ed. Kenneth Baynes, James Bohman and Thomas McCarthy (London: MIT Press, 1987), pp. 296–315; and chapter 5, section i below.

5 For an attempt at making this history available to English-speaking philosophers, see Andrew Bowie, *Aesthetics and Subjectivity: from Kant to Nietzsche* (Manchester: Manchester University Press, 1990).

6 Charles Taylor, *Sources of the Self* (Cambridge, MA: Harvard University Press, 1989), p. 510. The sympathies of this present work to Taylor's will become obvious. Indeed, my doubts about how far a linguistic or communitarian turn in philosophy can take us echoes Taylor's cautioning words against the language of commitment and Habermas' theory of language (pp. 509–10). Where I depart from Taylor is that he employs the discourses of

artistic modernism directly (chapters 23–4), while I believe that it is not the contents of these works which is most significant but their forms, which allows them and not philosophy to be the place where alternative conceptualizations of self, world and community are germinating (or as I believe, hibernating). Taylor makes too little of the fact that it is in art and aesthetics that he finds 'epiphanies' of sources of moral meaning beyond the self. In so doing he leaves open the charge that these epiphanies are just imagined, mere possibilities without cognitive purchase on us.

7 T. W. Adorno, *Prisms*, tr. Samuel and Shierry Weber (London: Neville Spearman, 1967), p. 34.

8 H. Arendt, *On Revolution* (Harmondsworth, Middlesex: Penguin Books, 1973), p. 52. See also her *The Human Condition* (Garden City, New York: Doubleday Anchor Books, 1959), pp. 64–6.

9 Adorno, *Prisms*, passim.

10 Arendt, *The Human Condition*, passim; G. W. F. Hegel, *Philosophy of Right*, tr. with notes T. M. Knox (Oxford: Clarendon Press, 1952), p. 10.

11 H. Arendt *Lectures on Kant's Political Philosophy*, ed. with an interpretive essay by Ronald Beiner (Hassocks: Harvester Press, 1982).

Chapter 1 Memorial Aesthetics: Kant's *Critique of Judgement*

1 Mary Mothersill, *Beauty Restored* (Oxford: Clarendon Press, 1984), p. 210.

2 Paul Guyer, *Kant and the Claims of Taste* (London: Harvard University Press, 1979), pp. 320–1.

3 See, for example, ibid., pp. 322–3; R. K. Elliot, 'The unity of Kant's "Critique of Aesthetic Judgement"', *British Journal of Aesthetics* 8, 3 (July 1968), p. 245; Ralf Meerbote, 'Reflection on beauty', in *Essays in Kant's Aesthetics*, ed. Ted Cohen and Paul Guyer (London: University of Chicago Press, 1982), p. 81; Salim Kemal, 'Aesthetic necessity, culture and epistemology', *Kant-Studien*, 74 (1980), pp. 203–4.

4 For a detailed reconstruction and criticism of this argument see Guyer, *Kant and the Claims of Taste*, ch. 8. For the argument which follows see esp. p. 295, and Elliot, 'Unity', p. 245.

5 See, for example, Elliot, 'Unity'; Kemal, 'Aesthetic Necessity'; Donald W. Crawford, *Kant;s Aesthetic Theory* (Madison: University of Wisconsin Press, 1974), chs 6–7; Kenneth F. Rogerson, 'The Meaning of Universal Validity in Kant's Aesthetics', *The Journal of Aesthetics and Art Criticism* 40 (1981), pp. 301–8.

6 Guyer, *Kant and the Claims of Taste*, p. 146.

7 Ibid., p. 143.

8 F. Nietzsche, *On the Genealogy of Morals*, tr. Walter Kaufmann and R. J. Hollingdale (New York: Vintage Books, 1969), third essay, section 6.

9 See Ted Cohen, 'Why beauty is a symbol of morality' and Dieter Henrich, 'Beauty and freedom: Schiller's struggle with Kant's aesthetics', both in Cohen and Guyer (eds), *Essays in Kant's Aesthetics*. Both these excellent essays pursue a reading of Kant's aesthetics along the lines I am intending to

follow, without, however, connecting their analyses to the status of the third *Critique* as a whole.

10　For detailed criticism of this line of interpretation see Guyer, *Kant and the Claims of Taste*, pp. 351–7; and Jeffrey Maitland, 'Two senses of necessity in Kant's aesthetic theory', *The British Journal of Aesthetics*, 16 (1976), pp. 347–53.

11　See Elliot, 'Unity', p. 258; and Crawford, *Kant's Aesthetic Theory*, pp. 133–42.

12　See n. 10 above.

13　Eva Schaper, *Studies in Kant's Aesthetics* (Edinburgh: Edinburgh University Press, 1979), ch. 4, 'Free and dependent beauty', passim.

14　I. Kant, 'What is orientation in thinking?' in *Immanuel Kant: Critique of Practical Reason and other writings in moral philosophy*, ed. and tr. Lewis White Beck (New York: Garland, 1976), p. 294.

15　Francis X. J. Coleman, *The Harmony of Reason: a study in Kant's aesthetics* (Pittsburgh: University of Pittsburgh Press, 1974), pp. 109–11.

16　P. de Man, 'Phenomenality and materiality in Kant', in *Hermeneutics: Questions and Prospects*, ed. Gary Shapiro and Alan Sica (Amherst: University of Massachusetts Press, 1984), pp. 121–44.

17　I. Kant, *The Doctrine of Virtue*, tr. Mary J. Gregor (Philadelphia: University of Pennsylvania Press, 1971), p. 448.

18　Ibid.

19　My way of formulating the issues in this section has been heavily influenced by my reading of Meerbote, 'Reflection on beauty'.

20　I. Kant, *Logic*, tr. Robert S. Hartman and Wolfgang Schwarz (Indianapolis, The Bobbs–Merrill Co., 1974), p. 100.

21　Meerbote, 'Reflection on beauty', p. 58.

22　Gilles Deleuze, *Kant's Critical Philosophy: the doctrine of faculties*, tr. Hugh Tomlinson and Barbara Habberjam (London: Athlone Press, 1984), pp. 59–60. For a detailing of this thought in terms of Kant's theory of schematism see Meerbote, 'Reflection on beauty', pp. 62–8.

23　That Kant's account of aesthetic judgement is finally psychological in character is the ultimate view of Guyer, *Kant and the Claims of Taste*.

24　This is the argument of sections V and VI of the 'Introduction' to the third *Critique*, which is worked out in more detail in I. Kant, *First Introduction to the Critique of Judgement*, tr. James Haden (New York: Bobbs-Merrill Co., 1965).

25　Meerbote, 'Reflection on beauty', p. 70.

26　Ibid., pp. 74, 79–80.

27　Ibid.

28　I. Kant, *Reflection*, 686, as quoted in P. Guyer, 'Pleasure and society in Kant's theory of taste', in Cohen and Guyer (eds), *Essays in Kant's Aesthetics*, p. 42. For the following objection see ibid., p. 52.

29　Kant, 'What is orientation in thinking?', p. 303.

30　Arendt, *Lectures on Kant's Political Philosophy*, esp. 'Sessions' 6, 7, 12 and 13.

31　Guyer, *Kant and the Claims of Taste*, p. 97. For the following thesis, pp. 97–8.

32 The 'looseness of fit' between the transcendental and empirical levels in
 Kant's epistemology has been the core of Gerd Buchdahl's valuable writings
 on Kant. See his *Metaphysics and The Philosophy of Science* (Oxford: Basil
 Blackwell, 1969), ch. 8, esp. pp. 651–65. The 'looseness of fit' underwrites
 the significance of the teleological element in Kant's philosophy of science,
 which itself makes Kant's epistemology begin to look a great deal more
 Hegelian than is usually supposed.
33 Henry Allison, *Kant's Transcendental Idealism* (London: Yale University
 Press, 1983), p. 225. For a critique of the idea of Kant as a phenomenalist,
 see pp. 30–4.
34 Meerbote, 'Reflection on beauty', pp. 72ff.
35 Guyer, *Kant and the Claims of Taste*, pp. 251, 252.
36 See J. M. Bernstein, *The Philosophy of the Novel: Lukacs, Marxism and the
 dialectics of form* (Hassocks: Harvester Press, 1984), pp. 101–2.
37 This objection was pointed out to me by Robert Pippin.

Chapter 2 The Genius of Being: Heidegger's 'The Origin of the Work of Art'

1 For an underlining of this see, Jacques Taminaux, *Recoupements* (Bruxelles:
 Ousia, 1982), chs 1–2.
2 M. Heidegger, *Kant and the Problem of Metaphysics*, tr. James S. Churchill
 (Bloomington: Indiana University Press, 1962), p. 194.
3 John Llewelyn, 'Heidegger's Kant and the middle voice', in *Time and Meta-
 physics*, ed. David Wood and Robert Bernasconi (Coventry: Parousia Press,
 1982), pp. 87–120; and his *Derrida on the Threshold of Sense* (London:
 Macmillan, 1986), pp. 117–18.
4 M. Heidegger, *Being and Time*, tr. John Macquarrie and Edward Robinson
 (New York: Harper and Row, 1962), sections 72–7.
5 *Hegel's Aesthetics*, tr. T. M. Knox (Oxford: Oxford University Press, 1975),
 p. 103.
6 This is the standard misreading of the essay; it construes Heidegger as
 offering an atemporal definition of what art is. For example see: David
 Halliburton, *Poetic Thinking* (Chicago: University of Chicago Press, 1981),
 ch. 2; and Sandra Bartky, 'Heidegger's philosophy of art', in *Heidegger: the
 man and the thinker*, ed. Thomas Sheehan (Chicago: Precedent Publishing,
 1981), pp. 257–74.
7 For a Heideggerian reading of Kant's aesthetics that follows on from *Kant
 and the Problem of Metaphysics*, see Jeffrey Maitland, 'An ontology of
 appreciation: Kant's aesthetics and the problem of metaphysics', *Journal of
 the British Society for Phenomenology*, 13, 1 (1982), pp. 45–68.
8 Gerald Doppelt, 'Kuhn's epistemological relativism: an interpretation and
 defense', *Inquiry*, 21 (1978), esp. p. 41.
9 Reiner Schürmann, *Heidegger on Being and Acting: from principles to anarchy*,
 tr. Christine-Marie Gros and Reiner Schürmann (Bloomington: Indiana
 University Press, 1987), p. 56.
10 On this see Michael Allen Gillespie, *Hegel, Heidegger, and the Ground of*

History (Chicago: University of Chicago Press, 1984), p. 171; and David Kolb, *The Critique of Pure Modernity: Hegel, Heidegger and after* (Chicago: University of Chicago Press, 1986), p. 227.

11 Schürmann, *Heidegger on Being and Acting*, p. 280.

12 See Mary McCloskey, *Kant's Aesthetics* (London: Macmillan, 1987), p. 108.

13 Ibid., p. 133 for a similar view.

14 Christopher Fynsk, *Heidegger: thought and historicity* (London: Cornell University Press, 1986), pp. 132, 135.

15 On Kant's genius-to-genius argument see Timothy Gould, 'The audience of originality: Kant and Wordsworth on the reception of genius', in *Essays in Kant's Aesthetics*, ed. T. Cohen and P. Guyer (London: University of Chicago Press, 1982), pp. 187–90. It was Gould's article and Guyer's 'Autonomy and integrity in Kant's aesthetics', *Monist*, 66 (1983), pp. 167–88, that first directed me toward the implications of Kant's theory of genius and its connections to artistic modernism. Gould ends his piece by saying: '…I suppose that the idea that a serious work of art must instruct its audience, that the instruction will tend to take the form of provocation, and that the effort to create works that bear the burden of human significance runs the risk of a radical failure of sense, are all articulations of modernism' (p. 192).

16 Ibid.

17 For a defence of art and 'progressive culture' see Salim Kemal, 'The importance of artistic beauty', *Kant-Studien*, 71 (1980), pp. 488–507; and his 'Aesthetic necessity, culture and epistemology', *Kant-Studien*, 74 (1983), pp. 176–205.

18 Guyer, 'Autonomy and integrity in Kant's aesthetics', pp. 165–186.

19 Ibid.

20 S. Cavell, *Must We Mean What We Say?* (New York: Charles Scribner and Sons, 1969), p. 52.

21 John McDowell, 'Virtue and reason', *Monist*, 62 (1979), p. 332.

22 For a sharp defence of the view that Heidegger takes his idea of a new (second) beginning from Descartes, see Robert Bernasconi, 'Descartes in the history of being: another bad novel?', *Research in Phenomenology*, 17 (1987), pp. 75–102.

23 Kolb, *The Critique of Pure Modernity*, p. 145.

24 On the epoch of technology as the eschatological fulfilment of metaphysics see Gillespie, *Hegel, Heidegger, and the Ground of History*, pp. 135–6, 144, 149–64.

25 For the necessity of linking art and technology in this way in Heidegger see Otto Pöggeler, '"Historicity" in Heidegger's late work', tr. J. N. Mohanty, *Southwestern Journal of Philosophy*, 4 (1973), p. 64.

26 Fynsk, *Heidegger*, p. 134.

27 For the most complete account of 'earth' in Heidegger see Michel Haar, *Le Chant de la Terre: Heidegger et les assises de l'Histoire de l'Etre* (Paris: L'Herne, 1985).

28 On the rift see Fynsk, *Heidegger*, pp. 142ff; J. Derrida, 'Le retrait de la métaphore', *Poesie*, 7 (1978), pp. 103–26; and Rodolphe Gasché, 'Joining the Text: from Heidegger to Derrida', in *The Yale Critics: deconstruction in America*, ed. Jonathan Arac et al. (Minneapolis: University of Minnesota Press, 1983), pp. 156–75.

29 Fynsk, *Heidegger*, p. 144.

30 Gregory Schufrieder, 'Heidegger on community', *Man and World*, 14, 1 (1981), p. 34.

31 M. Heidegger, *Einführung in die Metaphysik* (Tübingen: Max Niemeyer Verlag, 1953), p. 102; *An Introduction to Metaphysics*, tr. Ralph Mannheim (Garden City, New York: Anchor Books, 1961), p. 113. Translation here and for the next quote follows Schufrieder, p. 35.

32 Heidegger, ibid., *Einführung*, p. 117; tr. p. 128; Schufrieder, 'Heidegger on community', p. 36. For a delicate presentation of the Hegelian account of this same issue see Gillian Rose, *Hegel Contra Sociology* (London: Athlone Press, 1981), pp. 124–6.

33 Following the implicit hint in the writings of Gadamer and Arendt, Robert Bernasconi and Jacques Taminiaux have been tracing this work of retrieval in Heidegger's thought: Robert Bernasconi, 'The fate of the distinction between *praxis* and *poiesis*', *Heidegger Studies*, 2, pp. 111–39; Jacques Taminiaux, 'Poiesis and praxis in fundamental ontology', *Research in Phenomenology*, 17 (1987), pp. 137–69.

34 My departure here from the reading of Heidegger by Bernasconi and Taminiaux is grounded in the view that they read Arendt too naively. While it is certainly true that her concept of 'action' in *The Human Condition* (Garden City, New York: Doubleday Anchor Books, 1959) is an attempt at retrieving Aristotelian *praxis*, her placement of action in the *polis* is dubious. As becomes evident in her *On Revolution* (Harmondsworth: Penguin Books, 1973), esp. ch. 1, her attribution to 'action' of freedom and a concern for new beginnings draws heavily on the modern experience of revolution, one which she relates back to the new science and Descartes (p. 46). In brief, Arendt's *The Human Condition* operates the same backward-looking projection onto Aristotle that I am claiming Heidegger operates, a lapse made good in *On Revolution*.

35 Heidegger, *Being and Time*, §74; the translation here follows that in Phillipe Lacoue-Labarthe, 'Transcendence ends in politics', tr. Peter Caws, *Social Research*, 49 (Summer 1982), p. 426.

36 This primacy of the speculative and theoretical over the political in Heidegger has been elegantly documented in Lacoue-Labarthe, ibid., passim.; and in Taminiaux, 'Poiesis and praxis in fundamental ontology', pp. 157–62. This suppression of the political is a direct consequence of Heidegger's treatment of freedom. In his excellent 'Dawn and dusk: Gadamer and Heidegger on truth', (*Man and World* 19 (1986), pp. 21–53) Francis J. Ambrosio correctly states that for Heidegger freedom 'is thought in terms of *Ereignis/Aletheia*, understood as giving Time (extending the Open) and Being (destiny) and thereby binding and guiding thought to itself as the matter to-be-thought...*Ereignis/Aletheia*...frees time and Being by appropriating them first to each other and then secondarily to Dasein...' (pp. 48–9). For a literal application of this thought to the question of justice, see N, 165–9.

Recent work on Heidegger's politics do not seem to me to have added anything substantial in particular Luc Ferry and Alain Renaut, *Heidegger and Modernity*, tr. Franklin Philip (London: University of Chicago Press, 1990);

Jean-François Lyotard, *Heidegger et 'Les Juifs'* (Paris: Galilée, 1988); and Lacoue-Labarthe, *Heidegger, Art and Technology*, tr. Chris Turner (Oxford: Basil Blackwell, 1990). This last falls short of what Lacoue-Labarthe had achieved in his essay on the same topic, although on pp. 56-60 and 64-74 there are some suggestive comments on the whole question of the aestheticization of the political in Heidegger.

37 The claim that the overcoming of modern futility requires a reconstituted political realm is essential to the argument of Arendt, *The Human Condition*. I have tried to say something more about nihilism and political/aesthetic legislation in my 'Autonomy and solitude', in *Nietzsche and Modern German Thought*, ed. Keith Ansell Pearson (London: Routledge, forthcoming).

38 Space prohibits me from providing a detailed account of Gadamer's conception of aesthetic alienation. Nonetheless, three points should be metioned. (i) Gadamer regards Kantian aesthetics as a work of subjectivization. At bottom, this subjectivization is for Gadamer a work of consciousness, its abstracting or differentiating the work from the world (TM, 73-8). (ii) What is subjectivized in aesthetic discourse is the discourse, language and practice, of civic humanism. This humanist tradition is thus the explicit and concrete historical instantiation of the lost common sense I proposed in chapter 1. In providing this historical substance to aesthetic subjectivity, Gadamer is attempting to reconnect art and life, to return art to the world and cognition. (iii) Gadamer's account fails quite simply because he fails to take the separation of art and world in modernity seriously enough, a fact adumbrated in his making aesthetic alienation a fact of consciousness. Nonetheless, it should be clear to the reader that the path I am pursuing owes much to Gadamer's diagnosis and analysis.

39 Meyer Schapiro, 'The still life as a personal object: a note on Heidegger and Van Gogh', in *The Reach of the Mind*, ed. M. I. Simmel (New York: Springer Publishing Company, 1968), pp. 203-9. This will be discussed in chapter 3, sections ii and iii below.

40 See M. Heidegger, 'Art and space', tr. Charles H, Seibert, *Man and World*, 6/1 (Feb. 1973), pp. 3-8. For a commentary on this stretch of Heidegger's thought see Kathleen Wright, 'The place of the work of art in the age of technology', *Southern Journal of Philosophy*, 22, 4 (1984), pp. 565-82. While I find myself in agreement with Wright's analysis of modern sculpture on p. 576, it reads to me as modernist in an Adornoesque sense. Conversely, I find her invocation of a dwelling place with respect to the Van Gogh unpersuasive; worse, it drifts very close to the idea of affirmative culture. Nonetheless, Wright is one of the few authors who place Heidegger's writings on art in the appropriate context.

Chapter 3 The Deconstructive Sublime: Derrida's *The Truth in Painting*

1 M. Heidegger, *On Time and Being* (New York: Harper Torchbooks, 1972), p. 9.

2 Ibid.

3 Ibid. On this in relation to Hegel see Robert Bernasconi, *The Question of Language in Heidegger's History of Being* (London: Macmillan, 1985), ch. 1.

4 J. Derrida, 'Sending: on representation', *Social Research*, 49, 2 (1982), pp. 317–22.

5 Rodolphe Gasché, *The Tain of the Mirror: Derrida and the philosophy of reflection* (London: Harvard University Press, 1986), pp. 242–6.

6 Maurice Blanchot, *Le Livre à Venir* (Paris: Editions Gallimard, 1959), p. 320. Olivier Serafinowicz drew this passage to my attention and provided the translation. On the movement from being to text, see Rodolphe Gasché, 'Joining the Text: from Heidegger to Derrida', in *The Yale Critics: deconstruction in America*, ed. Jonathan Arac et al. (Minneapolis: University of Minnesota Press, 1983), pp. 156–75.

7 See John Llewelyn, 'Belongings', *Research in Phenomenology*, 17 (1987), pp. 117–35.

8 Jacques Derrida, *Spurs: Nietzsche's styles*, tr. Barbara Harlow (London: University of Chicago Press, 1979), pp. 115–19.

9 Jacques Derrida, *The Post Card: from Socrates to Freud and beyond*, tr. Alan Bass (London: University of Chicago Press, 1987), pp. 468–78.

10 Jacques Derrida, *Dissemination*, tr. Barbara Johnson (London: University of Chicago Press, 1981), p. 223. My account follows Gasché, *The Tain of the Mirror*, pp. 256–62.

11 Jacques Derrida, *Positions*, tr. Alan Bass (London: Athlone Press, 1982), p. 69.

12 Gasché, *The Tain of the Mirror*, p. 257.

13 Derrida, *Dissemination*, p. 291.

14 Gasché, *The Tain of the Mirror*, pp. 258–9.

15 Derrida *Positions*, p. 69.

16 Gasché, *The Tain of the Mirror*, p. 261.

17 Jacques Derrida, 'From restricted to general economy: an Hegelianism without reserve', in *Writing and Difference*, tr. Alan Bass (London: University of Chicago Press, 1978).

18 See Christopher Fynsk, *Heidegger: thought and historicity* (London: Cornell University Press, 1986), ch. 1 for a splendid account of this, esp. pp. 34–9.

19 Derrida, *Writing and Difference*, pp. 256–7. On this see J. M. Bernstein, 'Lukács' wake: praxis, presence and metaphysics', in *Lukács Today*, ed. T. Rockmore (Dordrecht: Reidel, 1988).

20 The phrase is Jonathan Lear's, in 'The disappearing "we"', *Aristotelian Society* suppl. 58 (1984), p. 233.

21 Derrida, *Dissemination*, p. 258; see Gasché, *The Tain of the Mirror*, pp. 212–24.

22 Meyer Schapiro, 'The still life as a personal object: a note on Heidegger and Van Gogh', in *The Reach of the Mind*, ed. M. I. Simmel (New York: Springer Publishing Company, 1968), pp. 206–7.

23 Derrida, *Spurs*, p. 111.

24 See Jacques Derrida, 'On the essence of truth', in *Basic Writings*, ed. David F. Krell (London: Harper and Row, 1977), pp. 135–6.

25 J. Derrida, *Speech and Phenomena*, tr. David B. Allison (Evanston: North-western University Press, 1973), pp. 48–87.

26 The 'non-transcendentalizable' other of this reading of the beautiful concerns disgust and vomit (E, 22–5). In *Glas*, tr. J. P. Leavey, Jr and R. Ravel (London: University of Nebruska Press, 1986), pp. 150 and 162, Derrida thinks the non-transcendentalizable other generally as 'the system's vomit'. How such relates to Platonic mud and hair is a moot question.

27 Jacques Derrida, *Of Grammatology*, tr. G. C. Spivak (Baltimore: Johns Hopkins University Press, 1976), p. 158. See Gasché, *The Tain of the Mirror*, pp. 279–82.

28 I. Kant, *Anthropology from a Pragmatic Point of View*, tr. Mary J. Gregor (The Hague: Martinus Nijhoff, 1974), §68, pp. 110–11. All the following quotes from this text are from these pages.

29 I. Kant, *Critique of Practical Reason*, tr. L. W. Beck (New York: Bobbs-Merrill Co., 1958), p. 30. On the awakening of self-consciousness through the threat of violence see P. Hoffman, *Doubt, Time and Violence* (London: University of Chicago Press, 1988).

30 Gasché, *The Tain of the Mirror*, ch. 6.

31 Ibid., p. 231.

32 S. Freud, 'Mourning and melancholia', in *On Metapsychology: the theory of psychoanalysis*, Pelican Freud Library, vol. 11 (Harmondsworth, Middlesex: Penguin Books, 1984), pp. 245–68.

33 J. M. Bernstein, 'From self-consciousness to community: act and recognition in the master-slave relationship', in *The State and Civil Society*, ed. Z. A. Pelczynski (Cambridge: Cambridge University Press, 1984).

34 Jacques Derrida, *Glas*, tr. John Leavey and Richard Rand (Lincoln: University of Nebraska Press, 1986), p. 139 (all references are to the left-hand column).

35 Ibid., p. 167.

36 G. W. F. Hegel, *The Phenomenology of Spirit*, tr. A. V. Miller (Oxford: Oxford University Press, 1977), pp. 402–7.

37 Derrida, *Glas*, p. 102.

38 Ibid., p. 166.

39 P. Lacoue-Labarthe, 'On the sublime', ICA Documents 4: Postmodernism (London, 1986), p. 9. See also his *Typography* (London: Harvard University Press, 1989), pp. 109–10ff.

40 This is elegantly argued in the second part of William Booth's *Interpreting the World: Kant's philosophy of history and politics* (London: University of Toronto Press, 1986).

41 I. Kant, *The Metaphysical Elements of Justice*, tr. John Ladd (New York: Bobbs Merrill Co., 1965), p. 321.

42 Derrida, *Writing and Difference*, p. 126.

43 Gillian Rose, *Dialectic of Nihilism*, pp. 162–9.

44 Jacques Derrida, 'Like the sound of the sea deep within a shell: Paul de Man's war', *Critical Inquiry*, 14 (Spring 1988), p. 62. The following argument was suggested to me by Olivier Serafinowicz.

45 Derrida, *Glas*, p. 243.

46 Jacques Derrida, *Limited Inc.* (Evanston: Northwestern University Press, 1989), pp. 148–9. For a less autobiographical statement of the same, see *Of Spirit: Heidegger and the question*, tr. Geoffrey Bennington and Rachel Bowlby (London: University of Chicago Press, 1989), pp. 129–36. Much of what Derrida says here in making affirmation logically prior to reflection and questioning is plausible, for example 'Language is *already* there, in advance...at the moment at which any question can arise about it. This advance is, before any contract, a sort of promise or originary alliance to which we must have in some sense already acquiesced, already said *yes*, given a pledge...whatever may be the negativity or problematicity of the discourse which may follow' (p. 129). Given this plausibility, let me clarify the direction my questioning will take. What I am attempting to question is the providing of this 'yes' with a transcendental status, a priority that is resistant to what, historically and empirically, comes of it. Part of my doubt concerns the way in which this affirmation voids history of its constitutive effects. But even this would not matter if it were possible to decipher what Derrida's pre-originary affirmation, 'pledge', 'promise' or 'faith' was an affirmation of or faith in. What Gillian Rose says of Foucault (*Dialectic of Nihilism*, p. 207) applies with equal force here: 'Neither positive nor negative, such affirmation is without determination or characteristic; it does not represent an encounter with the power of another but an ecstasy of blind laughter or blinding tears, which...is simply that old familiar despair.' Certainly, what Derrida says here about language does not help to give any direction or determination to this (transcendental) affirmation. Thus even if it is the case that affirmation is in some sense conditional for undertaking certain or all activities, that we make this affirmation concrete only as a result of specific entanglements, that actual affirmations are empirical, defeasible and a *result*, deprives the idea of pre-originary affirmation of any force – or rather its meaning and force is so utterly dependent on what comes of actual affirmations or their opposite that the pre-originary disappears as an identifiable kind of relation. To believe otherwise would be to separate the event of affirmation from its effects, its meaning from its reception. And while believing in this radical separation may simplify our ethical lives, it also radically falsifies it. This, of course, is just the Hegelian challenge to the transcendental/empirical distinction, whose most emphatic presentation is to be found in his account of the 'causality of fate'. I have discussed this, among other places, in my 'The causality of fate: modernity and modernism in Habermas', *Praxis International*, 8, 4 (Jan. 1989), pp. 407–25. As will be clear from that, to deny pre-originary affirmation is not the same as denying pre-thematic involvements that do matter to our ethical lives.
 I should add that I doubt that the Kantian self-description that Derrida now offers actually does apply to his work of the 1960s; and hazard that the long footnote in *Of Spirit* which is a biographical tracing of affirmation in Heidegger is also a kind of autobiographical apologia.

47 My colleague Simon Critchley will argue in a forthcoming book on Derrida and Levinas, *The Ethics of Deconstruction*, that: (i) deconstruction is a reading of the texts of the tradition of metaphysics at its closure; (ii) the ethical force

of deconstructive reading is and must be, Levinasian; and (iii) no significant politics can emerge from the ethics of deconstructive reading.

Chapter 4 Constellations of Concept and Intuition: Adorno's *Aesthetic Theory*

1 The conception of modernism as a Kantian categorial quest for the autonomous meaning of some artistic domain is best worked out in the writings of Clement Greenberg and Michael Fried. For an account of their work in the context of philosophical modernism see Stephen Melville, *Philosophy Beside Itself: on deconstruction and modernism* (Minneapolis: University of Minnesota Press, 1986), ch. 1.

2 Jean-François Lyotard considers that the sublime presentation of the unpresentable affirmatively exhausts the meaning of modernity and postmodernism. See his *The Postmodern Condition* (Minneapolis: University of Minnesota Press, 1984).

3 Peter Bürger, *The Theory of the Avant-Garde*, tr. Michael Shaw (Minneapolis: University of Minnesota Press, 1984); and J. M. Bernstein *The Philosophy of the Novel: Lukacs, Maxism and the dialectics of form* (Hassocks: Harvester Press, 1984), pp. 217–20 (on Mann).

4 At AT 201 Adorno states that art is not a synthesis. Procedurally, Adorno is always intent on demonstrating the limits of theoretical classifications. This is part of what is involved in acknowledging the non-identity of the phenomena discussed.

5 I. Kant, *The Moral Law: Kant's Groundwork of the Metaphysic of Morals*, tr. H. J. Paton (London: Hutchinson, 1948), p. 96.

6 Fredric Jameson, 'Postmodernism, or the cultural logic of capital', *New Left Review*, 146 (July/August 1984); all references are to pp. 58–9.

7 See Bernstein, *The Philosophy of the Novel*, pp. 120–2, 139–45.

8 See J. Habermas, *The Philosophical Discourse of Modernity*, tr. Frederick Lawrence (Cambridge: Polity Press, 1987), p. 14.

9 T. W. Adorno, *Illuminations*, tr. Harry Zohn (London: Fontana Books, 1970), p. 258.

10 On this see Michel Haar's superb 'The end of distress: the end of technology?', *Research in Phenomenology* 13 (1983). On the account I am pressing here Heidegger's difficulty is that he cannot sustain finitude except by anchoring it; being is that anchoring. Thus our neediness becomes dependent upon being's, and thereby secondary. Heidegger cannot explain why our suffering matters except as derivative from being's – which then makes ours not matter, unable to enter into the narrative of need. While it may be tempting, therefore, to think that when Heidegger says 'A regard to metaphysics prevails even in the attempt to overcome metaphysics. Therefore our task is to cease all overcoming, and leave metaphysics to itself' (*On Time and Being*, p. 24), he is opening up the possibility of a vision of finitude without support, this takes too little heed of both how difficult such a vision is, and

above all why he thought that the language of lack needed displacing by some form of affirmation. Turning is following being in its withdrawal; this resolute passivity is the opening to transcendence in Heidegger. It is also the moment that leaves subjects bereft.

11 I. Kant, *The Doctrine of Virtue*, tr. Mary J. Gregor (Philadelphia: University of Pennsylvania Press 1971), p. 470.

12 Ibid., p. 472 for this and the next quote.

13 But see Derrida's 'The politics of friendship', *The Journal of Philosophy*, 85, 11 (Nov. 1988), pp. 632–44. For a hint as to how he might read Kant, see p. 640.

Chapter 5 Old Gods Ascending: Disintegration and Speculation in *Aesthetic Theory*

1 J. Habermas, *The Theory of Communicative Action*, vol. I: *Reason and the Rationalization of Society*, tr, Thomas McCarthy (London: Heinemann, 1984), p. 144.

2 J. Habermas, 'Philosophy as stand-in and interpreter', in *After Philosophy: end or transformation?*, ed. K. Baynes, J. Bohman and T. McCarthy (London: MIT Press, 1987), pp. 298–9.

3 H. H. Gerth and C. W. Mills (eds). *From Max Weber* (Oxford: Oxford University Press, 1969), p. 328.

4 Ibid. On the clash between the religion of brotherliness and the 'unbrotherly aristocracy of the intellect', see p. 356. For the beginning of a substantive account of Weber along the lines suggested here, see Stephen Kalberg, 'Max Weber's types of rationality', *American Journal of Sociology*, 85, 5 (1989), pp. 1145–79.

5 Ibid., p. 357.

6 Ibid., pp. 147–8.

7 Ibid ., p. 149.

8 Ibid., p. 144. If the argument I am pursuing here is right then Richard Rorty's claim in *Contingency, Irony, and Solidarity* (Cambridge: Cambridge University Press, 1989) that 'The vocabulary of self-creation is necessarily private...[and] the vocabulary of justice is necessarily public and shared' (p. xiv) misplaces the difficulty that private and public, art and politics have become for us; how, above all, that division leaves the privte futile and the public empty. Indeed, Rorty is a perfect example of how refusal to reflect on just such categories as public and private, politics and art, leaves the deformations of those realms of experience invisible, and thus the anxieties attaching to them unreflected. As if we knew and were content with our private self-creations; as if these had not become a source of bewilderment and frustration through their continuing inability to deliver their promise; as if, finally, who I fashion myself *as* can be sensible, above all to me, apart from questions of suffering and justice. Rorty's irony is not so much false as too easy; his sense of contingency too absolute. See here the concluding arguments to chapter 4 above.

9 For an examination of the role and limits of form-giving (construction) and mimesis in the novel see J. M. Bernstein, *The Philosophy of the Novel: Lukács, Marxism and the dialectics of form* (Hassocks: Harvester Press, 1984).

10 Dieter Henrich, 'Beauty and freedom: Schiller's struggle with Kant's aesthetics', in *Essays in Kant's Aesthetics*, ed. Ted Cohen and Paul Guyer (London: University of Chicago Press, 1982), p. 244.

11 T. W. Adorno, *Philosophy of Modern Music*, tr, Anne G. Mitchell and Wesley V. Blomster (London: Sheed and Ward, 1973), p. 126.

12 The 'loss of meaning' at issue here has the precise Weberian/Nietzschean sense of traditional categories of meaningfulness losing their authority through the fragmentation dislocating particular forms of practice from the totality.

13 For a brief account of Adorno's project for a modernist philosophy see J. M. Bernstein, 'The causality of fate: modernity and modernism in Habermas', *Praxis International* 8, 4 (Jan. 1989), pp. 413–15. A revised version of this will appear in J. M. Bernstein, *The Fate of Critical Theory from Habermas to Adorno* (London: Routledge, forthcoming).

14 I have attempted to explicate some of Adorno's comprehension of Beckett and provide an Adornoesque reading of *Endgame* in J. M. Bernstein, 'Philosophy's refuge: Adorno in Beckett', in *Philosophers' Writers*, ed. David Wood (London: Routledge and Kegan Paul, 1990). For an analogous reading of the play see Stanley Cavell's 'Ending the waiting game', in his *Must We Mean What We Say?* (New York: Charles Scribner and Sons, 1969), pp. 115-62.

15 Habermas, *The Theory of Communicative Action*, vol. I, p. 391.

16 Ibid., p. 390.

17 See Bernstein, 'The Causality of Fate', pp. 407–25.

18 *Aesthetics and Politics: debates between Bloch, Lukács, Brecht, Benjamin, Adorno* (London: New Left Books, 1977), p. 123.

19 Most notably in T. W. Adorno, *Negative Dialectics*, Part III, Section II, 'World spirit and natural history'.

20 All the quotes here are from G. W. F. Hegel, *The Phenomenology of Spirit*, tr. A. V. Miller (Oxford: Oxford University Press, 1977), pp. 37–9. The best single piece on speculative propositions in Hegel is Jere Paul Surber, 'Hegel's Speculative Sentence', *Hegel-Studien*, 10 (1975), pp. 212–30.

21 See the introduction and essays in J. M. Bernstein (ed.), *The Culture Industry: selected essays by T. W. Adorno on mass culture* (London: Routledge and Kegan Paul, 1990).

22 See note 21 above.

23 T. W. Adorno, *Aesthetics and Politics*, tr. Thomas McCarthy (London: Heinemann, 1984), p. 194.

24 Habermas, *The Theory of Communicative Action*, vol. I, p. 238. For an excellent interrogation of Habermas on this matter, see Thomas McCarthy, 'Reflections on rationalization in *The Theory of Communicative Action*', in *Habermas and Modernity*, ed. R. J. Bernstein (Cambridge: Polity Press, 1985), pp. 177–91. The inadequacy of Habermas's views here has also been subject to a thorough discussion in David Ingram, *Habermas and the dialectic of reason* (London: Yale University Press, 1987), pp. 172–88.

25 Seyla Benhabib, *Critique, Norm, and Utopia* (New York: Columbia University Press, 1986), p. 341.

26 Ibid., p. 409. For an extended critique of Benhabib see J. M. Bernstein, 'The politics of fulfilment and transfiguration', *Radical Philosophy*, 47 (Autumn 1987), pp. 21–7. This essay also will appear in Bernstein, *The Fate of Critical Theory*.

27 I borrow this phrasing from Gillian Rose.

Index